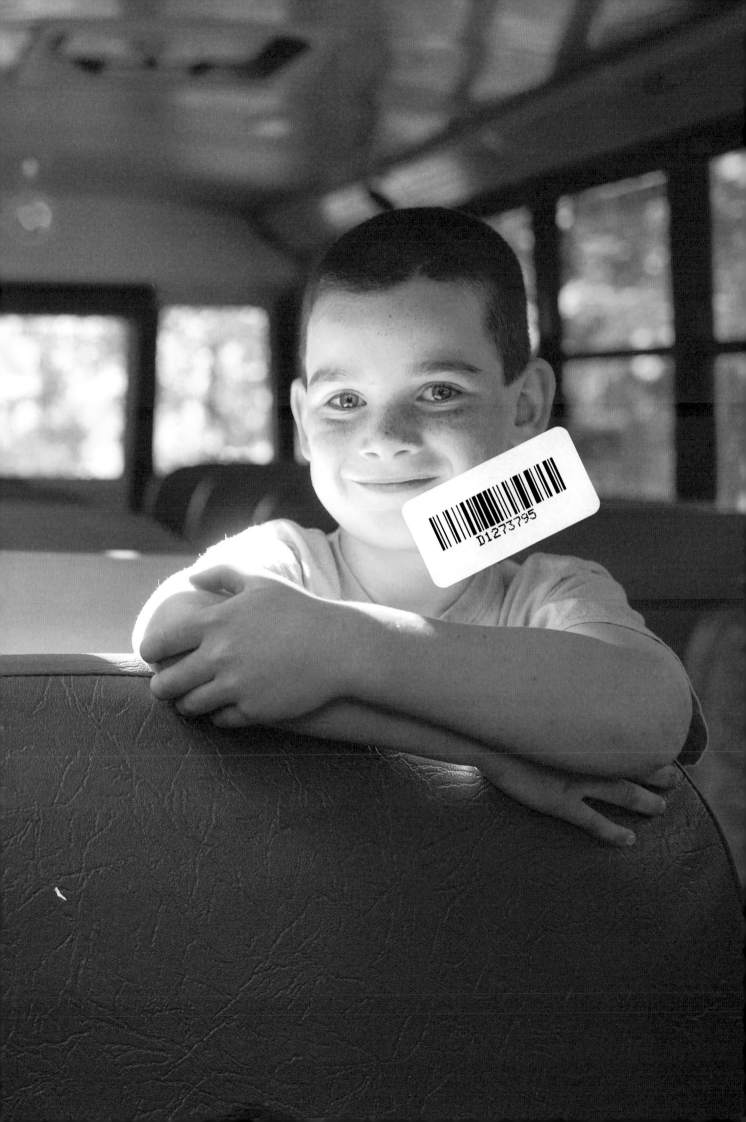

ANOTHER LIFE IS POSSIBLE

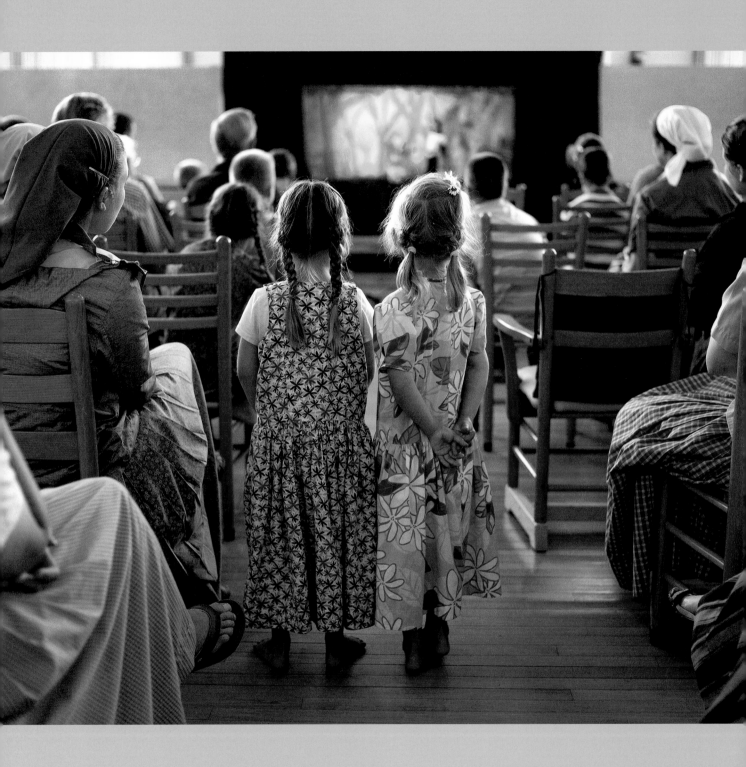

ANOTHER
LIFE IS
POSSIBLE

INSIGHTS FROM
100 YEARS OF
LIFE TOGETHER

CREATED BY
CLARE STOBER
PHOTOGRAPHY BY
DANNY BURROWS
FOREWORD BY
ROWAN WILLIAMS

Plough

PLOUGH PUBLISHING HOUSE

Published by Plough Publishing House
Walden, New York
Robertsbridge, England
Elsmore, Australia
www.plough.com

AnotherLifeIsPossible.com

ISBN: 978-0-874-86316-1

24 23 22 21 20 1 2 3 4 5 6 7 8

Library of Congress Cataloging-in-Publication Data

Names: Stober, Clare, 1955- author.
Title: Another life is possible.
Description: Walden, New York : Plough Publishing House, 2020. | Summary:
 "A stunning photo essay paired with 100 stories of members gives a rare
 glimpse into an intentional community that has stood the test of time"
 --Provided by publisher.
Identifiers: LCCN 2019056801 (print) | LCCN 2019056802 (ebook) |
 ISBN9780874863161 (hardback) | ISBN 9780874863178 (ebook)
Subjects: LCSH: Bruderhof Communities--Biography | Bruderhof
 Communities--United States--Biography. | Bruderhof Communities
 --Pictorial works.
Classification: LCC BX8129.B68 A25 2020 (print) | LCC BX8129.B68 (ebook)
 | DDC 289.7/3--dc23
LC record available at https://lccn.loc.gov/2019056801
LC ebook record available at https://lccn.loc.gov/2019056802

CONTENTS

FOREWORD
BY ROWAN WILLIAMS

The church of God is repeatedly reminded of what it actually is by the way God calls believers to take community seriously, generation after generation. The church, in the widest sense, constantly slips back into being either a hierarchical body where some decide and others obey, or else a loose association of individuals sharing a common inspiration but little else. The Bruderhof movement has, over the last century, firmly and consistently declared that neither of these will do. The Good News is nothing if not embodied in a style of living together – learning, praying, working, deciding together – that simply manifests what God makes possible. As our civilization shakes and fragments, and begins to recognize belatedly what violence it has done to the whole created order as well as to the deepest levels of human dignity, this embodied witness is more and more significant.

The Bruderhof communities are not the creation of wild and eccentric religious speculation. These are people who accept the great central mysteries of the Christian faith – the eternal threefold life and love of God, the coming of God's Word in the flesh – and seek only to live in faithfulness to the gifts of the Spirit and the guidance of Scripture, read prayerfully and intelligently in fellowship. For all who call themselves Christian, this simple witness to the implications of the classical central affirmations of faith should give pause. If God is truly as we say; if Christ's spirit is truly manifest – as Paul says – in the style in which we live together without resentment, rivalry, and fear; if the Christian is truly set free from the violent power structures of this world; why are the priorities and practices of the Bruderhof not more evident in other Christian communities? The Bruderhof gently holds up a mirror to the Christian world and asks, "Why not this?"

My own contacts with the community have been a joy and enrichment over many years. The Darvell community has welcomed me as a guest, and I have had the special pleasure of sharing a little in the educational life of the group, speaking with children in the school and discussing some of the publishing work. One of the most striking things about the Bruderhof is what you might call their spiritual and intellectual hospitality – as warm as the literal hospitality the visitor experiences. This is a community willing to learn from and to celebrate the early Christians and Saint Francis, Catholics such as Dorothy Day and Thomas Merton, Jean Vanier and the L'Arche communities, Russian

Christians such as Dostoyevsky and Tolstoy, and many more. In that sense, this is a genuinely catholic reality, a community seeking to nourish itself with the wisdom and experience of the whole Christian family extended in time and space. There is no sectarian aggression here – clear and uncompromising principle, yes, but not the urge to demean or despise others.

This is a beautiful book on several levels, beautiful in the images it gives of simple and harmonious relation with an environment, but beautiful also in its chronicling of lives that have been held and healed in this shared enterprise of the Spirit. It is a gift, and a welcome one – but above all a gift that speaks of the first and greater gift of the presence of the Bruderhof in this world. My friends on the Bruderhof are witnesses to the peaceable kingdom – not merely people who believe peace is an ideal worth pursuing, but men, women, and children who trust the God of peace sufficiently to give their lives to incarnating the peace of God. I hope this book will help all its readers learn something of how such trust becomes possible and real.

Rowan Williams, Archbishop of Canterbury from 2002 to 2012, is a master of Magdalen College in Cambridge and chancellor of the University of Wales.

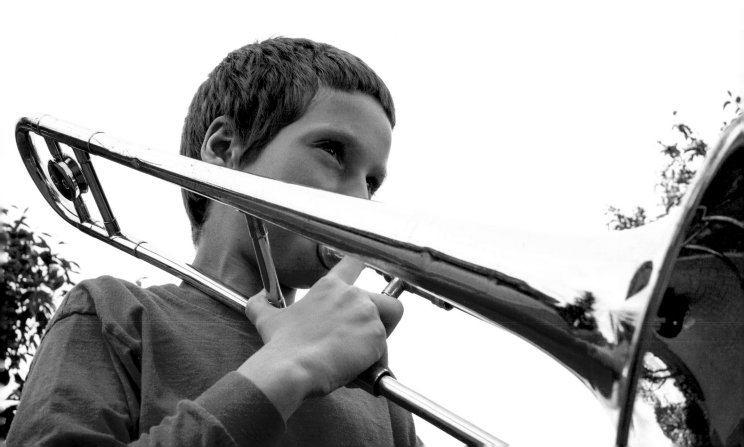

AUTHOR'S INTRODUCTION

This is the book I wished for when I first visited the Bruderhof almost thirty years ago. Back then the community's publishing house, Plough, had only published a couple of songbooks for children, a collection of Christmas stories, and half a dozen other books of talks and essays. But there wasn't one book that told what members of the community believed and how that influenced their daily life together. I hope this book will do that and much more.

Many things about the community struck me on my first visit, but the strongest impressions I took back with me were the stories people shared about their own journeys to find an alternative life – a life where loving God and loving your neighbor are truly daily priorities. Not long afterward, I returned for good and became a member (see my story on page 17). Since then, I've had the chance to talk with hundreds of others in the community, and have realized how diverse the paths are that brought each of us here. I found myself thinking, "These stories need to be told."

So when, almost three years ago, Plough asked if I'd be interested in collecting stories for a photojournalism book on the Bruderhof, I jumped at the chance. I left my job marketing Rifton Equipment, the community business that manufactures equipment for people with disabilities, and started scheduling interviews with very different people located around the world. It doesn't get much better than that.

With the hundredth anniversary of the founding of the Bruderhof approaching, it seemed natural to bring these stories together in a book (and on a website) to show how an assortment of people could live out their shared vision of a just society. One of the most challenging parts of this project was choosing which hundred stories to include. There are literally thousands of possibilities, many of them fascinating and colorful – which should be featured? In the end, I decided to focus on stories that, taken together, would provide a candid and balanced view into the community for readers who have never heard of it. Plough's team of seasoned editors then helped shape the narratives that I collected into the finished text; my thanks to them, as well as to all those who assisted in transcribing dozens of interviews. Most of all, I thank each of the individuals who agreed to share their stories for this book.

We all agreed we did not want a history book full of sepia-toned photos. I remember being impressed, on my first visit, by the inner vitality of the older members and their

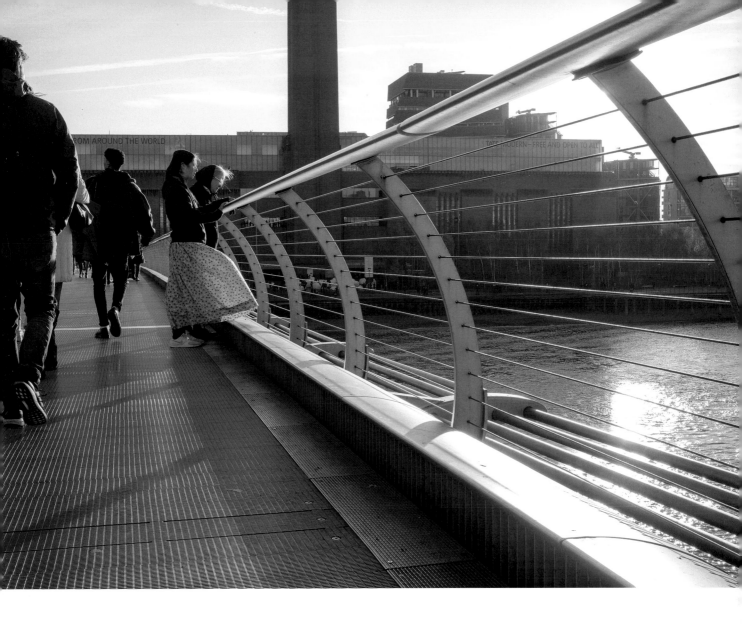

freedom from nostalgia. They rarely talked about "the good old days," but instead lived in the present and looked toward the future, encouraging younger members to take on responsibility and leadership. So this collection of stories includes a representative cross-section of young and old; men and women; people, like me, who came as adults, as well as people who grew up in the community. It is not a list of achievements or milestones, but a record of God's working in the lives of individuals.

The next challenge was how to show a unique way of life. I wanted current photos of our communities, if possible all by one photographer. That's when someone suggested Danny Burrows. Danny is a British photojournalist who had been documenting the plight of North African refugees in the Calais Jungle, the huge shantytown in France that sprang up during the European migrant crisis of 2015 to 2016. He turned out to be the perfect fit. After Danny agreed to the assignment, he and I visited communities around the globe, he shooting and I recording interviews. (See Danny's perspective on page xix). Danny took thousands of photos and gave us more than three thousand that he felt were artistically worthy to carry his name. From that selection we've used about two hundred in this book. You can see many more on the accompanying website.

∧
Ryanne and Clare
spend a cold moment
on the Millennium
Footbridge en route
to the Tate Modern
in London.

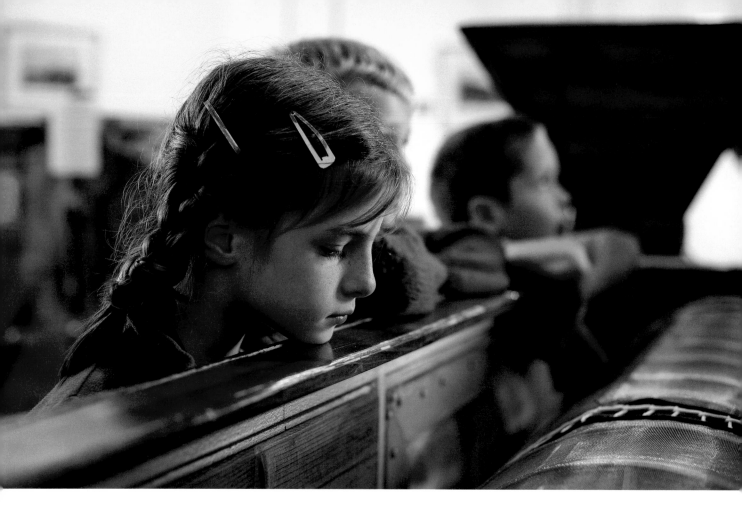

So if you're that rare person who actually reads introductions, here's the brief overview of the Bruderhof that I missed having thirty years ago.

Simply, we're a group of men and women who have each chosen to follow Christ above all else, and who have felt called to follow him, together, for our entire lives. We live with our families – or, as in my case, singles as part of families – in communities where we share meals, work, and income. We believe that God wants such a life for his people – a life of peace and unity, where no one is richer or poorer than another, where the welfare of the oldest, youngest, and weakest is a shared priority; where family life is treasured; where there is meaningful work for everyone; and where there is time for laughter, friendship, and children.

Today there are twenty-six Bruderhof community settlements around the world (see map on page xvi), each distinctive but sharing the same purpose. The bigger communities (200 to 350 people) are like small villages, each with an elementary school, dining hall, community kitchen, medical and dental clinic, community laundry, workshop, and other workplaces, like our publishing house, where I spend my workdays. Families eat breakfast together and then walk to school or work, meeting again at noon for lunch in the community's dining hall and then returning to work (for the adults) and afternoon activities (for the children). Evenings may include a family dinner or, after the younger children are in bed, a community worship meeting, an all-hands-on-deck project in the workshop or garden, or just time for relaxation, socializing, or hobbies. (Since coming to the Bruderhof, I've spent many creative hours in the pottery.)

^
During a school field trip to a working windmill, inspecting a sifter used for refining white flour

Daily life at the dozen smaller communities scattered throughout the world is naturally different, although they also meet for regular meals and worship. Some of the small communities run service businesses, while at others people have jobs outside the community or volunteer with local charities. Regardless of how income is generated, though, all of it is donated to the community, following the personal vow of poverty each member has taken. In return, people's needs are all provided for.

Our life together comes out of faith in Jesus and a desire to follow his commandments. The founders of the Bruderhof were inspired by the Sermon on the Mount, with its uncompromising call to a life completely dedicated to God's will. A glimpse of what that life might look like is found in Acts 2 and 4, which describe the first church in Jerusalem where "all who believed were together and had all things in common, and they sold their possessions and goods and distributed them to any as had need."

Just as Jesus called the first disciples to "drop your nets," each of us has felt the same call to give up everything to follow him in a dedicated life. We've promised to give everything we have – "the whole strength of your body and soul" – in service of that calling. Because membership is for life, each of us has to feel called by God to make this commitment. Conversely, when someone asks to become a member, the circle of existing members also feels a responsibility to discern the depth of his or her calling. Baptism based on belief (sometimes in one's late teens, and often later) is the first step toward membership. Only when someone has become an adult at twenty-one can he or she ask for membership – we do not have birthright membership. Wherever we live, all of us members have taken the same vows of lifelong loyalty to Christ and to each other.

Life in community is different from living as a Christian who attends a church for a few hours a week. Because we believe that every aspect of life has the potential to be an act of worship – working together, sharing a meal, singing together – actual church services are relatively simple. Led by one of the appointed pastors or another community member, we meet each day to sing, pray, and hear Scripture or other readings. Several communities often gather to celebrate more formal events such as weddings, baptisms, and acceptance of new members. Friends and neighbors from the public frequently attend these celebrations as well.

Our shared beliefs are simple: we read Jesus' words and try to put them into practice in daily life, guided by the witness of the earliest Christians as well as the sixteenth-century Anabaptists of the Radical Reformation, who likewise sought to return to a discipleship guided by the words of the Bible. We believe that the church (of which the Bruderhof is only a small part) is an eternal work of God and cannot be identified with any state institution or human hierarchy. That said, we recognize Jesus' power to work in all people, regardless of their creed or walk of life. We are happy to join with other Christians and people of good will to work toward a better world, whether by volunteering in a local soup kitchen or working with organizations such as World Vision and Save the Children on disaster relief efforts.

As I discovered, and as I hope the photos on the following pages show, we love children. We love being out in God's creation. We love working, singing, and celebrating together. Community offers a life lived to the full, where difficult times are shared and where each individual can find fulfillment.

Millions of Christians have read C.S. Lewis' *Mere Christianity* on the path to conversion, and I was no different. I encountered it when I was twenty-one and it changed my life more than any other book at the time. Lewis guides the reader step by step through what it means to be a Christian and then considers the practical effects of discipleship:

> The New Testament, without going into details, gives us a pretty clear hint of what a fully Christian society would be like. Perhaps it gives us more than we can take. It tells us that there are to be no passengers or parasites: if man does not work, he ought not to eat. Everyone is to work with his own hands, and what is more, everyone's work is to produce something good: there will be no manufacture of silly luxuries and then of sillier advertisements to persuade us to buy them. And there is to be no "swank" or "side," no putting on airs.
>
> To that extent a Christian society would be what we now call Leftist. On the other hand, it is always insisting on obedience—obedience (and outward marks of respect) from all of us to properly appointed magistrates, from children to parents, and (I am afraid this is going to be very unpopular) from wives to husbands. Thirdly, it is to be a cheerful society: full of singing and rejoicing, and regarding worry or anxiety as wrong. Courtesy is one of the Christian virtues; and the New Testament hates what it calls "busybodies."
>
> If there were such a society in existence and you or I visited it, I think we should come away with a curious impression. We should feel that its economic life was very socialistic and, in that sense, "advanced," but that its family life and its code of manners were rather old fashioned—perhaps even ceremonious and aristocratic. Each of us would like some bits of it, but I am afraid very few of us would like the whole thing.

Reading those words today and looking around I think, well, that pretty much describes how we are trying to live. As Danny and I went around trying to capture iconic community events in photos, it struck me that much of our life is experienced in the small ways we relate to one another every day—and that's something photos will never fully capture. For that, you'll just have to come and see for yourself.

Clare Stober, Fox Hill, 2020

BRUDERHOF TIMELINE

1920
First Bruderhof established

The Bruderhof was founded in Germany by the Protestant theologian Eberhard Arnold, his wife, Emmy, and her sister Else von Hollander, who moved with Eberhard and Emmy's five children to the village of Sannerz. There, inspired by the teachings of Jesus, they started to live in community.

1934
Community in Liechtenstein

When the community was notified that the school would be taken over by a Nazi teacher, all Bruderhof children and their teachers fled Germany to the Liechtenstein Alps, where they were soon joined by their parents and men of military age.

1936
A new start in England

The community purchased a farm in the Cotswolds in 1936 as a possible refuge should Nazi persecution force the community to flee Germany.

1937
Escape from Germany

The expelled members traveled via various routes to the new Cotswold Bruderhof in England. The men who had been arrested were eventually released and traveled to England as well. In early 1938, shortly after Germany invaded Austria, the Liechtenstein community was closed and all members moved to England.

1939
World War II

By 1940, following the outbreak of war, the English government had begun a policy of forcible internment of enemy aliens. The community was faced with a choice: internment of all German nationals, or leaving the country as a group. Committed to staying together, they sought refuge abroad.

1942
Wheathill in England

There continued to be so much interest in community in England that the three remaining members were asked to purchase a new property there. The community at Wheathill, a farm in Shropshire, grew quickly as young men and women visited and requested to join a life lived as an alternative to war.

FIRST BRUDERHOF

COTSWOLD

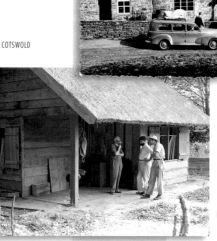

WHEATHILL

LIECHTENSTEIN

PARAGUAY

1933
Growth and opposition by the Nazis

In its first ten years the Bruderhof grew to over a hundred people, also opening its doors to orphans, single mothers, and others. It survived on farming and the sales of books from its publishing house, still active as Plough. Poverty became more acute after 1933, when the Nazis banned the sale of the community's books and crafts.

1935
Death of Eberhard Arnold

Eberhard Arnold died unexpectedly during surgery for complications to a broken leg. In his last months, he protested Nazi policies, and spoke repeatedly on the theme of the greatness of God's cause in the face of the suffering world. At the time of his death, the Bruderhof had 150 members living in four locations.

1937
Bruderhof in Germany raided by the Gestapo

Hundreds of storm troopers surrounded the community, imprisoned several men, and gave the rest forty-eight hours to leave Germany. As a Gestapo official wrote in an internal memo, the Bruderhof "represents a worldview totally opposed to National Socialism."

1938
New members in England

The Cotswold community grew to 350 members over the next years. Many who had become pacifist through the horrors of World War I came to visit and later joined the Bruderhof. Others heard about it through its publications, including the Plough magazine.

1941
Travel to Paraguay

The only country willing to accept a multinational group of pacifists in wartime was Paraguay. By the end of 1941, the whole community — except three members who remained in England to sell the Cotswold property — had traversed the submarine-infested waters of the Atlantic and set out to build community in the jungle.

1945
Building community in Paraguay

Life in Paraguay, with a harsh and unfamiliar climate, tropical diseases, and limited access to the wider world, was difficult. Over the next twenty years, three Paraguayan locations were established, as well as a hospital that served both the community and local indigenous Paraguayans.

1954
Woodcrest in New York

After World War II, dozens of young Americans interested in communal living visited the Paraguayan communities. In 1954, Woodcrest, the first North American Bruderhof, was founded in New York State. Meanwhile, other communities had been founded in Europe as well. By 1962 the Paraguayan communities had closed and members had emigrated to the United States and Europe.

1971
Darvell in England

In 1971, a new Bruderhof was founded in East Sussex. Since immigration to the United States was difficult, many Europeans who wanted to join the Bruderhof found a home there.

1985
New communities in the United States and England

Over the next years, the Bruderhof continued to grow and spread. Several new communities were started in the 1980s and 1990s: Maple Ridge in New York's Hudson Valley, Spring Valley in southwestern Pennsylvania, Platte Clove in the Catskill Mountains, Fox Hill, also in the Hudson Valley, and Beech Grove in Kent near Canterbury.

2002
Return to Germany

When the Bruderhof's original home in Sannerz, Germany, was available for purchase, the Bruderhof bought it and a small community was established there. Two years later, the Holzland community was started in the village of Bad Klosterlausnitz.

2009
Back to Paraguay

The founding of Villa Primavera, a small community in the city of Asunción, marked the Bruderhof's return to the country that welcomed them in the 1940s.

2019
Korea and Austria

Baeksan House in Taebaek, South Korea, and the Gutshof in Retz, near Vienna in Austria, are the two newest Bruderhof communities.

HARLEM

DARVELL

WOODCREST

THE MOUNT

1960s
Community Playthings

As the Bruderhof established itself in a new country, it continued to develop and was supported by Community Playthings, a business making wooden toys and furniture for children.

1977
Rifton Equipment

Rifton Equipment began as an offshoot of Community Playthings when Bruderhof designers were asked to custom-build a chair for a disabled child near a Bruderhof in Connecticut. Today, it produces a range of products for people with disabilities.

1999
Bruderhof in Australia

Danthonia, the first Australian community, opened in 1999. In 2005, a house community in the town of Armidale was started.

2003
Communities in the city

A group of young couples and singles moved into a derelict building in Camden, New Jersey: the first urban Bruderhof community. The house community model has since been replicated in London, Brisbane, New York, Pittsburgh, and several other cities.

2012
The Mount Academy

In 2012 the Bruderhof founded the Mount Academy, a New York State registered private high school, to educate teens whose parents are Bruderhof members, as well as students from the neighborhood and abroad.

2020
At 100 years . . .

The Bruderhof communities are now home to around 3,000 people of many nationalities on twenty-six communities in the United States, Great Britain, Germany, Austria, Australia, Paraguay, and Korea, with small mission outposts elsewhere around the globe.

BRUDERHOF COMMUNITIES TODAY

UNITED STATES

COLORADO
Denver 2019*

FLORIDA
Bayboro 2006

MINNESOTA
Crossroads 2018

NEW YORK
Woodcrest 1954
Maple Ridge 1985
Platte Clove 1990
Fox Hill 1998
Bellvale 2001
Rondout 2004
Butler 2006
Harlem 2006
Parkview 2006

NORTH CAROLINA
Durham 2015

PENNSYLVANIA
New Meadow Run 1957
Spring Valley 1990
Pittsburgh 2016

WEST VIRGINIA
Morgantown 2005

▼ LARGE COMMUNITY
▼ HOUSE COMMUNITY
 * YEAR FOUNDED

PARAGUAY
Villa Primavera 2010

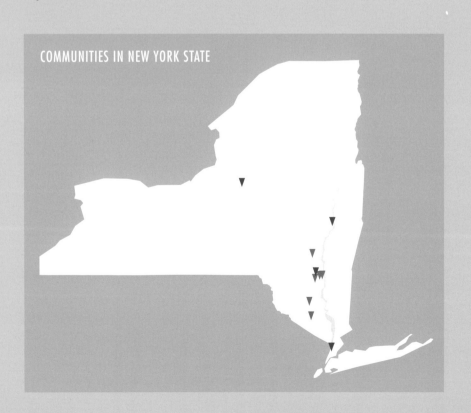

COMMUNITIES IN NEW YORK STATE

UNITED KINGDOM

Darvell 1971
Beech Grove 1995
Peckham 2016

GERMANY

Sannerz 2002
Holzland 2004

AUSTRIA

Retz 2019

KOREA

Baeksan House 2018

AUSTRALIA

Danthonia 1999
Armidale 2005
Brisbane 2017

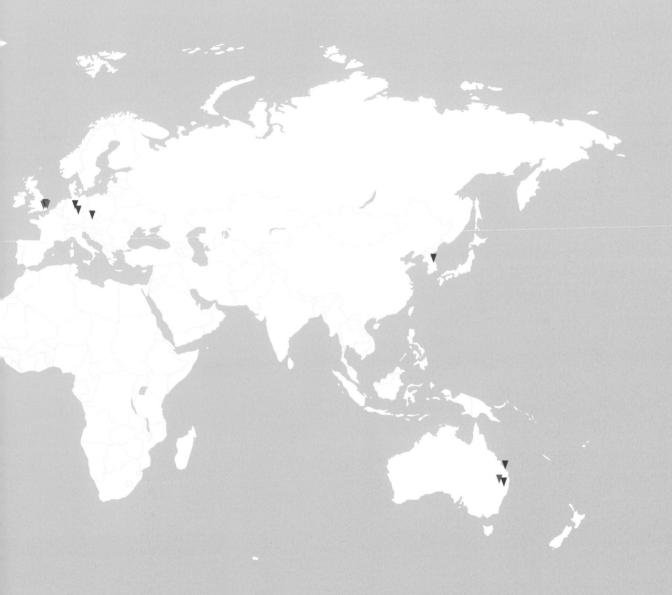

PHOTOGRAPHER'S NOTE

I first met the Bruderhof while documenting the refugee crisis in a sprawling camp in Calais, where the distinctive dress and light American accents of a group of volunteering teenagers caught my attention.

I spoke with them briefly, and on my return to England I wrote to ask if I could make a photographic documentary about the Bruderhof. A reply soon came from Bernard Hibbs, who invited me to lunch at Beech Grove to discuss my ideas. We corresponded sporadically until about a year later, when Bernard rang again to ask if I would photograph a book to celebrate the community's centenary. I jumped at the chance.

Over the following year I visited Bruderhof communities around the globe, from England to the USA and Germany to Australia. In each community I was warmly welcomed and (perhaps to the frustration of those supervising the project) spent many hours chatting about the world, politics, and life over a glass of wine or homemade beer – thank you, Jeff, for the latter! And more than once I was moved to tears by the stories we shared.

It was the Bruderhof's commitment to pacifism and community of goods that initially sparked my interest, and it was a pleasure to experience these values in practice. As a photographer, I am meant to observe my subjects objectively, but I have to admit that I grew to admire the community. That is not to say that I didn't encounter ideas that were contradictory to my own, but I respect their commitment to family and loved ones, the absence of wealth and possessions, the enjoyment of nature, and an immersive experience of faith. The more I experienced the more I began to appreciate what the Bruderhof refer to as "another life," a working alternative to "my world."

My final assignment was Sannerz, Germany, where the community began its journey. Watching the sun set over the countryside was the perfect end to the project. To all who welcomed me as I worked on it: thank you for letting me experience your life.

Danny Burrows
dannyburrowsphotography.com

∧
Danny puts a young
subject at ease.

>
Neighbors gather
for a campfire
at the Danthonia
community.

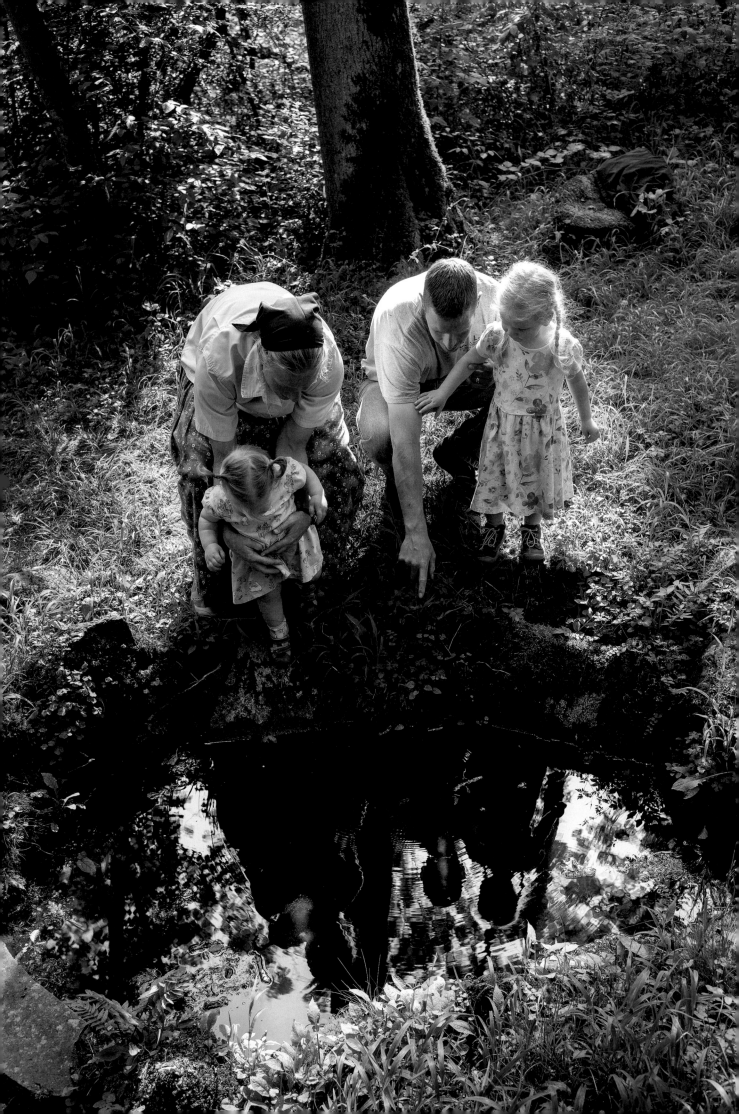

EBERHARD ARNOLD

1883–1935

Eberhard Arnold, a German theologian and philosopher, founded the Bruderhof in 1920.

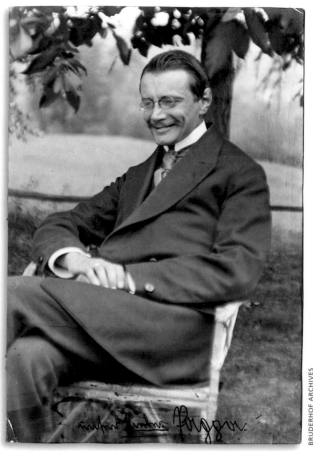

Born into a long line of German academics and himself a doctor of philosophy, Eberhard Arnold abandoned middle-class life to found the community now known as the Bruderhof. His own words describe his journey best:

In my youth, I tried to lead people to Jesus through the Bible, and through addresses and discussions. But there came a time when I recognized that this was no longer enough. I began to see the tremendous power of greed, of discord, of hatred, and of the sword: the hard boot of the oppressor upon the neck of the oppressed. . . . I had preached the gospel but felt I needed to do more: that the demands of Jesus were practical, and not limited to a concern for the soul. . . . I could not endure the life I was living any longer.

His spiritual awakening had begun years earlier when, as a teenager on summer vacation at the home of "Uncle" Ernst, his mother's cousin, he had read the New Testament with fresh eyes. Ernst, a Lutheran pastor who had lost his church position after siding with the poor weavers of the region during a labor dispute, impressed him deeply. By the

<
At Sannerz in Germany, site of the first Bruderhof and today home to about twenty, including Steve and Mim and their daughters

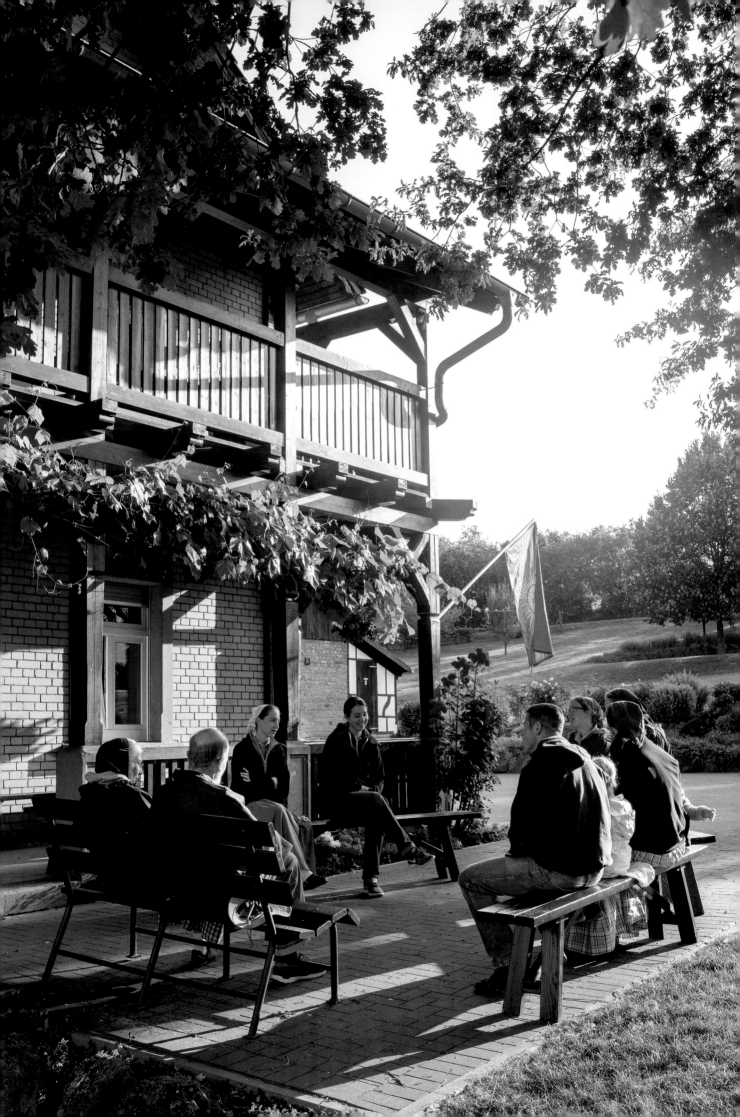

time he returned home, Eberhard was burdened with a new consciousness of his privileges and the plight of the impoverished.

The next years were tumultuous. He volunteered with the Salvation Army, started an intensive Bible study, and neglected his secondary school studies to such an extent that his desperate parents finally sent him to boarding school. When he graduated he clashed with them over the next step: Eberhard wanted to study medicine, while his father insisted on theology. Eberhard yielded.

This did not lead to the respectable career in the state church his father hoped for, however, as he was ultimately barred from sitting for his final exams. Through his study of the Bible and the influence of the evangelical revivalist movement, Eberhard came to believe that infant baptism was not valid and was re-baptized as an adult. This decision disqualified him from completing his degree. His parents disowned him, and the father of his fiancée, Emmy von Hollander, denied him permission to marry her until he had successfully defended another doctoral dissertation.

Eberhard switched his course of study to philosophy, completed a thesis on Nietzsche, and married Emmy in 1909. Meanwhile, he was making his voice heard as leader of the local chapter of the Student Christian Movement. The newlyweds moved from one city to another, following his work as a public speaker, while hosting gatherings in their home that attracted a lively and diverse attendance, from pious housewives to communist revolutionaries.

The First World War led the couple to read the Bible in a new light. Counseling wounded soldiers in an army hospital, Eberhard was shattered by what he heard and saw. Formerly an energetic advocate of the German cause, he embraced pacifism as truer to the gospel.

The end of the war in 1918 heralded little in the way of peace: there were strikes, assassinations, revolutions, and counterrevolutions, and finally the haphazard birth of the Weimar Republic. In Eberhard's words, the hour demanded a discipleship that "transcended merely edifying experiences." Increasingly he pondered the evils of mammon, the god of money and material wealth. "Most Christians have completely failed in the social sphere and have not acted as brothers to their

"Christ's love calls us to give up our possessions, too. That is the only way to help the world; it strikes at the root of our selfishness, making it possible for us to live in harmony — to live a life of love and justice and community."

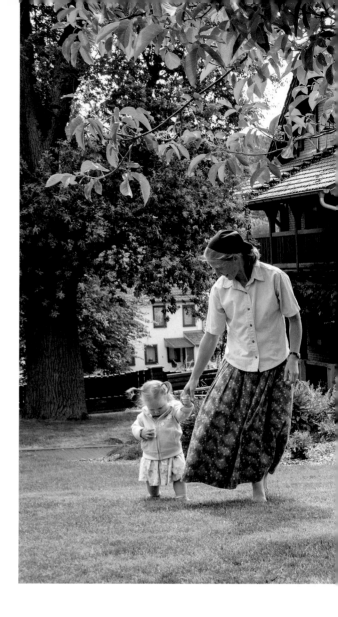

fellow man. They have risen up as defenders of money and capitalism," he said. An alternative emerged, simple but all-consuming:

Jesus says, "Do not gather riches for yourself." That is why the members of the first church in Jerusalem distributed all they had. Love impelled them to lay everything at the apostles' feet; and the apostles distributed these goods to the poor.

Christ's love calls us to give up our possessions, too. That is the only way to help the world; it strikes at the root of our selfishness, making it possible for us to live in harmony – to live a life of love and justice and community.

As Emmy wrote in an unpublished memoir:

Social contradictions such as the fact that one person can enjoy the plenty of life without sweating, while another does not have bread for his children despite working like a slave, occupied us more and more. Through reading the Bible, we realized that this is not God's will.

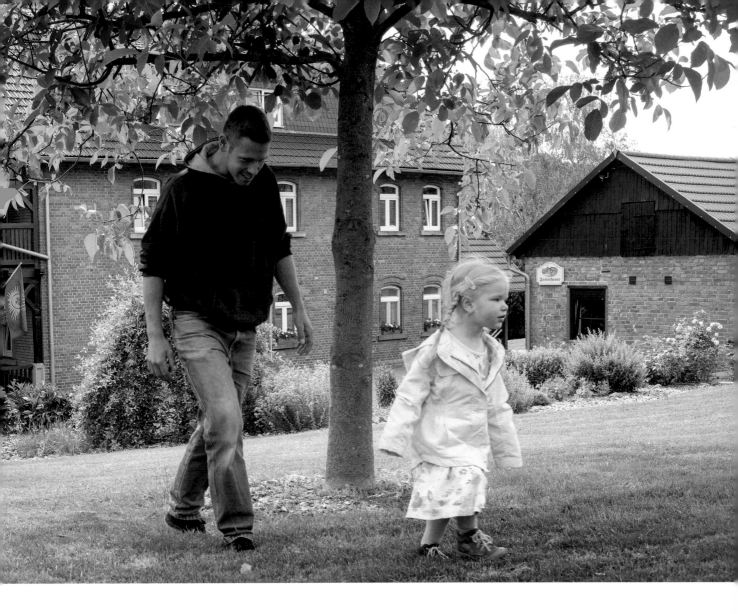

From the outset of our friendship, Eberhard and I had wanted to give our lives in service to others. That was our primary concern. So it was perhaps natural that we now found ourselves joining with people who were dissatisfied and were challenging public life and human relationships with the old slogans of freedom, equality, and fraternity. These ideals were drawing people from all walks of life; and all of them were struggling to find God's will, even if few would have expressed it like that. . . .

At a series of open evenings in our house we read the Sermon on the Mount and were so overwhelmed by it that we decided to completely rearrange our lives according to it, cost what it may. Everything written there seemed to have been spoken directly to us: what Jesus says about justice, about hungering for righteousness, loving one's enemies, and finally, about actually doing God's will.

But Eberhard's radical pacifist and economic views were incompatible with his employer, Die Furche, the publishing house of the Student Christian Movement

where he had worked since 1915. In early 1920, Eberhard gave notice and, in June of the same year, the Arnolds took the plunge. Surrendering their life insurance policy for cash and leaving their comfortable Berlin home, they moved with their five children to Sannerz, a poor farming village, where they began living in full community with several other like-minded seekers, including Emmy's sister Else.

Starting such a community, as Emmy wrote later, required a leap of faith:

We had no real financial basis of any kind for realizing our dreams. Not that it made a difference. It was time to turn our backs on the past, and start afresh – to burn all our bridges, and put our trust entirely in God, like the birds of the air and the flowers of the field. This trust was to be our foundation – the surest foundation, we felt, on which to build.

The Arnolds were hardly alone in their thinking: their fledgling community was one of dozens of similar settlements that had sprung up across Germany at the time, attracting young people disillusioned with both bourgeois piety and social inequality. More than

∧
The Bruderhof re-acquired the Sannerz House in 2002. The original Bruderhof community was here from 1920 to 1927.

> Klaus Barth, one of the last living members who remembers Eberhard Arnold, enjoying a moment of winter sunshine.

>> Hans Brinkmann tends the grave of Eberhard Arnold in the community burial ground near Sannerz, Germany.

a thousand guests descended on the community in Sannerz during its first year.

From his new home base, Eberhard soon resumed publishing with the mission, as he wrote, of "allowing the gospel to work in creation, producing literary and artistic work in which the witness of the gospel retains the highest place while at the same time representing all that is true, worthy, pure, beautiful and noble." He saw Sannerz and other exemplars of voluntary Christian community as beacons of hope – models that could inspire other attempts at social and economic renewal. This would surely happen, he believed, once people's eyes were opened to the possibilities of brotherhood and the joy of sharing everything in common, as opposed to competing for every last coin. As he said at a lecture in 1929:

People tear themselves away from home, parents, and career for the sake of marriage; they risk their lives for the sake of wife and child. In the same vein, people must be found who are ready to sacrifice everything for the sake of this way, for the service of all people.

Community is alive wherever these small bands of people meet, ready to work for the one great

goal, to belong to the one true future. Already now we can live in the power of this future; already now we can shape our lives in accordance with God and his kingdom. This kingdom of love, free of mammon, is drawing near. Change your thinking radically so that you will be ready for the coming order!

By this time the community had grown, its ranks expanded by homeless war veterans and single mothers, orphans and day laborers, people with disabilities and mental illness, anarchists and communists, Christians and Jews. To accommodate this new influx, it resettled on a farm in the Rhön hills.

Meanwhile, Eberhard had become increasingly interested in the example of the Anabaptists, who emphasized unity, sharing of possessions, nonviolence, and the church as a "city on a hill." He learned that one branch of this movement, started by Jakob Hutter in the sixteenth century, had existing communities in North America, and he reached out to establish a relationship with them.

The rise of National Socialism in the 1930s presented Eberhard and the other members of the Bruderhof with the challenge of remaining faithful in an

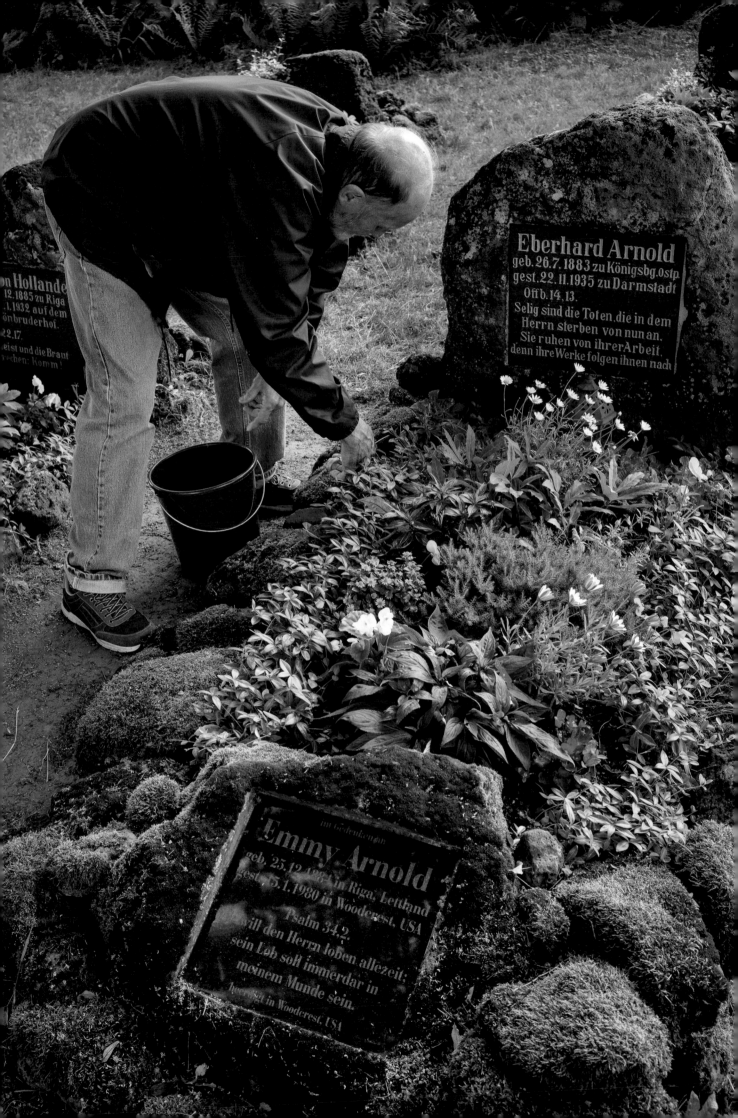

increasingly hostile state. The pacifism of the early Anabaptist movement remained a core principle of their identity, despite the persecution they knew it would bring. This also meant that, from the very beginning, they distanced themselves from the regime. The Bruderhof's connections to Jewish communities also strengthened their resolve against the anti-Semitic aims of the Third Reich.

The first of several Gestapo raids occurred in 1933. Eberhard was not intimidated, and sent off reams of documents to the local Nazi officials, explaining his vision of a Germany under God. He even wrote to Hitler, urging him to renounce the ideals of National Socialism and to work instead for God's kingdom – and sending him a copy of his book *Innerland,* which spoke forcefully against the demonic spirits that animated German society at the time. Not surprisingly, this letter was never answered.

Following the raid, Bruderhof parents quietly began the process of evacuating the community's children to Liechtenstein. When a Nazi-sanctioned teacher showed up to take over the school in 1934, she found no pupils waiting for her. With hostilities in Germany rising, the whole community soon moved to Liechtenstein, but did not stay for long – from there they left for England, and later Paraguay.

Eberhard did not live to shepherd them through these changes, however. His death came suddenly in 1935, the result of complications following the amputation of a poorly set broken leg. Under extremely difficult circumstances, others took up the work he had begun.

Remembered a century later, his "voice of one crying in the wilderness" delivers "a wakeup call for the religiously sedated and socially domesticated Christendom of the Western world," writes Jürgen Moltmann, a German theologian. "He saw down to the root of things, leading to uncompromising decisions in the discipleship of Jesus between the old, transient world and the future of God's new world."

"It may seem strange that such an insignificant group could experience such lofty feelings of peace and community, but it was so," Eberhard wrote shortly before his death. "It was a gift from God. And only one antipathy was bound up in our love – a rejection of the systems of civilization; a hatred of the falsities of social stratification; an antagonism to the spirit of impurity; an opposition to the moral coercion of the clergy. The fight that we took up was a fight against these alien spirits. It was a fight for the spirit of God and Jesus Christ." ◆

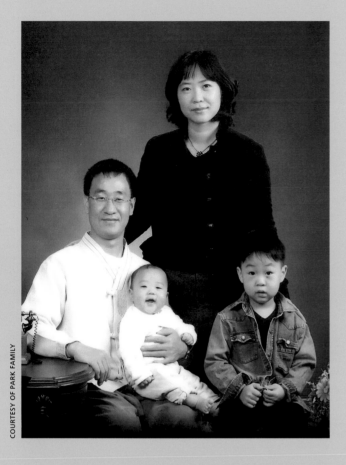

SUNG HOON PARK

1972–

We were living in Seoul with our two little boys when we heard about the Bruderhof. My wife, Soon Ok, had worked at Samsung headquarters and then become the director of a daycare center. She was working on her master's degree. My parents are animists but I had become a Christian, studied theology and education, and worked at a publishing house. We owned a nice house and a car.

On the surface we were happy, but underneath, our marriage was almost broken. We were both so busy, and I was burned out and depressed. There was a desperate emptiness in my heart: I was hungry for a real Christian life.

At work, I was involved in publishing books from the Bruderhof that said they loved one another, but I was skeptical. Everywhere I looked there was such a big gap between what people said and the way they lived.

But, during our first visit to Woodcrest in New York we learned that if we opened our hearts and followed our hearts, God could work. We sold our house and car and got rid of our expensive laptop and camera. In return, we found joy! We found out what is really important: love and family. God healed our marriage: I could apologize to my wife, and she could forgive me.

People might think living here is not easy, especially for a Korean. There are so many cultural differences: language, food, dress. But God is so much bigger than that. I wish many, many other people – Asians, Europeans, people from all continents – could find their way to this life and joy.

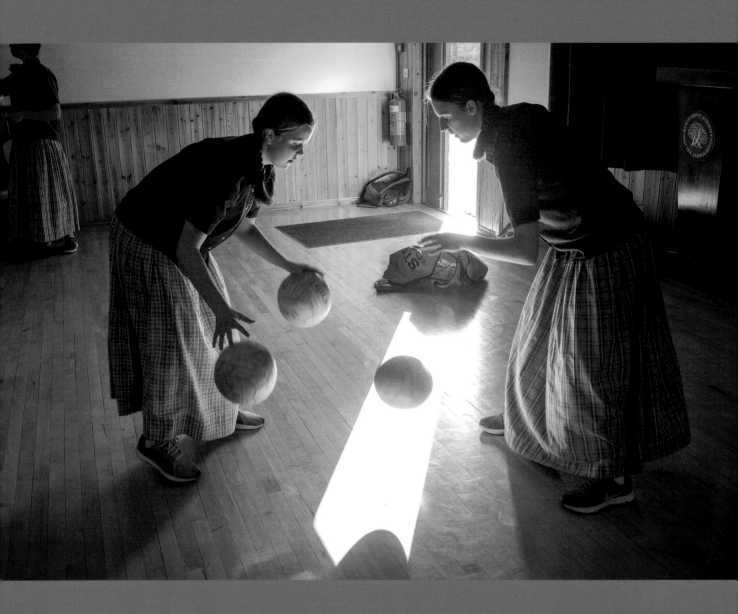

What we would like to do is change the world – make it a little simpler for people to feed, clothe, and shelter themselves as God intended them to do. And to a certain extent, by fighting for better conditions, by crying out unceasingly for the rights of the workers, of the poor, of the destitute . . . we can to a certain extent change the world; we can work for the oasis, the little cell of joy and peace in a harried world.

Dorothy Day, founder of the Catholic Worker Movement
1897–1980

^
High school girls
perfect their ball-
handling skills.

NORMA WARDLE

1953—

Born into a large Irish-Catholic family near Pittsburgh, Norma won a popularity contest as a child, and then struggled for years with an unexpected aftereffect: the need to maintain her image at all costs. By eleventh grade, she was a beauty queen, class president, and head of the cheerleading squad. She dated the quarterback of the football team and the captain of the basketball team: "I didn't follow the trends at my school; I set them." The problem was, it all cost money — money she didn't have: "We were a lower-middle-class family, so I had to work hard to keep up my image. In fact, I had two afterschool jobs. I could have shopped at bargain stores but wouldn't. They lacked class. Instead, I went to the high-end department stores. I also shoplifted."

At college, Norma reveled in the new freedoms of the early 1970s: "You could let your hair go and forget about makeup. I went to hash parties. I embraced the whole counterculture thing." What seemed like freedom wasn't, however: "You had to go to the right concerts,

and you still had to wear the right things: T-shirts with sequins, hoop earrings, and bell bottoms. Sure, we protested the war and talked about peace and love. But a lot of it was still driven and steered by commercialism."

Fast forward a few years, and Norma had joined the Jesus People, a loose network of Christian fellowships and communes then at its height. One weekend she visited the Bruderhof:

Culturally, it was completely foreign to me, but these people looked past my appearance. They wanted to know what I was thinking about, and they listened. I never thought I'd join, but something kept drawing me. Before, money and clothes defined me. I had lived for myself. These people were living together as brothers and sisters, for one another, trying to build up a truly new society. That goal inspired me so deeply, nothing else mattered anymore. At the community, I found something no amount of money can buy.

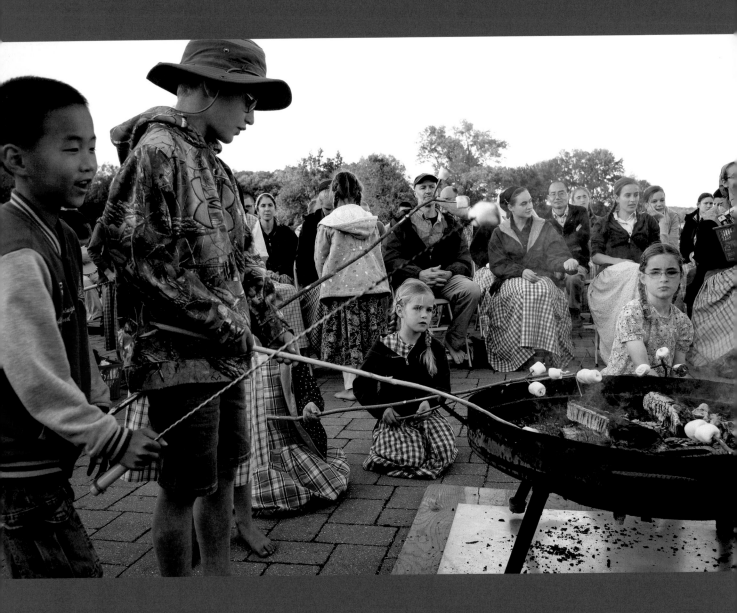

As thou takest thy seat at table, pray. As thou liftest the bread, offer thanks to the Giver. When thou sustainest thy bodily weakness with wine, remember him who supplies thee with this gift, to make thy heart glad and to comfort thy infirmity. Has thy need for taking food passed away? Let not the thought of the Giver pass away too.

Basil of Caesarea, bishop and theologian
AD 329–379

^
Community campfire
with s'mores

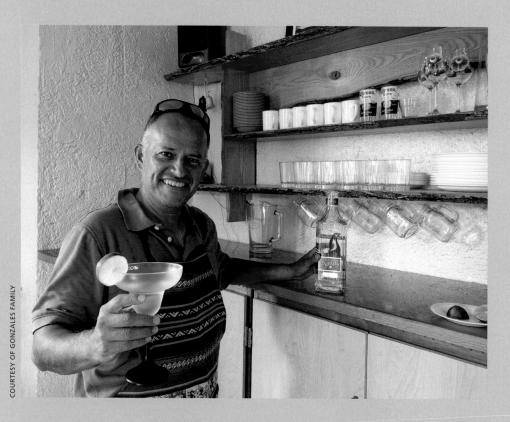

CARLOS GONZALEZ

1965–

Carlos lives in a Bruderhof in upstate New York with his wife, Berenice, and their three daughters. He enjoys pointing out that his birthplace, Jalisco, Mexico, is where tequila comes from. "And I'm a very Jalisco person," he adds.

I studied industrial design, and later worked for Volkswagen. Then I did publicity for restaurants and hotels, then opened a restaurant of my own. It was a successful investment, but too stressful. Later, I sold electronics, worked in the tourism industry, and enrolled in a graduate program. I lived in a Jesuit community and did human rights work with an NGO. I realized that I liked to help people – to serve. It was around then that I got in touch with the Bruderhof through a young woman from the community who had come to Mexico to work in a children's home.

Today, Carlos has a reputation as the ultimate host, and not just for fellow community members, but for guests from the neighborhood too.

Gathering is pretty much my culture, my background. I love to make margaritas. And to cook: enchiladas, chilaquiles – simple, traditional stuff. Of course, the most beautiful thing is to have time to interact with others, to get to know them. Everything else is superficial in the end. What is essential is the atmosphere, the joy of community. When you receive that, you have received a gift for life. Come by! My house is always open.

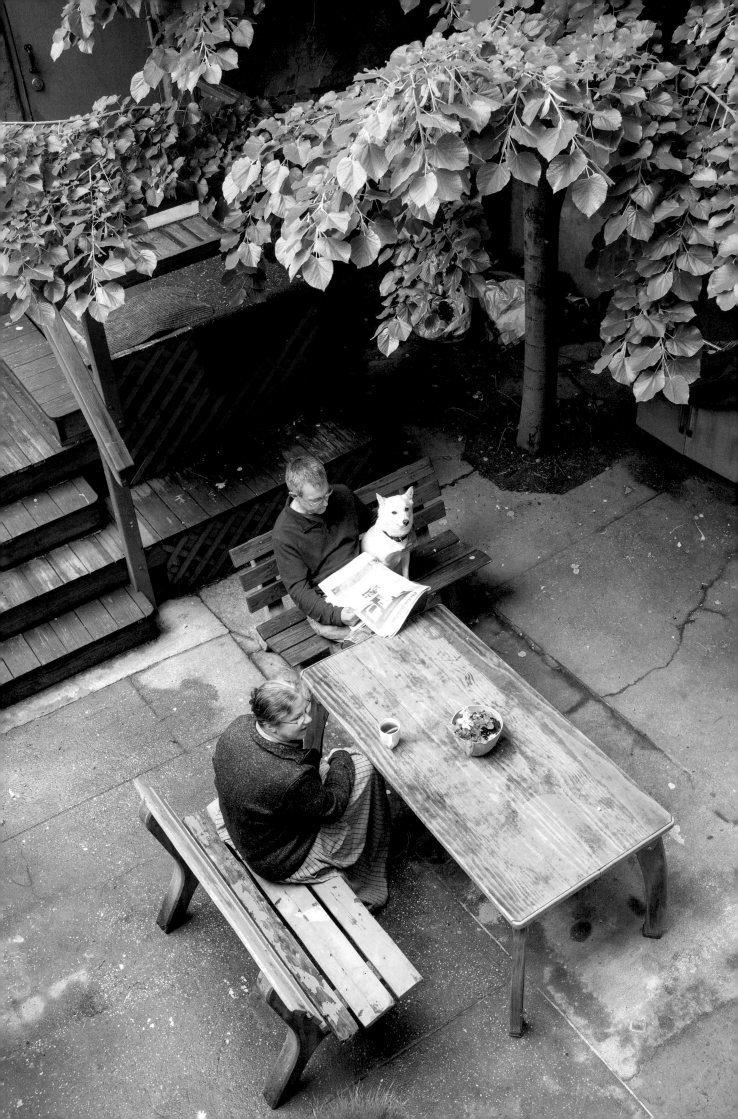

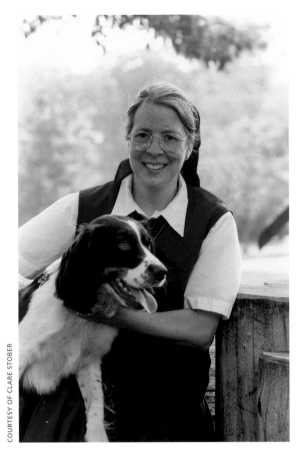

A successful entrepreneur who realized that living a life of meaning had nothing to do with wealth

CLARE STOBER

1955–

<<
Tim and Kathleen
with Sammy behind
the Harlem House
community

A college dropout who built
up a successful graphic design and
advertising agency near Washington,
DC, Clare was the perfect example of
someone who achieved the American
Dream.

Ironically, it was out of that place
of financial success that I was able
to see through the dream. I had
everything I wanted; I could go
anywhere; I could buy anything
I wanted. I was pulling down
$150,000 a year. Adjusted for
inflation, that's about $350,000
today. I had worked very hard to
get there, but, deep down, I knew
I did not deserve what I was get-
ting in the way of compensation. I
knew of countless people of color
or people with other economic
disadvantages who worked harder
than I did and were not making it.

That basic inequity made me feel
very uncomfortable. And along
with that I felt so empty inside.

Fifteen years earlier, I had experi-
enced what I think you could call
a conversion. I was working alone
in a darkroom (a great place to
think), and I remember standing
there and being overwhelmed with
all the deceitful, selfish, evil things
I had done in my short life. Among
other things, I had no relationship
to speak of with my parents, I had
had an affair with a married man,
and my own marriage had lasted
all of eight months. One by one, I
saw the faces of the people whose
lives I had ruined in my drive to
get ahead.

It was frightening, but even worse
was the realization that I was not

"Desperate, I begged for help from a God I wasn't even sure was real."

able to redeem myself. I had tried before, and here I was once again, having left even more trampled people in my wake. What was it going to take? I did not want to have a rerun of this revelation on my deathbed with fifty more years of broken relationships added on top.

Desperate, I begged for help from a God I wasn't even sure was real. In answer, two alternatives became clear: continue calling my own shots and deal with the messy consequences as best I could, or let go of everything and allow God to take control of my life. The latter was clearly the less glamorous choice, but I went for it.

That's when Clare started the design business with a fellow Quaker. Together, they worked hard for fifteen years and built up a strong business. But, in the process, their dependence on God was slowly replaced by self-reliance, business acumen, and a desire to meet ever higher financial goals. It was another moment of realization that forced Clare once again to choose between having a wealthy but stressful life or slowing down and regaining a life of faith and joy in God. Choosing God would mean leaving the agency she had built up and co-owned.

Before leaving, I had to settle affairs with my business partner.

This was complicated: he and his wife had once been my close friends and spiritual mentors, but over time we had grown apart.

It took multiple offers and counteroffers to come to a final agreement, but the result was that I ended up paying $50,000 in taxes which my partner should have paid. When I realized how he and his accountant had conspired to crush me, I was so consumed by anger that I couldn't sleep for days. Sure, it was "only money," and I didn't need it at the time. But it was a lot of money, and it was mine. Obviously, the IRS could not be put off, though, so I wrote the check and hoped in a God of vengeance.

Clare says her journey to forgiveness took two years, and was part of her deeper quest for renewal: the search for what Tolstoy calls the "true life." Along the way, she says, she stumbled on new treasures: vulnerability, humility, trust, and joy.

In the end, the renewal I was looking for cost everything. I sold my antique furniture, my vacation home on Nantucket, and after that, my townhouse in McLean. I dropped my career. My whole life took a new turn as I tried to discern what God wanted me to do. But with every step, I was amazed to realize how quickly the deepest

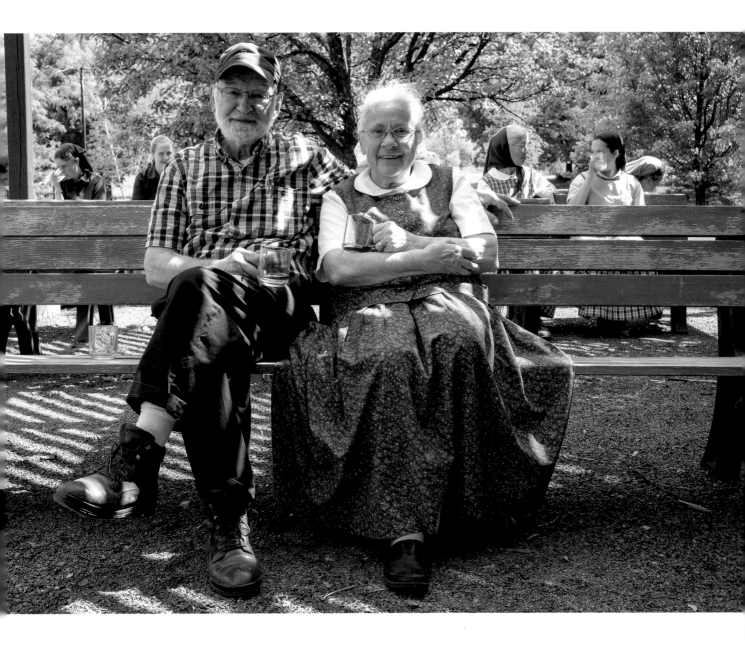

yearnings of my heart were filled. I felt like I was given a clean slate to start life completely over. Beyond that, the experience led me – further than I had ever been led before – out of myself and to community with others, where I am still learning what it means to truly share your life – practically, and in the spirit – with brothers and sisters. This is what God created us to do.

In my former life, I used money as a way of building security against imagined catastrophes, for a comfortable retirement, and to live a good life in beautiful surroundings. When I was a guest of the Bruderhof wrestling with whether or not I was "called" to this way of life, I woke many nights at 3 a.m. with

the icy fingers of fear gripping my heart and wondering, "What if the community collapses? What about retirement and insurance?" These were real fears that I had spent all my adult years working to address. The irony is that once I joined the community, I never even thought about those fears again. They completely dissipated.

Life doesn't stop. No community is perfect. As life-changing as that morning in the darkroom was, I've come to realize that if I am going to live authentically, I must continually go through new cycles of repentance and renewal – that there must always be new beginnings. I look forward to them, because that's when I'm most alive. ♦

∧

Married over fifty years, Dan and Hanni have nine sons, fifty-two grandchildren, and two great-grandchildren.

OLIVIA BARTH

1978–

Born in Surrey, England, Olivia came to the Bruderhof as a nine-year-old with her parents and younger brother. Now a mother of four sons, she is an account manager for Community Playthings:

Ironically enough, living in community doesn't necessarily make you less materialistic. I still have this tendency to hang on to certain things for myself. I'm a big fan of my public library, and if I want a new book I get the library to order it. But then, there are some books I can hardly bear to return. Or – this is a silly example, but it's true: because I can't go and buy the one perfect bag, I find myself collecting second-rate bags!

I've read blogs about minimalism and find it very appealing. But minimalism isn't necessarily the opposite of materialism. I would like to have a very bare house with a couple of things placed artistically here and there, but my family loves to read and so I think it's important to have books on every surface of the house, and then there are the school projects and half-made Lego creations as well. And I welcome that because ultimately I want my house to be a friendly, hospitable place, not a work of art.

>>
Early morning sun
on the linden tree
at the center of
Darvell community

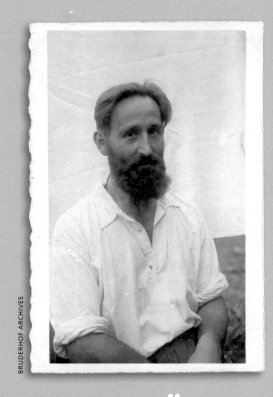

BRUDERHOF ARCHIVES

JOSEF STÄNGL

1911–1993

Josef was born to a poor Catholic family in rural Bavaria and raised in a boys' home where beatings were a daily occurrence and afterschool recreation meant peeling potatoes. He was later apprenticed to an uncle who was a baker. At seventeen, he took to the road, along with thousands of other young men. It was the height of the Great Depression, and in Germany, some five million were estimated to be jobless. Happening upon the Bruderhof — then a poor farming community near Frankfurt — he was struck by the sight of uneducated peasants working along-side professionals, and by the brotherly love he witnessed among them.

Instead of the "divisive spirit that rules the world," Josef found, in the community, "the struggle for God's kingdom. . . . It was here that the message of the gospel dawned upon me: that all classes, all social strata which are separated from one another in the world, are united in the gospel; and that Christ came for all — that every individual, no matter his background, would be welcomed and included."

Ten years later, during the darkest days of World War II, Josef affirmed the reality of this truth in a most personal way, through his marriage to fellow community member Ivy Warden. The daughter of a wealthy doctor whose patients included Vanderbilts, Morgans, and Rockefellers, Ivy had grown up in Paris and on the French Riviera, where she played tennis with the future Queen Elizabeth II, and attended Edinburgh University. After breaking off her engagement to an English lord, she had embarked on a search for another life, and found her way to the Bruderhof. Josef and Ivy had eight children, four sons and four daughters. For decades, he served the community as a baker.

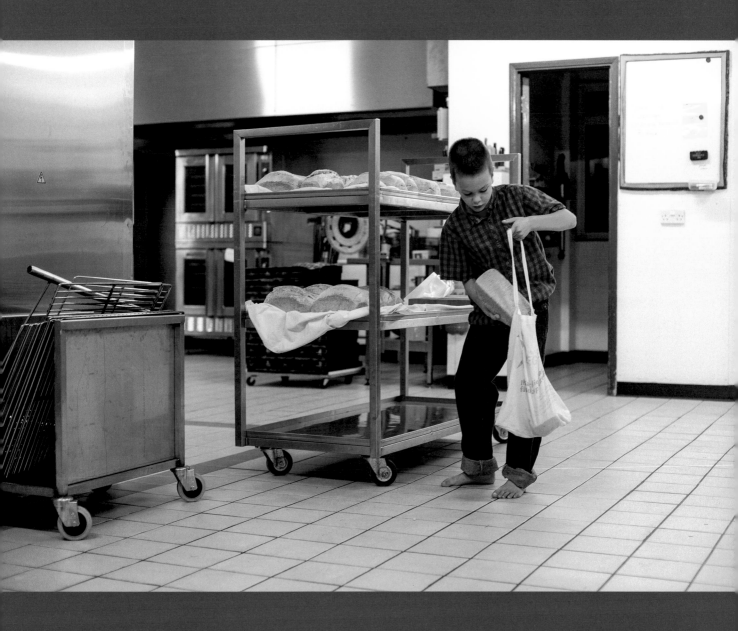

Our work as a whole should provide for the common table at which all sit down and every one satisfies his hunger. This was the experience of the Jewish people after liberation from Egyptian slavery and it was the experience of the early Christians in Jerusalem who, aglow with the spirit of Christ, lived together in peaceful, just, and united community, sharing their possessions communally.

Hans Meier, engineer and Bruderhof member
1902–1992

^
Fetching fresh bread
for breakfast from the
communal kitchen

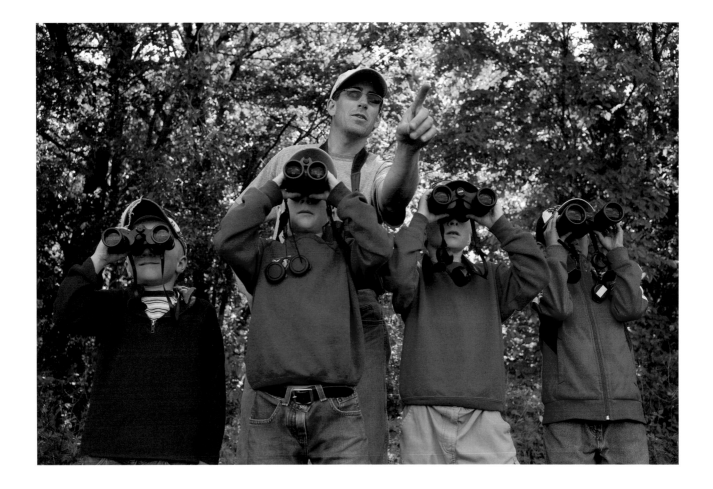

BRIAN DUNN
1974–

An educator who teaches sharing as part of every lesson

^
Brian guiding
young birders
on a Saturday
morning outing

<<
The communal
dining room in
Sannerz

The son of an industrial arts teacher and a nurse, Brian was born on Long Island and came to the Bruderhof as an eight-year-old with his parents and four siblings. A musician and teacher who has taught in the community's elementary schools for more than twenty years, mostly in southwestern Pennsylvania, he has naturally spent hours observing children. In recent years he has given a lot of thought to the harmful influences of materialism and the way they can be overcome. To Brian, it's a vital aspect of education:

Sharing always comes out of a culture of sharing. And this culture is first instilled in us by our parents. I remember two incidents from my childhood as clear as day: I was seven, and we were still living on Long Island. A neighbor knocked on the door, looking for food, and there was ground meat and steak in our freezer, and my father gave him the hamburger. The neighbor was grateful, but as soon as he was gone, my mother asked my father, "Why didn't you give him the steak?" That made a deep impression on me.

The other incident: my father had taken us kids to a camp for migrant workers who were picking apples in the area. We brought them Dunkin' Donuts. As we passed them around, we noticed that nobody was eating. Dad asked, "Is something wrong?" They said, "Oh no. We're just waiting until everyone has one before we begin." They cared about each other.

Brian also tries to teach generosity and selflessness in a more focused way, right in the classroom, mostly through literature:

There's Aesop's fables, Grimm's fairy tales, there's Dr. Seuss, and there are longer works like Dickens's *A Christmas Carol,* where the children can see the distinct change in Scrooge's life once he stops thinking about himself.

Brian notes that most children have "an innate sense of justice and

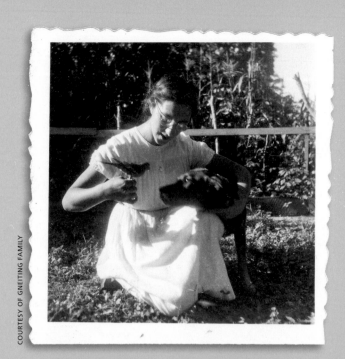

JULIANA GNEITING

1932–

Juli came to Primavera, the Bruderhof's South American community, at fourteen, through a well-to-do family who had taken her in as a maid (a member of the family joined the community, and thought she'd be interested too). She herself was dirt poor, and grew up sleeping in a hammock — out of reach of snakes — in a windowless hut. Juli never knew her parents but was raised by her Italian grand-mother, who had married an indigenous Paraguayan.

Generous to a fault, Juli caught the eye of her future husband, Jakob, on an outing to Asunción when she impulsively took off her only jacket and gave it to a shivering young woman right on the street.

Juli is still giving things away. Describing shopping trips with her, her granddaughter Denise says, "She'll have a whole list of people in her head who need something: a candle, a pack of stationery, a tablecloth, a box of chocolates. In February, she's already thinking of the old friend who has a birthday in April. But it's not about shopping. It's about having a heart for others. If a child is crying in the supermarket, she'll say, 'Poor thing!' and then engage the child and mother. Barriers don't exist for her."

Juli's love extends beyond people, to birds and animals and insects: "No squishing spiders: you take them outside. Ants? Why poison them? They also need food!" Nor is she one to put aside special things for special occasions: "What if we're dead tomorrow? Then you'll regret not sharing it!"

fairness, of whether things are bal-anced or right" – and that this can simply be nurtured and encouraged.

For years, I've run a weekly session where I choose five or six different current events, and we discuss them. And whenever there is something relating to poverty or war, or refugees, or civil rights, the reaction of the children is the same. They see the difference between rich and poor and say, "That's so unfair." They can under-stand world politics at that basic level, and they'll respond from their hearts.

Several years ago, one of my fourth graders won a $100 gift certificate in an art contest. That week we talked about a devas-tating earthquake that had just happened in Nepal, and how the

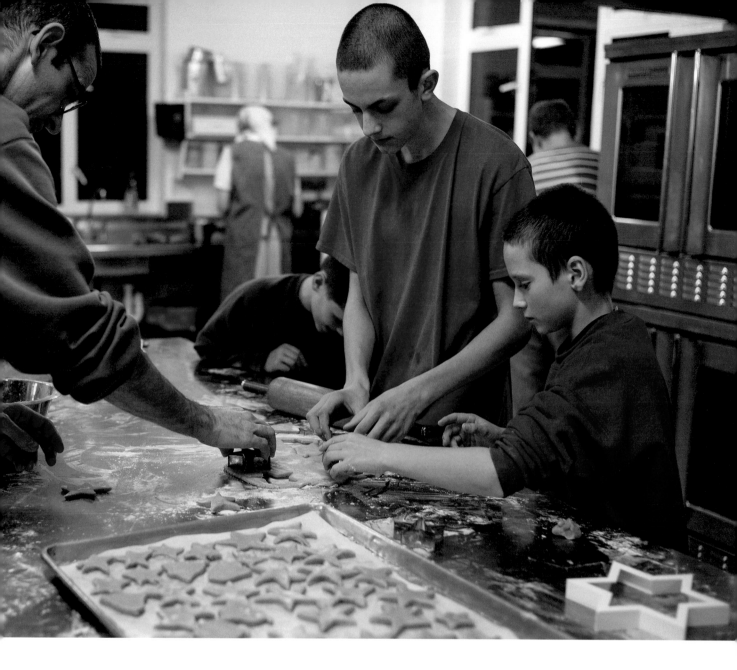

children there must be suffering. The girl who won the $100 suggested we use it to buy supplies for a school in Nepal, and that's what we did.

Still, even among children, human nature is what it is. Yes, there are moments when kids will spontaneously give to others. But that's not always the case. In fact, it's mostly not the case. So as educators, as parents, it is our duty to help them to put others first. This is vital if our children are going to grow up to become productive members of society. And that will never happen as long as they are guided by selfishness. Selfishness is a disease!

But a lot can be accomplished by ensuring that children are given the time and space to grow up in a world not needlessly cluttered with things:

I have found that the more you give children materially, the less grateful they are, and that the less you give them, the more likely they are to be happy anyway – happy with less. When I was student-teaching at a non-Bruderhof school, I once had a class that was nothing short of spoiled: they knew every restaurant in town, they belonged to every club in the neighborhood, they were on all the teams; but the first thing they'd ask when they got to my classroom – I was running an after-school program – was, "Brian, can we play outdoors?" And they were truly happy doing that.

Obviously you have to supervise them, but if you let them, kids will spend hours just playing: building stick houses and dams, playing fort, finding nests or watching birds. And the experience of losing themselves in outdoor play will give them something no amount of toys or gadgets or things can compete with.

Everyone wants the best for their kids, but often the best means giving them less materially, and rather giving them more of your time and attention. What children need most – a time and a place to play, and to be at peace with themselves, their family, and their friends – can't be bought. That's what we try to give them at our schools on the Bruderhof: memories that last, and – I hope – a lifelong habit of generosity. ♦

∧
Fathers and sons making cookies to share with a rival team at the next soccer game in the village

COURTESY OF BRIAN BUTTON

BRIAN BUTTON

1993–

Born and raised on the Bruderhof, Brian studied accounting, economics, and information systems at a private college in upstate New York and interned at an international accounting firm. At the end of the internship, he was offered full-time employment and a comfortable salary. He declined, however, and moved back home to the Bruderhof. But his education didn't stop there:

After college I spent six months with a small Christian NGO that does relief and development work in Myanmar and Bangladesh. It was my first experience of extreme poverty and oppression, and it opened my eyes.

The realities in front of me did not fit the neat economic frameworks that I had learned about in business school. I saw children growing up in refugee camps where desperation, hopelessness, hunger, and disease are the norm, and medical care, education, and hope are denied on the basis of their ethnicity.

I saw how the displacement of an entire ethnic group, the Rohingya, is directly related to the government's efforts to accommodate the international investors who circle like vultures over the region's natural resources.

Sometimes the work I was doing felt effective; at other times I felt helpless—overwhelmed by the enormous scale of the problem. When you have three hundred food packs to distribute to twelve hundred families, it is impossible to ignore the nine hundred you can't feed.

Today, Brian works in an office most of the day, managing the Bruderhof's insurance portfolios. But he does not forget his months overseas:

Moving between a world where revenues are measured in the millions and one where a few dollars make the difference between life and starvation, I felt validated in my decision to live a life outside of the capitalist system whose primary goal is the accumulation of money and power.

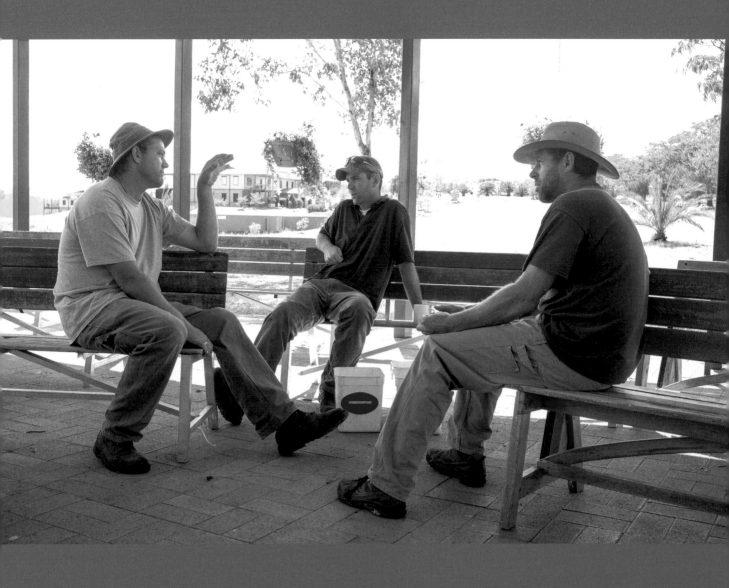

Men pray to the Almighty to relieve poverty. But poverty does not come from God's laws – it is blasphemy of the worst kind to claim that. Poverty comes from man's injustice to his fellow man.

Leo Tolstoy, Christian anarchist and pacifist
1828–1910

^
Deciding how to
approach a project on
the community farm

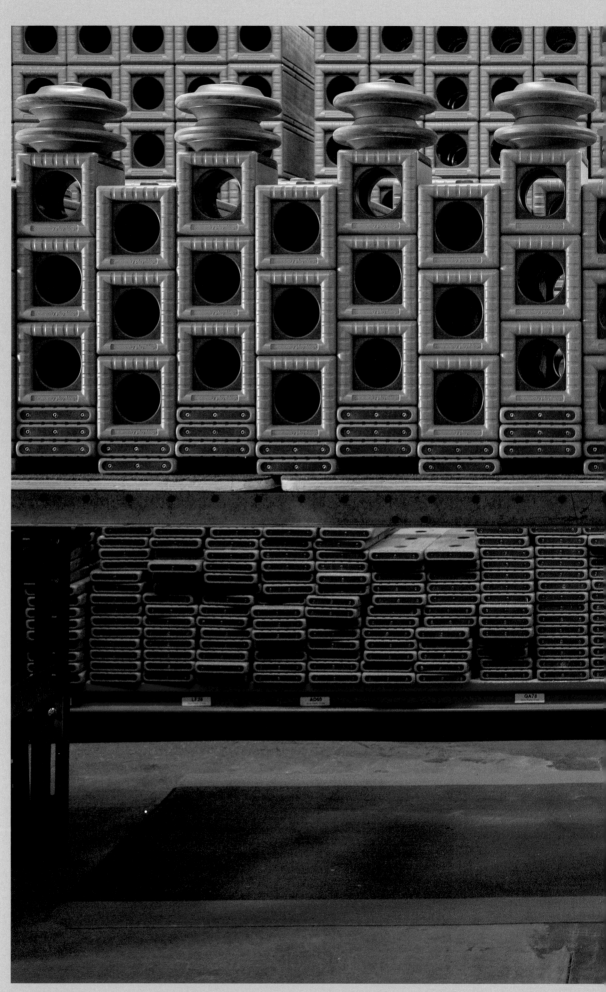

> Gary finishes a quality check on "Outlast" components in a Community Playthings factory. Outlast is a system of interlocking blocks and planks for outdoor imaginative and active play.

WORKING FOR A PURPOSE

BRUDERHOF ARCHIVES

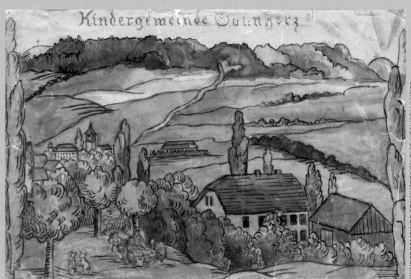

"KINDERGEMEINDE SONNHERZ" BY ELSE VON HOLLANDER

ELSE VON HOLLANDER

1885–1932

Born in Riga, Latvia, this professor's daughter was studying art when a revival swept through her German university town and opened her eyes to Jesus' command to "leave everything and follow me." Answering that cost her further education and a middle-class marriage (she turned down a proposal), but left a legacy that lives on today through the Bruderhof, which she cofounded with her sister Emmy and brother-in-law Eberhard Arnold.

From 1913 until her death nineteen years later, Else lived with the Arnolds: first in Berlin, as an art editor and business director at the publishing house with Eberhard, and then as the community's main fundraiser and accountant in its formative years.

Known at the Sannerz community (shown above in her painting) for her recklessly selfless devotion to "the Cause," as she called the young community's vision of a

new society, she disappeared on begging trips for weeks at a time in an open horse-drawn cart, even in winter. She dressed in a brown cape inspired by Franciscan devotion to Lady Poverty.

News trickled in by telegram: "500 marks promised, 2000 more in the mail." It must have been humiliating for someone of her rank to beg for money, but Else had freely chosen it: "If I demand a better standard of living than my neighbors, how can I claim to love them as myself?"

Else suffered from tuberculosis, and turned down offers of sanatorium retreats in order to continue working. As she was dying, she said of her efforts: "If it helped further the Cause, it is good. In any case, it was only a small, mousy effort." Asked if she had a dying wish, she replied, "To love more."

>>
Midmorning
coffee break at the
Sannerz community

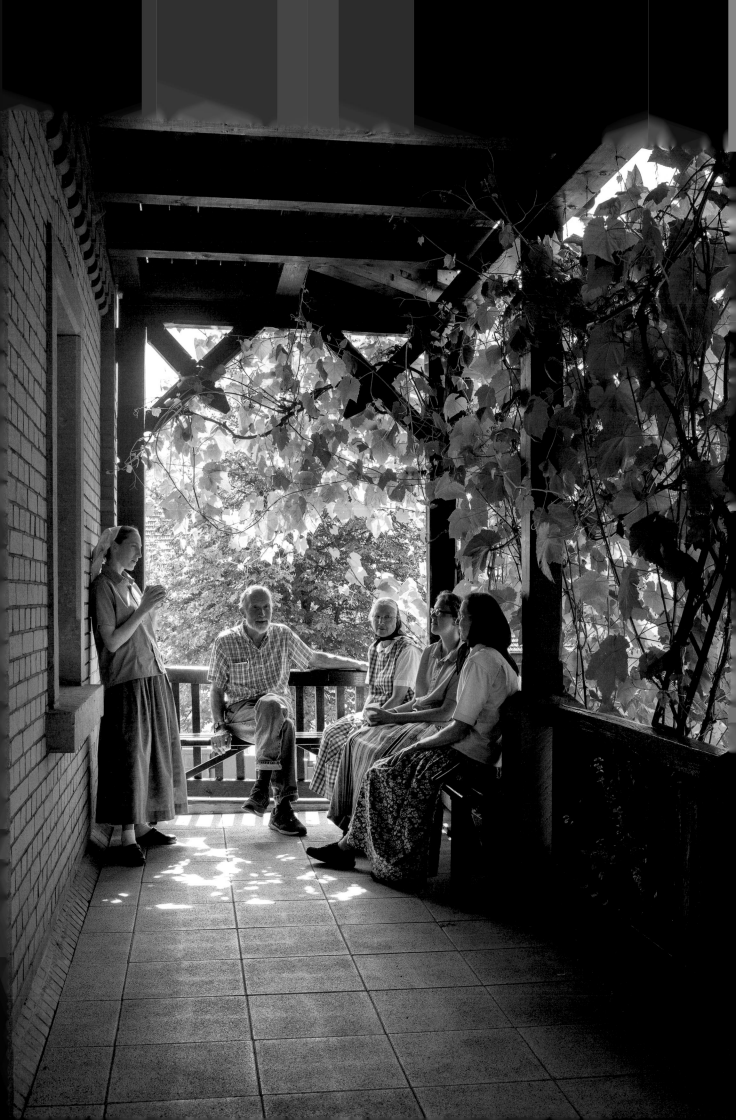

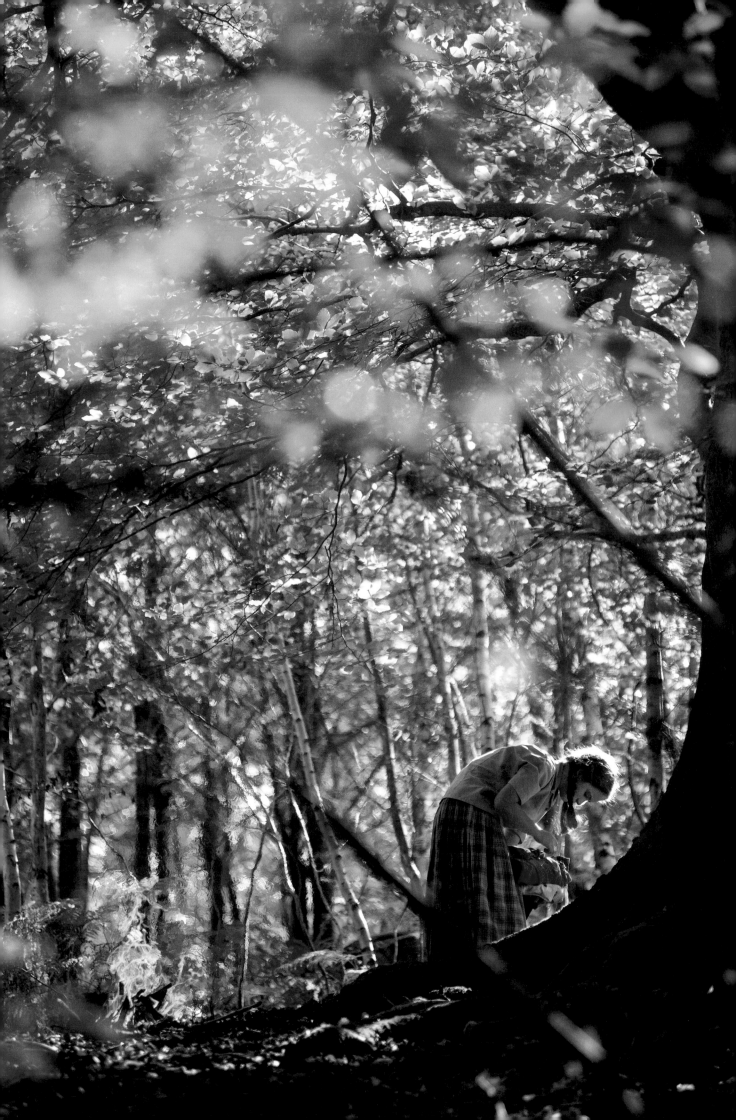

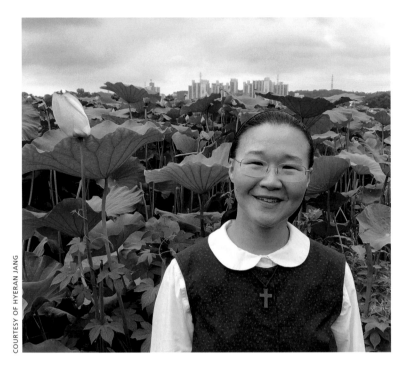

It was through prayer and pilgrimage that Hyeran found her calling.

HYERAN JANG

1973–

<<

Each year, as part of the school curriculum studying the Paleolithic Era, the middle-school students spend twenty-four hours alone in the woods. Within an hour this student had her fire lit, soup on the boil, and a stack of firewood ready for the night.

Hyeran learned to pray from her mother, a devout woman who, after converting to Christianity early in Hyeran's childhood, attended prayer meetings at 4:00 every morning. Prayer formed the background for her child-hood, despite her father's atheism and her family's troubles. As a ten-year-old, Hyeran discovered that her father had a mistress and "another family." How could such a situation be resolved? She had no answer beyond her mother's example of constant prayer.

As a teenager, Hyeran's questions about identity also played out against that background of prayer.

I was like Jacob in the Old Testa-ment who always struggled with his identity, and asked: Who am I? And then wrestled with the angel, saying, "I won't let you go until you give me a name." And then he got the name Israel, his identity, finally.

When I was a teenager, I was not just asking "Who am I?" but

I was trying to discover what my identity was in God's word. How much is God involved in what happens in the world? And then: What should I do for God?

When Hyeran was sixteen, she had a vivid experience of Jesus:

While I was praying, it seemed that a strong wind blew around me, and I was suddenly struck by the feeling that I was a sinner. Then I wept and wept; my sin killed Jesus. That was an experi-ence of being baptized by the Holy Spirit.

At the same time, Hyeran's awareness of the injustices of South Korea's competitive economic and educational system was growing. During a crucial examination period in high school, a teacher mocked the vocational stu-dents headed for Korea's factories: "It bothered me. A teacher should give his students hope and enthusiasm, but he was looking down on them." In protest, and despite being a usually

"I felt like I was on a cliff, and I had to either keep standing there, or jump. I decided to jump – to give up everything."

well-behaved student on the school's top academic track, Hyeran refused to take his test.

Her rebellion earned her punishment, both hands beaten with a wooden rod until they were swollen, and meetings with her alarmed parents and school administrators. She eventually gave in. (Later, Hyeran and her teacher found understanding and reconciliation.) "I graduated and went on to university, where I studied urban design and engineering. I had great hopes that we could change cities, especially housing and transportation systems. They weren't built with people's best interests in mind, and so many people suffer in them."

Hyeran had to fight to hold her own in a field heavily dominated by men. As well as being a woman, she was

also the only Christian in her college cohort. Social life was defined by heavy drinking, dirty jokes, and selfish individualism. Seniors demanded that underclassmen address them as God. One initiation rite involved "duck walking," a hike up a mountainside in squatting position, with their hands touching their ears.

After graduating, Hyeran joined a group that was praying for the reunification of North and South Korea. She helped plan a peace village to be built in the demilitarized zone between them, and publish a magazine about reunification, justice, and community.

Suddenly one thought came to my heart strongly. I felt that God wanted me to pray for our nation for a whole year. So I decided to quit my job to spend one year in pilgrimage

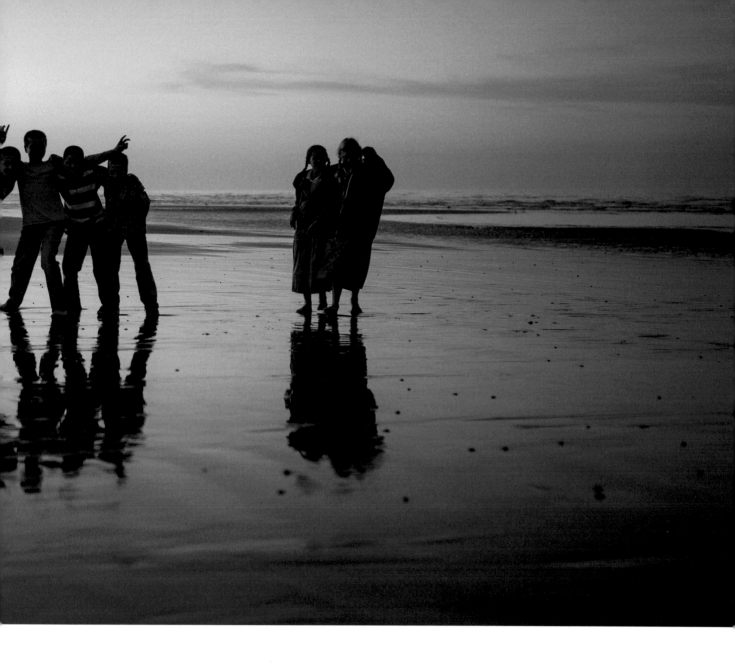

and prayer, traveling around Korea and visiting convents, abbeys, orphanages, and communities. I wanted to know how God was working in Korea, and I also wanted to find the place where God was calling me to be. During that year I was inspired by reading the Gospels, and was deeply moved by God's love for this world.

After that year, Hyeran visited Beech Grove Bruderhof, which she had learned about through her publishing work. She stayed there a while, then visited a few other communities in Europe, and then Danthonia. It was there that she decided to become a member.

I felt like I was on a cliff, and I had to either keep standing there, or jump. I decided to jump – to give up everything. After I made my vows, I was told: "Hyeran, now you belong to us, and we to you. You will be taken care of for the rest of your life." I wept. I had longed to find a place where such a mutual commitment is possible for so many years, but never found it.

I had such joy losing myself. I don't want my life to be about what I'm doing, or what I planned and then achieved. What I really want is that God's kingdom affects everybody's life, not only my life.

In early 2019, Hyeran moved back to South Korea with a few others to found a small Bruderhof community there. ♦

COURTESY OF DECKER FAMILY

JEREMY DECKER

1986—

Raised on a Minnesota farm, Jeremy was a teen when his family moved to a Bruderhof in upstate New York. He became a member in his own right at twenty-one. Now he and his wife, Sallie, an optometrist, have two children.

An active member of the local volunteer fire department, Jeremy has worked a variety of jobs inside and outside the community: in an orchard, in home improvement, as an auto mechanic, and his current job, maintaining inventory and parts flow and overseeing the jigs and tooling department in one of the Bruderhof's factories.

I wouldn't say I'm "called" to the specific job I'm currently doing. Living in community with brothers and sisters, sharing all things, and serving one another — that's my calling. Having said that, it's my readiness to work wherever I'm needed that makes community life possible. In other words, it doesn't matter so much what I'm doing, as what I'm doing it for.

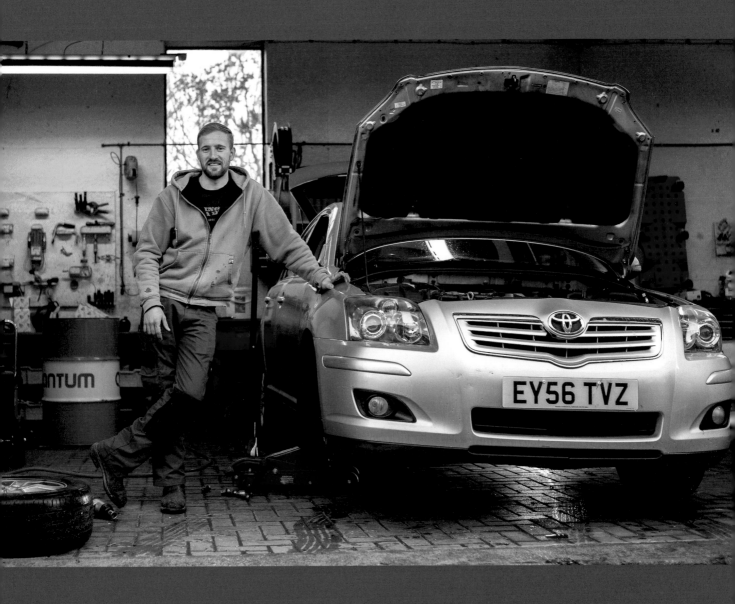

Think of the ingenious works of a clock, where one piece helps another to make it go, so that it serves its purpose. Or think of the bees, those useful little insects working together in their hive, some making wax, some honey, some fetching water, until their noble work of making sweet honey is done, not only for their own needs but enough to share with man. That is how it was among the brothers.

Kaspar Braitmichel, Anabaptist chronicler

d. 1573

∧
One of Caleb's responsibilities is maintaining the community's fleet of cars.

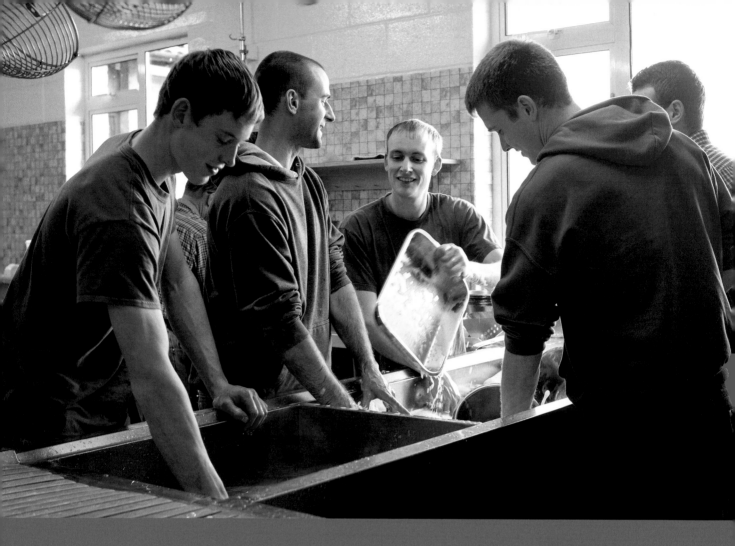

To lift up the hands in prayer gives God glory, but a man with a
dung fork in his hand, a woman with a slop pail, give him glory
too. He is so great that all things give him glory if you mean
they should.

It is not only prayer that gives God glory but work. Smiting on
an anvil, sawing a beam, whitewashing a wall, driving horses,
sweeping, scouring, everything gives God some glory if being in
his grace you do it as your duty.

Gerard Manley Hopkins, Jesuit poet
1844–1889

^
After community
meals, the men do
the dishes.

Klaas has worked in organic gardening, tool- and die-making, parts production for the automobile industry, and graphic design.

KLAAS VAN THOOR

1990–

While I was there, the company where I trained in Germany went from a friendly, comfortable place to a 24/7 production company with around-the-clock shifts. At one point our old boss was replaced. People didn't matter to the new boss: they were numbers on a spreadsheet. Soon we were doing rolling shifts — early, late, at night — that were entirely out of sync with the rest of the world. I know of colleagues whose marriages collapsed. Another left because he valued time with his family above a well-paying job.

Today, Klaas works in the graphics department for the Bruderhof's Community Playthings business.

I work with brothers and sisters all day long. Not under them, and not over them. Even my so-called boss is my brother, spiritually speaking. When there are tensions or problems, we talk about them openly. There's a sense of teamwork that I know is very rare elsewhere.

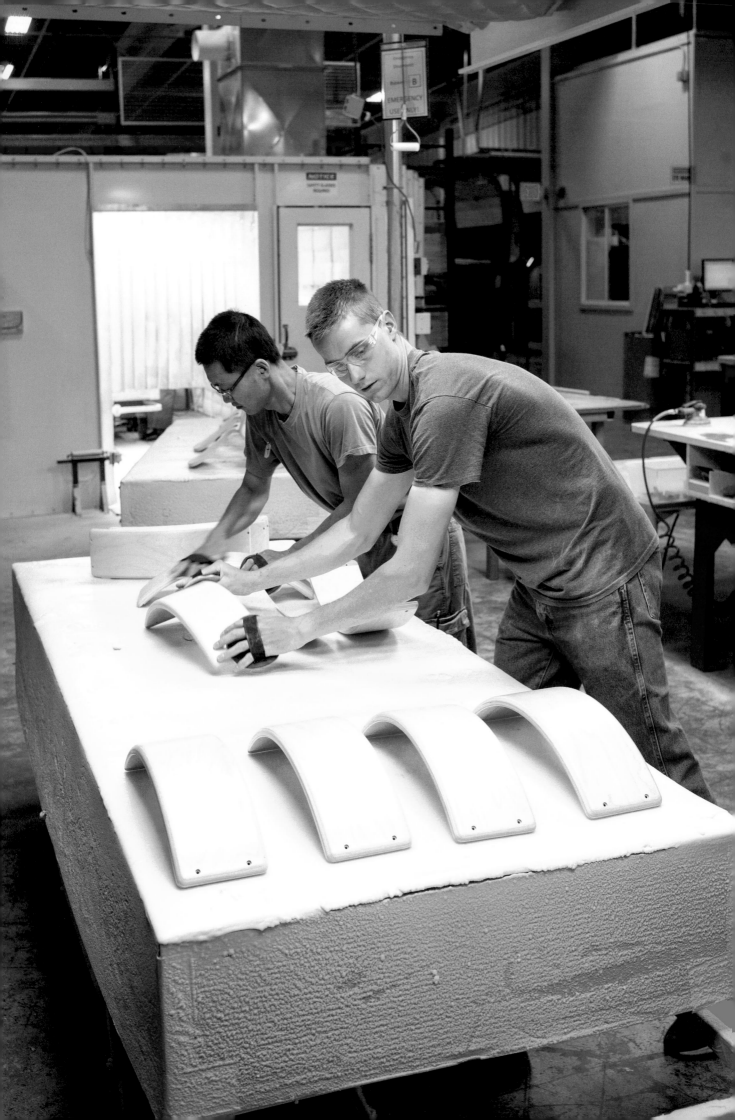

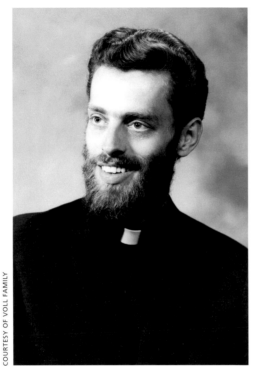

COURTESY OF VOLL FAMILY

JERRY VOLL

1941–

A pastor who discovered that true vocation is how you live, not what you do for a living

Already as a child in Louisville, Kentucky, Jerry knew he would become a minister: "Our family went to church regularly. Two of my older brothers were ministers. And my father had the notion that a minister was the highest category of Christian." Three years into his career, however, Jerry became convinced that the best way to serve God was to leave the pastorate.

Part of it was frustration with the lack of personal commitment he found in his congregation, whose members seemed satisfied with superficial relationships and a calming Sunday sermon. Part of it was also his own seven-year preparation for the ministry (four at college, and three more at a United Church of Christ seminary):

One book that really spoke to me during my studies was Dietrich Bonhoeffer's *The Cost of Discipleship*. It made me realize that I needed to be active in society, not only in my church. This was the era of the civil rights movement and Vietnam, and the issues of the day were all new to me. I had never realized how racist my supposedly good Christian family was; nor did I know anything about conscientious objection to war. (There were army men in our family, and serving in the military was not a subject for debate.) Now I began to see that as a follower of Jesus, I could not take part in killing.

As a pastor, Jerry's views soon landed him in trouble. One man known as a "pillar of the church" attempted to bribe him to lose the beard that marked his dissenting. Another complained about how hard it would be to get rid of him: "The only way you can remove a minister is if he's openly preaching heresy or running around with someone else's wife."

Ironically, that wasn't always true. When a married fellow pastor fell in love with another woman and obtained a divorce so that he could

<<
Jerry's grandson Jordan working with Jaehyoung, making furniture in the community workshop

"We hungered for something deeper – for real fellowship. But I knew in my heart that to find it, we would need to forget what we had and find something new."

remarry, Jerry confronted him with Jesus' clear words about marital faithfulness in the Sermon on the Mount. The man retorted, "You can't take the Bible so literally." In short, what Jerry had regarded as a calling was viewed by his congregants in a very different light: as a profession.

By now I had been serving our parish for about three and a half years, and there was a strange uneasiness growing inside of me. Financially, Nancy – my wife, an English teacher – and I were making it. We had a house and a brand-new Pontiac. We were good tithers, as were many others.

But there seemed to be very little desire to follow Jesus one hundred percent, and I began wondering why people attended church in the first place. To me, it was becoming clear that it was just another institution, and that my involvement could only continue within the framework of that institution. We hungered for something deeper – for real fellowship. But I knew in my heart that to find it, we would need to forget what we had and find something new.

Then, at a weekend retreat, someone told us about this community in Connecticut called the Bruderhof.

The Volls made their first visit over Easter in 1970, and discovered, in Jerry's words, "the church as an organism made up of people who have given their hearts and lives to Jesus and to one another. They were not going to church, they were the church, all day, every day." Back home, they took stock of what they had experienced, and made several decisions:

One was that I had to get out from underneath professional ministry. Another was that we had to get our own life in shape. There were things that weren't right in our marriage: we were used to things being excused or swept under the carpet, and now saw that they required repentance. Finally, we realized that Christians are called to community (not necessarily the Bruderhof) and that we ourselves had to answer this call.

In June 1970, Jerry resigned, and moved, with Nancy and their one-year-old daughter, into an intentional community: a big farmhouse with

two other families and two college students. That effort fell apart due to a lack of trust and common vision and, about a year later, they moved again, this time to the Bruderhof. Jerry and Nancy became members in 1973. Since then, Jerry has worked for the community in numerous capacities: making classroom furniture and designing equipment for people with disabilities, helping in the publishing house, and serving as a pastor and youth counselor.

All this has transformed the way he thinks about vocation:

There is such an emphasis on choosing and building the right career, on finding myself and my vocation. But the real question is this: "What does Jesus call each one of us to?" or, put another way, "How does God want me to live?" These questions are valid no matter what your line of work.

On my first visit to the Bruderhof, I told a member that my goal was to be an effective pastor. "We are not called to be effective," he answered forcefully. **"We are called to be faithful." ♦**

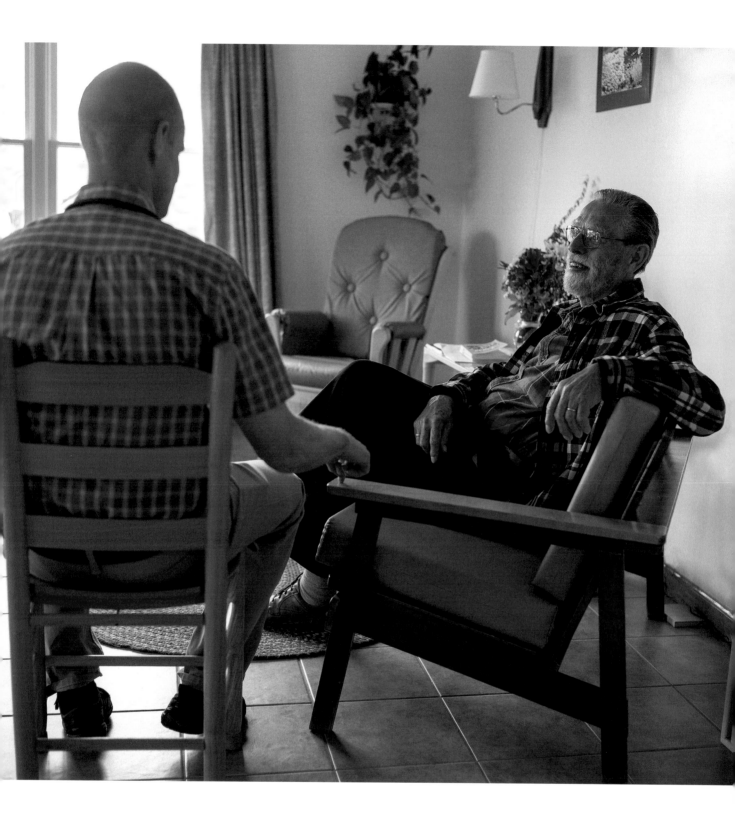

^
Jerry reviewing
medical options during
a house call from
Jake, his primary
care physician and a
fellow member of the
Bruderhof

STAN EHRLICH

1920–2004

Born to a Jewish businessman and a concert pianist, Stan was attending business school in Brussels in 1940 when the Nazis invaded Belgium. He fled for his life, illegally crossing numerous borders until he left Europe from Spain, eventually settling in Buenos Aires, where he met and married Hela, a Jewish refugee from Dresden. In Buenos Aires, they lived "the classic bourgeois life."

Despite financial security and the cosmopolitan trappings of their social life — the Ehrlichs each spoke four languages and were conversant in philosophy, literature, and modern art — the young couple was dissatisfied. They considered themselves survivors, and as Stan put it years later, they were searching for "something transcendent, something that could relate our life to eternal truths and values, and give our work substance and meaning."

They discovered the Bruderhof and joined in 1954. Stan's sense of gratitude and awe, even personal indebtedness, before what he perceived to be a miracle — the communal life they had found — never dimmed. Over the next decades, Stan worked for the community's businesses in sales and shipping and in its factories. An odd fit for someone with his interests and intellectual gifts? Stan would beg to differ. As he wrote to a granddaughter: "Happiness and inner peace do not depend on your work. They depend on the purpose you have discovered for your life." Writing in his seventies to an old friend, he said:

I still work a few hours every day in our factory. A joy! The way the windows are set, so that the place is flooded with light; the height of the ceiling; the atmosphere of peace on the floor — all of a sudden it occurred to me that this was a cathedral. Light, joy, peace, service: isn't that what cathedrals are about?

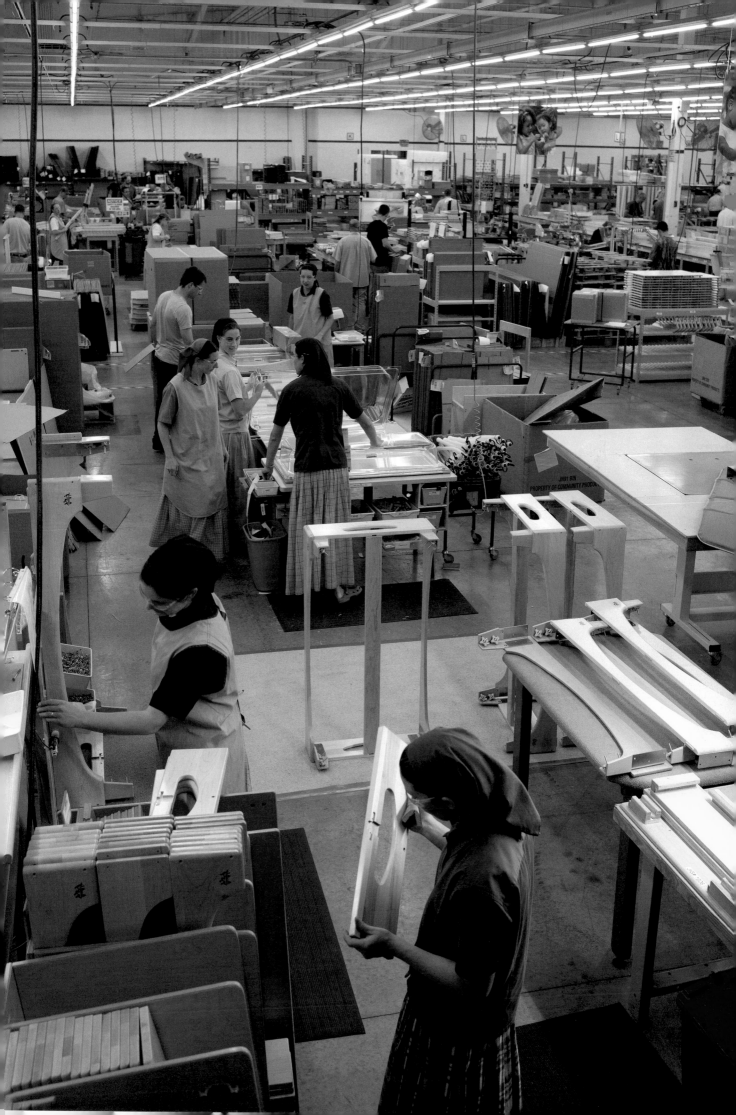

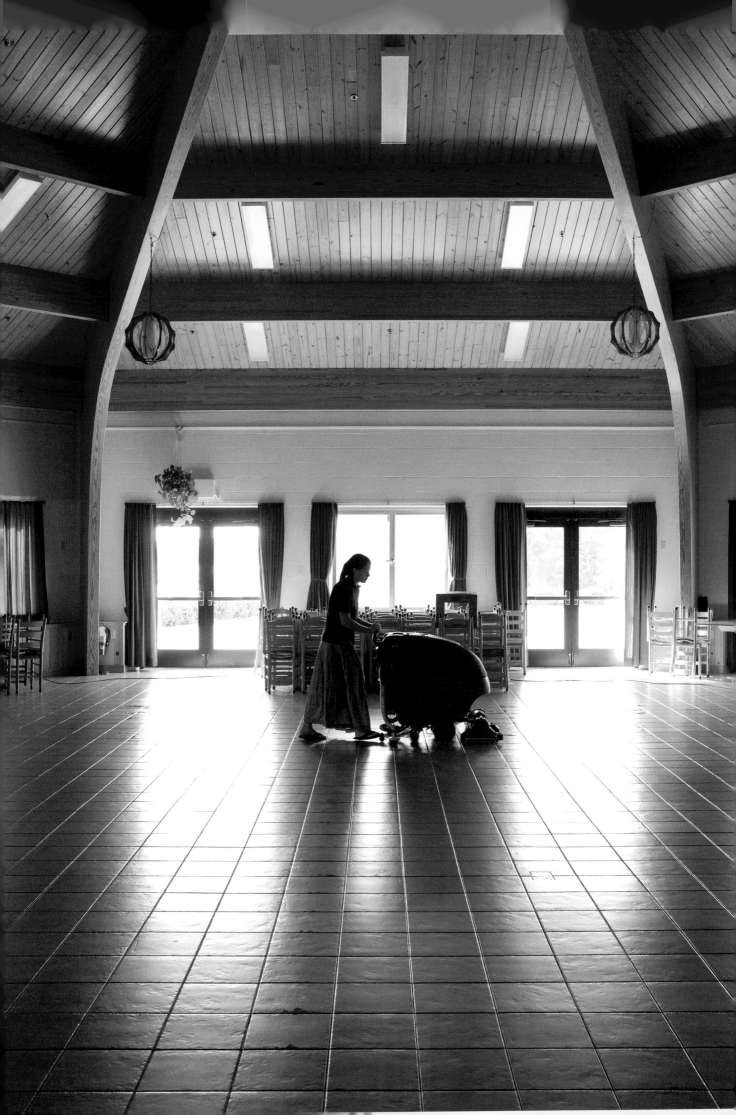

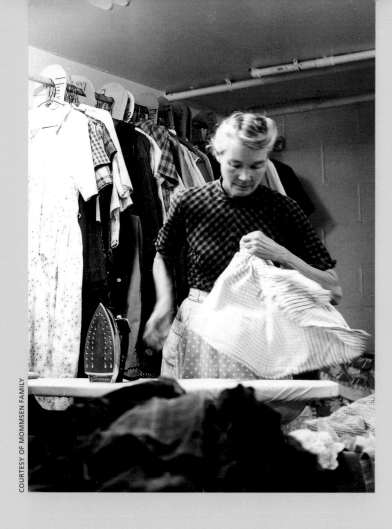

DOROTHY MOMMSEN

1922–2007

A nature-loving young woman from Miami, Dorothy studied sociology, worked for a campus peace committee, did war-relief work, and taught school in rural Virginia. After World War II, she married a conscientious objector, Arnold, and the two helped build up Macedonia, a humanist cooperative farm in Georgia. They eventually had five children. In 1957 they and many of their fellow communitarians joined the Bruderhof. For the next quarter-century, Dorothy worked in the community's laundry, then primitively equipped and located in a basement.

Those were the years when everything had to be hung on lines and rushed indoors when it rained. Washing and folding laundry for up to three hundred people was hard work, so when the piles of sheets and jeans got overwhelming, Dorothy liked to go home, fry a batch of doughnuts, and call an impromptu break in the sunshine and fresh air. Only when she was in her late sixties did she suggest to the community that she might enjoy working elsewhere, and soon became the school librarian.

Dorothy loved birds, trees, and poetry, which she collected in scrapbooks where famous poets—A. E. Housman,

Langston Hughes, Gerard Manley Hopkins—jostled with writers like Dom Hélder Câmara and George Borrow. She liked to quote the latter: "There's night and day, brother, both sweet things; sun, moon and stars, brother, all sweet things; there's likewise a wind on the heath. Life is very sweet, brother." Handwritten copies of poems were given as birthday presents to her twenty-four grandchildren and to the many friends with whom she corresponded, including dozens of prison inmates. As she lay dying, a former inmate who had exchanged letters with her for close to twenty years of incarceration flew halfway across the country to say goodbye: "She's my mother. I owe it to her."

A usually gentle woman who could be tart on occasion, Dorothy's attitude to work might best be summed up by this insight from a favorite author, George MacDonald: "I begin to suspect . . . that the common transactions of life are the most sacred channels for the spread of the heavenly leaven."

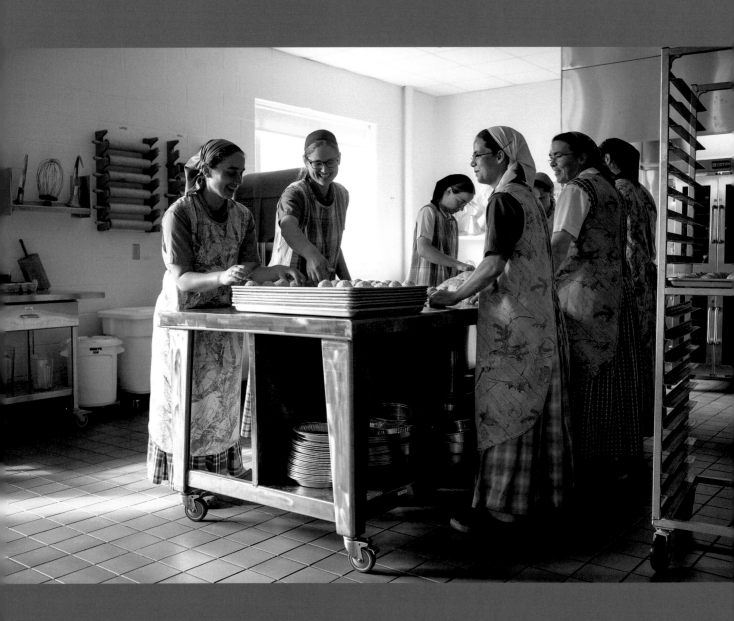

We are grateful that we can live to demonstrate unity with peoples of all nations, and help to build up, not destroy, the brotherhood of man. And, whether we wash or cook is small in comparison with that vision. It's a case of "I would rather be a doorkeeper in the house of my God, than to dwell in the tents of wickedness" [Psalm 84:10]. I find happiness in washing for the kingdom of God, where I'd only find misery in making, say, ammunition for its destruction.

Nina Wright, teacher and Bruderhof member. Written in 1942.

1911–2008

BRONWEN BARRON

1995–

Bronwen is a nurse and works in the medical clinic in Bellvale. At age nineteen, before attending nursing school, she worked for a year in the community kitchen, overseeing the team putting food on the table for 250 people every day, a responsibility that meant she was often in the kitchen after hours.

A friend and I started making granola and yogurt for the other young people who would come to the kitchen after work to make coffee and heat up leftovers. The kitchen became a kind of informal hangout: in off hours there would be a lot of young people in there, sitting on counters with their bowls of granola and talking. People really appreciated it: it was a good way to make space for friendship and conversation. On days when I don't really connect with anybody—work-related chatter doesn't count—I'm left feeling kind of blank. But even one good conversation about real life can make my day worthwhile.

That's just one example. It's easy to get into the mindset that once I've done my allotted work I can sign out for the day, but that's not what discipleship means. In fact, sometimes focusing on my job gets in the way of actually living in community with people—taking time to talk, to go the extra mile giving practical help to an older person, or just finding ways to bring a smile to someone's face. But because I live in community I have the freedom to prioritize people over the work that needs to be done.

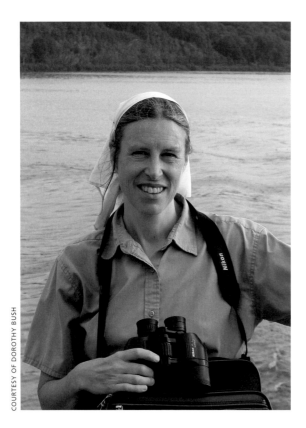

COURTESY OF DOROTHY BUSH

DOROTHY BUSH

1964–

**A nurse who calls
many places – the United
States, Nigeria, Germany,
and England – home**

Born in Connecticut to British members of
the Bruderhof, Dorothy, a nurse, has lived and
worked in Nigeria, Australia, England, New York,
and Germany, where she currently lives at the Holz-
land Bruderhof while working in the burns unit of a
rehabilitation center. But no matter where she goes,
there's always one constant: her wish to help others.

Already as a child, I knew I wanted to help peo-
ple. When a classmate had a mishap, and when
my teacher had an ice-skating accident, I was
interested in their injuries. I read *The Day of the
Bomb*, which is about the aftermath of Hiroshi-
ma. I got involved in my school's fundraising
project for Vietnamese "boat people" – that was
the refugee crisis of the late 1970s.

By the time I was fourteen, my family left the
Bruderhof and I had lost my childhood faith.
How could there be a good God, yet so much
pain? I volunteered at a camp for teens with
disabilities, and immersed myself in human
rights issues while participating in Model UN
and Model Congress.

When my parents returned to the Bruderhof, I
decided to move out on my own. The Bruderhof
was nice, I felt, but too comfortable. I wanted to
do something about the needs of the world.

Late one night I climbed out onto the rooftop
fire escape to look at the stars. There they were,

in their familiar patterns, vast, silent, eternal.
Suddenly I was aware of something powerful
and good embracing the entire arch of heaven,
as well as the whole earth. Since that moment,
I have known that God is there, and good, and
that all that is wrong stems from a separate
and evil power waging invisible battle here on
earth. And I was free to choose which power
to serve!

First I moved to a small town near Jackson, Mis-
sissippi, and worked in an educational program
there. From there I moved to St. Louis, where I
worked at a treatment center for neglected and
abused children. Soon I was answering ambu-
lance calls for the city as an EMT and training to
become a paramedic.

During this time, Dorothy began to see that the
individual tragedies that surrounded her were the
consequences of larger societal problems, and found
herself grappling, once again, with the meaning of
human suffering:

It often felt like we were trying to solve soci-
ety's problems with bandages: wiping the pus
off the surface of the wounds and then covering
them with clean dressings. Could anything
stop the spread of the underlying cancer? I
wondered about "my" kids at the center. In
ten years, how many of those precious five-
year-olds would be in jail or themselves young,

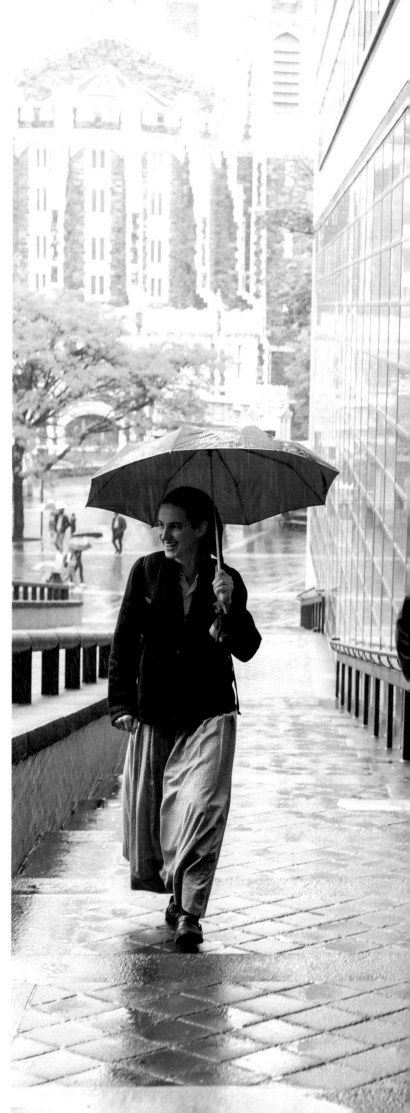

overwhelmed moms, caught in cycles of neglect, abuse, and despair?

I discovered that being poor or oppressed is not a virtue; that is, it does not free people from selfishness, or from attempting to get ahead by pushing down others.

I felt bankrupt, and realized with a jolt that I was part of the problem. I was fueling these destructive forces with my own selfishness, my dishonesty, with my drive to be in control, to be right. I saw that it wasn't enough to "serve people" as a neutral party. I had to allow light to totally cleanse and change my heart. At the same instant I knew that that light was Jesus, who had given sight to the blind, compassion to prostitutes, life to the dead. He had also said "love one another" and "become one." I felt personally invited to the service of unity and love, of Jesus' kingdom.

Not worrying over details, but knowing that she needed a community where she could be "part of a body" rather than an isolated pair of helping hands, Dorothy picked up the phone, dialed the nearest Bruderhof community a thousand miles away, and asked to come back and become a member. This moment of saying yes remains an anchor to her life of service in community, which has not been without struggle.

I remember panicking on my first day when I looked around the community dining room and saw all those healthy, happy, stable families. I momentarily felt I had forsaken "my" children in St. Louis. But then I imagined where everyone might be, if not for the gift of this church: some would be wealthy, some would be the victims of broken marriages, some would be at risk of neglect and abuse. It made me all the more determined to help build up a new, different society, on the basis of justice and love.

As it happened, the Bruderhof needed nurses at the time, and Dorothy was asked if she would be willing to go back to school.

After graduating, I worked in a little clinic run by our community alongside a doctor with decades of experience. Among other things, I

learned the importance of humility, the readiness to admit when you've made a mistake. And I learned the value of working as a team, also with your patients' families, instead of adhering to the professional hierarchies that separate people in so many healthcare settings. I learned more during my first year there than I'd learned all the way through nursing school.

As a member of the Bruderhof, Dorothy has had many opportunities to use her skills outside of the community. For example, she lived in New York City for several years, working as a hospice nurse case manager, making house calls to patients up and down Manhattan. She loved that work, often feeling that she was at the receiving end of these interactions with her patients. It wasn't all easy, but offered important lessons.

My job included visiting patients in some of the most notorious housing projects in upper Manhattan. I often wore a stethoscope around my neck as a badge of intent. Once I found myself in an elevator where the only other passengers were young men whose black and gold marked them as Latin Kings. As I got off a few floors later, I said, as I always did, "Have a good day," which was met by a vigorous volley of well-wishes: "Take care, ma'am!" "Get home

safe!" Just kids, wanting to belong. I felt as secure as if they had been angels!

Late one afternoon in Harlem I saw a crowd gathering around an ambulance, and several squad cars, so I crossed the avenue and kept walking. Medics and police were trying to restrain a young man and load him into the rig. As the doors slammed shut, an elderly woman stepped forward, raised her arms and called out over the crowd, "Who is this man's family? Who here is gonna pray for him?"

I immediately felt put to shame for only thinking about my own safety, and still hear this grandmother's plea whenever I run into distressing situations – a highway accident, or a patient's frustration. Whether or not I can help as a medical professional, there is always something else I can and need to do: pray that God intervenes.

After three decades on the job, Dorothy finds herself occupied with an issue familiar to anyone who works in the caring professions: the cost of possessing skills that are always useful, and always needed by someone.

I felt happy and fulfilled caring for children at a Bruderhof house in Germany, having finally learned enough German to interact with our

<

Caring is often
simply accompanying
someone you love
through her daily
routine. Maria and
Olgi walk to work.

neighbors. Just then, however, our communities in England put out a request for another nurse and I was asked, at a moment's notice, to move there. For whatever reason, I found it very difficult. It wasn't that it was a surprise. All members in our community promise to live and work wherever they are needed; and as a single woman and as a nurse, I'd moved many times, and was actually used to it.

Being single was not my choice, but that's how it worked out, and it had given me the chance to be available for service in a different way than if I had had a husband (with his work to take into consideration) or children to look after. It has brought me the chance to travel again and again, and the freedom to respond wherever there was a need, whether for the short or long term. Sure, it often meant parting with friends and familiar routines, but I'd always seen it as a positive thing: an opportunity for a new beginning. This time, however, I suddenly realized that I wasn't responding with the sense of adventure that I'd had in earlier years.

I thought: "You're in your mid-fifties, and you still don't really have a place you think of as home." A friend tried to encourage me: "On the other hand, you have many homes—more than a dozen!" I moved, but struggled for months.

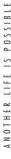

> *Availability for service is one of the most marvelous gifts that we can find in community. People who have this gift trust those in authority and community itself, and take on whatever is asked of them.*
>
> *Jean Vanier, founder of L'Arche*
> *1928–2019*

Nevertheless, I was happy while working during this time, maybe because my vulnerability made me better able to hear the pain of others.

Then I remembered a book someone had given me years ago, when I was living in St. Louis, before I'd joined the Bruderhof. It was a used book from a thrift store, by Jean Vanier. It was called *Community and Growth*. In this book, there's a wonderful chapter on gifts, and in it Vanier says that availability for service is one of the most marvelous gifts there is in a community.

When you hear that someone is gifted, you tend to think that they're artistic or musical or very intelligent. And here is Vanier saying that availability is a great gift that we can each give one another. So I reread this, and found inspiration again.

I don't know what opportunity might come up next, but I know that wherever I land, the chance for service will be there. The challenge is to not miss the opportunities that come along – to keep your heart open. ♦

Christmas in England:
two girls deliver
presents.

A software developer at Maple Ridge, a Bruderhof in upstate New York, Sheera has done international relief work with refugees several times, on the Greek island of Lesbos and in a hospital in Jordan.

You can run all over the world on wonderful initiatives, but I've come to feel that it's what you do for people who are part of your life from day to day that has the greatest impact. That's why I love the "normal" work that comes with living in a community. There are endless opportunities: opening your home to someone who is lonely, caring for a child or elderly person, cleaning for a neighbor who's feeling overwhelmed. The catch is self-sacrifice: How ready are you to go out of your way for others?

As a third-generation Bruderhof member, I'm concerned that we remember this—that our community doesn't become just another lifestyle, but that the spirit of Jesus keeps us alive, so that we can keep alive the vibrancy of the original vision: mutual service in communal work and worship.

And the fact is that this mutual service makes it possible for us to send out groups of volunteers at short notice to respond to disasters. In 2015, at a time when thousands of refugees were making the sea crossing from Turkey, I went to Lesbos with a group of twelve that mobilized over a weekend to volunteer there with Save the Children. None of us had to worry about losing our jobs or that our families wouldn't be taken care of while we were gone, because the whole community rallied behind that effort.

SHEERA MAENDEL

1991–

^
Sheera with Marlys Swinger, a composer and great-grandmother

>
Sheera volunteering with Save the Children on the island of Lesbos.

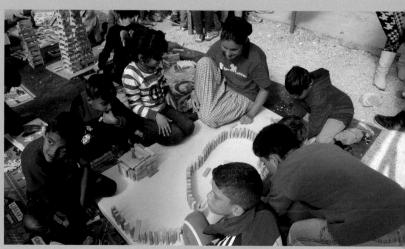

COURTESY OF MAENDEL FAMILY

> Bruderhof young people learn practical skills that can be put to use in service and disaster relief work.

BUILDING JUSTICE

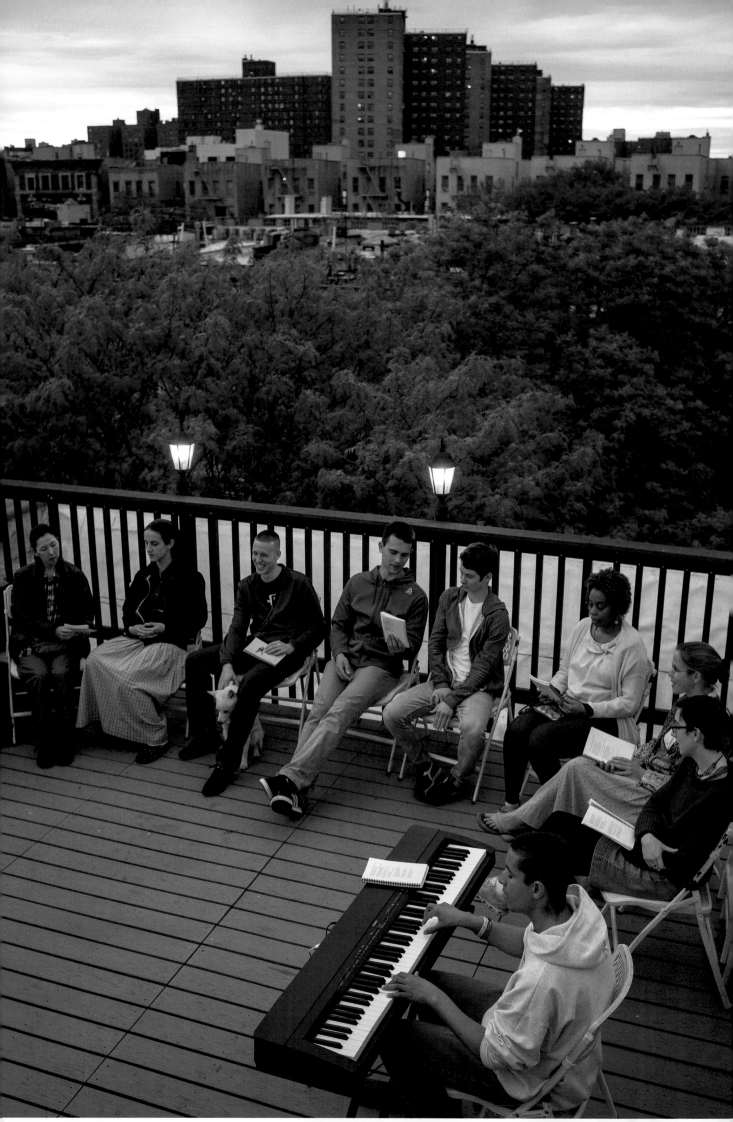

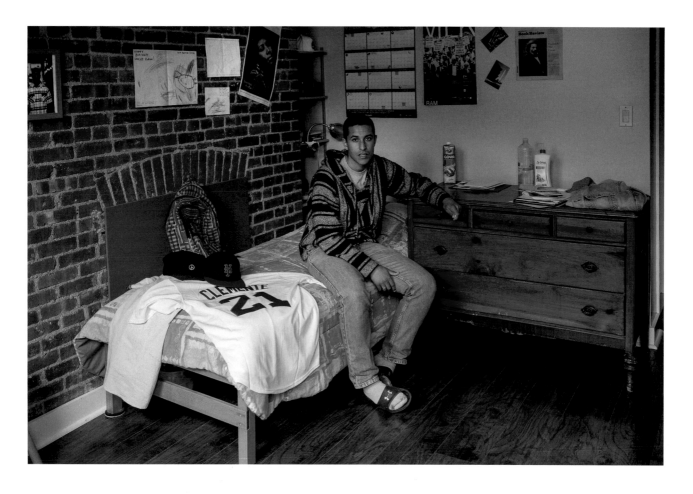

RUBÉN AYALA

1997–

**A young man strives
to carry on his father's
legacy of working
for justice.**

<<
Evening worship
with members of the
Harlem community on
their rooftop deck

Growing up in the predominantly white
Bruderhof, Rubén was only vaguely aware that
he was different. Then, in the second grade, his
class made a field trip to a nearby public school, and
a kid on the playground there called him the n-word.
Today, a senior at City College in Harlem – one of
the nation's most diverse campuses in its best-known
African-American neighborhood – he says he is still
learning who he is. Far more importantly, his eyes are
being opened to the realities of inequality and injus-
tice, and he is learning through real-life experiences
how the people most affected think these injustices
can be overcome.

Rubén's first teacher was his father, a tough-as-nails
Puerto Rican who was raised on the streets of Brook-
lyn and went to prison at seventeen. After being
released ten years later, he struggled with drugs
and alcohol, and ended up at The Bowery Mission,
a Christian organization that helps people escape
homelessness and addiction. There he met a group
of volunteers from the Bruderhof. After several years
of off-and-on visiting, he joined. In 1993, he married
Emilie, who had been raised within the community.

When Rubén was three, recurring battles with
alcoholism led his father to leave the family and the
community, and for the next several years, his mother

> Rubén's favorite
mementos from his
father: a Mets hat,
Roberto Clemente
jersey, and a photo
with his father's hands
on his shoulders

raised him on her own. When he was ten, his father returned, and the family was reunited.

Only now, as an adult, does Rubén realize how much his father shaped his cultural identity in those critical years. A lot of it he simply absorbed:

He loved to cook, and in summer he'd invite anyone who wanted to join us in front of our house. He'd turn up his music – salsa, merengue, reggae, hip-hop – and then start preparing the food: arroz con gandules, arroz con pollo, octopus salad, and all kinds of things. Mom, who also likes to cook, would make dessert. Afterward we'd play stickball for hours, while my dad's cat, Brooklyn, and my dog, Shea, would chase each other and fight and add to the general craziness.

But just as much was transmitted through intentional lessons:

Anyway, one day when I was in sixth grade he pulls down this book and says, "You need to read this." It was Chancellor Williams's *The Destruction of Black Civilization*, an Afrocentric

history of the colonization of Africa. It's openly biased, but important because it's from a perspective you won't find in any standard histories.

I told him, "I'm not reading that big fat thing." But he was like, "Yeah, you are." I did plow my way through it over time, and, more than any other book, it's the one that got me interested in my major, history. It got me interested in digging for the truth.

Rubén's father also opened his eyes to many social justice issues:

Take the Puerto Rican nationalists of the sixties and seventies. That was a cause Dad believed in, and he didn't just show it by the flag that was always hanging in our living room. He was passionate about the history of oppression on the island. He told me about the mass sterilization of Puerto Rican women in the 1950s, and about the repression of the Young Lords, who started out as a street gang in Chicago but became known for their activism.

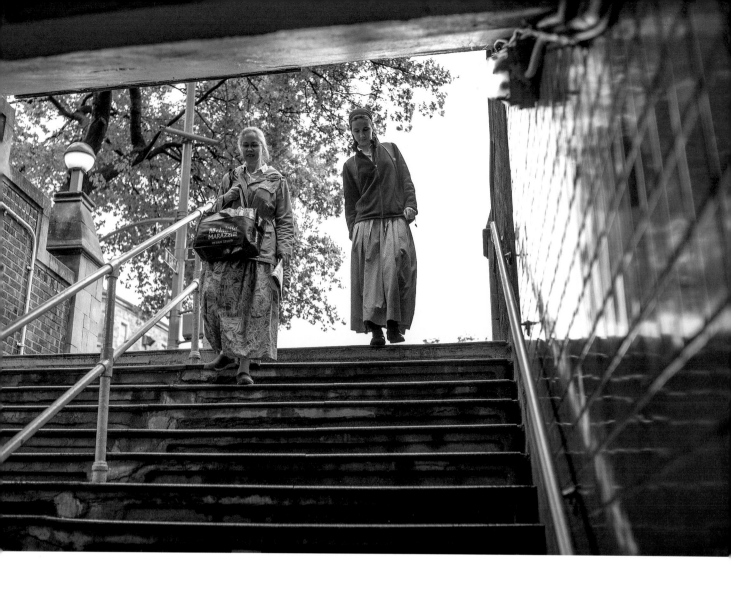

Another thing that concerned Dad was mass incarceration and capital punishment. As someone who had been incarcerated, he was set on raising awareness of what he called the "rotten-ass system."

The war and famine in Darfur was another major concern of his, and in 2008 our family traveled to the Sudan to see what was going on firsthand. We went with an organization our community had donated to, though Dad was just as interested in the history of the region, which is regarded as the birthplace of the Nubian kingdom. That trip opened my eyes to the reality of suffering in many ways, but there's one particular incident I'll never forget: in one village we stopped at, a woman tried to give my mother her baby. She literally begged Mom to take the baby back to America with us, and said, "He's just going to die if he grows up here." I can still see her face.

By 2010, Rubén's father was struggling with his addictions again and decided to leave once more.

Love does not begin and end the way we seem to think it does. Love is a battle. Love is a war. Love is growing up.

James Baldwin, author
1924–1987

∧
Members of the
Harlem community on
their way to volunteer
at a local church

I was in the eighth grade, and struggling with who I was in this community where almost everybody else had two parents, and things seemed to be going fine. I was always popular at school and had good grades, but I was all beat up inside and would often get angry at home.

But even if his father wasn't physically present, Rubén says the memory of his lessons continued to guide him:

I began to realize why my dad had exposed me to so many things and told me so many stories about his life. He had wanted to make me aware of things I would one day face on my own. In fact, he once said as much: "These are my experiences, and they made me who I am, but you're different than me, so you're going to have to fight your own battles and figure things out for yourself."

During his father's absence, Rubén says it was his mother who exerted the single most powerful influence on his developing view of the world:

Mom's family is German-American, from the Midwest. Culturally, she had nothing in common with my father, but in terms of her concerns, she was the same. For example: she'd often drive me to neighbors and friends outside the community. We would have dinner with them and discuss things. One woman I especially remember worked with juvenile delinquents. Mom made sure I listened to this woman about her experiences with the courts.

In late 2012, Rubén's father returned. He died at the Bruderhof several months later, of heart disease. Two years later Rubén graduated from high school. He spent a gap year in Australia before moving to New York City to go to college. He became a full member of the Bruderhof in April 2019.

Not surprisingly, living in Harlem has brought to life the stories his father used to tell him in a way he never could have imagined from the protected vantage point of his childhood:

I used to think, "Wow, Dad went through all this stuff? That's crazy." But now it doesn't surprise

me at all. The things that happened to him are not so far out. They happen all the time. Racism is still alive and well. It's wrong. It's maddening. It seems archaic. But the particulars aren't illegal, so it goes on and on, and millions of people are trapped in it.

Asked for his insights on how injustice can be fought, Rubén says that one of the biggest obstacles to progress is people's inability – or unwillingness – to admit that certain problems exist.

Take something like racism, or more specifically, police brutality and the way it affects people of color. To many whites, it's just a made-up thing. They so badly wish it was over and done with that they only see what they want to see.

But hey, I live in Harlem, and I've witnessed it. I've seen a boy riding a bike, and five cops jumping on him and just slamming him to the ground. Or take a movement like Black Lives Matter. I've heard people dismiss it by saying, "All lives matter." Of course every life matters, but that's a cynical response. Or they say they get the basic

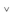

City College,
Manhattan

Sammy, Harlem
House's dog, welcomes
everyone.

∨

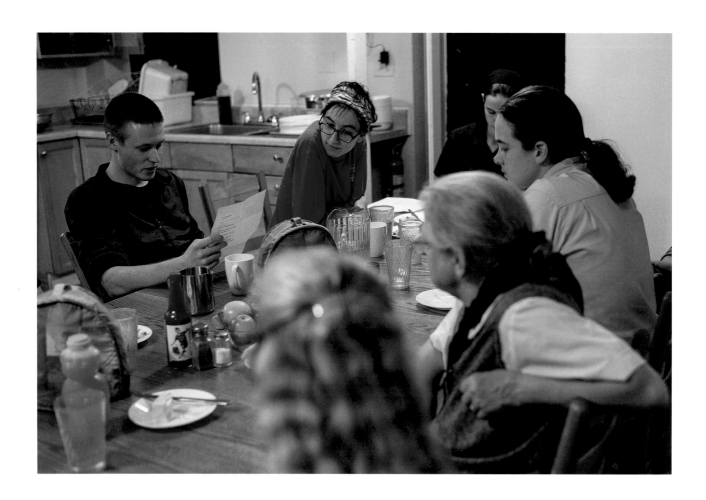

issue, but not the anger behind it. They seem unable to see that there might be a cause for that anger, and that you can't just condemn it and hope it will go away.

Unless you have had a personal experience connected with a life-and-death issue like this, maybe you shouldn't make too many sweeping statements. And if you don't have that connection, maybe you should take time to listen to someone who is actually affected by it.

I think justice can begin when people are no longer trapped by external circumstances or victimized by the power other people hold over them. For those of us who already have those freedoms, I think it's a call to action: to respect the culture and history of whoever is disenfranchised. And to show solidarity in the sense of being willing to learn, rather than always wanting to be the teacher. And to make sacrifices so that others can have a chance at getting ahead.

People–I'm talking about all races here–tend to congregate with their own kind, with others who have similar backgrounds and life experiences. And so the cycle continues. It's just a

fact that if you can't understand the people "on the other side," the easiest solution is to ignore them. But the problem is that in the long run, you end up being scared of each other.

My dad's feeling for justice came from a personal place. His anger and his energy came from what he experienced as a child and young man. And yet he ended up joining the Bruderhof. That used to puzzle me. Now I see that he deliberately chose to live in a way where he could break down the walls that separate people. I think joining the community was a deliberate move toward that. In fact, he told me multiple times, "Yeah, I believe that people should live together and work out their differences." So even though he knew what racism was, he still wasn't scared to live with white people or to marry a white woman. I honestly think that at least in part, it was to break down the barriers of inequality, first of all for himself, because he didn't want to be trapped in a world of us versus them. He was looking for true justice, the kind built on love and community. ♦

REBECCA
NEWTON

1992—

A teacher at the Bruderhof's high school in England, Rebecca studied education in the United States and Germany, where she received her master's degree. One thing that has occupied her over the years is the way educational systems reinforce and perpetuate class:

Already in the fourth grade, German students are identified, on the basis of a teacher's recommendation, as candidates for the university track, or for a shorter education that prepares them for a blue-collar job. In theory, parents have a say in this. But studies show that the reality is different. Almost always, educated parents will push to get their child into a higher class, whereas uneducated parents won't dare to question the teacher's authority.

I did my student teaching in an alternative school which was theoretically egalitarian. But you should have seen the difference between the way migrant children and the children of lawyers or professors were treated.

In our Bruderhof schools, there's no pressure to prepare a student for a certain career, or for life in a certain income bracket. Our main goal is not to turn out high achievers. We want to prepare our graduates to use the knowledge or skills they gain to serve humanity and to value themselves and others, not on the basis of their achievements, but simply for who they are.

A wealthy businessman, bothered by the contradictions of capitalism, traveled to Paraguay to see if a life based on love was possible.

TOM POTTS

1908–1999

Tom Potts was born into a prominent Philadelphia Quaker family. He went to Haverford College, where he was a fullback on the soccer team, and then started working at the steel warehousing company his extended family owned. During World War II, the steel industry was regulated in service of the war effort and Tom, who took Quakerism's traditional pacifism seriously, refused to cooperate. Instead, he went to work for the American Friends Service Committee, and was assigned to manage Civilian Public Service camps during the war as an alternative to military service. Florrie, whom he had met and married in 1934, came with him.

After the war, Tom and Florrie resumed their life in Philadelphia: Sunday gatherings at the Friends Meeting and private schools for their three children. As Florrie later described, "we were on a lot of committees and working with good causes, race relations and sharecroppers. But nothing specially came of it." Through their Quaker connections, they met

and eventually hosted members of the Bruderhof who were travelling in the United States fundraising for the hospital in Paraguay. Tom and Florrie's decision to travel there and then to become members of the Bruderhof is best explained by Tom in an open letter that he sent to the Friends Meeting in 1952:

For all my adult life I have been frustrated by the contradiction between ordinary American life and the impossible teaching of Jesus' second commandment, "Love thy neighbor as thyself." I make out all right during the week: I have a good job and I am part owner of a steel warehouse. We have a most congenial working group and enjoy the game of competing in the marketplace for the available business. We advertise honestly, we charge fair prices, we are concerned about good employee relations, we have a Christmas party, we give generously to the community chest, and we have a profit-sharing scheme. But do I

<<

The stackable Woodcrest Chair is part of Community Playthings' line of classroom furniture. Made of molded maple, it is shown here in the lacquer curing oven.

"Each person surrenders his will, his talents, his possessions to God, and together they seek a life of true unity based on love for all.

Unbelieving, I took my wife and three children 10,000 miles to see if it could be true. And it was."

love my neighbor as myself? Am I concerned for the clerk who has come to work in the streetcar while I drive a big car? Do I give the community chest just what I don't need anyway? Do I share the profit in reality, or do I save a big percentage for my old age, before the distribution? Yet, if I gave it all away, what would my family and I live on? How foolish can you get?

But Jesus did not say, "Love your neighbor after taking care of yourself." Then on Sunday when I go to meeting for worship of the Society of Friends I realize again and again that all men are children of God and brothers to each other. But what do I do about it? Periodically Friends ask themselves searching queries such as: "Do you keep to simplicity and moderation in your manner of living, in your pursuit of business?" We have two cars. We send our children to private schools and buy them all the

clothes and incidentals they want for keeping up with the Joneses. We get for ourselves pretty much what we want. Is that simplicity? How about the business? To what purpose would I spend my major time and energy for the next (and last) twenty years in building our business to two, three, ten times its present size? I would double my income, triple my worries, and perhaps donate more to good causes. But would the donations of money, however large, serve to bring the kingdom here on earth, as would the widow's mite of my waning energies devoted to a Christian system?

America is rapidly being taken over by the military. I pay a healthy income tax, far more than I am able to give to the Friends Peace Committee. Yet another query says: "Do you faithfully maintain our testimony against preparation for war as inconsistent with the

spirit and teachings of Christ?"

Our social and economic system is based on the premise that if each looks out for himself the end result will benefit everyone. But does it? What about the third of our nation who are still ill fed, ill housed, and ill clothed, not to speak of the millions upon millions in the underdeveloped parts of the world? The query says, "What are you doing to create a social and economic system which will so function as to sustain and enrich life for all?"

The contradiction is everywhere apparent. In order not to feel completely frustrated during these times of soul-searching, I have long reasoned that Jesus must have been setting up an ideal towards which mankind should work and might attain in a few thousand years. And then we discovered the Society of Brothers

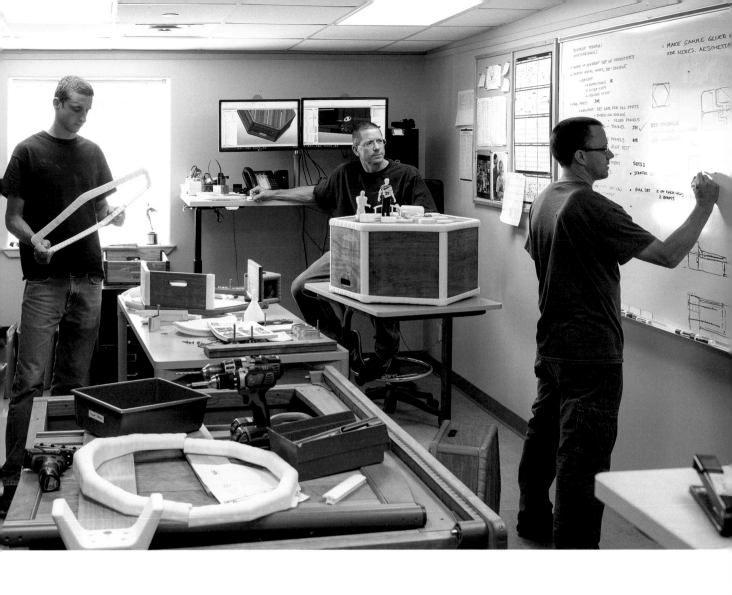

[as the Bruderhof was known at the time]. They said they were trying to live by the Sermon on the Mount. Traveling brothers told us of the communities in Paraguay, Uruguay, and England, where more than 850 people are living a life of complete sharing. Each person surrenders his will, his talents, his possessions to God, and together they seek a life of true unity based on love for all.

Unbelieving, I took my wife and three children 10,000 miles to see if it could be true. And it was. Their social and economic system is based on the premise that if each one, having faith in God, looks out for his brother, the end result will benefit all, including himself. Men and women from eighteen countries, formerly from all walks of life and all rungs of the social ladder, are living together as brothers and sisters, helping one another, working hard, and

experiencing deep spiritual joy. How can I do anything else but settle my affairs and join the work of spreading the news that it is possible to live in accord with the spiritual laws of the universe here and now?

My contribution will be small. But however small, I shall be advancing a practical way of living which does, in actuality and in the words of the query, accept all without discrimination because of race, creed, or social class, and where all are treated as brothers and equals.

And so Tom and Florrie's life in community began. When Woodcrest, the first American location, was founded in 1954, the Potts family moved there and Tom was asked to manage the community's woodworking business. Florrie was his secretary, working at a desk facing his and helping to organize the sales staff. At that time Community Playthings' product line

^
A Community
Playthings design
team develops outdoor
play equipment using
a strategic design
process with the
help of 3D printed
prototypes and a
whiteboard.

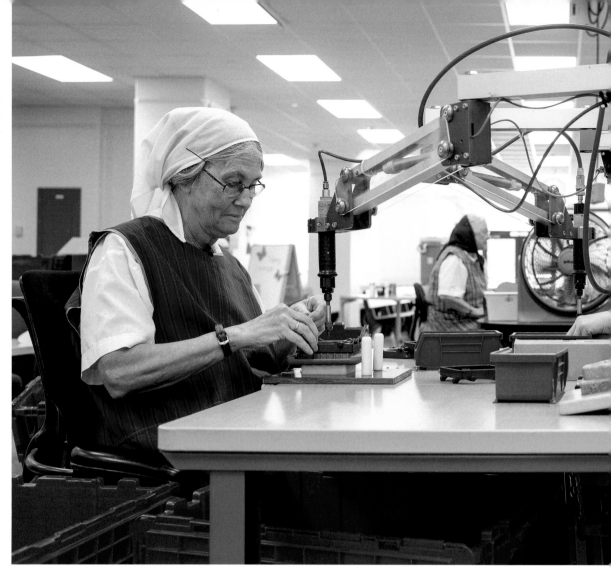

consisted of wooden building blocks and a limited selection of classroom furnishings which were marketed to schools and nurseries. The manufacturing facility was primitive and the community was in debt. Under Tom's leadership over the next four decades, Community Playthings became a well-regarded, internationally distributed company selling wooden toys, play equipment, and classroom furniture. In the late 1970s, when children with disabilities began to be integrated into classrooms, teachers from a school near one of the Community Playthings workshops requested chairs modified for these new students. Under Tom's leadership this opening developed into a new business, Rifton Equipment, which now matches Community Playthings in size.

Together, the businesses provided not only income to support the communities in the United States and England, but meaningful work for its members. The core purpose of the community was always more important to Tom

than profit: if sales were high and the overtime required to make the products started interfering with community life, Tom would quietly put some orders in a desk drawer to wait for calmer times. He always took care that the operation of the businesses reflected the community's values: that customers and vendors were treated with respect and that the design and manufacture of the products reflected love for the children who would use them. (Tom's three business principles were quality, quality, and quality.) He felt accountable to the community membership for his business decisions, once apologizing in tears during a church meeting for spending money on a new marketing approach that had failed to pay off.

Tom was a humble man who never took himself too seriously. Hearing himself described as an expert he once said, "Oh, you know what an expert is. An ex is a has-been, and a spurt is just a drip under pressure." Known to the children of the community

as "Wolfie," he would interrupt a business call or meeting to growl theatrically if a child looked in the door of his office (as they were welcome to do, knowing that there was candy hidden in the desk).

And then, after four decades of managing a successful business, Tom handed over responsibility for it to a younger brother, John Rhodes, who had been learning from him for some years. (See John's story on page 241.) Too old to lead a business, but still full of life, Tom went to work in the Rifton Equipment shop, threading straps on the sandals of mobility equipment. A visitor to the shop once asked him about his work. "You could say I am assembling this part," Tom said, "but what I am really doing is thinking about the child that will use it one day."

Tom and Florrie never lost some aspects of their Quaker upbringing. Evening gatherings at their home ended at 10:00, "Quaker midnight."

Quakers are "plain people" and the Pottses loved simplicity: anyone was welcome at their table at noon on Sunday (and many came) when they served "Sunday soup" made from leftover vegetables from the community kitchen. And they addressed each other in the Quaker manner as "thee" and "thou" with the great love that defined their relationship. "Now here comes Florrie," Tom would say as his wife of sixty-four years approached. "Doesn't she look lovely?" ♦

MAY 1961

CARROLL KING
1924–2010

The son of a Quaker socialist, Carroll was a pacifist until World War II convinced him that Hitler and Mussolini could only be overthrown by force. He joined up and was soon navigating a B-24 bomber over Europe.

After the war, he and his wife, Doris, found and joined the Bruderhof. But the guilt of his participation in bombing civilians never left him. At seventy-four, determined to atone for it in some way, he and Doris took part in an initiative called Bridges to Baghdad, which sent human shields to Iraq to deter threatened American airstrikes and call attention to the suffering of Iraqi civilians caused by foreign sanctions.

While there, Carroll met a woman who had lost nine children in a bombing raid: "I asked her forgiveness and told her my sorrow for what my country had done. I was amazed at the softness and real compassion she had for me. She gave her forgiveness wholeheartedly." The encounter filled Carroll with the hope that even the worst injustices could be redressed by personal acts of repentance and forgiveness. "It may be a wild dream," he wrote, "but I would rather live with that dream than with the nightmare our world is facing now."

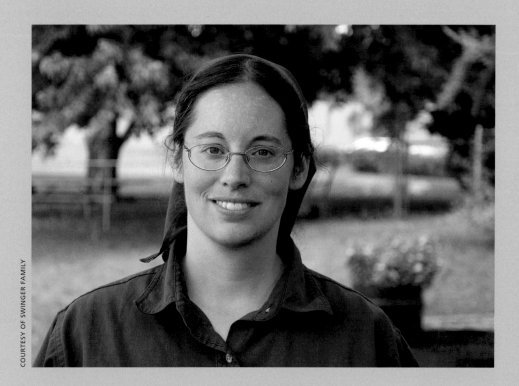

MAUREEN SWINGER

1978–

Maureen is a writer and editor at Plough Publishing House, and also a mother of three.

My husband, Jason, and I took a three-year break from the community when our children were young. During that time we lived in rural Connecticut and decided to homeschool the kids. Jason found a good job so we had the means. I loved it, but I really missed my job and the adult conversations that are part of a normal work routine.

Now that we're back, one thing I really love is that a good work–life balance is built into our daily schedule. Whether you're working in the communal kitchen, the workshop, or the publishing house, it's a given that if your children need you, that comes first. If it's time to nurse the baby, or if an older child is struggling and needs some time with mom or dad, off you go. You can really just leave.

There's also no overtime expected from parents. If we do work overtime, someone's likely to say, "What are you doing? The day's over." The work will be there for us tomorrow, and we'll pick it up with new energy when we get back. But meanwhile there's a family to raise, and children to guide, and that's my most important task right now. God gave us these children and what could be more important than to raise them to contribute well to the world?

Both Jason and I grew up in homes full of love and security. Without a lot of talk, our parents demonstrated daily faithfulness through good times and tough times. Now, as our children grow toward their teens, we're determined to take up our parents' example, and make sure our home is full of laughter, music, openness, and trust. If the house looks like an unnatural disaster, but the homework got done and we sang and prayed together, we're going to call it a good day.

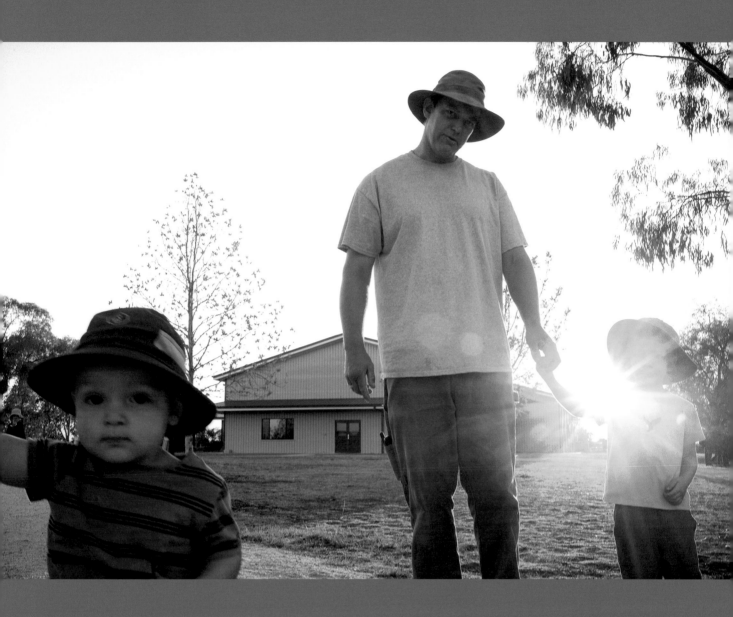

*What have I learned? I no longer believe I can change the world.
I believe God can and will. I still want to protest injustice, but I
feel it is the daily little acts of love that prove our sincerity. It is
easy to become frustrated at the power of evil in the world, but
we can turn our indignation into dedication to a brotherly and
sisterly life.*

Derek Wardle, teacher and Bruderhof member
1922–2008

^
Lester drops off his son
at school as he walks
to work.

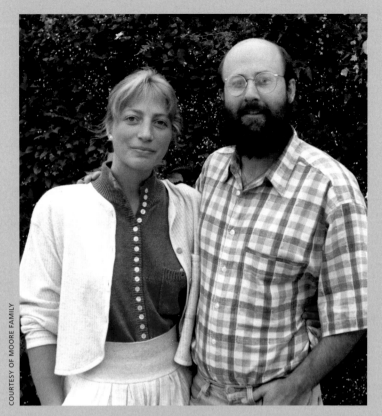

CHARLES MOORE

1956 —

Charles was studying and teaching philosophy and theology at Denver Seminary when it dawned on him that a lot of what goes on in academia has less to do with the attainment of truth than with the desire for power.

One of the things I often pondered as a young Christian was that no matter the setting—politics, business, the academy, wherever—people seemed driven by the need to be in control and to exercise authority. In the secular world, that's a given. But what alarmed me was how this mentality had infiltrated the religious groups and fellowships I was part of. How did this square with Jesus, I wondered? The Jesus who said he came to serve, who washed his disciples' feet and told us to wash one another's feet?

He eventually left the seminary and, in 1982, he and his wife, Leslie, founded an inner-city community in Denver, where they lived in solidarity with the poor. But they were still not satisfied. A decade later, they discovered and joined the Bruderhof. As Charles explains:

At the Bruderhof, I found a society where relationships are not based on power and privilege, but on love. Leslie and I found people who talked about the importance of dismantling personal power, and treated one another as brothers and sisters.

Human nature is human nature. A drive for personal power can reappear in community life. We are not immune from that, so we have to keep reminding ourselves that to be a servant to others in a spirit of love *is* freedom. Power enslaves us. It separates us and keeps us from being who we truly are.

>>
Charles taught for eight years at the Mount Academy, the Bruderhof's four-year high school in Esopus, New York.

JOHANNES MEIER

1970–

When Johannes and Anne moved with their four children to Danthonia in 2004, the social fallout of Australia's Millennium Drought was painfully obvious. Decades of conventional farming methods had leached the land of its fertility, and an entire way of life was threatened. Local farmers were despairing, and some were even committing suicide.

Today, Johannes, who is responsible for Danthonia's farming operations, is eager to show visitors how the 5,500-acre property is now thriving as a result of conservation initiatives such as planting 100,000 trees.

In actual fact, a lot of what we're doing represents a return to old approaches—so old, they've been virtually forgotten. The story is not about us, but part of a much bigger picture. It's about how, through working with nature, a wounded landscape and a wounded world can be healed. Sustainable farms equal sustainable lives.

What's more, Danthonia's efforts have earned it the trust of the local aboriginal community:

Many tell us they feel kinship because of our emphasis on community and custodianship—on the idea of being nurturers and caretakers of the land.

Of course I'm thrilled by the way nature is responding to our work. But caring for our property is only a small part of the picture. We need to care about the natural world as a whole—for our neighbor, but also for the child starving half a world away, and for future generations. For everything God has created. And we need the humility to recognize our own responsibility for the mess we've made of this planet.

Greed and demand drive the markets—industrial agriculture has a lot to answer for in that regard. But as consumers, each of us is complicit in today's global ecological disasters. And so the question is, do I care enough to change the way I live?

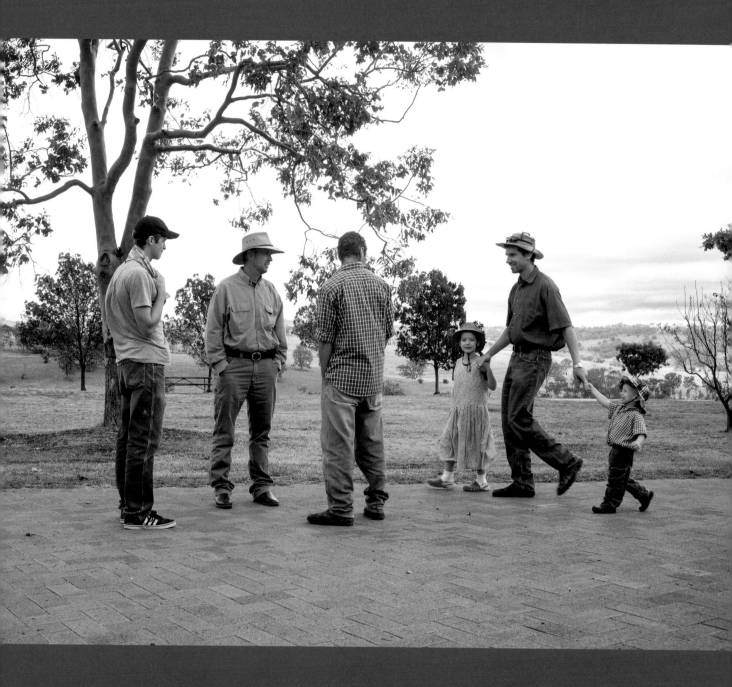

Christianity is being concerned about [others], not building a million-dollar church while people are starving right around the corner. Christ was a revolutionary person, out there where it was happening. That's what God is all about, and that's where I get my strength.

Fannie Lou Hamer, activist and musician
1917–1977

^
A fall afternoon in
Australia

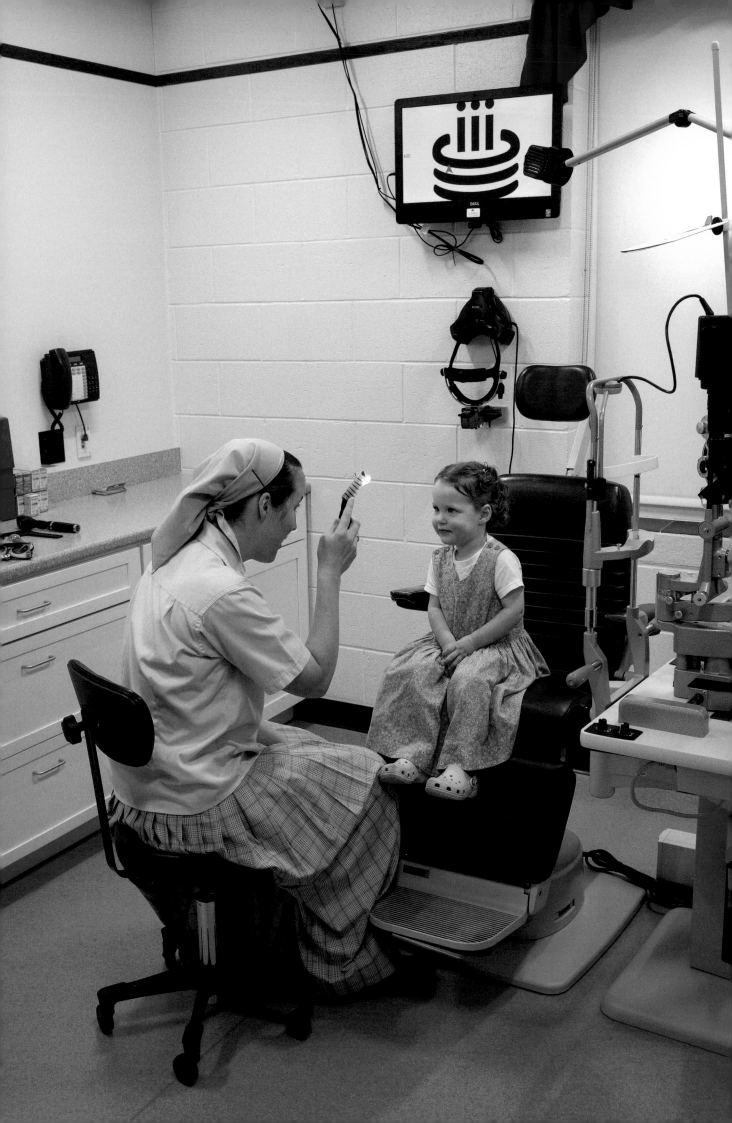

SHANNON MCPHERSON

1996–

In 2014, Shannon graduated from the Bruderhof's Mount Academy. She left home and spent a year at a Bruderhof in Australia before deciding to try her own wings. With the community's help, she found an opening among the volunteer staff at Casa Juan Diego, a Catholic Worker house in Houston.

Founded in 1980, Casa is the city's best-known refuge for recent arrivals to the United States. Aside from the hundreds of immigrants that Casa weekly assists at the door, more than one hundred thousand have been given shelter in its overnight quarters over the years. No matter their origin, Casa welcomes them with hospitality, food, clothing, and medical care–all offered at no cost.

Working at Casa meant participating in daily dramas, most of them heartbreaking.

Pregnant women who had been raped by "coyotes" and were seeking abortions. Mothers looking for lost children. Criminals wanted by the police. A large man, high on drugs, who entered my office and, blocking the door, demanded food. A violent, mentally deranged woman whom I had to drive to a psych ward, where I spent an entire day trying to convince three professionals that the woman really needed their help. And then there was a three-week period when, because of staffing issues, I was running the entire place alone. I was nineteen, and my Spanish was only borderline adequate, in terms of projecting authority. It was tough, very tough. But I survived and after that nothing really scared me.

Run by volunteers and funded by donations, Casa has never lacked wealthy patrons.

The wealth in Houston is unreal. At Christmas, we'd get truckloads of donations. A lot of it was trash, and so we'd have to sort it all. But even the useful stuff was overwhelming, in terms of the sheer volume. By the end of the holidays I was literally sick of dealing with material things. Meanwhile, what we really needed was another building to expand into, or several. Houston may be the fourth-largest

<<
Sallie, an optometrist at Maple Ridge community, with a young patient

"We were giving almost
everything, but never the last
inch: we could still get into our
cars when we needed to
and drive home."

metropolitan area in the country,
but the city government has a
miserable record when it comes
to helping immigrants and the
homeless.

And yet, no matter how much energy
Shannon and her fellow volunteers
expended on behalf of their clients, it
seemed that the gulf between givers
and takers, helpers and those in need
of help, could never be breached.

We were giving almost everything,
but never the last inch: we could
still get in our cars when we need-
ed to and drive home. Houston is
ringed with gated communities,
and I often spent time unwinding
at the home of a woman who
lived in one. I had that liberty, but
I felt – I still feel – that until you
deny yourself completely, you are
still playing into the hands of an
unjust system. That dichotomy
kept me thinking about how the
best efforts can still fall short of
providing a real answer, when it
comes to inequality.

As she grappled with these questions,
Shannon continued to marvel at the
dedication of Mark and Louise Zwick,
the founders of Casa:

To them, what others might call
social work was simply a call-
ing – a way of quietly trying to
fulfill Jesus' demand to love one's
neighbors as oneself, regardless of

trending hype and shifting politics.
Mark was dying of Parkinson's and
I couldn't see how Louise could
continue their work in the long
run. Personally, I knew that what
I was doing was unsustainable,
in terms of the resources in my
own heart.

That spring, Shannon visited Wood-
crest over Holy Week and Easter. It
was a decisive week. During the Good
Friday service, she says: "I remember
tears streaming down my face and
thinking Jesus' hand is the only one
that is big enough for all of this.
And also big enough for me." She
completed her year at Casa and then
returned home.

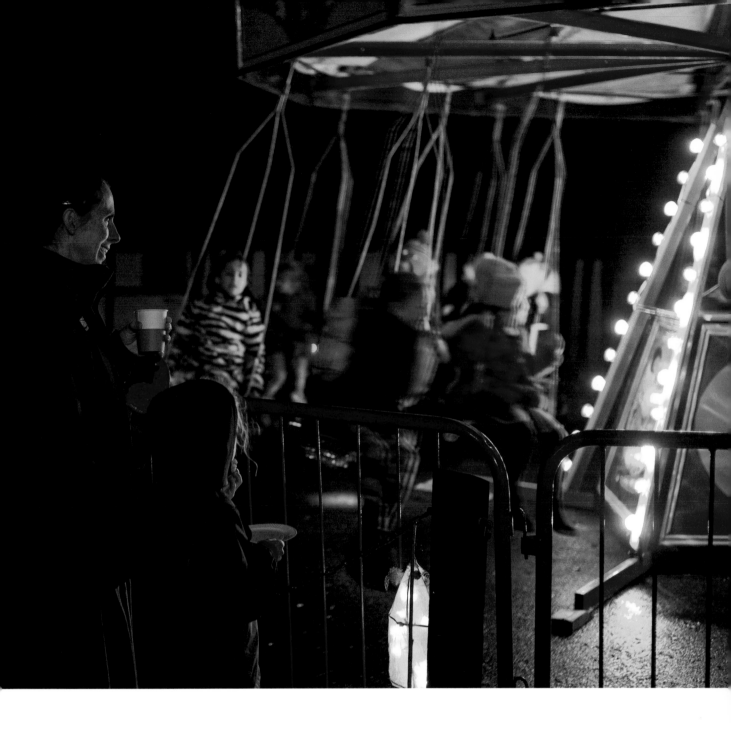

Shannon is currently studying Spanish in Bogotá, Colombia, with the hopes of directing her skills and energies into the Plough Publishing House after graduating. She still wrestles with how best to bring the plight of the poor to the attention of the wealthy, who would often prefer to look the other way or build walls to keep them at bay.

Because society is so fractured, I've come to feel that the first and most important step toward change is to try to truly understand the "other side." In reality, that always means the other person. Reducing individuals to a group or entity and seeing them as "other" is easy.

It relieves us of the imperative to love them as we love ourselves.

But if I really believe that each of us on this planet is equally human, then I can never belittle or dismiss someone, or cast them in a stupid or inferior light. I'm not advocating some artificial equilibrium in which we all have to sidestep each other, and no one is allowed to speak the truth. Still, as we fight for justice, we need to remember that there is never just another side. It's always a matter of people, and ultimately, each of them deserves respect. ♦

∧
Families from
Darvell community at
the local fair

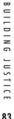

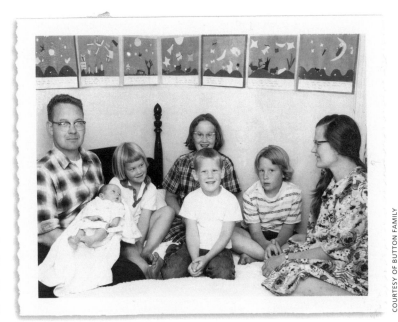

An outspoken artist, mother, and social critic who followed her convictions

DOTTI BUTTON

1929–2017

A Michigan native, Dotti talked loud, laughed loud, and dressed loud too. She thrived on excitement, hated routine, and felt it her duty to get those around her to live with the same wholehearted purpose.

In her twenties, as a self-consciously sophisticated art student, Dotti found her life upended in one short weekend when she reluctantly attended the 1952 Annual Conference of the Women's International League for Peace and Freedom. In her words:

When I left home on Thursday, I was what I had been brought up to be–a middle class, college-educated young lady. When I returned home on Sunday evening, I was a totally different person. My whole attitude toward war, toward minorities, toward poor people, toward unions, toward everything was completely changed. The focus of my life after that was to work for world peace, for justice, and for reconciliation between people.

It was her Christian faith that gave context to her new commitment. Dotti and her husband, Bill, were churchgoers and, like the other members of the progressive, integrated Methodist church they attended in Detroit, focused their faith on social justice and racial reconciliation. In the summer of 1962, intrigued by reports about a pacifist Christian community whose members share all things in common, they decided to go see for themselves. And once again, in the course of a few days, the direction of Dotti's life changed.

Three things they experienced on that first visit to the Bruderhof drew them: the members' obvious joy despite their impoverished circumstances, the fact that people were able to disagree and yet still come to unity, and the outreaching love that Dotti felt from the gathered community. This love was evident in the community celebrations, but it also shone through as members honestly and openly confronted each other.

<<

Morning chores: taking the recycling before school

"I had become
discouraged, disillusioned,
and our marriage was in
danger of breaking up.
That one weekend turned
everything around and
gave me a real
joy in life."

In the car on the way back to Detroit,
Bill announced, "I'm going back."
Dotti later recalled:

Bill did not say, "We are going back," or, "Are we going back?" or, "What do you think?" He said, "I am going back." He was called. That is something I have hung on to. No matter what happens in life, Bill was called to this life by God, and so was I. I had become discouraged, disillusioned, and our marriage was in danger of breaking up. That one weekend turned everything around and gave me a real joy in life.

In 1967, just five years after Dotti and her family had come to the Bruderhof, her husband Bill abruptly left. The reasons were complicated – decades later, Bill would simply say that he'd had "a heartless mind and a lot of stubborn pride." He'd intended to take his wife and children with him, but Dotti refused to go. Instead, she stayed true to the conviction that they'd been called to follow God in community. Over the next five years

she single-handedly raised their six children, ranging in age from three months to fifteen when he left, all the while not knowing if Bill would return.

He did, but the time after his return wasn't easy. Dotti, who had managed years of single parenting, now had to reaccept a husband who doubted his faith and himself, and depended on her support. It took years for Bill to get back on solid ground spiritually and emotionally, and more years for his children to once again respect and love their father. But the miracle was that their marriage was healed, and that together they continued to

live, always with great intensity, never without excitement, for the common purpose that had brought them to the community. Their home was always open for free-spirited discussion. Dotti, a skilled gardener, created and tended colorful displays around the community. Bill, a teacher, self-taught plumber, and self-taught carpenter, kept busy in the school and around the community. He was also a voracious reader and prolific writer, and he and Dotti were endlessly interested in world events and issues of economic and environmental justice. When Bill died in 2016, they had been married for over sixty-two years.

In her last years, Dotti suffered chronic pain from various debilitating health problems. Two weeks before she died she made one final splash when she joined a community celebration in her wheelchair. Her favorite Louis Armstrong song, "What a Wonderful World," was playing. Dotti somehow got out of her chair and started to dance, her crippled feet remembering the old-time box step. She grinned from ear to ear as one young man after another took her hands and followed her lead. After ten minutes of dancing, she was helped back into her wheelchair, exhausted but triumphant. ♦

∧

The Mount Academy's mock trial team — state finalists in 2019

Detlef's porch garden
has something new
each day for the
children to visit on
their way to school.

SEEKING AND MAKING PEACE

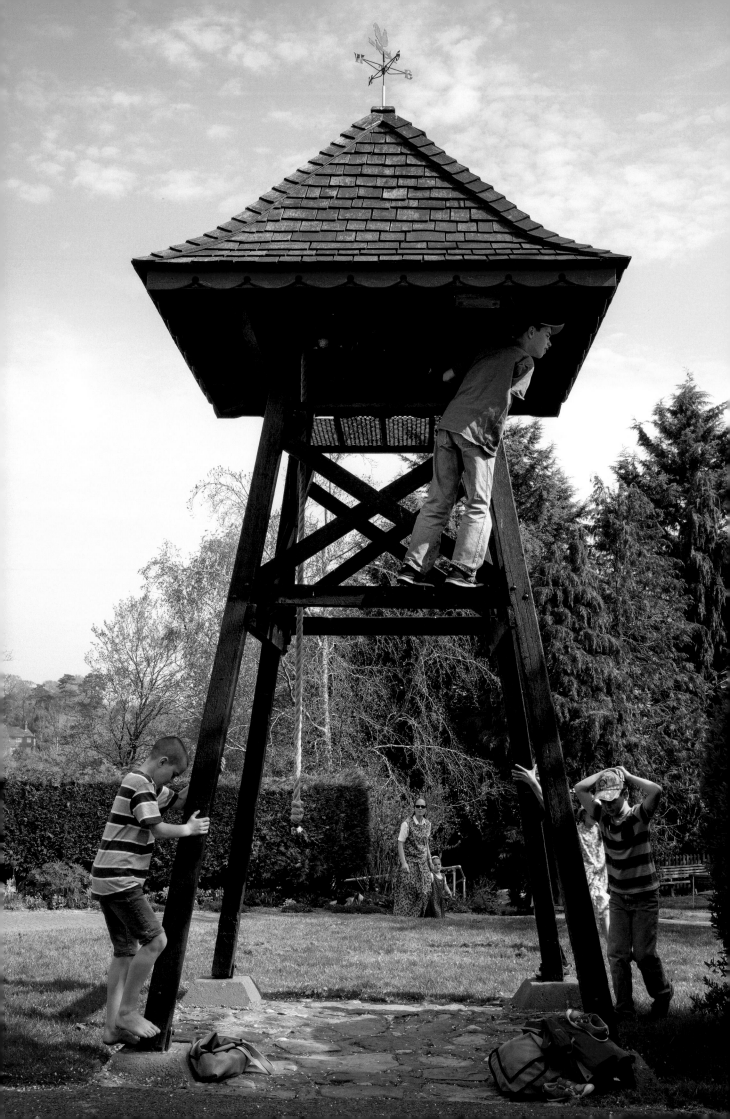

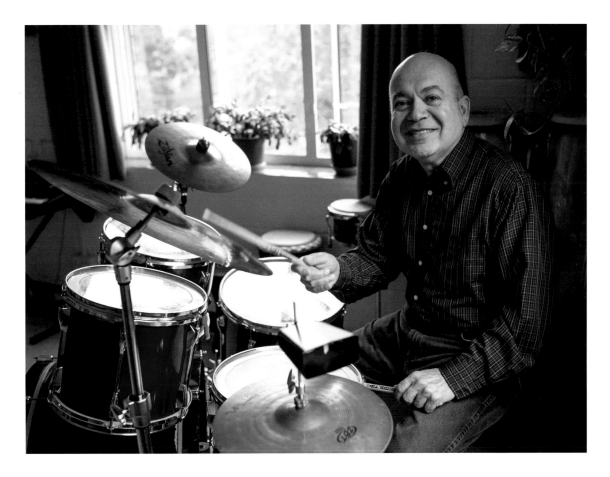

JACOUB SHEGHRAM

As a soldier in Saddam Hussein's army, Jacoub became convinced that he could no longer kill.

<<
The custom of ringing a bell to start the school day goes back to the Bruderhof's beginning in a German village.

Unhappy partners in an arranged marriage, Jacoub's parents divorced when he was two, and he was raised by his father, who doted on him, sent him to the best schools in Baghdad, and encouraged his love of music and sports. On vacations in the picturesque mountains of northern Iraq, he stayed in first-class hotels with live bands and poolside dancing; and there were annual trips to an aunt in Lebanon whose summer home was situated in a village so pretty, it seemed "like paradise on earth."

In 1976, Jacoub enrolled at the University of Baghdad to study chemical engineering. Four years later, in 1980, war broke out between Iraq and Iran.

A dreadful atmosphere settled over the country. Sirens blared in the cities whenever there was incoming Iranian aircraft. Everyone rushed to find a hiding place, or stood and watched, as Iraqi and Iranian fighter jets fought in the skies above us. It wasn't long before "war martyrs" started to return: taxis, each with a flag-draped coffin strapped on top, flooded the streets.

In 1981 Jacoub was drafted. "No one wanted to join up, but we didn't have a choice. Draft dodgers were

>>
Neighbors gather to
sing folk songs at
day's end.

"I began to see that war is only a reflection of the human condition. When we stop listening to the voice of our conscience, when we close our hearts to our fellow humans, then war is inevitable, whether it is a family fight or the sort of major conflagration that tears countries apart."

executed." After six months of basic training, he was transferred to a naval construction unit in Basra, where he was unexpectedly arrested by the Wasps, Iraq's feared military police, because his beard was not regulation length. "I was locked up like a criminal. Later I learned that the sergeant of the police unit that arrested me had set a quota of fifty heads each day. I had simply been in the wrong place at the wrong time."

At the military prison, Jacoub and fifty other men were forced into a broiling, stinking, closed shipping container. It was summer, the latrine was an open bucket, and sleeping meant dozing while leaning against another inmate, since there was no room to lie down. In prison, Jacoub met men who were serving terms of up to ten years. Luckily, he was able to negotiate a speedy release through a lieutenant who was an old acquaintance from engineering school.

After some eighteen months with the construction unit, Jacoub was transferred to combat training, and then sent off to a unit on the front.

It took army life to awaken me to the bitter truths of life in my country: blatant inequality, injustices of every kind, institutionalized slavery, and restricted freedom – especially freedom of expression. Our society in general seemed to be structured on hypocrisy and falsehood, but this was especially evident in the army. The gears of

the whole machine were greased with bribes, favoritism, and behind-the-scenes manipulation.

During the war, the government gave substantial material inducements to the professional military staff: fat salaries and bigger mortgage loans, as well as other perks. For instance, the government ordinarily gave out a one-thousand-dinar "marriage grant" for couples getting married, but military personnel got three times that amount. Even more incredibly, professional staff could purchase a new car for one dinar. Depending on their rank, they could get anything from a Passat to a Mercedes. Those with means could buy their way out of the army. Old and disabled people ended up at the front, while people with political connections stayed in the rear lines or in the cities.

I began to ask, "What purpose is this war serving? Who is it benefiting?" As I saw it, it was the high government and military officials earning fortunes through greed and deception. The arms manufacturers raking in hundreds of millions. The politicians exploiting the war machine for their own personal advantage while holding forth on "freedom and democracy."

Meanwhile, the coffins of the dead began to flood the cities and villages. Like some deadly combine, the war was harvesting thousands of

souls from both sides of the battle lines. Many who were not killed lost limbs or had other serious injuries. Soon there were thousands of widows and orphans. Countless people lost houses, jobs, businesses, or farms and became refugees. Worse still, people lost their ethical principles. A deep depression swept over the nation.

At the front, Jacoub was soon questioning not only the war he was fighting, but war in general:

No one can truly know the horror of war until they have taken part in a battle: the deafening noise, eruptions on every side from falling artillery shells, screams, and the bloody, mangled bodies of people who were living comrades only moments before. Once, Hunnah, one of my relatives, was fleeing a dangerous situation with a friend during an offensive. As he ran, he looked over in horror: his friend, beheaded by shrapnel, continued to run for several more meters before collapsing. Hunnah blacked out. After he came to, he was so traumatized that he had to be hospitalized for a month.

I had entered a realm on the border of hell. Faces were pale with terror and

exhaustion. Even the hardiest men were often reduced to cowering, whimpering children. I saw the specter of death wherever I turned.

The enemy was often a mere seventy-five meters away from us. Bombs, bullets, and shrapnel were continually flying in every direction. The dead and dying were on every side. I was tormented – not only by the horror of war, but also by the burden of my own guilt.

Around this time, Jacoub experienced a dramatic conversion that changed the course of his life: as he described it years later, a voice deep inside him cried out, "Enough!" He sought the priest of their local church and poured out everything that weighed on him in the darkness of a confessional. "I emerged light as a feather, and full of joy and hope. That was the most decisive moment of my life. It felt like a veil had been lifted, and I could see everything in a clearer light – the light of God."

Suddenly, Jesus' command to love one's enemies and to return good for evil made perfect sense, as did his warning that those who "take the sword" will be killed by it:

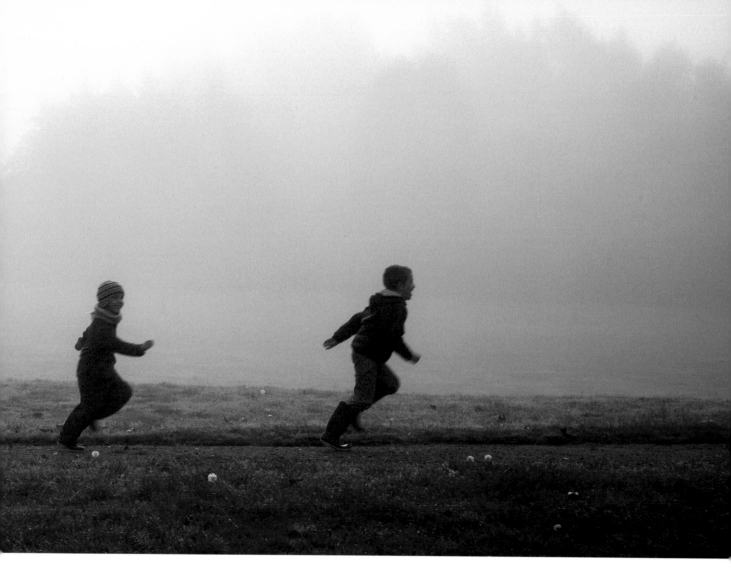

Jesus refused to defend himself. So how could I defend myself with violence and still claim to be his follower? I could no longer hate others; I had to love them – to love all people. I had experienced the joy of forgiveness, a gift that gave me inner security and true peace.

I began to see that war is only a reflection of the human condition. When we stop listening to the voice of our conscience, when we open ourselves up to anger and hatred, when we close our hearts to our fellow humans, then war is inevitable, whether it is a family fight or the sort of major conflagration that tears entire countries apart. And if I can admit that I am part of the cause of every war, why can't I also be part of the process of peace? I saw how forgiveness can break down barriers and pave the way for loving and harmonious relationships. I could be an instrument to help combat violence.

As he recounts in his memoir, *I Put My Sword Away*, Jacoub first considered simply going to the authorities and stating his position. But that seemed foolhardy: punishment for refusing to

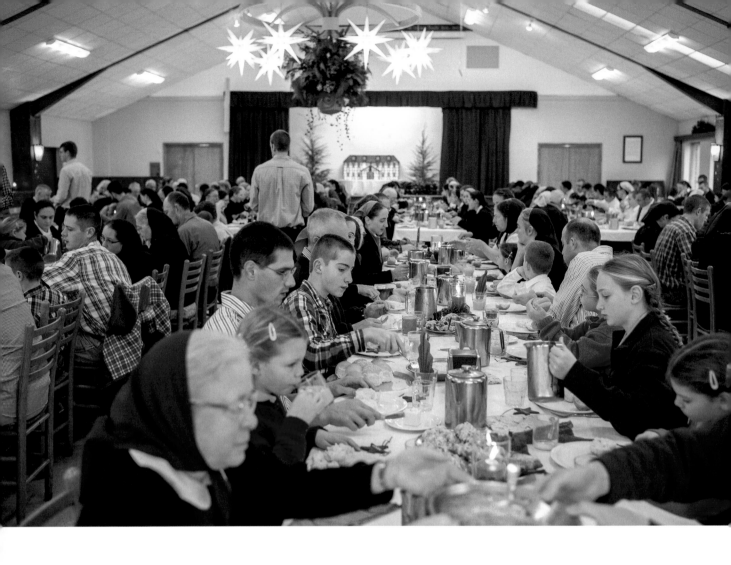

obey orders was death, and in any case, he knew of no church that would support him. Another route he contemplated was defection to the Iranian side, but that only tempted him until he considered its impact on his family. They would surely be interrogated and harassed. Another possibility, given his academic credentials, was volunteering to become a noncombatant professional. Or he could apply for a military-related job in the civil sector. "Of course, that also did not sit well with my conscience. After all, I would still be contributing to the violence just as much as if I were actually fighting." One last option he considered was working for Iraqi intelligence.

Before long, though, I recognized that all these paths were nothing but compromises with the devil. And didn't Jesus warn, "What will it profit you to gain the whole world, but forfeit your life?" So I felt I had no choice but to stay in the army and pray that the war would soon come to an end. I vowed to myself, however, that if I came face to face with the enemy, I would not kill, but rather let myself be killed. This decision cost me tears and intense prayers for God's strength. But once I made it, I was determined to stick by it. ♦

∧
A festive
Christmas brunch

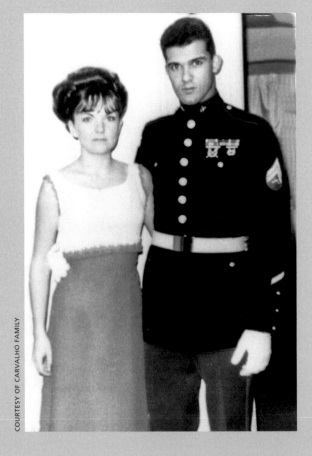

COURTESY OF CARVALHO FAMILY

MANUEL CARVALHO
1944 –

Manuel, a veteran of the armed forces, has been a member of the Bruderhof since 1982. He is constantly reaching out to other veterans, visiting VA hospitals or participating in organizations like Veterans Breakfast Club, a Pittsburgh-based initiative that publicizes veterans' stories.

I joined the Marines in 1963 as a naive kid, fresh out of high school and at odds with my father. I enlisted out of rebellion. Before I knew it, I found myself on the shores of South Vietnam. We were sent as an expeditionary force, and set up Da Nang Air Base. Two years later, on a bright sunny day, I found myself in a firefight and got hit by several rounds. Everything went black, and my life passed before my eyes. When I came to my senses, I was being dragged out of a rice paddy by one of my buddies.

It was only after being discharged in 1967 that I really realized what I had taken part in. I had earned a Purple Heart and a Bronze Star. But I had been conned. I had been part of a killing machine.

I recently had a run-in with a recruiter in Brooklyn. I told him, "We're on opposite sides. I'll do anything I can to stop anyone from signing his life away." They won't tell you the reality—what shooting someone is like.

^
Manuel and Nan
before their wedding
in 1967

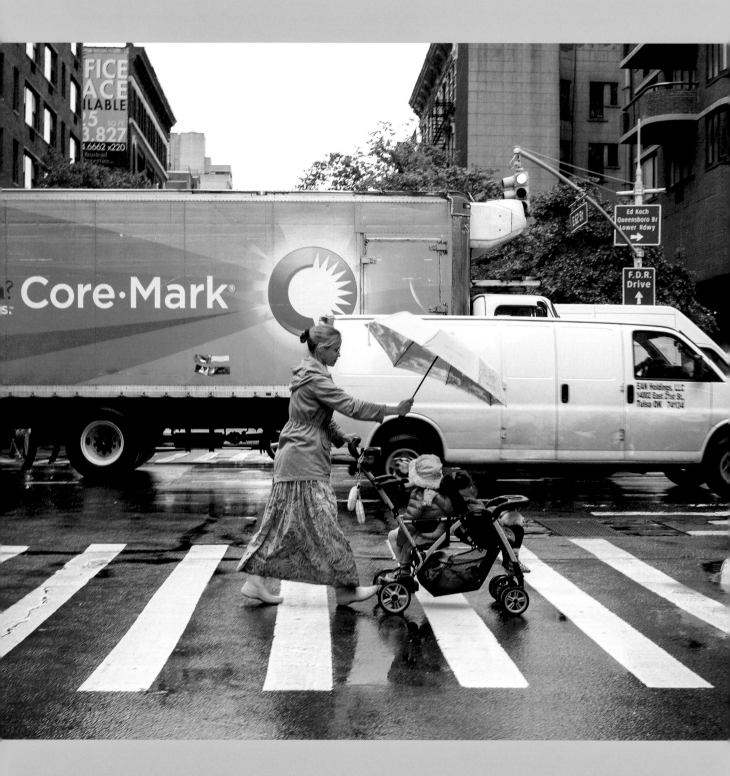

We may ignore, but we can nowhere evade, the presence of God.
The world is crowded with him. He walks everywhere incognito.

C. S. Lewis, author and Christian apologist
1898–1963

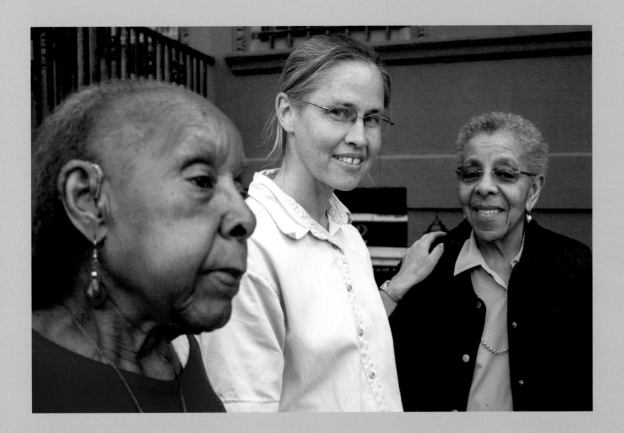

ANITA CLEMENT

1977–

Anita has lived in Harlem House, the Bruderhof's outpost in Upper Manhattan, for nine years, working mostly as a nanny and freelance graphic designer. She also volunteers at The Bowery Mission every week and loves to organize local block parties — you can usually find her at the facepainting table, working a line of eager young customers.

I love Harlem. It's home to me, even though it's very different from rural Connecticut where I grew up. I always say that I'd rather see people than trees, and with so many people around me there are always chances to connect to someone who might need encouragement. Like one time on the train I saw a woman down the car from me who had her head back, her eyes were closed, and tears streaming down her face. There was an empty seat next to her, so I went and sat down and asked her if she was okay, and she told me that her grandmother, who

had raised her, had just passed away in Florida, and she couldn't go.

I missed my stop and decided to stay on the train as long as she wanted to talk. And then I gave her my number and said, "If you need somewhere to go tonight, you're welcome at my dinner." She did end up coming over, and I think she was a little surprised when she walked in and saw the whole community at the dinner table, but as it turned out she had been to our house a couple years earlier. She said, "I've been to your table before."

For me, coming home to the community dinner every night and sharing a common purpose with the people I live with makes me more confident in reaching out and trying to share that peace with people who seem lonely or sad.

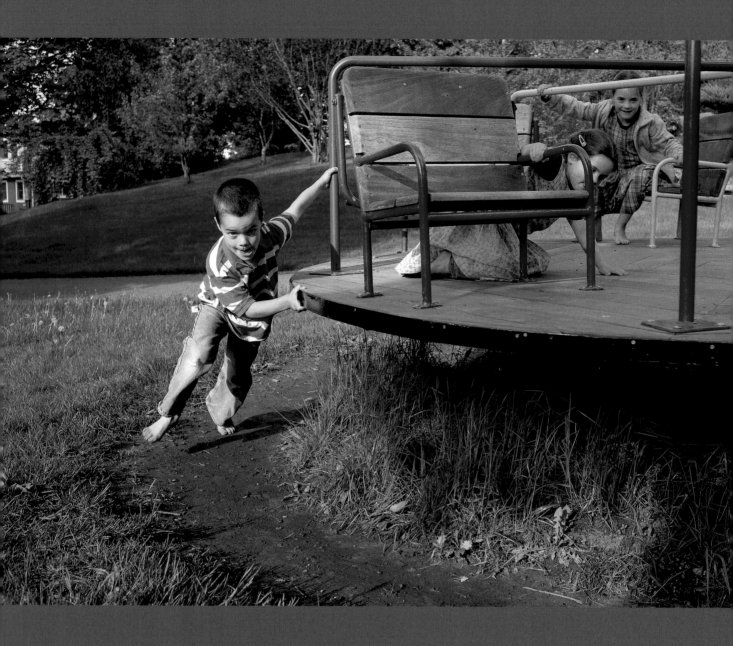

If we don't find a real humility and submission to God with whatever he plans for our lives, then things can go very wrong. But each one of us, no matter how our lives have been, has the chance to turn around and live for Jesus and live for our brothers and sisters. It isn't the number of years one has, especially, but how intensely we live and serve.

Norann Blough, librarian and Bruderhof member
1934–2017

Powering the same
merry-go-round that
spun their parents

BRIAN BACHMAN

1964–

Brian Bachman was born in Connecticut. His parents divorced during his childhood, and his young adulthood was difficult. After a stint with the Marines, he joined the Bruderhof in 1990, but then left again some years later.

I drove a tractor trailer for a long time, and it was pretty much to run away from the things I felt I'd done wrong. But when you sit in a tractor trailer for all those years, you realize you really didn't run away from anything; you're the only one in there. I finally got tired of the videotape of my past that was playing through my mind, and one day driving along, I just cried out, "Father, I'm tired of this, please, please, show me what I got to do to forgive myself." I knew he forgave me. But I couldn't forgive myself.

One day, I just pulled my truck into the terminal, handed everything in, and quit. I started doing volunteer work, hoping to fill that hole. It never worked, and then one day, it dawned on me: by me not forgiving myself for my mistakes, I robbed Jesus

of what he did for us. Our Father's love is forgiveness and no matter what you've done you can be forgiven and you can live for more than just yourself.

While volunteering in Georgia, Brian met old friends from the Bruderhof, and that encounter convinced him to return. He visited Fox Hill in 2018, and came back for good shortly afterward.

There are Mondays here as well. I mean I had three Mondays in a row this week. But on the other end of the spectrum, if every day was wonderful we wouldn't know what a wonderful day is. There's all spectrums of emotions and feelings and realities here—anybody who thinks that this is easy, come and live with us for a while.

But here I am, and I wouldn't trade it for the best tractor trailer in the whole world.

In 2019, Brian married Rosemarie.

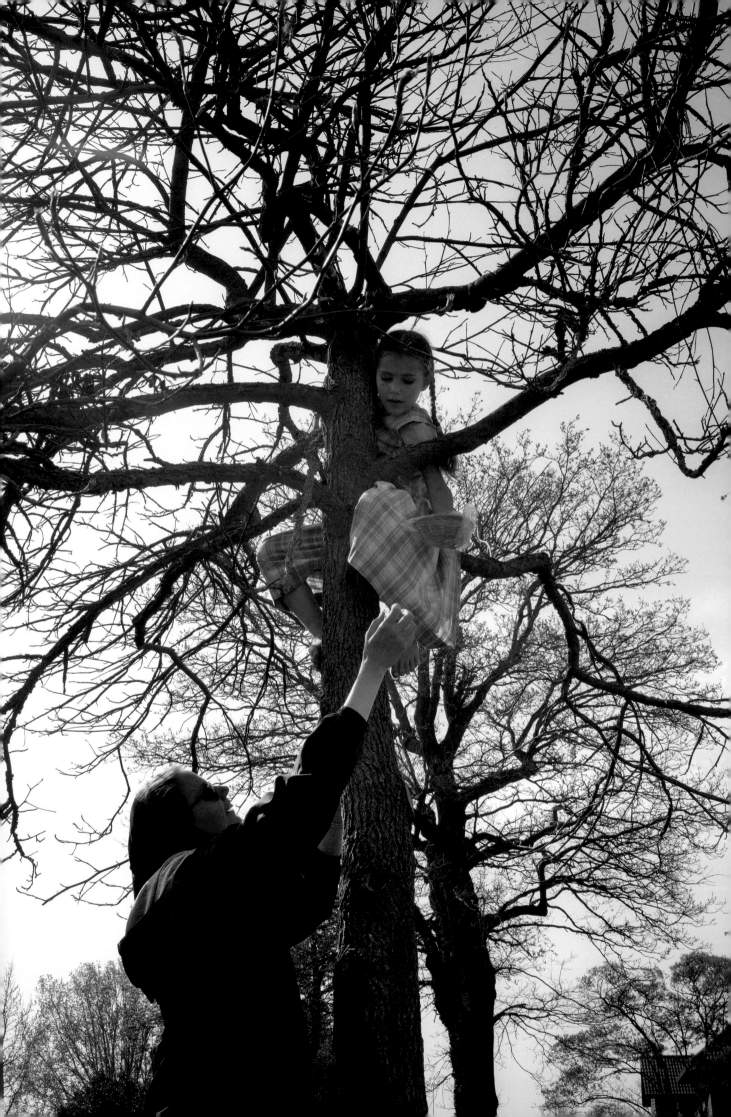

COURTESY OF TRAPNELL FAMILY

KATHY
TRAPNELL
1948–

A sixties flower child who found lasting peace where she least expected it

<<
Hanna helps a child find her basket at the Easter egg hunt.

To be twenty-one and pregnant wasn't something Kathy, the daughter of a wealthy Park Avenue dentist, felt ashamed about:

It was my life, and my peers didn't judge me. A longstanding friendship had dissolved into lust in the backyard of my parents' suburban Connecticut home on a starry summer night, after a big party and too much drink. Later, the father of my child helped me out of my "difficulty" by driving me down to a New York abortion clinic. He paid half of the cost and we never talked about it again; the whole thing was "simply a procedure," though to be honest, details like the clear-glass vacuum bottle still haunt me today, half a century later. All I had to say to the one and only friend who challenged the morality of what I had done was a cocky, "God wouldn't want me to bring a child into this situation."

And yet, Kathy says, her flippancy masked a deep unease – an unspoken yearning for peace that had accompanied her from childhood, when she sensed a lack of harmony in her own home and among her friends. And her abortion certainly didn't help matters.

Enrolled at Catholic schools from the first grade through college, she dutifully went to confession, and says that the subsequent feeling of "being right with God was always a source of peace." On the other hand, she would not have described herself as religious. If anything, she was troubled by the church as an institution. "It seemed so corrupt, and represented so much power and wealth."

I guess you could say my search was more like a bowlful of discontentment, something that was sort of boiling in me. It's true that I wanted peace. But how should I even start to look for it? I knew I couldn't buy it, or barter myself

"I was my own god:
I was the standard by
which I judged my life and
other people's lives. I was
frightfully, sinfully, willfully
my own boss, and I tried to
do everything in my own
strength. It doesn't work."

for it. I could see the truth of that all around me – the truth of the Beatles song, "Can't buy me love." After all, in Fairfield County, where I lived, there was more than enough opulence. But there was also so much unhappiness, and so many shattered families. Something in me was crying out for something other than that.

Somewhere along the way I heard something that some philosopher said: to find happiness, the individual has to give up himself – to empty and rid himself of everything self-serving and give his heart over to serving others. That really impressed me.

But then came the rebellion of my student years and my anger against the status quo and everything in it that I thought worked against peace and love. I proudly imagined I was making peace: by trying to end the Vietnam War through marching, singing, supporting war resisters, and so on. I thought I could bring some fairness to the plight of the migrant

workers by boycotting grapes and causing chaos in the local supermarkets that carried them.

None of it brought me peace because my whole orientation was wrong. Not that I wasn't serving good causes, but I was my own god: I was the standard by which I judged my life and other people's lives. I was frightfully, sinfully, willfully my own boss, and I tried to do everything in my own strength. It doesn't work.

Anyway, by around 1971, I was living in a hippie commune on the land, pooling my money with others, doing yoga, eating brown rice and veggies, and filling whatever void was left with drugs and sex, when a small voice sought me out.

At a book display, I ran into two humble, loving people who radiated a spirit totally new to me. They were from a place called the Bruderhof. "I'd buy one of your books," I told them, "but I only have a dollar." That dollar changed my life. The little book I bought

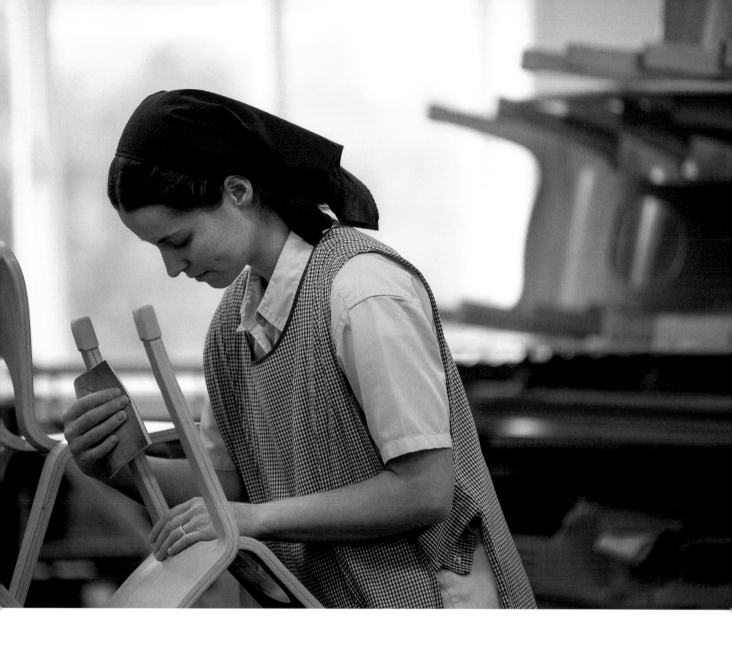

with it – a collection of writings by Eberhard Arnold – not only challenged every aspect of my life but also gave me positive answers. Reading it made me realize that everything I was looking for could be found in that radical revolutionary, Jesus Christ. I wasn't seeking him, but he called me. What's more, the people who had sold me the book not only believed in its message but were trying to put it into practice. I knew I had to see it for myself.

During her first visit to the community, Kathy still secretly smoked her pot. She told her hosts there were many other ways to find God. They didn't argue with her, but they didn't have to. Far more convincing was the atmosphere which enveloped her.

The book I'd bought had talked about the community as an embas-sy where the laws of the kingdom of God apply, a place where every sin can be confronted and forgiven, and peace reigns. I experienced that as reality. No other place could have fostered the inner change, growth, and healing I so desperately needed. Nowhere else could I have been so clearly and lovingly pointed to the cross, and away from myself and my agony.

And so I joined the Bruderhof. I was relieved to find out that it wasn't just a holiness trip but a simple, practical life, open to anyone. Undergirding it all was a new (for me) understanding of peace: the peace that points away from the self, and toward community, toward God's future reign of joy and love. In surrendering and giving myself to that goal, I found what I had always been looking for. ◆

JULIE BAIRD

1951–

I was raised in what appeared to be a good family in Dayton, Ohio. But no one knew about the violent tempers or tension which were part of daily life. I grew up confused, fearful, and very insecure. On the outside I was a normal, decent, even religious young woman. Yet on the inside there was extreme pain and turmoil.

When I married, I half-hoped my wounds would heal. They didn't. I had always known self-doubt and self-hatred, but now I began to project those feelings on others. I was angry. I felt rejected and worthless. I desperately wanted to be loved, and I looked for love in everyone around me. I sought peace through Christian counseling, and through prayer, but it remained outside my grasp.

It was only years later, at the Bruderhof, during a retreat for new members (my husband and I had been looking for a communal way of life, and joined

in 1987), that I found peace through squarely facing my past. I realized that the root of my anguish was my self-centeredness. Hell-bent on my own happiness, I had become an emotional leech. It was a humiliating discovery, but it was also redemptive. Suddenly I was able to feel remorse for the hurts I had caused others, instead of always feeling sorry for myself. I even felt a desire to forgive those who had injured me in the past. In those days something Jesus says in the Gospel of Mark became real to me: "I have not come to call the righteous, but sinners."

I still have to battle anxiety at times. I still lapse into old worries. I still have to struggle against the temptation to please others. But there's no longer a divide between my façade and the real me. That's peace.

Ed and Julie
celebrating their
wedding anniversary

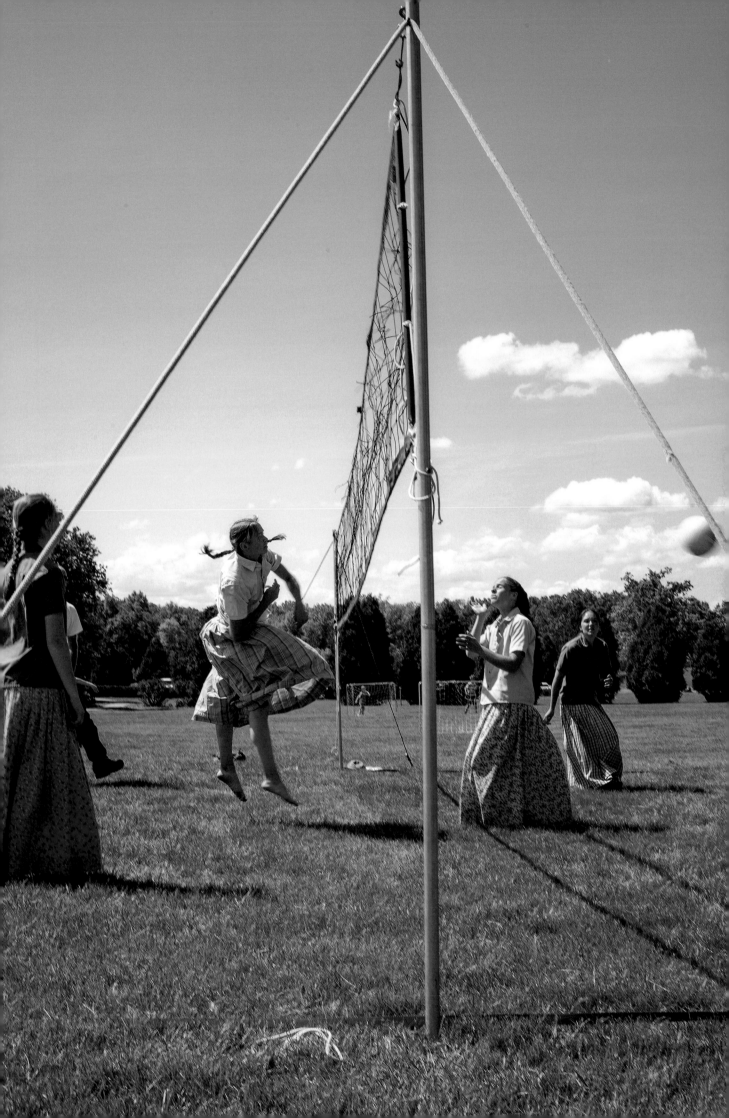

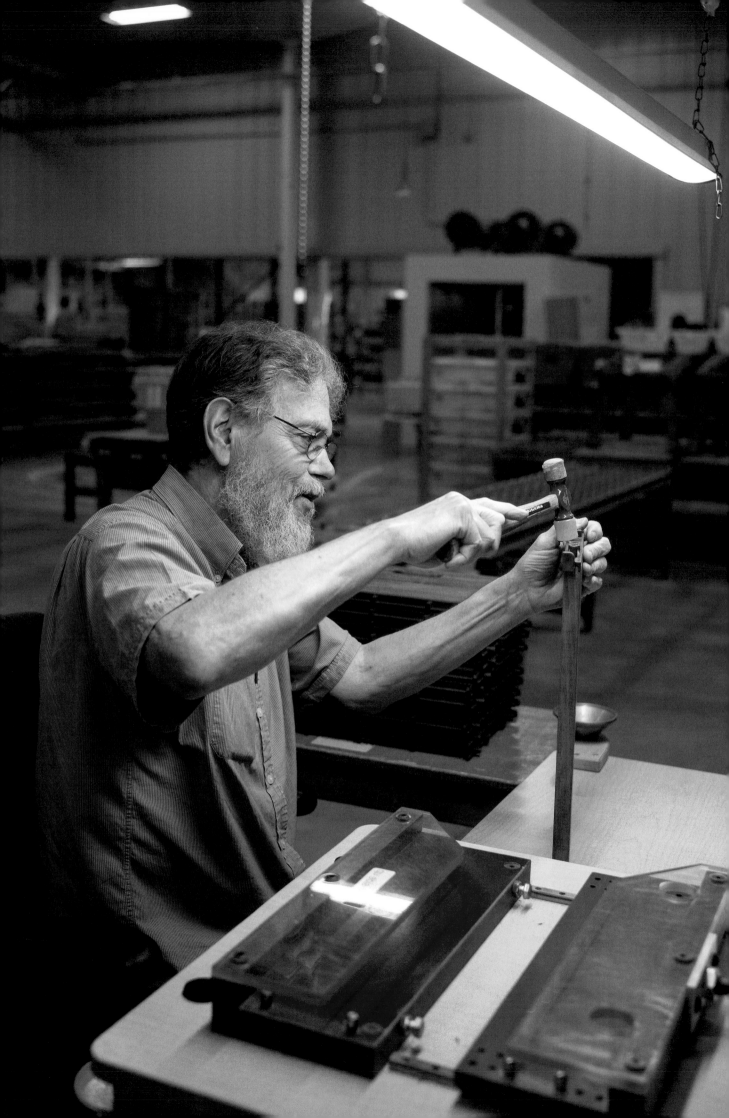

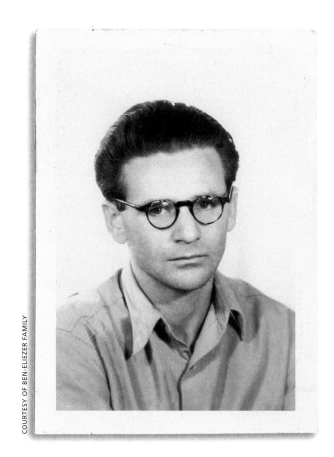

COURTESY OF BEN-ELIEZER FAMILY

He survived the Holocaust, served in the Israeli army, then set out to find true brotherhood.

JOSEF BEN-ELIEZER
1929–2013

Josef was born in Germany in 1929. One of his earliest memories was of a group of Nazi storm troopers marching through his street in the old merchant city of Frankfurt, singing, "When Jewish blood spurts from our knives . . ." A four-year-old, he did not know whose blood they were referring to, but the look on his parents' faces was answer enough.

Not long afterward, the family left Germany for the apparent safety of Poland, where, a few years later, Hitler's armies caught up with them. Driven from their homes on foot by the SS, they fled further east, to Russia, where they were interned with other Jews and then tricked into boarding a train of box cars headed for the freezing wilds of Siberia and its labor camps. Ironically, this probably saved Josef's life: had his family been returned to Poland – their goal – they might have ended up in Auschwitz.

In 1943, after his mother's death from starvation, Josef's father sent Josef and his younger sister to an "absorption center" for displaced children near Haifa. By the end of the war, Josef was attending an agricultural

<<
Gary assembles
outdoor play
equipment.

school at a Zionist settlement. Among his peers were survivors of places such as Bergen-Belsen who, though teens like him, looked like old men.

Meanwhile, he remained a refugee in every sense of the word. When asked to name his mother tongue, he could give no clear answer. Most burdensome, his heart brimmed with hatred – for the Germans, because of the Holocaust, but even more for the English, because of their attempts to restrict the immigration of concentration camp survivors and refugees like him into the Promised Land.

Like other Jews, I promised myself that I would never again go like a sheep to slaughter, at least not without putting up a good fight. We felt we were living in a world of wild beasts, and we couldn't see how we would survive unless we became like them.

The next years brought a stint in the Haganah, the underground military force then fighting for the establishment of the State of Israel. During one campaign, Josef served in a unit that forcibly evacuated Arab villagers from an area desired by Jewish settlers. He participated in interrogations, beatings, and even murder. This incident reopened the memory of his own suffering, which ate at him and brought on waves of guilt. He eventually left the army, then abandoned Judaism, and then religion as a whole:

Around this time I thought it was nonsense to believe in a higher power. After everything I had experienced and heard, I was indignant that my forefathers brought so much suffering on themselves through their faith in a god.

"But from that point on, I have had no doubt. I found what I had been seeking. This is the only answer to humankind's need, to open themselves to the spirit of God who wants to gather a people to live out his will."

Over the next years Josef stopped looking for the purpose of human existence, and for a just, equitable society. Capitalism was abhorrent to him; Zionism, too, had lost its appeal. Socialism and communism held his interest for a while, as did the writings of Jean-Paul Sartre. He delved into Esperanto, an artificial language championed by postwar European intellectuals who believed that a universal tongue would bring about universal peace. For several months he tried living with a community of idealistic Marxists in Paris. He spent several months in Munich, where he was horrified to stumble upon a neo-Nazi march and find admiration for the Führer alive and well. The riddle of why human beings cannot live together in peace and harmony drove him to despair. On more than one occasion, suicide beckoned.

In 1958 Josef came across the Bruder-hof. There, in a Christian community, of all places, he felt confronted by the God of his ancestors as never before. Though a convinced atheist when he arrived, and a skeptic bent on disproving the viability of community, he was irrevocably drawn. As he recounts in his memoir, *My Search:*

Until that moment, my inexorable logic had excluded any such spiritual dimension. But from that point on, I have had no doubt. I found what I had been seeking. This is the only answer to humankind's need, to open themselves to the spirit of God who wants to gather a people to live out his will.

I love the game of chess. In chess, it often takes a long time before you make a move. You look at all the possibilities and then you decide on your move. It looks completely logical since everything is all thought through. But sometimes your opponent makes a move that you hadn't thought of at all; it goes against your whole logic. You realize that your whole

approach was built on a false premise. You have to start from scratch, as if it were a completely new game.

Two years later, Josef committed his life to Christ through believer's baptism.

Decades later, Josef was contacted by a man whose father had been driven out of the village Josef's unit had forcibly evacuated when he was a soldier. This man had heard of Josef and was interested in meeting him. In 1997, with some trepidation, but also with fervent hopes of reconciliation, Josef traveled to Israel, where he met the man and his father, begged their forgiveness—and received it.

That trip encapsulates the way his quest for peace and his desire to be a peacemaker drove him onward, never resting or allowing that he had "arrived." At his side, or waiting for him at home, was always Ruth, his beloved wife of fifty years. Together they had seven children.

In a broader sense, Josef was a father to many more than his own children, both within the Bruderhof and beyond it. His cheerful, sage advice and his self-effacing humility (he was famous for prefacing opinions with, "Forgive me if I am wrong . . .") made him a trusted mentor to friends and acquaintances around the world.

When a massive heart attack took eighty-three-year-old Josef Ben-Eliezer, his family and hundreds of friends around the world were left stunned by the suddenness of his death. For Josef himself, it was a mercifully swift passage into the arms of a God he had once denied. ♦

A Sunday evening sing-along starts at eight and ends when the neighbors say it's enough!

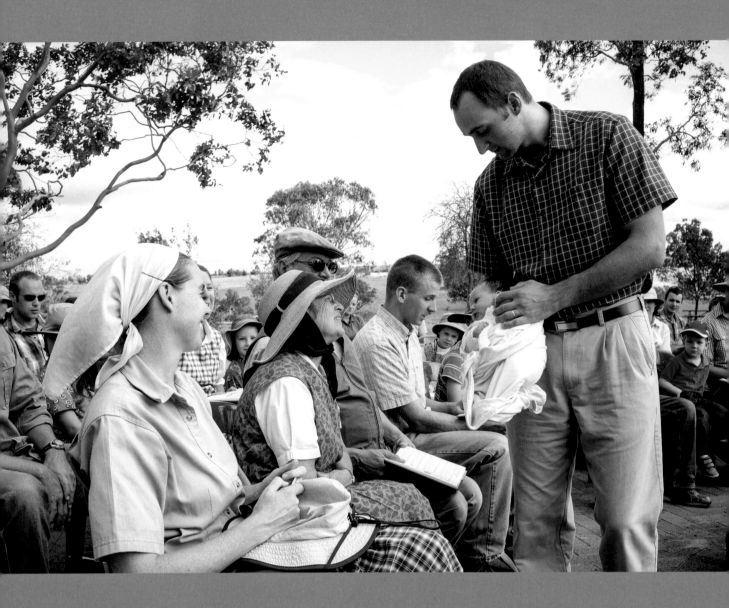

To be a man is to be responsible. It is to feel shame at the sight of unmerited misery. It is to take pride in a victory won by one's comrades. It is to be aware, when setting one's stone, that one is contributing to the building of the world.

Antoine de Saint-Exupéry, author and aviator
1900–1944

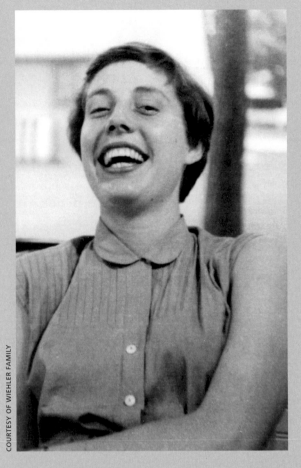

ANNE WIEHLER

1931–

A young Minnesotan with a passion for peace and justice, Anne saw sociology—her college major—as a means of understanding the wrongs of the world, and social work as a way of redressing them. Then she read about a movement of worker-run factories in France that were organizing to rebuild the economy, which was still struggling to recover after World War II.

Crossing the Atlantic, she dedicated herself to this "new economic order" but soon grew disillusioned: "I found envy, gossip, quarreling, tensions. At the factory where I worked, a boss ran away with the wife of a worker. I didn't see how a new way of life could be built out of this effort."

While in France, Anne met André Trocmé, a pastor who had turned his parsonage into a secret center for saving Jews during the war, and talked with him. "My French surely hurt his ears, but he listened to my questions:

What is the answer to violence, to poverty? Is it really possible for people to live in peace? He answered by telling me about the Bruderhof."

In 1956, Anne joined the community. Six decades later, she has no regrets, though she is quick to point out that the Bruderhof is no utopia. The peace she sought and found in community living has been tried and tested. She lost her first child, Dirk, when he was three months old. Later, with four children under the age of six, her husband abandoned her.

Asked how she has kept herself from becoming bitter, she says: "Keeping your eye on the prize, and knowing the power of forgiveness; putting yourself in others' shoes, and taking on their suffering; trying to keep the needs of the whole world alive in your thinking, and in your heart. That gives me peace."

ANDREW ZIMMERMAN

1977–

For years Andrew was the web editor for *Bruderhof.com* and lived at Woodcrest in New York. In June 2019 he and his wife, Priscilla, and their three children moved to Austria to help found a new Bruderhof north of Vienna.

It's ironic. Austria (or rather its predecessor, the Holy Roman Empire) was one of the most violent Catholic persecutors of the first Anabaptists in the early sixteenth century. And now we find ourselves warmly welcomed into Austria by the Archbishop of Vienna, Christoph Cardinal Schönborn, and by other friends in the Roman Catholic Church, as well as by the free churches, especially the Mennonite Brethren.

It all started when a group of Christians from various denominations started seeking some way to address and overcome the legacy of persecution against non-Catholic believers as part of the five hundredth anniversary of the Reformation. This so-called Round Table reached out to the Bruderhof asking if we could found a modern Anabaptist community in Austria as a step towards reconciliation. The reconciliation that we have found here is not just spiritual: it has hands and feet in the practical help we have received in setting up our little Bruderhof in Lower Austria. We are delighted to have found a home on the farmstead of the former Dominican monastery in Retz, where we can witness through our common life to the spirit of Jesus, which has inspired generations of Catholics and which actually kindles in every human heart a longing for discipleship and community.

These developments inspire me, and I hope they inspire you. If it is possible to overcome the kind of polarization that led to people being burned at the stake as heretics, then surely we can also overcome the polarization of our modern society.

God's covenant is an everlasting covenant, existing from the beginning and continuing into eternity. It shows that it is his will to be our God and Father, and that we should be his people and beloved children, and that he desires through Christ to fill us at all times with every divine blessing and all that is good.

Peter Riedemann, Anabaptist leader
1506–1556

Shopping for fruit at a
London market

107-year-old
Granny Gertie
greeting a
little visitor.

FINDING AND SHARING FAITH

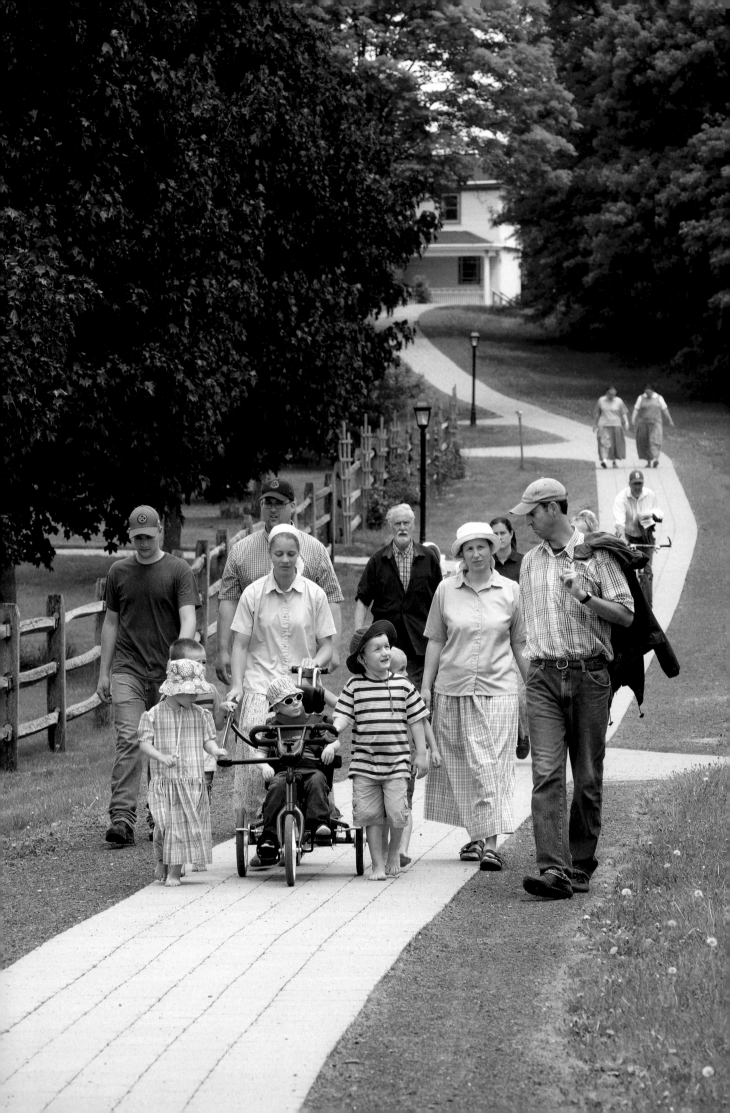

SIBYL SENDER

1934–2014

An atheist single mom set out to shock the religious fanatics and ended up staying forever.

<<
Lunch time:
Young and old
converge on the path
that leads to the
dining room.

R aised in New York, Texas, and Florida, Sibyl was the only child of upper-middle-class parents. After attending an exclusive school for girls, she enrolled at Radcliffe, the then all-male Harvard's separate college for women. Her wedding was announced in the *New York Times.* She was listed in the *Social Register*, the Northeast's go-to index of patrician families and members of high society. But in spite of all that, she defied the "stultifying conventions" of her upbringing, most especially the patina of religion provided by her family's occasional church-going, which she denounced as an "utter farce."

My story is a typical atheist's story. We come into the world with a preconceived idea. It's as if we have a pre-birth memory of better days. By the time of my fourth birthday, I knew the place was a mess. Burdened by an image of children lying, fly-covered, in gutters in India, I was sure I could do a better job, and vaguely wished, as I blew out the ritual candles on the cake, that whoever was in control would "make it all better."

Of course nothing got better. If anything, it got worse. At four and a half I attended my first

"Though I smoked hard,
and drank hard, and lived
hard, I could not suppress a
wrenching, clawing feeling
that there might be a
meaning to life,
after all."

Sunday school class. Upon being told where we were going, I thought, "At last, a chance to meet God face to face." Instead, we cut out white sheep and pasted them on green paper. Institutional religion never recouped itself in my eyes.

By the time I was fourteen, I had come to the end of my tether, inwardly. There was an overabundance of badness and, worst of all, I was beginning to see that the goodness was about 95 percent phony. In California, a three-year-old child lay dying in a narrow drainpipe she had fallen into. As men and machines tried to extract her, the entire nation prayed for her safe release. It was time for a showdown. "This is it, God, your last chance," I thought. "Get her out alive, or we're finished. Look, if it were left to me, I'd save her without even being worshiped." She died in the pipe.

So it was all over. The child and my regard for God were equally dead. Now I knew that human beings were nothing but animated blobs of protoplasm.

Then there was the idiocy of morality. It appeared to be deeply rooted in "what the neighbors would think." And what the neighbors thought depended on where you lived.

Morals, ethics, right and wrong, they were all purely cultural phenomena. Everyone was playing the game. I opted for nihilism and sensuality. And lived accordingly. Out with good and evil, out with morality of any kind, out with accepted cultural customs.

A line from *Knock on Any Door*, a 1949 film, summed it up: "Live fast, die young, and leave a good-looking corpse." I proceeded to live my beliefs, preaching atheism to any idiot who "believed." Though I smoked hard, and drank hard, and lived hard, I could not suppress a wrenching, clawing feeling that there might be a meaning to life, after all. In retrospect I see that I was so hungry, so aching for God that I was trying to taunt him out of the clouds.

During high school, my two closest friends and I discussed philosophy endlessly, worked on the God question, reaffirmed our atheism, and read C. S. Lewis so that, in case we'd really meet him one day, we'd be ready to "cut him down." Attendance at chapel was required, but I refused, as a matter of conscience, to bow my head during prayers. Caught, I was banished to the back row, where I defiantly sat and read Freud.

Radcliffe, she soon discovered, "was as phony as church," so she dropped out and married Ramón,

a student at Brandeis and the son of a dissident Spanish novelist whose mother had been executed by the forces of Spanish dictator Francisco Franco.

It was not long after this that a baby girl, Xaverie, was born to us. As I looked across the maternity ward of the big Brooklyn hospital where she was born, the absolute innocence and trust she radiated just tore at my heart. I could not understand how something so beautiful could be put into such a horrible, evil, cruel world. I knew I was a part of this world. I could not find the answer.

While I nursed her at night, I steeped myself in the writings of Dostoyevsky. Truths were coming at me, though I couldn't have defined them then. Ramón and I had acquainted ourselves with various offbeat religions, but none held the slightest appeal for me. It was Dostoyevsky that was the real religious experience. Today I can say that he was the one who delineated, for me, the realization that humans are buffeted and driven by dark forces greater than themselves, and that these forces chain us all – and (as he suggested in the gentlest possible way) that another, stronger, freeing power exists.

By the time Sibyl's daughter turned one, her marriage was falling apart, and Ramón had left the house. "I knew we bore equal blame," she later recalled. "If I were him, I would have left me."

My mode of life descended steadily into the swineherd's berth. Sometime during what I considered a final separation from Ramón, the man I was currently "in love with" decided I should abort our child. I hoped to the last minute that he would change his mind. But he didn't. And so, tough atheist that I was, I went through with the most devastating and most regretted ordeal of my life. Why, when I had been dedicated to the proposition that there was no such thing as right and wrong, when no intellectual, believer, or educator had been able to persuade me otherwise – why was I burdened with such guilt?

There soon came a time when Xaverie was all that stood between suicide and me. I had reached as close to the bottom as a person could. Then, on a hot August night in 1957, in surroundings I will not describe, I groaned to a Being I did not believe in, "Okay, if there's another way, show me." Two months later I was at the Bruderhof.

It all began with Ramón's startling appearance in my Manhattan office. A year earlier, he had left New York to join the Beats in San Francisco

– Kerouac, Ginsberg, and company – and we'd not seen each other since. Meanwhile, I was settled and had a good job as a magazine editor.

At a recent party in Greenwich Village, he had met someone who was on his way upstate to check out a religious community. Ramón had tagged along, and now he was on a mission to get me to visit this community.

Everything in me recoiled from the idea. The Christians I knew wore disapproving grimaces. They worried about their reputations. They were stiff and self-conscious – they waited for you to notice how good they were. Then, there was Ramón himself. I wanted nothing more to do with him. So I told him, "No, I'm not going anywhere with you, and most definitely not to some stupid religious joint."

Ramón left, but only to reappear a few weeks later. The same scene. It happened I don't know how many times. Once he took me to a restaurant and wept. It wore me down. "Okay,"

I finally told him. "I'll come, next weekend. I'll hate the Bruderhof and they'll hate me. And then you'll stop nagging me about it."

I picked my traveling clothes carefully: my fire-engine-red knit tube dress. That ought to ensure immediate rejection. Friday afternoon Ramón drove Xaverie and me upstate. All the way, I was cultivating a venomous attitude toward "that place."

Once she arrived at the community, however, none of Sibyl's preconceived notions fit the realities that met her. In her own words, "Everything seemed to be turned inside out, and set on its head." People greeted her, she later remembered, as if she were an old friend. So while Xaverie happily lost herself on a swing set, Sibyl, disarmed by a wave of love, found herself trapped in a life-changing dilemma.

And yet, I wasn't going to leap into the burning bush, not me. There was always hope that the Bruderhof would reveal itself to be utterly phony.

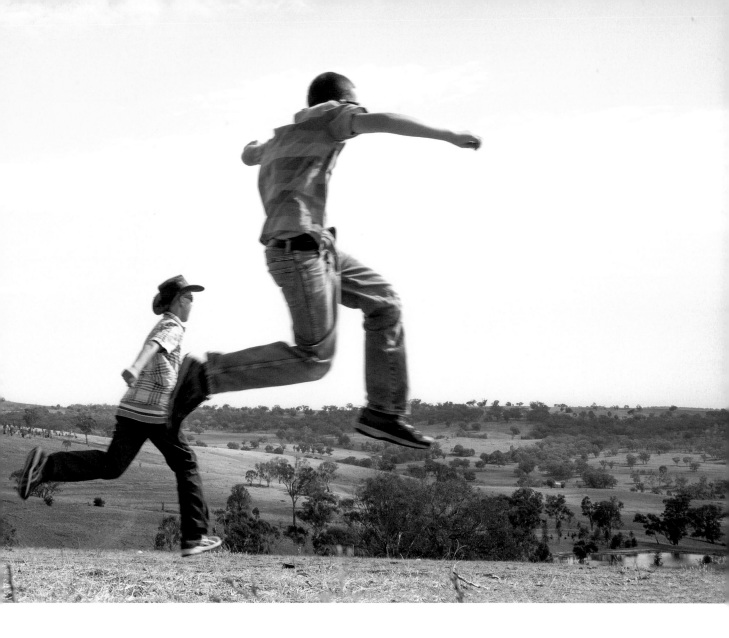

The heavens and hells I lived through in the next forty-eight hours were as several entire lifetimes. How could I be moved to tears in half my being, while the other half scorned my reaction and told me I was surrounded by seemingly mindless adults trapped in spiritual schizophrenia?

On Sunday morning, I looked forward to surcease in the battle. Surely the "religious service" would cure me of these strange leanings toward "goodness" that I was feeling. It would be like every other nonsensical religious powwow I'd been to. Empty. Nothing there.

But then the service began, and horrors – they were reading Dostoyevsky! "God, don't do this to me," I found myself pleading. "Don't hit me in the literary solar plexus like this!" It was a passage from *The Brothers Karamazov*, where Ivan, the intellectual, tells Alyosha, the believer, that he, Ivan, refuses to believe in a God who would countenance the torment of even one

innocent child. There followed for me the spiritual denouement. Worlds, galaxies collided, and I quietly accepted and embraced a brand new thought: it is not God who torments the innocent. It is Sibyl.

Afterward, Sibyl found herself pouring out the entire wretched contents of her personal life to a complete stranger named Heinrich, a pastor at Woodcrest.

Later it seemed to me that in talking, the two of us had lived through the entire gospel, and that the heart of it was, as I had always suspected way deep down inside, "C'mon in, sit down, and have a cup of coffee." It had nothing to do with wooden pews. It had to do with goodness's compassionate love for badness.

At the end, I told Heinrich that this did not mean I was about to join the Bruderhof; I had to return to New York City. He said, "That is death." I said, "I know." Still, I was determined to get back home and pick up living again as if nothing had happened. So I did.

> ^
> A riotous tag game through the Australian paddocks around Danthonia

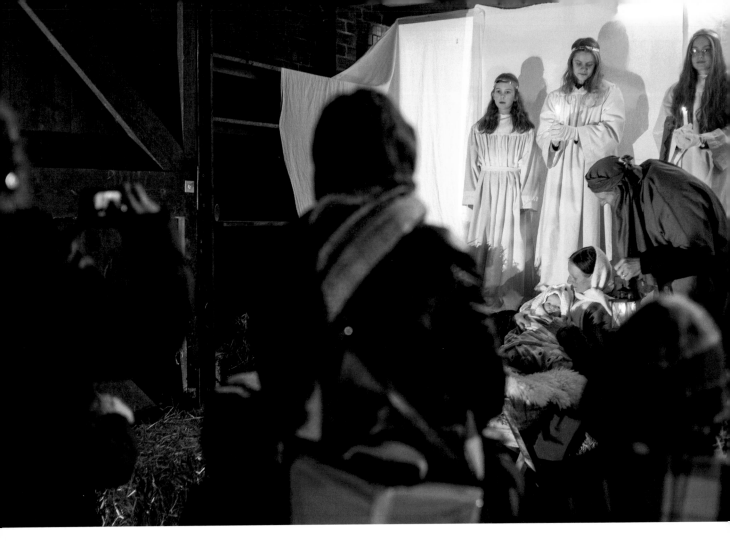

A live nativity scene

I spent the next three months trying to escape God and the call I felt – the call of total commitment, the death of the "old man." Oh, how the devil tried to lure me – and how I tried to follow him! He offered me money and fame in the strangest ways. But I could not eat the foul dish he set before me. I turned from it in disgust. What had happened to me? My taste buds had changed; my eyes were different, my ears, my nose, my sense of touch. I was Sibyl poured into a differently perceiving vessel. In the end, I had nowhere to go but back to the Bruderhof, until I could decide which way I would go forever.

After returning a second time, Sibyl knew it was for good:

I was as one in love. I was utterly consumed by the life of the community. The struggles of each member – their joys and sorrows, openly shared – seemed to be mine. But it was more like an ongoing adventure in discovering God's will. And it was punctuated by laughter, of all things! This adventure had nothing in common with a gloomy, introspective mining operation. Life was unutterably beautiful, wonderful. All I had been through – and was going through now, each day in community – was a miracle: of forgiveness, of mercy, of prayer, of God. And

that a wretch like me was allowed this!

There was a price to be paid. Sibyl's relationship with Ramón, which had never been stable or monogamous on either side, continued to crumble. In the end he left her once more, eventually divorcing her and moving to California. Sibyl was now a single mother raising Xaverie on her own.

Years later, when Xaverie decided to join the Bruderhof, Sibyl asked her: "How did you know what this was all about? I never used religious words." She answered, "Oh, Mama, Jesus was everywhere." This confirmed something Sibyl had always felt, that "if our deeds don't bespeak God's will, then there's no point talking about him."

In her late sixties, before moving to Bellvale, where she spent her last years, she told the Woodcrest community:

It's no good if we live by traditions, or what other people think of us. It'll be the death of our life together. In love there is total freedom. If we love our brothers and sisters, we can be totally free. If we don't love them, we are going to become uptight, watching for rules and doing what you think people want you to do. Don't let that happen or else I'm going to come back and raise HELL. ♦

ANOTHER LIFE IS POSSIBLE

126

ROGER MEIER

1995–

Roger grew up on the Bruderhof and became a member in 2016. He now studies education and geography in Vienna.

I don't bring up my faith with other students unless they ask me. Most can't relate to church, and seem to feel like the classmate who spoke up in a religion class and said he was sick and tired of the Jesus stories he'd heard since childhood. Faith is just like the ancient stone buildings they grew up worshiping in. Whereas for me, it's something living and real.

But I do ask them about their lives. A huge percentage seem dissatisfied, even repulsed, by the lifestyle they're trapped in – the hookup culture, binge drinking – and many are scarred by it. They're looking for something real and it's not hard to connect: to go out for a beer and have a good conversation about politics, justice, the environment, where society is heading, or our generation's future. Just about anyone can connect with Jesus' teachings on justice and peace and loving your neighbor as yourself, even if you don't frame them religiously. That, to me, is sharing your faith.

I always knew that if I prayed, I could trust that God, in his own time, would bring everything right again. And then I could get on with whatever work lay around. I found that peace can be had by putting away whatever is against Jesus and turning to him.

Ruth Land, physician and Bruderhof member
1913–2010

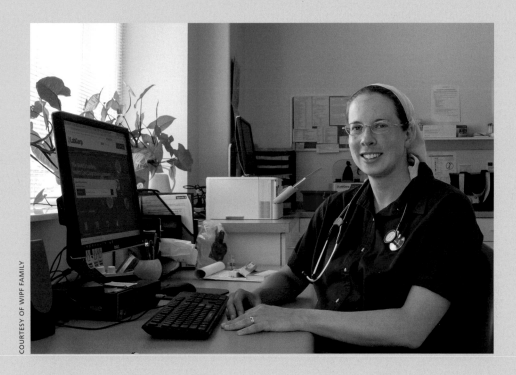

SHARON WIPF

1983–

A family physician who was raised on the Bruderhof and serves at one of its Pennsylvania clinics, Sharon is married to Rob, an electrician, and has three sons. Having worked at a large university hospital, she is familiar with the "normal" world of medicine, and says that practicing at the community is very different in several ways:

First, my colleagues are my brothers and sisters. Second, I live in community with my patients, so I can address their problems. No one's competing to get ahead. Third, I can address my patients' problems in a more comprehensive way than I could in a non-communal setting. For example, since I usually know my patients' families and what their home life looks like, I feel free to ask questions or make suggestions that might enhance their care.

Do they need a recliner? A hospital bed? If a person is dying, can we – the community – help arrange for someone to be with him or her at night? What about their spouse's work schedule? Can we lighten their responsibilities so they can focus on their loved one? I have time to fight insurance companies on my patients' behalf, and I have time to really go the second and third mile for patients. That might just be professionalism, but it also has everything to do with my faith: it allows me to do what I think is the most important part of medicine, which is to love others.

Regardless of where I've practiced, one thing is the same: I always carry my patients in prayer. Especially in a case where the best medicine proves ineffective.

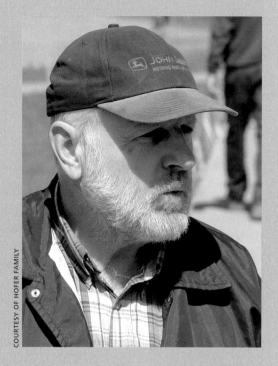

COURTESY OF HOFER FAMILY

RAY HOFER

1951–2011

Ray Hofer loved country music, the radio show *Car Talk*, his wife Emma's cooking, and fixing trucks. It would take a while after meeting him to guess he was a pastor. Yet his faith meant so much to him that at age forty-four, with his five children, ranging in age from ten to sixteen, he and Emma left the security of their conservative Anabaptist church in Minnesota because he could not reconcile himself to a Christianity that prized legalism over heartfelt love. As he wrote in an open letter to the congregation:

Could we come together sometime soon to make it clear where we stand? I myself am willing to give up everything I have – my self-will, and my opinions – and to give up my service [as your pastor]. Do with me whatever the Spirit tells you to do with me. We so easily say, "I want to give my life to Jesus." But are we living a Christian life? Do we truly love each other? Do we trust one another? Some of these questions could be answered with a definite "No." It is high time we turned around and made a new beginning. Jesus never said "Wait." He said, "Today, if you hear my voice . . ." I am a poor soul. Please help me.

Moving to the East Coast, Ray and Emma joined the Bruderhof. There, he was soon asked to renew his calling as a pastor. He became known as a mentor who never offered advice without listening deeply first, and for his deadpan humor.

Ray died of cancer at age fifty-nine. He didn't want to die – "You try being the one who won't be here this time next year" – but he was faithful to his calling to the end.

When we get our spiritual house in order, we'll be dead. The search goes on. You arrive at enough certainty to be able to make your way, but it is making it in darkness. Don't expect faith to clear things up for you. It is trust, not certainty.

Flannery O'Connor, writer
1925–1964

^
Keith putting the final
polish on a completed
monument sign for
Danthonia Designs

DAN HALLOCK

1960–

How an aerospace engineer struggling with cocaine addiction found Christ and community

"**By the time** I was sixteen, I doubted God even existed," Dan Hallock remembers. "I was much more preoccupied with the experiences of a typical teenager growing up in the mid-70s: flinging around the word 'radical' while smoking pot and behaving as irresponsibly as possible." The Catholic faith he had been raised in mystified him, and he saw church as a chore.

After high school, he attended Cornell University, where by day he studied aerospace engineering and by night attended concerts, took LSD, and drank. On graduating ("I survived, narrowly"), he landed a dream job at Sikorsky, a military contractor. Then his life began to unravel.

Everyone else seemed perfectly happy working toward a new car or condo, or another vacation in the Caribbean, but I was increasingly desperate. I was drinking almost a case of beer a night, along with whiskey, and I'd become addicted to cocaine.

The final blow came when my girlfriend suddenly left me. We'd been together four years, and had talked about marrying, but now she said, "You had your fun; now let me have mine." I was filled with rage and despair.

One night, drugged out of my mind, I got in my car and started driving very fast, with no destination in mind. I still don't know why I didn't just run into a tree or an overpass, because I definitely wanted to kill myself. But somehow I found myself back at home in the morning.

Around this time, Dan had a revelatory experience so unexpected and so powerful that he can still remember the date and hour it took place.

133

"I began to feel that the military-industrial complex was incompatible with my newfound faith. Fellow Christians at work didn't understand, but my agnostic Jewish boss did."

I was alone in my apartment. I picked up a Bible my mom had given me and began to read. I pored over Jesus' words as if I were reading them for the very first time. Suddenly, all the broken, filthy pieces of my life came together, and I could see them all at once. And I knew that he could see them too – the person who had been with me through all those years of darkness and pain and confusion.

I did not see Jesus with my eyes, but he was unmistakably there in the room with me, as a powerful, living presence. It is impossible to describe the compassion I felt radiating from this presence. Tears streamed down my face – not for minutes, but for days, on and off. Suddenly, that battered body I'd seen hanging from crucifixes as a boy was something I could identify with. I felt as if we were brothers. Jesus knew what I had gone through. I had hope.

I remember walking through the streets afterward, noticing people as if for the first time, and seeing the world in a completely new light. I saw my job differ-

ently too: I began to feel that the military-industrial complex was incompatible with my newfound faith. Fellow Christians at work didn't understand, but my agnostic Jewish boss did. He said, "Dan, something's come into your heart. If you don't follow it, if you aren't true to it, you're going to destroy yourself." So I followed it.

Higher up the ladder, they said I was nuts and offered me $100 an hour to stay. I could pick my hours. I still walked out. I was free. At first I worked in a vineyard alongside day laborers, earning $3 an hour. I began to look for concrete ways to follow Jesus – that is, to live out what I felt the Gospels required. I took care of elderly shut-ins; I tutored disadvantaged children; I worked at homeless shelters, in soup kitchens, and for Habitat for Humanity. But all the while, I was still living a kind of isolated middle-class life. It was still all about me.

Eventually Dan's search led him to the Bruderhof, which his mother had visited while on a retreat. After several visits, he joined in 1990. It was there, through baptism, that he finally found

<<
An outdoor production of *Much Ado About Nothing* by the Woodcrest middle school. Karl (as Benedick) bursts offstage and indoors.

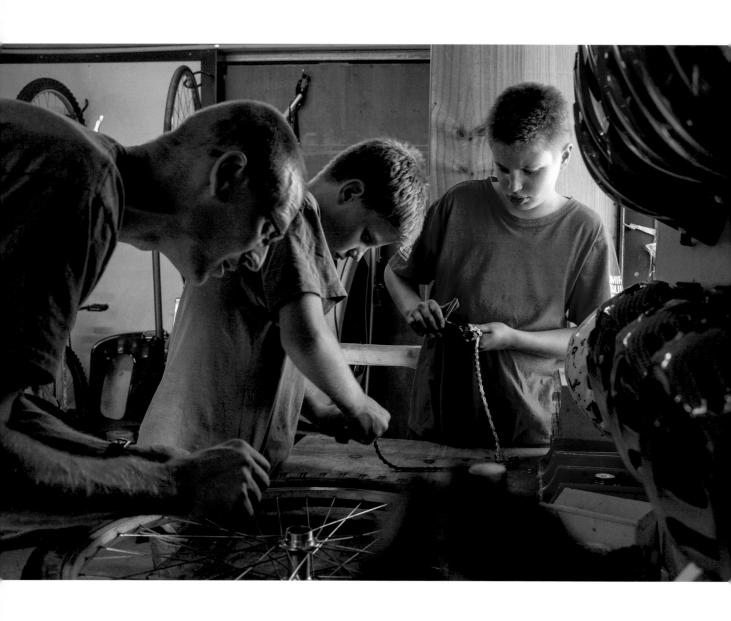

the courage to "confront my own depravity" and to "turn toward the light that had broken into my life." Years later, he met his wife, Emily, with whom he has three children.

Reflecting on his conversion, Dan says:

A lot of Christians seem to believe that all you need to do is accept Jesus as your savior, so that one day you can be taken up into the clouds or whatever. As I see it, Christianity demands the exact opposite: that once God transforms your life, you have an obligation to others. You're co-responsible for the state of the whole earth and everyone on it.

I didn't come here feeling, "Good riddance and goodbye to this terrible life I've led and to all the people I've known." On the contrary, I felt I was being given

a new chance and a new life for their sakes, too. That might sound grand, but all I'm saying is that if I were living here for myself, I couldn't justify it. I couldn't stay here another day. Our purpose, our reason for being, is much greater than that.

We are called to stand with all people on this planet who suffer in any way, no matter who they are, or where. That's how the early Christians lived. They served the poor – they served everyone they could – in the cities and towns where they lived. They believed they were, as they put it, God's hands and feet. ♦

∧
Passing on the art of bicycle maintenance: School afternoons are devoted to practical learning and play.

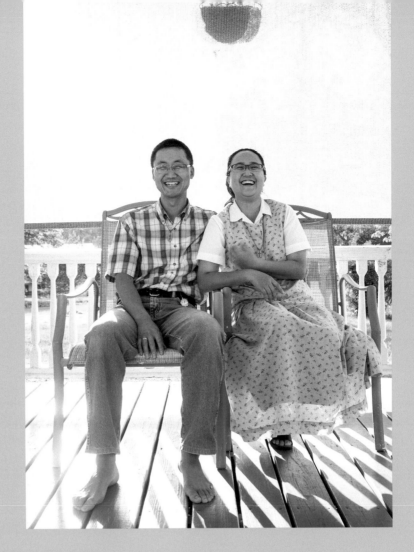

JAEHYOUNG JEONG

1979–

As a food engineer, Jaehyoung spent thirteen hours a day behind his desk, trying to extend the shelflife of ramen noodles. It was a life as unhealthy as the products his company was promoting. He began dreaming of raising vegetables on his own organic farm. That's what brought him to the Darvell Bruderhof in England in 2010: he hoped to find ideas in the community's garden.

At first, I had no interest in joining the community. Communism is not a good word in Korea! Besides, I was a good Christian. I gave 30 percent of my salary away. We could hardly speak English, and my wife, Hyeyoung, was Buddhist. But in the community she met Jesus for the first time. So we had no choice. We had to open our hearts to what we felt God wanted us to do.

In Korea, my life was always about competing with others. Even in my family, there were fights over money. But at Darvell, I was free. Like a bird that can fly anywhere.

After he and Hyeyoung stayed six months, they decided to join the community for good with their four young boys.

Later, we went through hard times. Life isn't a movie. There are times when I find my job in the wood-working shop boring. I have had to learn patience and trust — to be a brother, not a supervisor. But my wife and I keep finding things we never knew before: loving care for others; confession of sins, and forgiveness; freedom from self; and an atmosphere of love, of Jesus.

Though Martha grew up at the Bruderhof, her family left when she was eleven, and her childhood faith faded. It was a high-school literature teacher who awakened her social conscience and set her on a search "for truth, love, peace, justice." By the late 1960s, she was off to college, with dreams of becoming a journalist. "I was looking for a career where I could tell people the truth." After a year, she found a new focus at the London School of Economics, where she studied economics and international relations. As executive editor of the university newspaper, she sought to bring an objective approach to the political discussions around her:

MARTHA WOOLSTON

1950—

It was a time of upheaval and protest. Everyone was looking for something. But my activism wasn't taking me anywhere. Nor was my search for truth. People would say, "Well, it depends what you mean by truth — or justice, or peace." There was always some kind of stopper on any meaningful conversation or seeking.

Then, on a visit to the Woodcrest community in New York, Martha was stopped in her tracks.

I was hit in the face with the difference between the life I was living and what I saw in front of me. Here were the truths I had been looking for, as objective quantities. Nobody was sitting down to define them, or arguing about them as ideas. They were being lived. You could feel it in your bones.

In retrospect, the decisive thing about my visit was that I had met the Jesus of my childhood again — Jesus as a person with a real power and a very real message — and realized that he had to be the all-in-all in my life. I finished my studies in 1973 and came home for good.

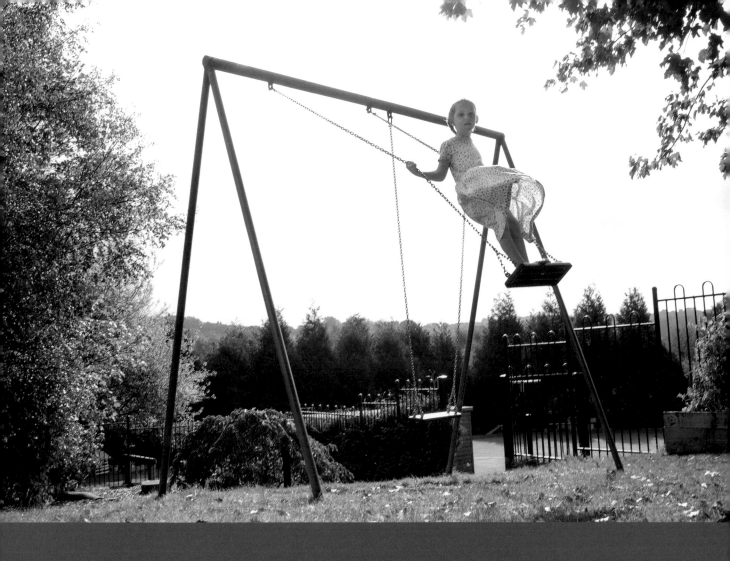

The wonderful thing is that Christ, in his own life and teaching, combines all the facets of the truth that earlier truth-seekers had represented in part, and goes even further. Christ himself said, "I came not to destroy but to fulfill" – that is, as regards all that is in accordance with the truth. He not only uttered the truth but also was the truth.

Augustine of Hippo, bishop and theologian
AD 354–430

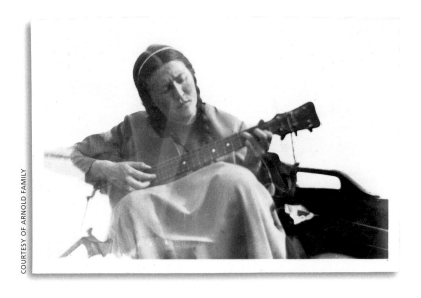

ANNEMARIE ARNOLD

1909–1980

Desiring to find truth at any cost, Annemarie found God.

The only girl at the German boarding school for boys run by her father, Dr. Christian Otto Wächter, Annemarie spent a carefree and happy childhood. Then adolescence hit, and with it, a precocious and persistent search for truth. "And what is God, then?" Annemarie asked her diary in 1929.

I don't know whether I believe in him or don't. I'm not able to pray. I have only read about him. I would rather be an atheist than be like this. There must be something that can rend my heart and take hold of me.

While studying to become a kindergarten teacher, she met Emy-Margret Arnold, the daughter of Eberhard and Emmy Arnold, founders of the Bruderhof. After visiting in 1930, Annemarie wrote to Emy-Margret:

You may ask me: What do you believe in? Do you believe in God, in Christ, in the good, or in anything else? All I can say is, I don't know. I do know that at the Bruderhof you claim to believe in Christ's message – in the possibility of community of all people in one Spirit – and act accordingly; and there is reality and life behind this belief, and not a lot of meaningless philosophical discussion. This makes me so happy.

Two years later she became a member of the community. Her decision was wrenching for her family, who had expected her to help run their school one day. Annemarie wrote home to her mother:

An experience of faith is always a personal, individual experience. Yet because of what it reveals of God's nature – God, who is love – it brings alive the call to community. The isolation that characterizes society today simply

>>
Playing in the Cuckoo
Woods, a favorite
haunt of Darvell's
children

Photo on next spread:
Undisturbed time in
nature is an important
part of childhood.

"The isolation that characterizes society today simply does not allow people to live in true love and brotherliness. That kind of relationship can be fostered only in a communal way of life."

does not allow people to live in true love and brotherliness. That kind of relationship can be fostered only in a communal way of life.

In another letter, she replied to her mother's suggestion that community life was an escape from the challenges of life in the "real world."

There is a full knowledge here of the burden and bitterness of the Way, and no sweetly gushing piety. What I have found here is a Christianity of conviction and faith and therefore of selfless action, and that is what makes all the difference.

The Cause is so great that each one committed to it must be ready to surrender his personal "freedom" for the privilege of living for it. I can think of no future work that would be greater and more worthwhile than what I have found here.

And to her brother in 1932:

The essence of life here, to which I feel committed, is an awareness of the kingdom of God – and not just a kingdom existing far away in some vague fantasy land that will come at some undetermined point in time, but a kingdom that must be lived and realized here and now. It is not an ideology or a product of philosophical recognition and theoretical deliberation, and therefore is not dependent on the relativity of human research and thought. No, it can exist only in the living reality of deeds – in the visible result of all that we do. Only so does this kingdom correspond with the will of God. Because God himself is absolute reality.

We wish to live in unity, social justice, brotherly surrender, and love. Unity is created through the power of the Holy Spirit: since God only

reveals himself to people through the Holy Spirit's working within us, we can only find a living, direct relationship to God in this way. However, this Spirit will, and must, bring about a very strong unity and unanimity – a profound community – among the people who have opened themselves to it. Life in community, therefore, is not something that is initiated and constructed by people, something that they can consequently just as readily abandon. People sought unity with God, and through it unity with one another was given to them. It would not be possible to build a community on human strengths and capabilities, as the countless unsuccessful intentional communities have shown. Life in community and unity is a gift of God to those who have made themselves ready to receive the working of his Holy Spirit. ♦

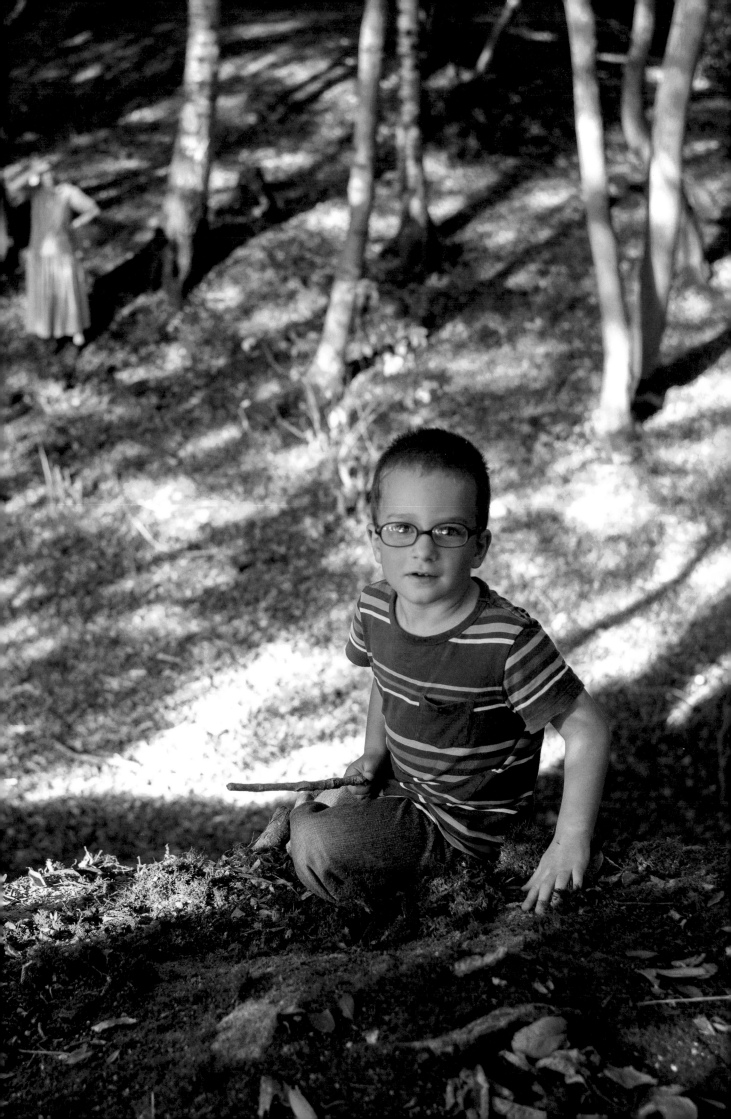

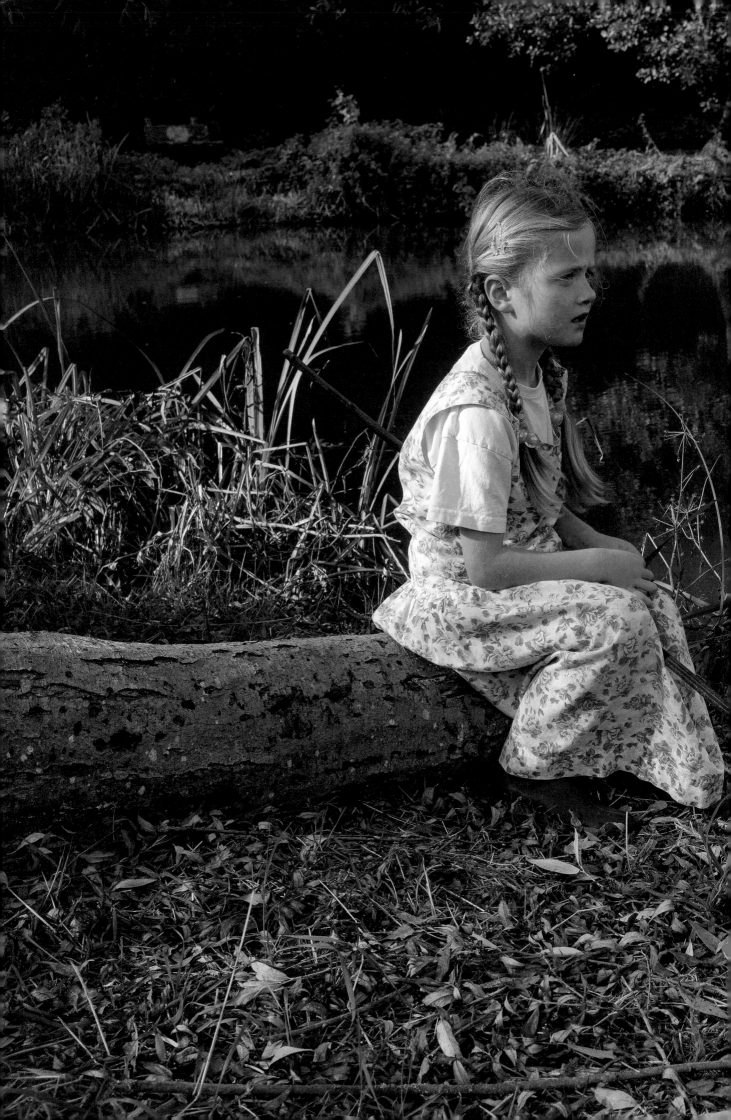

SUZANNE QUINTA

1945–

Suzanne was born in San Francisco to a naval family and traveled the world as a child. She met her husband, Tom, in college and together they embarked, like so many other young people in the sixties, on a search for what she calls "a life that was real. We felt that so much of what we saw around us was not genuine."

In 1967, after traveling to India to see if ancient Indian culture could hold answers to modern issues, they read about the Bruderhof, and visited for several months. "We loved the people there, and felt loved by them, but we weren't ready to give our lives to Jesus."

For the next seven years, the Quintas lived in a Zen Buddhist community in Maine, meditating five hours a day, baking their own bread, and raising the first two of eight children. Eventually, they left: "We didn't have much more in common with the group than our times of meditation, and there were tensions among us, and we didn't feel we were growing in love, or moving forward."

In 1976, they visited the Bruderhof again. "As we came up the drive, we knew we were coming home," Suzanne says. "I cannot tell you how strong that feeling was."

We met with a pastor, Heinrich, and told him, "Look, we're not Christians, but we want to seek Jesus with you here." (As a child, I had had an experience of Jesus that never left me.) Heinrich listened like a Zen master. He leaned back in his chair and just smiled. Finally he said, "So come." And that's what we did. As people who had done a lot of talking and reading and thinking, we had come to the conclusion that what really mattered was how you actually lived. And what we saw spoke to us. We've been trying to follow Christ here ever since.

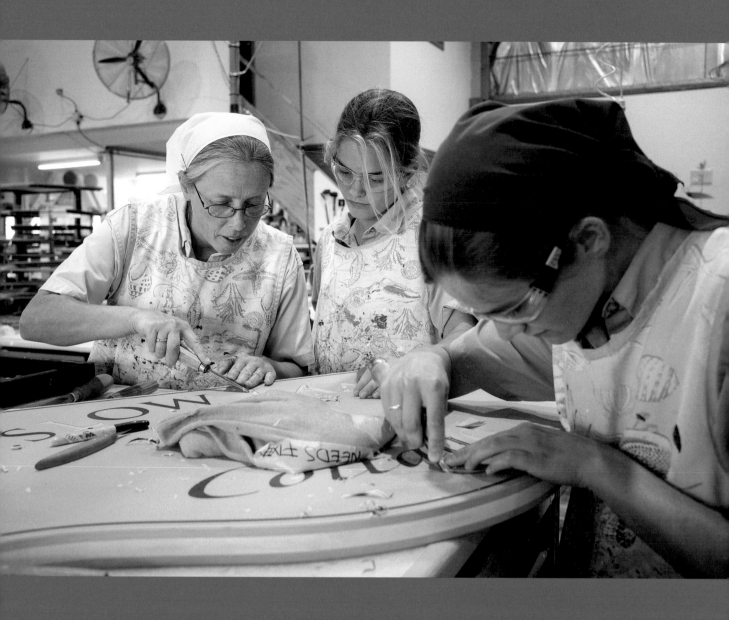

"You cannot prove to me that you have a father!" says the blind
sage, reasoning with the little child.

"Why should I prove it?" answers the child. "I am sitting on his
knee! If I could prove it, that would not make you see him; that
would not make you happy like me! You do not care about my
father, or you would not stand there disputing; you would feel
about until you found him! "

George MacDonald, author and pastor
1824–1905

Karen teaches Daralyn
the art of sign carving
in the Danthonia
Designs workshop.

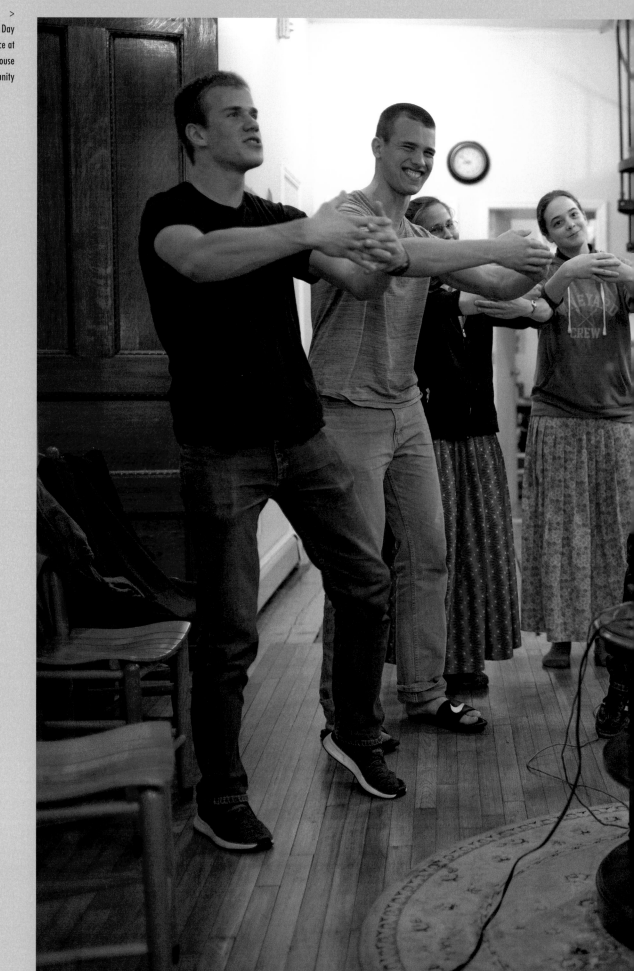

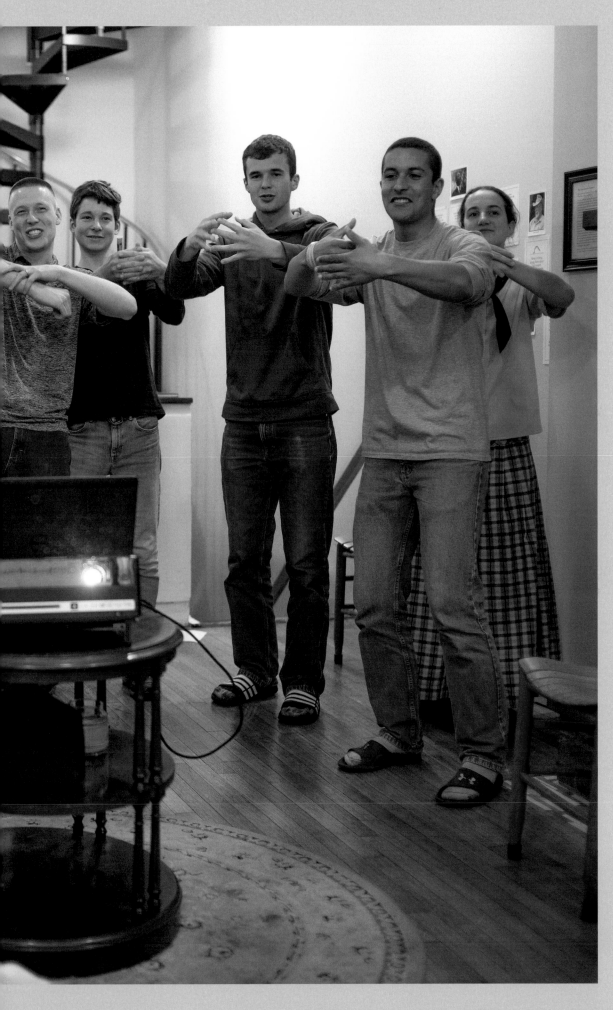

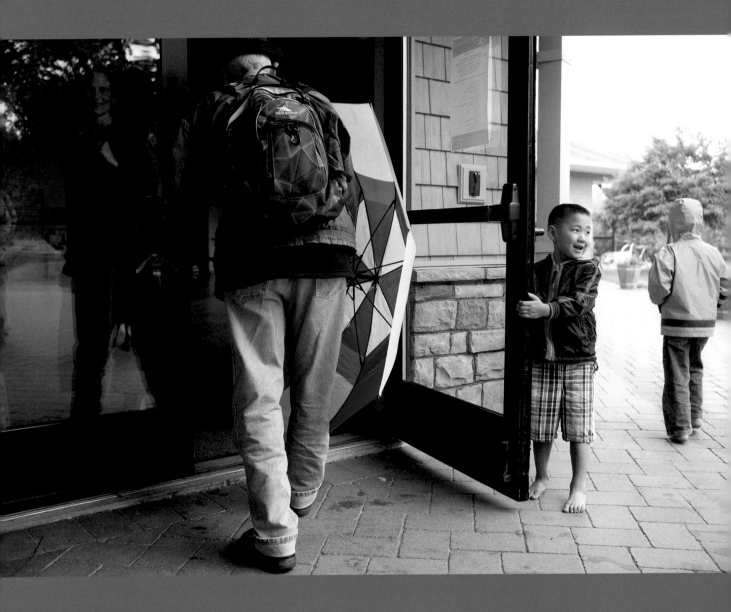

The opposite of freedom is not determinism, but hardness
of heart. Freedom presupposes openness of heart, of mind,
of eye and ear.

Abraham Joshua Heschel, rabbi and activist
1907–1972

^
"Quick! Come out
of the rain and
in for lunch!"

Erika grew up in the Bruderhof alongside her eight sisters, attended public high school, and spent the better part of the next decade studying in Albany, New York, and Erfurt, Germany, where she completed her master's degree in education. In 2016 she married Johann and their daughter was born in 2018.

University classmates would often ask, "Do you have to do what you're asked? Do you have to move where the community tells you, and work where

ERIKA BRINKMANN BARTH

1987–

you're told to work?" I'd always turn those questions around: "Look, I chose this life and freely affirmed my willingness to be used wherever my services are needed."

It was my decision to put myself at the disposal of the community, and the community is honoring that decision. I was the one who said I wanted to live this life; to give my faculties, time, and energy to help create a just society where everyone is treated with love and respect.

Society is obsessed with the hyphenated *self* words: self-expression, self-determination, self-actualization, and self-fulfillment. But it's the wrong orientation. The self isn't what gives a person true freedom and empowerment. The apostle Paul describes the "glorious freedom of the children of God," the freedom that Christ's followers—those who deny themselves for their fellow human beings—can be assured of. I am liberated in the certainty that God loves me for who I am, as I am, and that is what empowers me.

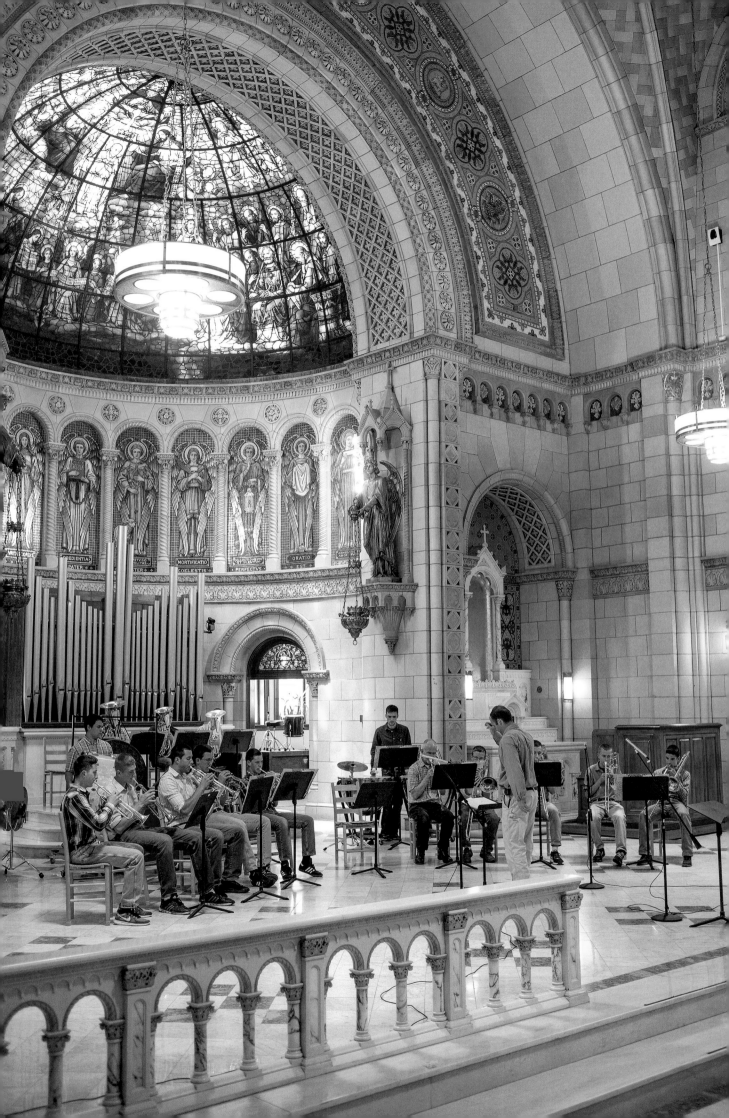

ERNA ALBERTZ

1979–

She was determined to make a difference and transform the world.

Headstrong and rebellious, Erna left the Bruderhof community where she was born and raised, planning to take a gap year after high school before returning. Soon, however, she was promising herself she'd never wear a skirt again. Dissidence was a family trait: her mother's family had resisted Hitler; and her father, an outspoken civil rights activist from New York, had spent a summer helping to register African-American voters in Mississippi.

Attending high school in Connecticut in the mid-1990s, she befriended a Bosnian girl who had come to the United States on a scholarship. Through their conversations, Erna developed an interest in the Balkan War and the suffering of that region's people in its aftermath. After graduating, Erna taught English to recent immigrants. One of her students was a Bosnian Muslim young man.

In time, his mother took to calling me her *snaha* **– daughter-in-law. His family was set on the American dream, and while I felt close to him, I knew a house, car, vacations, and the like would not**

spell fulfillment for me. They were only nominally Muslim but I also worried about not sharing the same faith. In the end, though, it was my newfound feminism that prompted me to drop the relationship: "freedom" seemed more important than love.

Still passionate about the Balkans, she took a volunteer position in a Bosnian camp for roughly 320 displaced people as a liaison for an international NGO.

It was a challenging assignment. I was twenty-one, the only non-Muslim, and the eyes and ears for the NGO administration as to what was happening on the ground. But it was just what I wanted: a chance to make a difference and make the world a better place.

The longer I stayed there, though, the more I realized my inadequacy in the face of the complexities I was dealing with. I expected to see their shared suffering and common faith bonding these families, but instead found gossip and division. I found myself thinking wistfully

<<

The Mount Academy's brass ensemble practices in the chapel. The school is housed in the former Mount Saint Alphonsus seminary, built by the Redemptorist Brothers in 1907 on the banks of the Hudson River. The Romanesque chapel is used for special occasions.

153

ANNE FINAUGHTY

1961–

Before joining the Danthonia Bruderhof in Australia in 2009, Anne, who has complex physical disabilities, spent up to nineteen hours a day sleeping, and her waking hours in front of the television. Despite her welfare check she was always short of money, and hated her work in a shop for people with disabilities: "It was like a prison. Horrible. Dead boring." Over time, she longed to put an end to it all. "I was literally waiting to die."

Today, Anne is often up at five in the morning, and runs a card- and sign-making business that she calls "Joy Is Love." She has produced hundreds of colorful greeting cards, door signs, and wheelchair tags. Some she sells, but most she gives away. Her goal? "To share the happiness I've found by cheering up and encouraging others."

Through allowing her creative side to blossom, Anne has found the freedom to be herself, and affirmation in sharing her gifts with others: "Painting has helped me by relaxing me and getting me out of myself. I still have my ups and downs, but the miracle is that through my artwork, I can always find joy. It might be hidden somewhere down inside me, but it always comes out eventually."

Asked if she's still waiting to die, she scoffs. "I gave that up, thank you very much. I do not want to die!"

of the harmony between the 320 people I had grown up amongst.

Not one to give up easily, Erna proposed a new program to her NGO, and before long she was offered a management position.

This was my dream coming true: financial security and independence while helping those in need. Was it a coincidence that I'd just made a secret decision to return to the Bruderhof? I now faced a choice between a perfectly acceptable form of service – and a truly radical one.

Again ducking commitment, Erna moved to Germany. There, she applied for midwifery school. One day, while interning in a clinic, she witnessed the abortion of a 23-week-old baby with Down syndrome:

One floor below us, in the neonatal intensive care unit, no efforts

were spared to save the lives of 24-week-olds. But because this child had a incurable genetic "disease," it was still defined as a disposable fetus. Who decided these things, and how?

Haunted by the realization that "the ultimate coefficient of a woman's freedom might be the murder of her unborn baby," Erna found herself reflecting on her parents and younger sister, Iris, who has Down syndrome.

What struck me was the miracle of how Iris and others like her were integrated into every facet of Bruderhof life. My parents never had to ask themselves whether they could "afford" to accept her, or whether she fit with their life-style. In community, the gifts Iris had to offer could be received. She was not only cared for; she was also able to reciprocate. My values of autonomy and success stood in stark contrast to that.

I began to reconsider freedom. I had been reading Kierkegaard, who wrote that you never actually have freedom until you use it to make a decision. If you just float along, you are not utilizing it. The Bruderhof members' commitment and solidarity was what created the space where freedom could flourish for all.

Paolo Coelho's book *The Alchemist* was the final peg in the coffin of my ideals. In it, a shepherd from Andalusia, Spain, has a recurring dream about a treasure buried beneath a pyramid in Egypt. He gives up everything to go on a long and harrowing search for this treasure, but on arriving there realizes, through a clue, that it lies under the roots of the very sycamore tree in Andalusia where he first had his dream. The message couldn't have been clearer to me: "The treasure lies buried at home." And "Real

freedom is to find your calling and give up everything for it."

Erna returned to the Bruderhof and became a member in 2004, several days after her twenty-fifth birthday.

Becoming a member of the Bruderhof means committing to Christ first, through baptism. People warned me this could mean the beginning of an inner struggle. But for me it was the other way around. I guess I'd done my struggling first. The day I was baptized (outdoors), a chilly wind was blowing fiercely, as if to chase away my old life and bring me something new. Afterwards I stood up, dripping wet, but filled with joy and peace. In binding myself to Jesus – and to others – I was finally free. ♦

^
Dr. Zimmerman teaches a biology class at The Mount Academy.

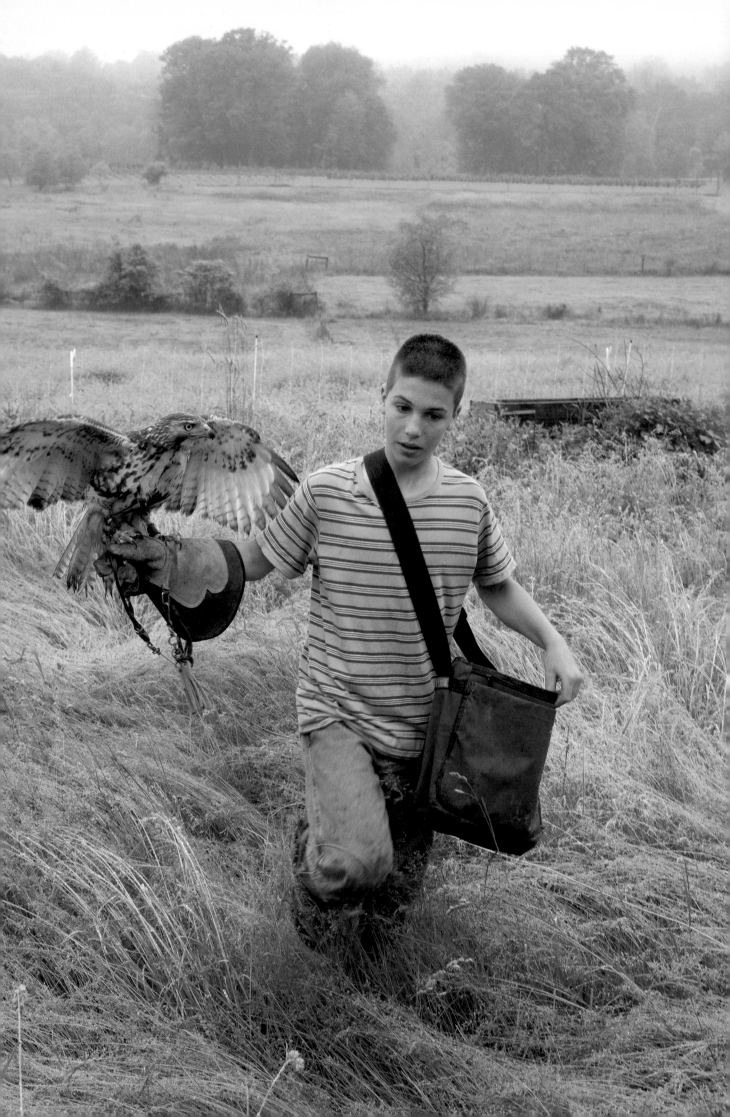

Born in Nova Scotia to a single mother, Malcolm was adopted by Steve and Edie Johnson, a white couple who joined the Bruderhof when he was five. As a teen, he left home in Connecticut and moved in with friends of the community in the Deep South. He spent the next several years there, going to school and figuring out who he was and where he belonged. "I'd always thought of myself as black, of course, but now people were telling me, 'You talk white.' Those were important years, connecting with my roots as a black person, and formulating my own thoughts on what I wanted to do with my life."

MALCOLM JOHNSON

1975–

After high school, Malcolm returned to the Bruderhof and is now a pastor. Today, he and his wife, Michelle, and their four children live in a community house in Kingston, New York. Now he finds himself helping his children navigate questions of identity:

Who you are matters. If you're not free to be yourself, you're not a complete individual. You have to be true to who God made you, and everybody was made different. People who check their heritage at the door and try to be like everyone else around them are doing themselves and the others a disservice. That's why I tell my kids, "Be proud of who you are — that your father is black, and your mother white."

If you use your freedom selfishly, you will destroy community. Martin Luther King Jr. didn't just talk about all men being equal, but about them becoming brothers. I think community is one of the best ways to work toward that.

<<
Coached by his teacher, a young falconer learns to master himself — and his hawk.

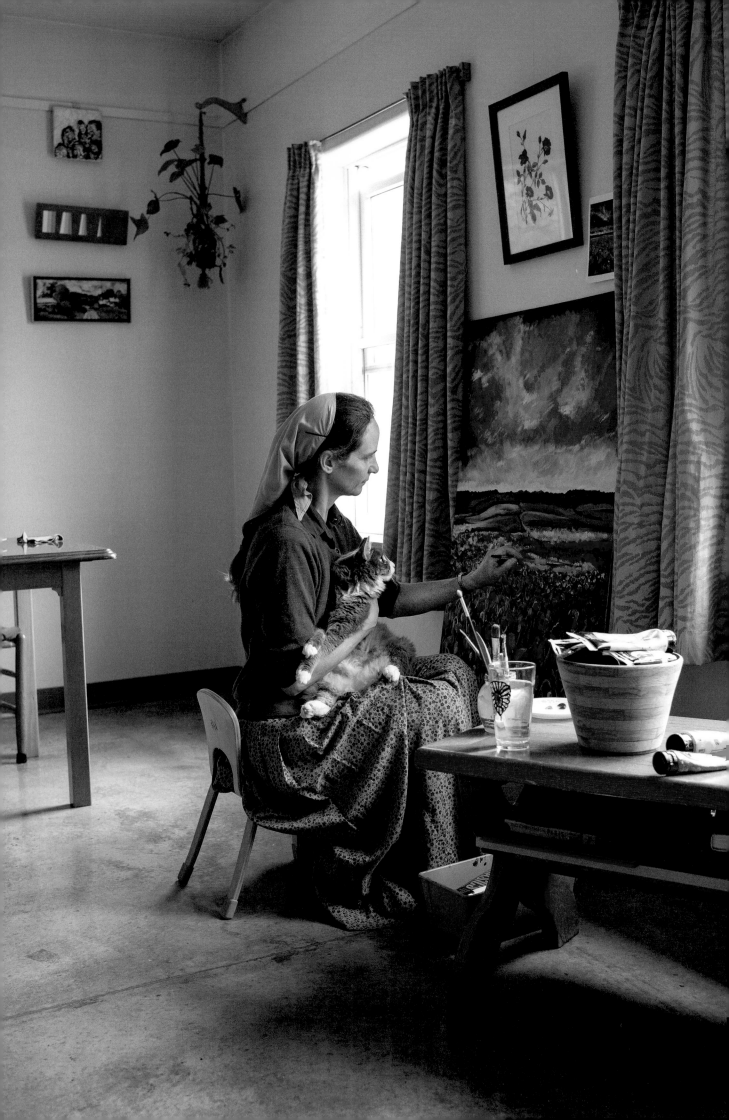

<<
Jenny, Phillip's wife,
finishes a painting
at home with their
cat, Cassius.

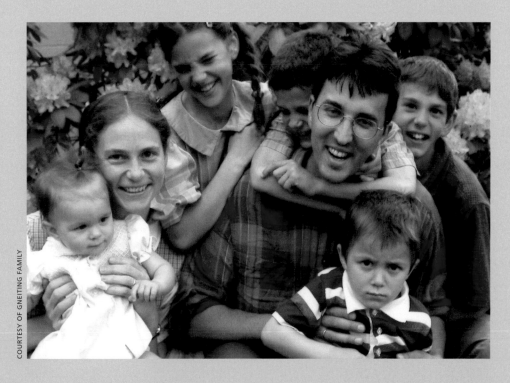

COURTESY OF GNEITING FAMILY

PHILLIP GNEITING

1967–

Artist, violinist, teacher, and father of six, Phillip lives with his wife, Jenny (also an artist, and a violist and nurse), at Fox Hill Bruderhof in New York. Over the years he's given plenty of thought to the unspoken drift in any organization toward conformity, to the place of the individual in relation to the community as a collective whole, and to the way that creative expression helps to counter this drift.

In living a busy communal life, it's important for me to know that there's a space I can enter and say, "This is my place, my time," and get my paints out. I love to use recycled materials: wood, cardboard, old paints, whatever. My supplies don't cost anything, so there are no limitations there. I don't paint to make other people happy, and most of what I do is probably not very good, but I find the process very engaging.

My first commitment is to using my energies and resources for others. But painting allows me to step out of my routine now and then and just be absorbed in something else. I am not selling anything or making a statement, and I can't guarantee that others are going to understand why it excites me. But that doesn't matter: it's important to be at peace with who you are.

Some of us are naturally inclined to see the world in black and white. If you ask me, life has a lot more grey areas. Those are the ones I'm most concerned about. I see my art as part of my struggle to understand life — as a search for beauty, or balance, or harmony, or whatever. Actually, I'm not necessarily looking for harmony, because dissonance is part of beauty, and the shadows are part of it all too.

159

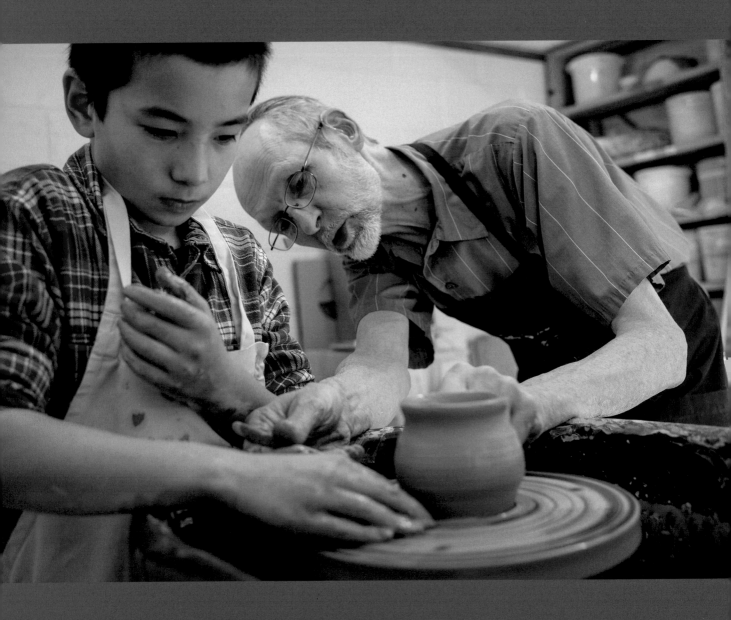

AUTUMN 1942

So we forsook our life that we might live,
Gave up all gifts, to have true gifts to give.
Spent our young lives to find the heart of youth,
Left earthly wisdom that we might know truth –

O God of life, who by a death unlocks
One truth entire from human paradox,
Through love's diversity, so make us one
To love all men in loving Thee alone.

Eileen Robertshaw
teacher and Bruderhof member
1920–2011

∧
Leonard passes on
pottery skills to his
grandson.

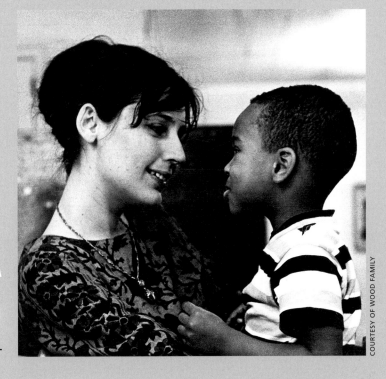

GIOVANNA WOOD

1942–

"Gio" grew up on the Bruderhof, but in her early twenties, she struck out on her own, determined to reinvent herself. By the late 1960s she was running a daycare in an inner-city slum, and intent on building a new society, free of oppression.

It wasn't long before she found what she thought she was looking for: Sun Myung Moon's Unification Church, a Korean cult that attracted thousands of young Americans in the late 1960s and early 1970s. She moved into a house with other members and quickly became a zealous recruiter for the group.

Over time, however, life among the "Moonies" began to lose its luster: "I saw brainwashing, corruption, the abuse of power." On a visit home to say goodbye to her dying father, the scales fell from her eyes: "Suddenly I knew that Jesus was the only way for me, and the truth; that I was living a lie; and that my bondage to Moon was nothing but darkness."

Soon Gio and a circle of similarly disaffected house-mates, all members of the cult, were reading the Gospels together. By the mid-1970s, nine of them had left the Moonies and come to the Bruderhof. Extricating themselves cost a legal battle. For Gio, it ultimately

meant a separation from her husband, Allen, a fellow Moonie. Shortly after their daughter was born, he chose a different path, while she decided to follow her calling with the community.

A teacher at the Bruderhof ever since her return, Gio recently retired from the classroom. But she still loves young people. Sometimes she will warn them against confusing freedom with rebellion: "I thought freedom meant setting aside old values, deciding for myself what was right and wrong, and using my own potential to make a difference in the world. Then I found Jesus. His teachings are not narrow, but based on love, and that love alone is freedom. That love and freedom is what I found here, and what I have come to embrace."

In 2018, in a remarkable turn of events, Allen, who also left the Moonies in the 1970s and spent years raising cult awareness and working with ex-members of cults, returned to her. In June 2019, after forty years of separation, their marriage was restored at a festive ceremony of reconciliation at the Mount, a Bruderhof north of New York City where they now live near their daughter, Serena, her husband, and their five children.

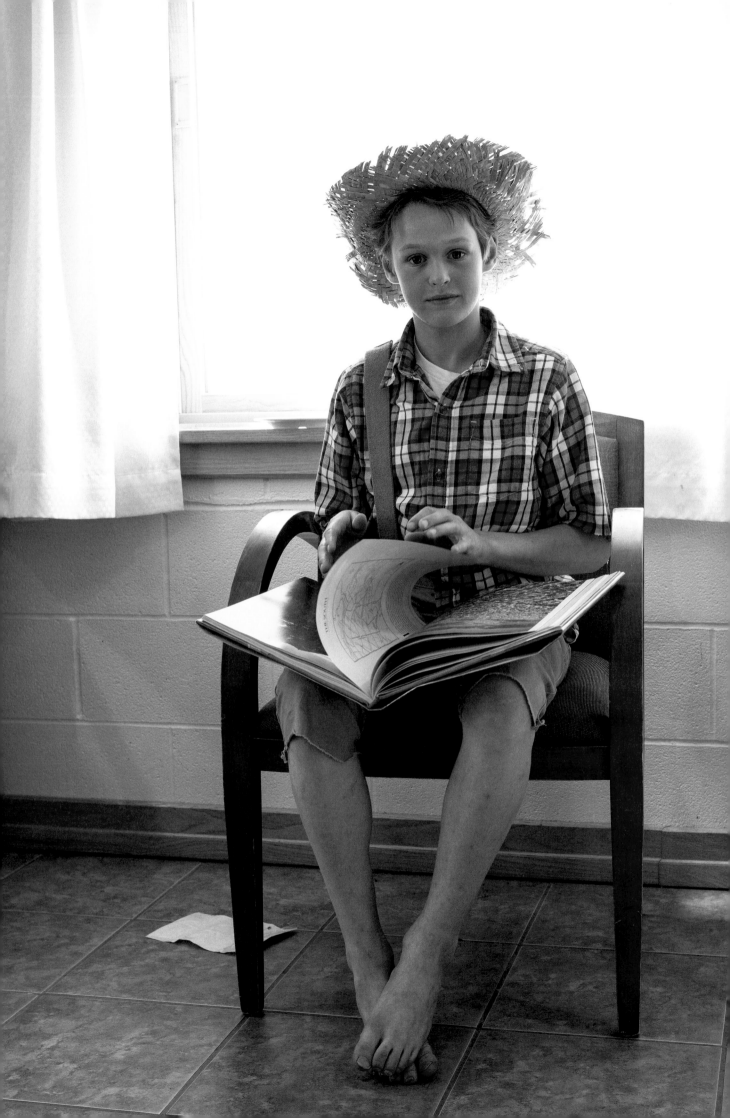

LARRY
MASON
1943–2014

A foster child who didn't belong until he found a home in community

<<
"Huck Finn" in the school play waits backstage for his cue.

Growing up on the streets of New York City, with an alcoholic mother and a father he only met once, Larry embarked on a life of crime by stealing milk and pastries. He cycled in and out of reform schools, where he was subjected to physical and sexual abuse. As a teenager, he began committing more serious crimes. "You name it, I've done it." At seventeen, he fathered a child. Marriage followed, and a second child, but the marriage didn't last. "I was no angel."

In 1967, at twenty-four, Larry was drafted, and the US Army defined the next six years of his life. He spent three of them in Vietnam, on the front lines of the war. "I killed, and saw people killed." Remembering a friend who died in combat, he said, "All that was left to send home was his boots."

When the war was over, Larry found himself a stranger in his own country. Honorably discharged but declared "mentally unfit for assimilation," Larry had no real home to go to. Nor did "normal" society

> "I still suffer the effects of PTSD and my exposure to Agent Orange in Vietnam. But God has given me real freedom from isolation and the bondage of evil and despair."

>>
Mike brings groceries
into The Bowery
Mission. He is one of
many young people
from the Bruderhof
who have worked here
over several decades.

hold any attractions for him. He told a group of young people:

When I came back to the USA and I got to the airport, there was no appreciation for what I'd done. Not that I was in favor of the war. Most of the guys over there were actually against it – we felt we were just fighting somebody else's civil war. But still: I was called a baby killer, and one guy actually spat at me. So I did what I knew best: I set up camp on Staten Island with a bunch of other vets, just like in Vietnam. No one went anywhere without a weapon. Meanwhile, I survived as a dealer until I was arrested in 1977 for robbery and attempted murder. I spent the next several years upstate, in prison, including Attica.

After being released in 1981, Larry soon found himself right back where he had left off:

I was a good narcotics salesman: I had connections from New York to Singapore. But I soon became my own best customer. At one point I was doing enough drugs to kill a bull elephant. I knew it was only a matter of time before I was dead, and often felt like blowing my head off, but I knew that a true soldier dies with his boots on and never by his own hand.

One day, in desperation, I went to my parole officer, laid the pistol I was carrying on his desk,

and begged him to lock me up again. By law, he should have. Instead, he directed me to The Bowery Mission, a Bible-based program on the Lower East Side of Manhattan that helps the homeless and addicts. I was skeptical at first but then decided to give it a chance.

He gave me money for a taxi downtown, and I promptly used it to buy a bottle of wine. But then I began walking. On the way down Fifth Avenue, I stopped at a small church. I don't know why. But sitting in that chapel I was suddenly overcome and wept tears of pain and remorse – for the first time since I was a child.

I had never been religious, but I had always believed in God and Jesus and this guy called the Holy Ghost. So I just started talking to God. I said, "Look, I'll tell you what: I've made a lot of deals with the devil. I've danced with the devil and never came out a winner. But if you can take my life and do something with it, I'll give you what's left."

As I left the building, I felt something, like a weight had been taken off me. I couldn't put my finger on it. But the sun was brighter, the air clear.

Larry stayed seven years at The Bowery Mission and became a pillar of its ministry to the poor. While

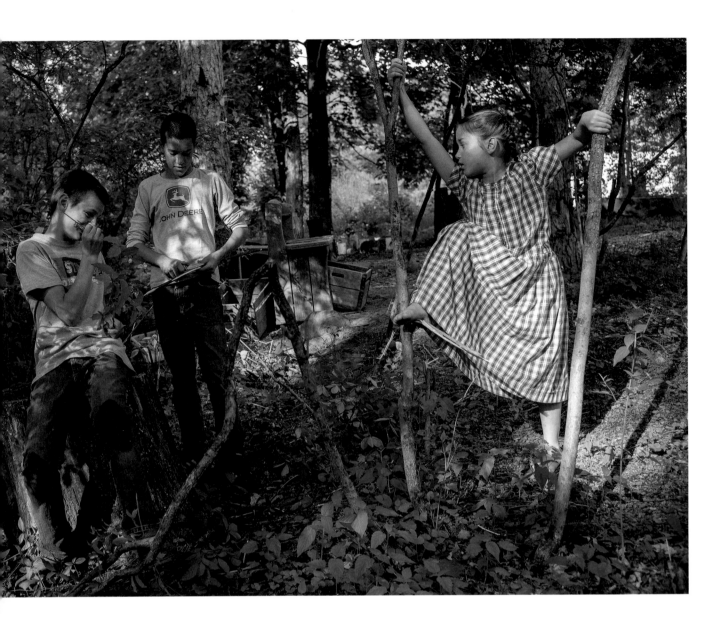

there, he also learned about the Bruderhof, which
he joined in 1991. Tragically, his old demons – flash-
backs, nightmares, and addictive behavior – kept him
from finding the new life he was after. He left a few
years later.

**Then, in December 2001, I got a Christmas card
from Carolyn, an old friend at the Bruderhof,
inviting me back, and I said to myself and my
cat, "Indiana, we're going home."**

**I had been reading in the Bible again, and
thinking about James 5, which talks about the
church using the "laying on of hands" in order
to free someone from demons and sickness. On
returning to the community, I asked for this, and
it was granted. I still suffer the effects of PTSD
and my exposure to Agent Orange in Vietnam.
But God has given me real freedom from isola-
tion and the bondage of evil and despair.**

Larry lived at Woodcrest, a Bruderhof in upstate New
York, for the next thirteen years, until his death from

cancer. Jason Landsel, a younger friend who counted
him as a mentor, recalls: "Larry was a hard worker
in our factory and loved assembling equipment for
people with disabilities. He was also active in our
church, assisting at baptisms and weddings. He was
known for his free-spirited renditions of 'Amazing
Grace' and for showing up in war paint and a kilt.
Off-hours, he mentored teens and young men, and
involved them in efforts like a yearlong project to
renovate an abandoned chapel. Along the way he
gave them lessons in work ethics, survival skills,
and – most importantly to him – Bible study."

Talking to youth groups about his years in Vietnam
and about his own personal war, Larry was always
brutally honest. But he was never sorry for himself.
Noting that there was never a victory that wasn't
preceded by a fight, he liked to quote the old army
slogan, "Freedom has a taste the protected shall
never know." ♦

When Japan bombed Pearl Harbor in December 1941, Bob Greenwood, a young Wisconsin native, was eager to join the army as soon as possible. Responding to President Roosevelt's call to defend humanity's "four essential freedoms" – freedom of speech and worship, and freedom from want and fear – he soon found himself on a ship to France.

BOB GREENWOOD

1921–2016

As a young officer he was disillusioned by military corruption, and after coming home, he found the same corruption in the corporate world of America's burgeoning postwar economy. He and his wife, Kathy, discovered the Bruderhof through friends and joined in 1955. Their marriage went through hard times, but they were supported by and faithful to the church in their search to find the inner freedom that only forgiveness can bring. During the celebration for their sixty-first wedding anniversary, Bob said:

We've had many times of trying to learn to live together in peace and harmony, just between the two of us. And we found the only way we could do it was through forgiveness. Without forgiving each other we never could have lasted together. You can't file away each little hurt or slight and then pull it out again the next time you have trouble. If we did that we'd soon be buried in troubles.

That was only possible with the help of brothers and sisters and the church. Without the help of brothers and sisters, and above all the help of God, we would not be here to share this joy and love tonight. What we gave up counts as nothing to what God has given us.

MICHELLE HINKEY

1994–

Michelle Hinkey, currently studying physical therapy at Duke University School of Medicine, has thought a lot about the circumstances and decisions that have brought her to where she is now:

I have been fortunate in many ways—I was born into a loving family and grew up knowing I had the support of my parents, my grandparents, and my community. I loved school and enjoyed a great high school education in Tannersville, New York, and undergraduate studies at CUNY City College. But I value my out-of-the-classroom experiences even more: I was surrounded by amazing people who taught me important lessons and skills which I would not have learned otherwise. I count the gap year I spent caring for my grandmother and working in the Rifton Equipment factory and community kitchen, as well as the time I spent as a companion for a young woman with cerebral palsy, among the many experiences that have shaped me and taught me the importance of service.

While I recognize that I am here at Duke partly because of my own hard work and determination, I know that without all those who have supported me along the way I would never have made it. So I'm inspired to give back to my community and to the world at large.

Gratitude is a good burden: it grounds me and points me in the direction of giving. My grandfather, who joined the Bruderhof in the 1950s, used to talk about *la dette* (French for "the debt"). This was the indebtedness he felt for having found faith and a way to live it out in brotherhood. I have the same debt: it will never be paid in full, but I can work towards paying it through loving service to others. I am determined to do my best as a student, and I am committed to caring for my brothers and sisters in the community.

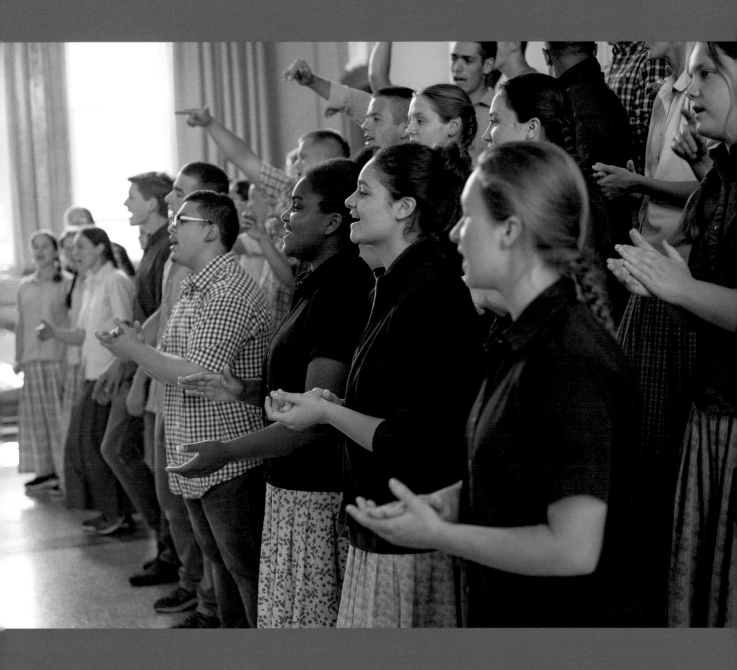

And when I have spent my selfe to the last farthing, my lungs to the last breath, my wit to the last Metaphore, my tongue to the last syllable, I have not paid a farthing of my debt to God.

John Donne, poet and priest
1572–1631

^
The last practice,
and the choir director
is asking for more
power

>>
Next spread:
Three generations
of Clements spend a
Saturday evening in
Grandpa Tony's and
Grandma Jenny's
campsite.

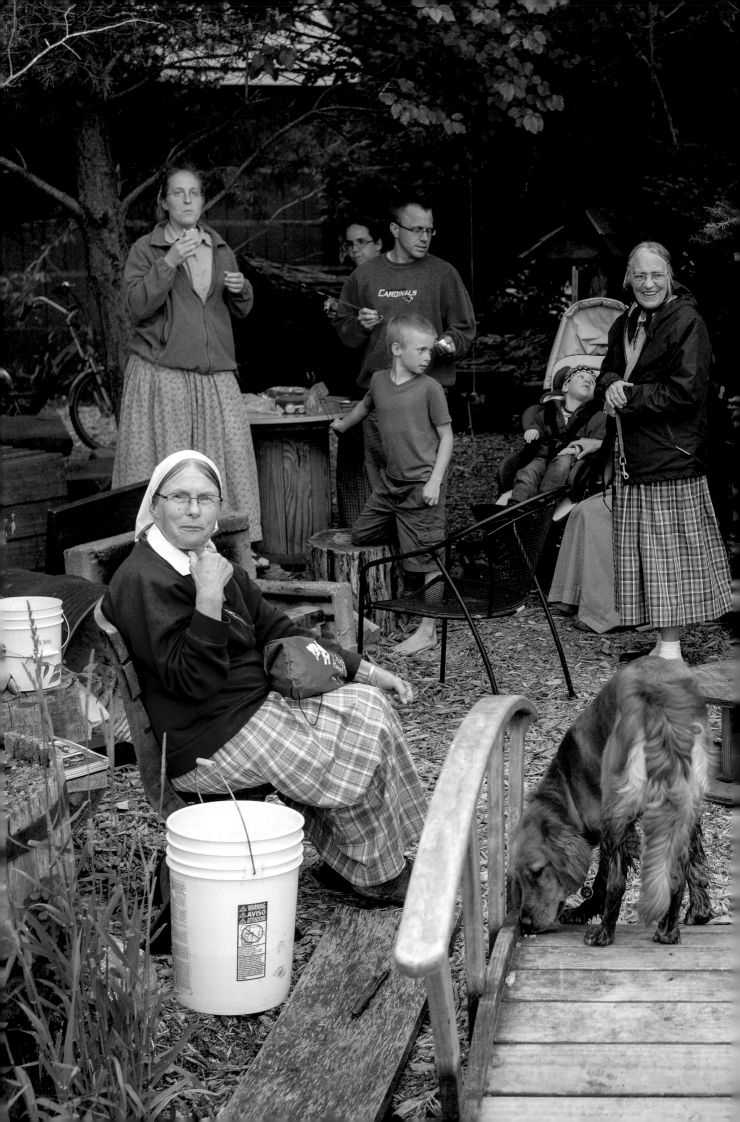

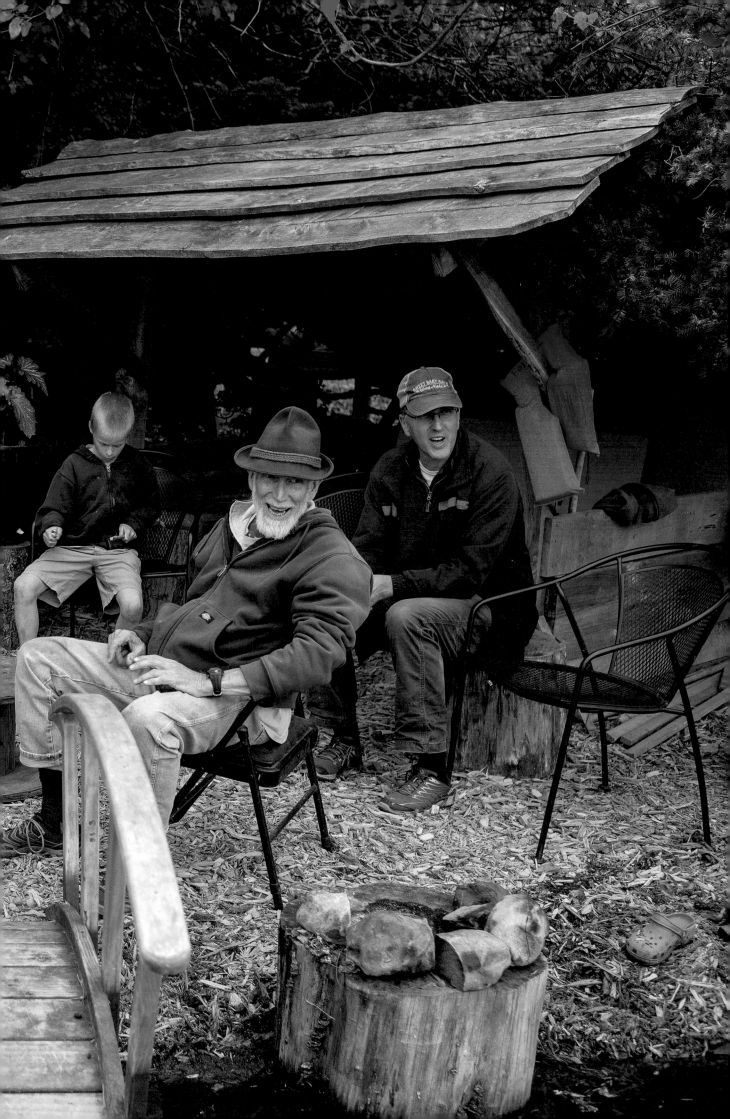

A poet, short story writer, playwright, teacher, and mother of seven, Jane's search for a genuine and uncompromised faith eventually brought her and her husband, Bob, to the Bruderhof. (The book *The Heart's Necessities* tells her story more fully.) This poem, written in 1938 when she was a college student at Smith, expresses the philosophy that stayed constant throughout her life.

JANE TYSON CLEMENT

1917–2000

FAITH

You who have watched the wings of darkness lifting
and heard the misted whisper of the sea,
shelter your heart with patience now, with patience,
and keep it free.

Let not the voiced destruction and the tumult
urge to a lesser prize your turning mind;
keep faith with beauty now, and in the ending
stars you may find.

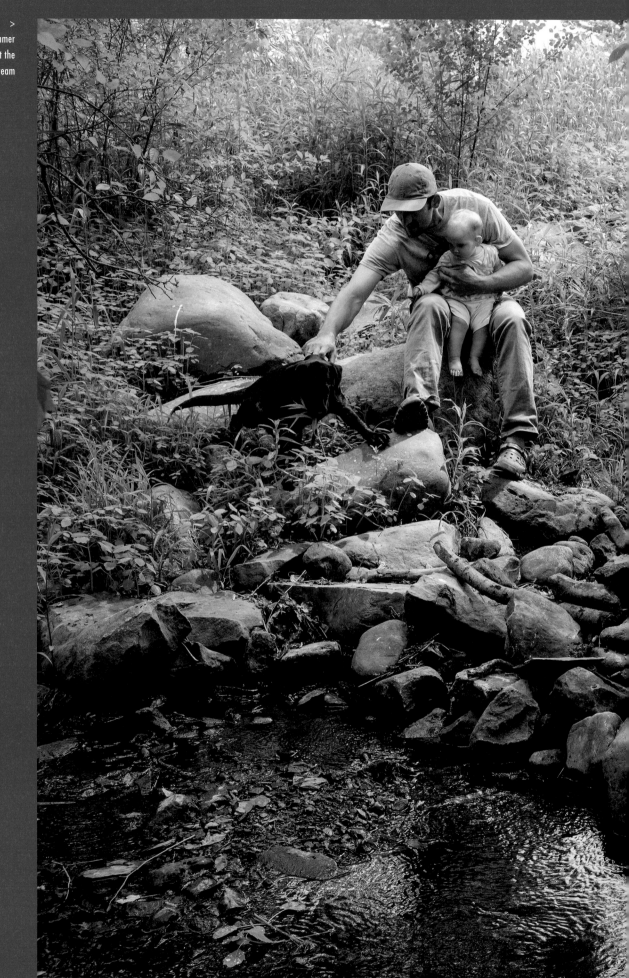

CHILDREN AND EDUCATION

When a child walks down the road,
a company of angels goes before
him proclaiming, "Make way for
the image of the Holy One."

Hasidic saying

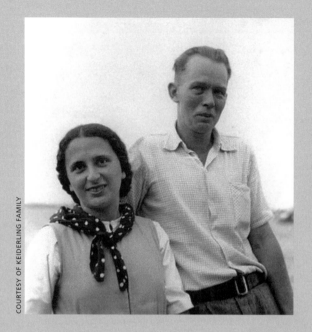
COURTESY OF KEIDERLING FAMILY

LOTTE KEIDERLING

1931–

Pastries in her father's bakery. Chestnut trees in bloom. Passover at the synagogue. The Ferris wheel in the Prater amusement park. Lotte's memories of Vienna are still vivid after eighty years, but not all of them are so happy.

It was March 1938 at the Hofburg; a man was screaming from a balcony. Suddenly Mama was pulling me from the crowd: "That's Hitler. He hates us." Another time a child ran after me, yelling, "It's a Jew!" Soon worse things were happening, like the looting of Jewish businesses.

In June 1939, Lotte found herself on a train, heading toward London. One of thousands of Jewish minors whisked out of reach of the Nazis by the Kindertransport, she was assigned to the Bruderhof, which had volunteered to take in four children.

On arriving, she stared: "All these women in kerchiefs and long dresses. I thought I'd landed on a different planet." And yet she was accepted with open arms and included in everything, as if she was one of the community's own children. Best of all, no one seemed to mind or

even know that she was a Jew. Soon she was thriving in what she called "the atmosphere of love."

After the war's end, Lotte, who was living at a Bruderhof in South America, received news that her mother had been killed in a Polish ghetto. Her father survived the concentration camps and emigrated to New York. Tragically, he died before she was able to reunite with him.

In 1950, when I was nineteen, a young man on the community fell in love with me. He was a German, but he didn't worry or care that I was Jewish. He just loved me and I fell in love with him. We got married in 1952 and, guess what, we had thirteen kids. And I said, "I gave Hitler a kick in the pants!"

In 2018, at the age of eighty-seven, Lotte finally returned to Vienna and the Ferris wheel of her childhood. Back then, her father had always said she was too little to ride. "Not today, Lottchen. But one day, I promise I'll take you." This time, the operator, who had been given a heads-up, called her to the front of the line. In minutes, the entire city was stretching out before her feet.

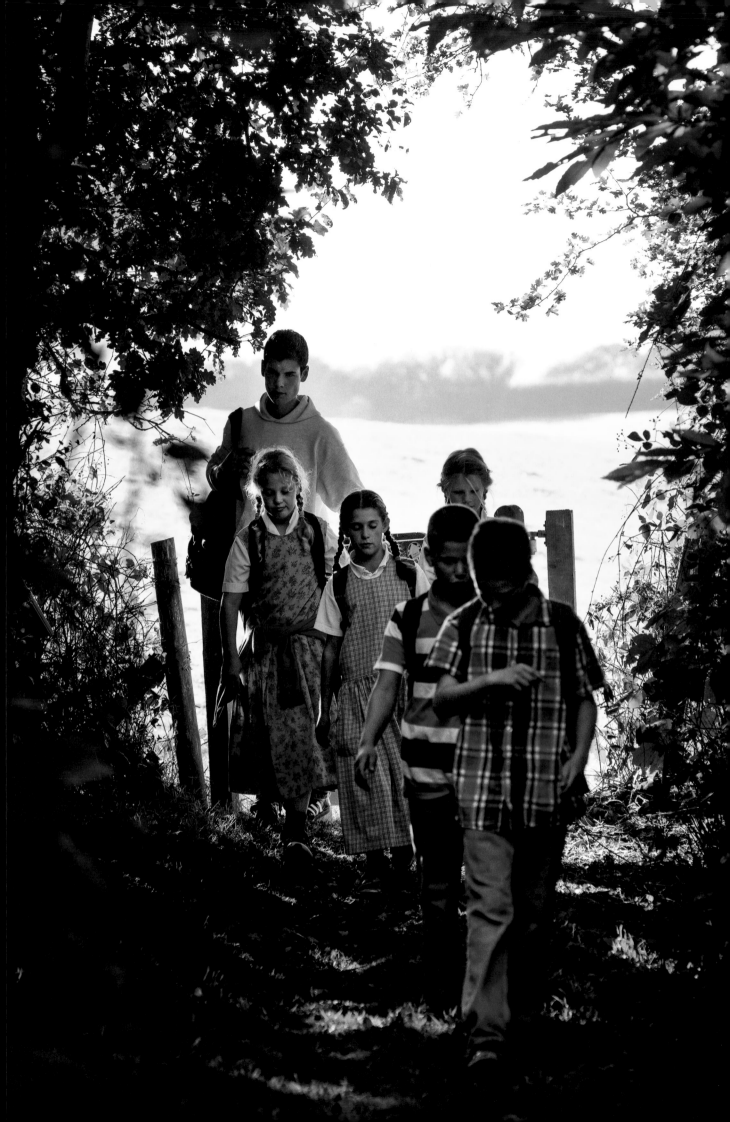

<< Homeward bound – conquering an all-day hike through the Sussex countryside

A big-hearted woman who never gave up on her childhood dreams of reaching out to children in need

ELSE ARNOLD
1973–

Else has worked with children and teens in London, Manhattan, South Africa, Nigeria, and Northern Ireland, as well as in Bruderhof schools in rural England, Pennsylvania, and upstate New York. Since 2007, she has taught at Keilhau, a progressive independent school in Germany.

Her interest was kindled at the age of eight, when a teacher showed her class photographs of starving Sudanese children:

Sudan was in the middle of a civil war, and there was no way of getting food convoys to these children. They had distended bellies because of malnutrition. I remember sitting there as a child and saying, "I'm going to do something about this." Those pictures made me determined to help other children, come what may: to save children dying because of injustice, greed, or war, or simply because no one loved them. As I grew older, I knew I wanted to follow Jesus, and that had to mean giving water to the thirsty and food to the hungry.

I finished high school a year early, landed a place at the university where I planned to study teaching, informed them that I was taking a gap year, and flew to South Africa to help in a kindergarten run by an acquaintance of my father's. I worked in an impoverished black township in the Kalahari Desert for the next nine months, caring for street urchins whose parents were at work all day – children as young as one and a half.

I remember visiting the family of one of the children we had in the kindergarten and they slaughtered the only hen for me. I felt terrible. I wanted to feed them, and they were feeding me. But I had to accept it because it was done with such love. I didn't need a chicken. It was almost a slap in my face: "Am I the answer to the need of the world? Who actually is putting food on the table?"

After violence erupted in South Africa I found myself in Nigeria, where the Bruderhof had

179

^
Every morning the
school principal
stands at the entry
to welcome each
child to school.

>>
A moment of
contemplation at
the fishing pond

a presence for some years. This time, money was available to feed and to give clothes to the children. But I never had the feeling that I was doing more than running crazily around trying to fill bowls that were always empty and give what was never, ever, enough – because, the fact is, we all are greedy and we actually all want more than our share. In a way, that bashed my trust in human nature. I left Nigeria discouraged, disheartened, and disillusioned, and wondering about who the poor really were.

Else returned to England and from 1992 to 1996 studied teaching at London's Roehampton Institute. During rotations at schools in some of the city's poorest neighborhoods, she found her idealism bumping against circumstances she couldn't escape or change. Despite her best efforts, she often saw only limited success, or none at all.

I always looked for schools on the Ministry of Education's "red list" – schools the government had condemned, pending a deadline for improvement – and chose them: I worked in Brixton, which was known for the Mafia's presence there, and Southwark and Bermondsey, which had huge numbers of desperately poor migrant families. Those children were trapped between terrible histories and bleak futures; they were doomed to fail before they ever started school. I was determined to do whatever I could to improve their lives.

In Brixton, Else was assigned a class of thirty-three children, all from troubled backgrounds.

One of them was a Sudanese boy whose mother had been killed in the civil war, and whose father had fled with him to London and remarried. This little boy's stepmother hated him, and locked him in his room every afternoon when he got home. He was being fed through the cat flap. The poor child was unkempt, and he smelled. To me, it was clear: he was the child I had dedicated my life to when I was eight.

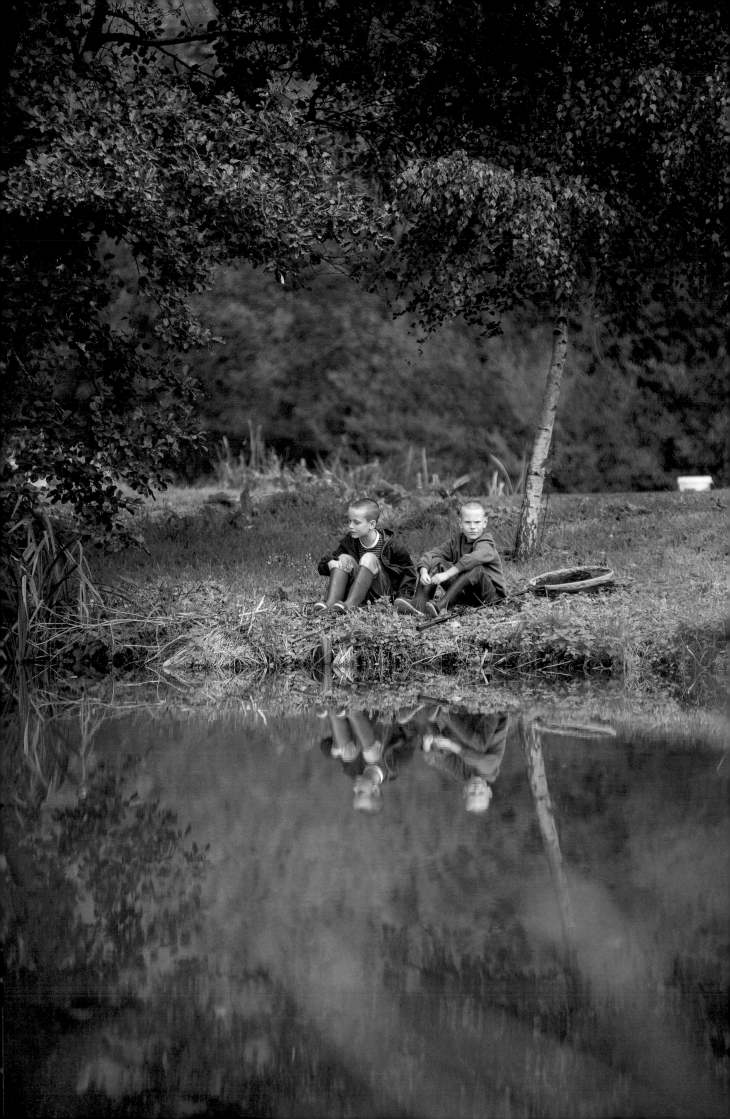

And yet, Else was unable to save him. On the
contrary, she was eventually forced to report him to
the authorities after a violent incident in which he
tried to stab a classmate with a knife – and ended up
cutting her when she intervened.

**That was the beginning, the very, very begin-
ning of a long, long walk. I returned to the
Bruderhof. I had to do something for the entire
world, and this was the only way I could do it.**

**I loved my work in the Bruderhof schools. I felt I
was doing something. It fulfilled the need in me
to feel like I was doing something for children,
for the future, for building up something posi-
tive that would help society at large.**

However, Else's road continued to be rocky. "I was a
popular, capable teacher with big classes," she says.
"What was missing was the knowledge which I'd
once had, and which I'd lost, that it's not me who
saves the world, it's Jesus."

She took a sabbatical, working with migrants in
Syracuse, New York, and digging deep in the Bible in
her search for answers.

**The first thing I did was to get a brand new
Bible. I said, "I'm starting new. I'm starting my
search from zero now." I went to my bedroom
and started reading it from page zero on. Of
course when you read straight through the Old
Testament, you're like, "Gosh, is there enlight-
enment here?" It can be pretty hefty.**

**Then at one point it came to me that every few
pages I was hearing the same message over, and
over, and over again, and that message was,
"And then they shall know that I am their Lord
and God." Suddenly the whole Old Testament
took on a whole new meaning. The whole New
Testament took on a whole new meaning: "And
then they shall know that I am their Lord, their
God." That was spoken to the whole earth, to
all the poorest, to all the hungriest, to all the**
**thirstiest, to all the neediest, to those who
could get their act right, to those who couldn't
get their act right. That was all that God want-
ed, that we would know that he was our Lord
and God.**

**It suddenly struck me that for all these years I'd
run. I'd run from truly giving everything to God
because I'd been proud, because I wanted to run
my own thing, because I hadn't recognized God
as Lord. I had been recognizing Else Arnold as
some kind of saving force, over and over again.**

Since 2007, the Bruderhof has asked Else to work at
Keilhau in Germany, the school previously owned by
Annemarie Wächter Arnold's family (see p. 141).

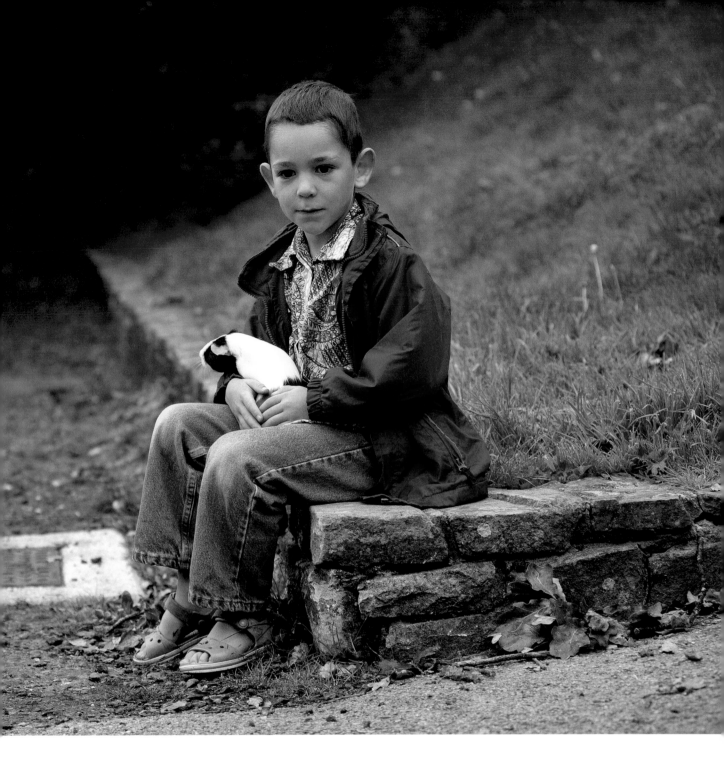

Keilhau is a 200-year-old integrated boarding and day school for students from the first through the tenth grades begun by Friedrich Froebel, the founder of the kindergarten movement. Else notes that his ideas about teaching form the cornerstone of Bruderhof education too:

Froebel believed that the purpose of education was all about the development of the whole child, to bring a child to unity with nature, unity with himself, unity with his fellow man and unity with God. He felt that the best setting in which to raise a child was a cohesive, communal one – a school where teachers work together in relation to the children in their care. One of his mottos was "Live for the children!"

In practical terms, Keilhau – much like a Bruderhof school – has an afternoon program, which includes everything from camp crafts to activities like trail maintenance in the woods surrounding the school, swimming in the school pond, learning to repair bicycles, and going on cycling excursions. In the younger grades, students are also given time each day for free, unstructured play.

If you send your child here, you're not doing it because you hope to ensure a place for them at some elite university. On the contrary, you're voting against that sort of education. You're making a decision in defense of childhood.

Next spread:
As Christmas approaches,
excitement builds as
students and teachers
take a day off to
make ornaments and
decorate the school.

Reverence for childhood is at the heart of Froebel's approach to education. He compared children to flowers. Every flower has the same basic needs: soil to grow in, and sun and rain. But beyond that, there are differences that must be taken into account, if each one is to thrive and bloom. What kind of soil? How much sun, or rain?

Speaking of Froebel's image of children as flowers, one of his last instructions, as he lay dying, was, "Look after my weeds, too." Keilhau does have weeds. As an integrated school, it has children of all backgrounds and abilities (or disabilities!), including high-achieving students from "good" homes and children from thoroughly dysfunctional situations who have suffered severe neglect and abuse. We have the whole range.

But if you take his instruction about "weeds" in the context of the theories and methods he dedicated his life to, it's obvious that he doesn't actually consider them as such. He called them that to draw attention to their hidden beauty – to help us see that a stray plant can have a precious flower too.

Else often wonders how children who spend much of their childhood between appointments with mental health professionals, social workers, and family counsellors can be expected to focus on academic work, let alone excel at it.

I often feel quite helpless when facing such children in my classroom. They're known as *verhaltensauffällige Kinder* in Germany – literally, kids whose behavior makes them noticeable, in a negative way, of course. All too often, they've been treated, for as long as they can remember, as a problem, a quandary, a source of frustration.

Given what some of them have experienced, it's hardly surprising. You can't easily heal the injuries that have been done to their souls. And yet, sometimes it is the most deeply wounded ones who are the most loving and grateful and, in a way, the most childlike. Maybe it's because they're so hungry for something else.

When children carry a wound openly, you can help them and interact with them, and very often, their peers will too. I'm always amazed by the community I sense here among children who are openly broken. They might not always get along, but they understand each other deeply and look out for one another.

On the other hand, I have students who are always in line. Good, quiet kids who seem to be doing fine, and might really be. Regardless of where I've taught, those are the ones I tend to worry about most. They're the ones who the other kids can't relate to. And nor can I, because they never give me a handle – a way to catch their heart. At the end of each school year, at graduation, there's always a handful of teens where I have to say, "There's a student I never reached." I may have said "Good morning" a thousand times, but beyond that, I find myself wondering, "Did you ever progress to talking with them about something that really mattered?"

Again, it comes down to love. If you love someone, you allow them to blossom. You unleash a positive force in that person, something that affirms life and then spreads and gives life to others. I think – this is true of me, and probably of most adults – that we're much too sparing with our love. ◆

LAURA JOHNSON

1974–

Laura, one of several Bruderhof members who support humanitarian aid initiatives around the world, moved to the Middle East in 2014. First stationed in Bethlehem, she now lives in Jordan, in a city where 60 percent of the population are refugees. Aside from distributing food, diapers, and other necessities, she volunteers as a translator for other foreign aid workers. But it's the children who are closest to her heart.

I have about ninety-five children between nine and fourteen in my care. I teach music on the side, but my main subject is English. Without that you can't get anywhere, career-wise, in Jordan.

I'd say that all of my children are traumatized, though most don't talk about it. But since most are refugees from Syria, you can imagine what they've been through. Some have had to learn that a classroom can be a place of safety, not terror. One girl whose school was stormed by soldiers couldn't function for two whole years. Now she's doing much better academically.

Reflecting on her work with children who have been exposed to so much violence, in terms of helping them overcome their trauma and giving them confidence and resilience for the future, Laura quotes the Russian novelist Dostoyevsky:

He says that "there is nothing higher and stronger and more wholesome and good for life in the future than some good memory, especially a memory of childhood, of home. . . . If a man carries many such memories with him into life, he is safe to the end of his days, and if one has only one good memory left in one's heart, even that may sometime be the means of saving us."

That's why, apart from listening, I try to help them displace their bad memories by creating new and happy experiences. We do fun activities like games with water balloons and trips to the zoo. We make chocolate pudding. Slowly but surely, it seems that most are able to rebuild their capacity for trust. The fact that they are able do so continually gives me hope.

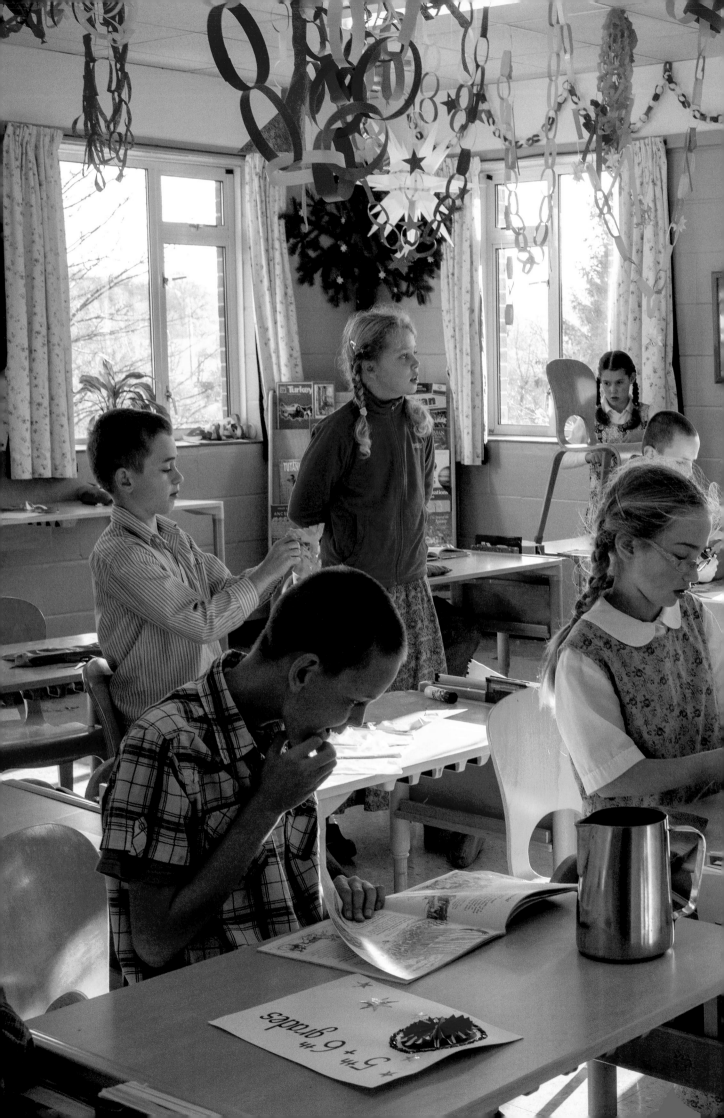

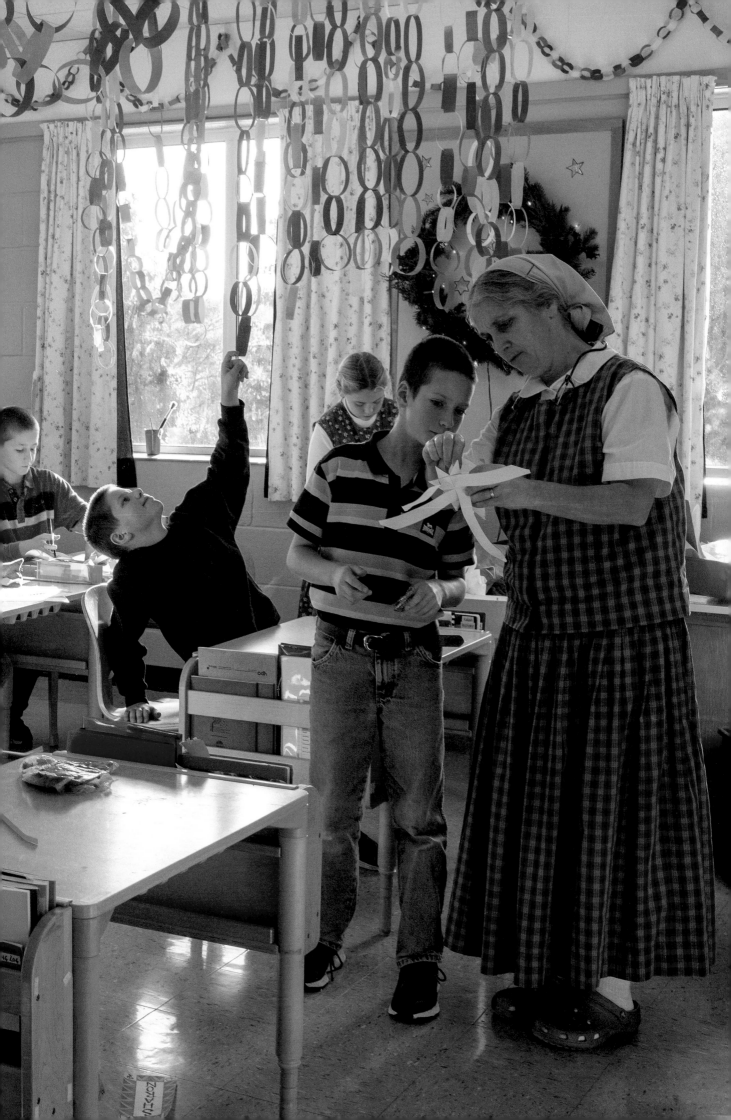

FRANCIS WARDLE

1947–

>>
Schoolchildren work
on their wilderness
survival skills.

Francis Wardle grew up on the Bruderhof and then left, as a young man, to pursue a career in education. He has a PhD in child development and early education from the University of Kansas, and has been a Head Start volunteer, education coordinator, director, and national reviewer. He has taught preschool, kindergarten, and first through fourth grades.

As I look back on my life, I realize how formative my childhood on the Bruderhof was, especially the hands-on skills I learned. My first woodwork lesson as a young boy is a vivid memory: our teacher, Owen, showed us how to make toast boards. Mine was not very square and the rounded corners looked odd. But I was hooked on woodwork!

As I grew up, I enjoyed other woodwork classes taught by different teachers. I also loved to wander into Harry's carpentry shop, smell the rich aroma of newly carved wood, and watch his gnarled hands magically transform a nondescript piece of wood.

Fast-forward to my career as an early childhood teacher and administrator: I discovered that my love of carpentry could be used to design and build playgrounds for young children. I built playgrounds for hospitals and a variety of early childhood programs in Kansas City, Missouri, as well as in three Colorado locations: Denver, Greeley, and Commerce City.

I also designed and built a playground for a créche (a nursery or childcare center) in the middle of Brazil! Was that an adventure! I couldn't speak Portuguese, I was not familiar with the metric measuring system, and the wood used for construction in Brazil is totally different from what I was used to. But eventually, with the help of local volunteers and funding from Partners of the Americas, we built a playground using ipe wood and eucalyptus posts, car tires, chain, sand, and slate (to retain the sand).

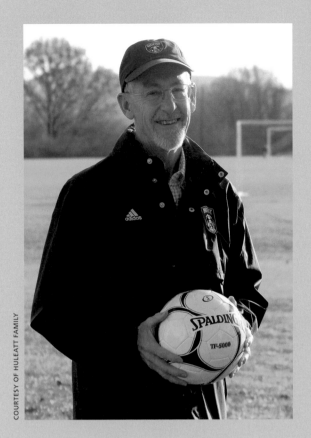

TOM HULEATT

1949–

Tom, who joined the Bruderhof in 1977 with his wife, Bonnie, is the head of the English department at The Mount Academy, a Bruderhof high school in upstate New York. But he's just as passionate about soccer as he is about literature. In fact, it runs in his blood. The eldest of four brothers, all captains of their college teams, he led the soccer team at Bowdoin, where he graduated in 1971, and now coaches at The Mount.

Musing on the way the world has changed over the years, Tom notes that the game itself, and the higher purpose of athletics, has not:

Joining a team is about learning respect, responsibility, self-discipline, and honesty. And not just agreeing that those things are important, but remembering them in the heat of the moment, and honoring them on the field.

When we made it to the state championship in our first season and lost, the press noted that our guys did not shed a tear. They held their heads high and celebrated that they'd still come in second. That attitude set the tone for our team: you don't have to be stars, you just need to do your best.

I'm also concerned about what happens off the field: how you're getting along at home with your parents, or in the classroom with your peers. In my own experience — I went through some rough times in college — your team will often hold you accountable.

Interestingly enough, sports is one of the things that eventually led me to this community. The idea of each one doing his part with a greater purpose in mind. The sense of camaraderie — the feeling of going through something together, good or bad. Whether you win or not, you stick together, because you're all part of the same team.

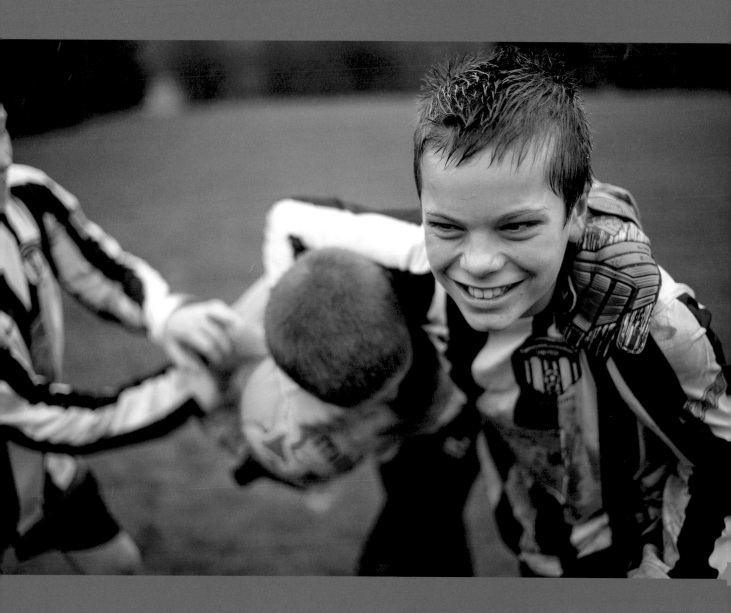

Toil together, fight, run, suffer, rest, and rise up together as God's stewards, companions of his table, and his servants! Let none of you desert the flag!

Ignatius, Bishop of Antioch
AD 35–108

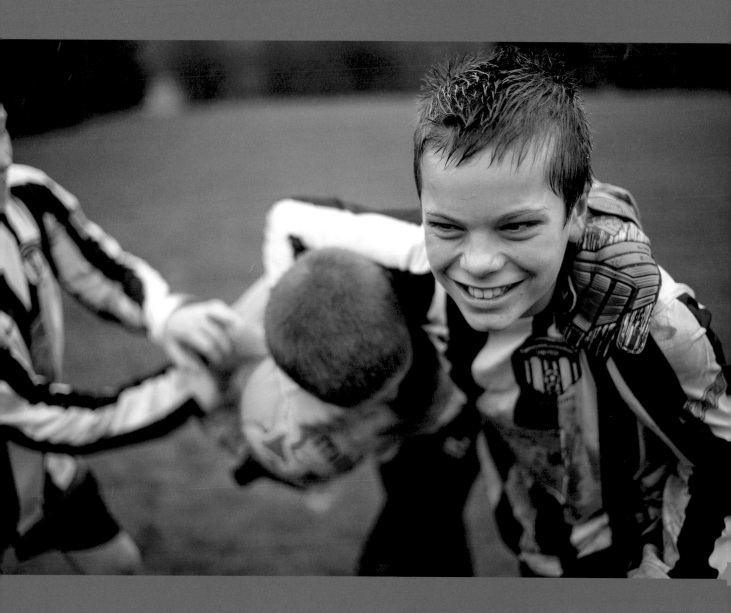

^
Afternoon soccer
practice with the
Robertsbridge
village team

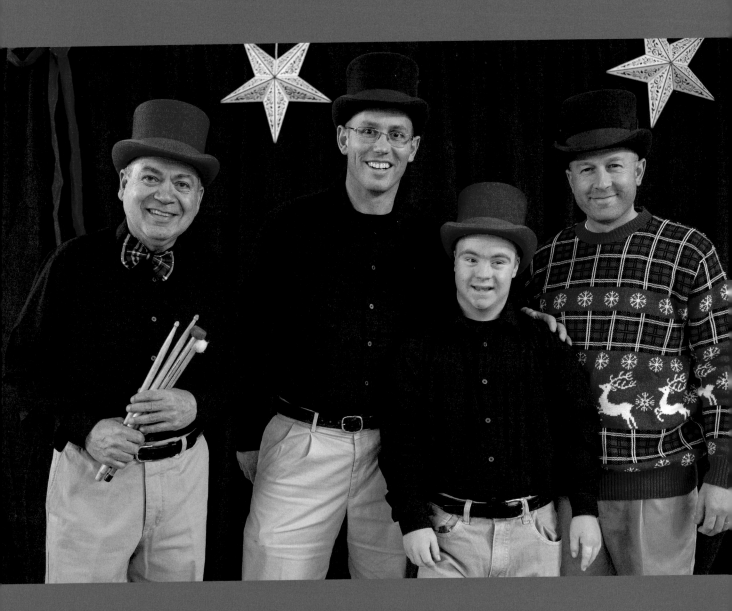

For it is good to be children sometimes, and never better than
at Christmas, when its mighty Founder was a child Himself.

Charles Dickens, novelist and social critic
1812–1870

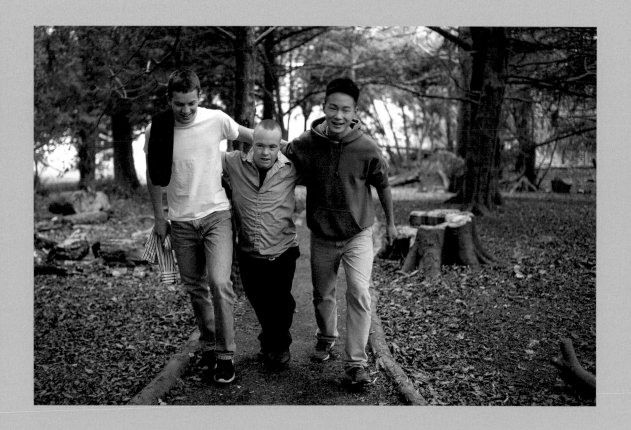

BEN BEN-ELIEZER

2002–

Ben, the youngest of six children born to Eldad and Edna, has Down syndrome. When he was born, his mother, who has worked with disabled children, welcomed the prospect of raising him. But she admits that "Ben's childhood was anything but easy. He was up every night, and had all sorts of food-related intolerances."

As members of the Bruderhof, however, Ben's parents were never on their own in caring for him and from early on, he was integrated with his peers. His father notes that "being included pushed Ben to succeed simply because he wanted to do what his classmates were doing. He had two therapists, and we visited them on occasion, but he always made the best progress when he was with his friends."

At school, Ben learned to read and write, to hold a bat and kick a ball, and even to swim. One year a teacher helped

him grow a prize-winning giant pumpkin. At thirteen, at his bar mitzvah — Ben's grandfather (see page 109) was Jewish, and the family has kept several traditions alive — he invited his entire class. After salmon, cake, a speech, and a Torah reading, Ben made a wish for world peace: "for all the bad guys to throw away their guns."

Seventeen years after his birth, Ben's parents are still in awe at the way he has enriched their lives. In Eldad's words, "I'm a doctor, and society highly regards the expert advice and care that is associated with this profession — yet so often one feels powerless to change lives. Ben will never achieve academic success or vocational qualification. And yet his special gift to reach peoples' hearts with his encouraging interest and genuine joy has impacted the lives of individuals far more than I ever will."

Working to avert violence, bullying, and suicide: the Breaking the Cycle program keeps this mom motivated.

HAVILAH KING

1978–

<<

Sergio broke free from a life of gang membership, violence, and drugs. Now, as a speaker for Breaking the Cycle, he inspires students to dare to make a change.

A mother of five who grew up on the Bruderhof, Havilah worked in customer service for eleven years before joining the staff of Breaking the Cycle.

Breaking the Cycle (BTC) is a program our community runs in public and private schools throughout the New York metropolitan area. We offer to host assemblies on nonviolent conflict resolution featuring various speakers who tell their stories and then moderate a Q and A. Each of them has overcome incredible tragedy and heartache through forgiveness.

Our main goal is to counteract youth violence, bullying, peer pressure, and racism, and to promote self-respect and respect for others. It's also about nurturing relationships between educators, parents, students, and the community at large. We always invite local dignitaries like mayors, judges, DAs, and law enforcement

officers to our events. They tend to be our biggest advocates.

Havilah has worked with BTC for eight years, but the program was born much earlier, with the 1997 publication of a book about forgiveness by Bruderhof author Johann Christoph Arnold. One of the stories Arnold featured was that of Steven McDonald, a NYPD detective who had been shot while on duty. Though the injury had left him paralyzed from the neck down, Steven had forgiven his assailant.

Christoph got to know Steven, and they began speaking at schools together. They started locally, but after the Columbine shooting in 1999, the program took off, with requests from New York City and across the region, and it's been going nonstop ever since. To date, we've done a total of almost nine hundred assemblies and given out over 350,000 copies of Arnold's book *Why Forgive?* from England

> "We'll never know how many lives we've changed or saved. But that doesn't matter. As a mother, I'm just grateful to be involved in some small way in something that can give young people hope."

and Northern Ireland to Israel and Rwanda. And all over the United States, of course. Mostly in the Northeast, but also in California, Florida, Virginia, and Indiana.

Along the way, other speakers have joined us, and their stories have become the centerpiece of our presentations. One is Hashim Garrett. He's an African American from Brooklyn, and a former gang member who turned his life around after almost losing it. Another is Sergio Argueta, a community activist on Long Island who is originally from El Salvador. Both men have lost friends and family members to violence and are committed to helping young people address their problems in a positive way, instead of trying to solve them with guns. Obviously, they connect well with urban

youth, since they both speak the language of the street.

Before she got involved with BTC, Havilah says she found its premises so obvious that they almost seemed simplistic. "On a theoretical level, I think most of us accept the idea of talking things through, rather than resorting to violence." But as she has seen since then, whether fielding the desperate requests of school administrators who contact her office and beg for an assembly, or sitting in a high school auditorium watching teens break down and cry, the reality is often very different. Forgiveness is a rare attitude, and needs to be championed and promoted. To quote Christoph Arnold, from a BTC event in 2003:

It's true there's one school shooting after another. But in many cases, the trouble starts over small

things. Not drugs, not gangs. But over cliques, bullying. That's how violence can start, right here in your halls and classrooms: when you gossip, when you're jealous or nasty. When you pick a fight.

So there's plenty you can do to work for peace right here, today. Show your peers that you're above hitting back, above holding a grudge, above retaliating. Show them that you're smart enough to work things out with words. Talk. Reach out. Forgive that person who's making you angry.

By the way, forgiving is not pretending something didn't happen. It means just the opposite: looking at the person who has hurt you and saying, "Even though he did this to me, I am not going to get him back." That may sound crazy. But think about the consequences,

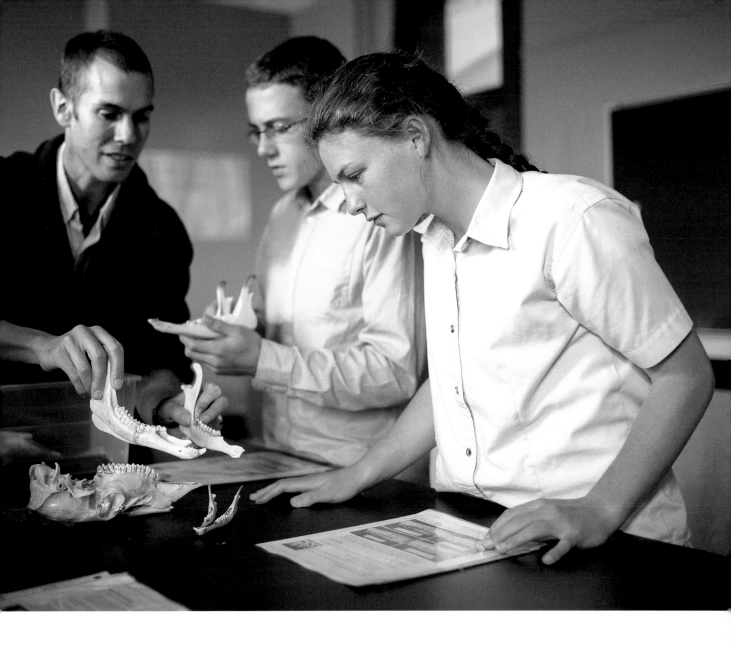

if you do plan on hitting back. **Who are you going to hurt, in the end? And who will end up paying for it?**

Although BTC's initial focus was on promoting forgiveness as the key to solving conflicts, it has gradually expanded its program to address a broad range of issues affecting children and young people. In 2014, it brought onboard two speakers who are passionate about addressing suicide and drug overdoses, both skyrocketing causes of teen mortality. The first, Ann Marie D'Aliso, lost her son to suicide; the second, Randi Kelder, lost a brother to heroin.

As time goes on, Havilah says, BTC staff have noticed that their audience is expanding too, beyond the teens they have always focused on: "It's not just students. Teachers, staff, and even cops are often moved to tears. After

one recent assembly, the local chief of police got up and spontaneously bared his soul to everyone present. He was abused by his father as a child and hadn't spoken to him in fifteen years, but recently found the strength to forgive." Just hearing a story like that, Havilah says, can sometimes be enough to give a desperate young person a glimmer of hope, and "a reason to keep going."

At the end of the day, Havilah says, she wishes BTC didn't have to exist. In the meantime, however, she finds it rewarding to watch the program reach teenagers' hearts:

We'll never know how many lives we've changed or saved. But that doesn't matter. As a mother, I'm just grateful to be involved in some small way in something that can give young people hope. ♦

^
Neal, a science teacher at The Mount Academy, coaches the school's Envirothon team, by studying a deer's jawbone to determine age and habits. The Mount team has won two championships in the National Conservation Foundation Envirothon.

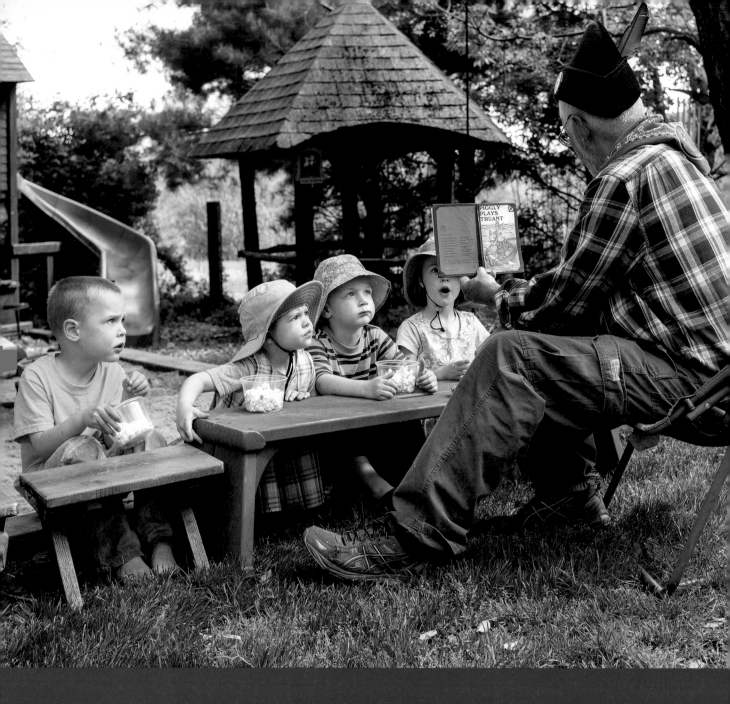

The most important thing is that children have time to play.
They don't need to be rushed around all kinds of places. On a
walk, listen and see what they see, stop at the little beetle, stay
by a puddle, admire a flower, each walk will be different. It's
important that teachers don't have too much of an agenda,
that the children have time for their own discoveries.

Heidi Barth, kindergarten teacher and Bruderhof member
1932–2007

^
A story and popcorn
made over the fire in
the Wood Island

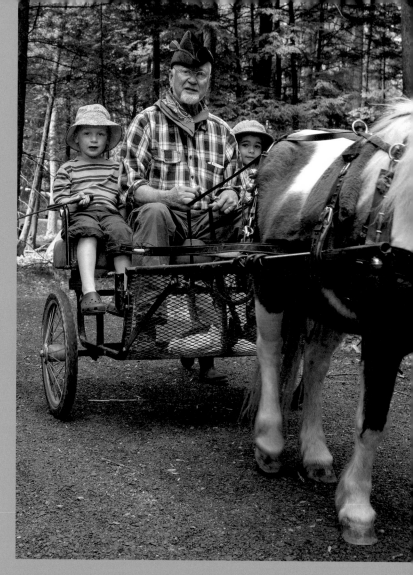

IAN WINTER

1947–

A teacher and principal in Bruderhof schools for more than forty years, Ian is still active as a mentor to young teachers. But the best part of his job, he says, is "Threes afternoon."

For fifteen years, the highlight of my week has been spending an afternoon with the three-year-olds at our daycare center. Why? At this age the child, now beyond infancy, is full of curiosity, adventure, inquisitiveness for life — eager to put all this to use and find expression for it. If play is truly the noblest expression of what's in a child, it should be encouraged!

My wife and I have developed a little area, "the Wood Island," about half a mile from the classroom. We hike out there with Blaze, our miniature horse, pulling the sulky. They take turns to ride and love to help hold the reins. Once there, the kids love to play in the sandbox and on the climbing frame, slide, rope swing, and rope ladder, or draw water from a tiny well to make the water wheels turn. Sometimes we make popcorn over an open fire. There are rabbits to hold, and a tiny pool with goldfish. We always make time for a story, sometimes acted out.

In the fall, we do tracking. They can identify fox, deer, squirrel, and rabbit. Another thing we do is balancing: there's this huge tree someone felled, which they learn to balance along and then jump off, by themselves, learning to be brave — overcoming fear. Or we drive down to the Hudson River and throw pebbles into the water and watch the barges going by — something big to expand their little horizons.

Best of all, we have a seesaw. Federal guidelines now outlaw seesaws in public playgrounds, but I think that's wrong. What is a seesaw, except the beginning of physics? Plus, you learn to be considerate of the other person!

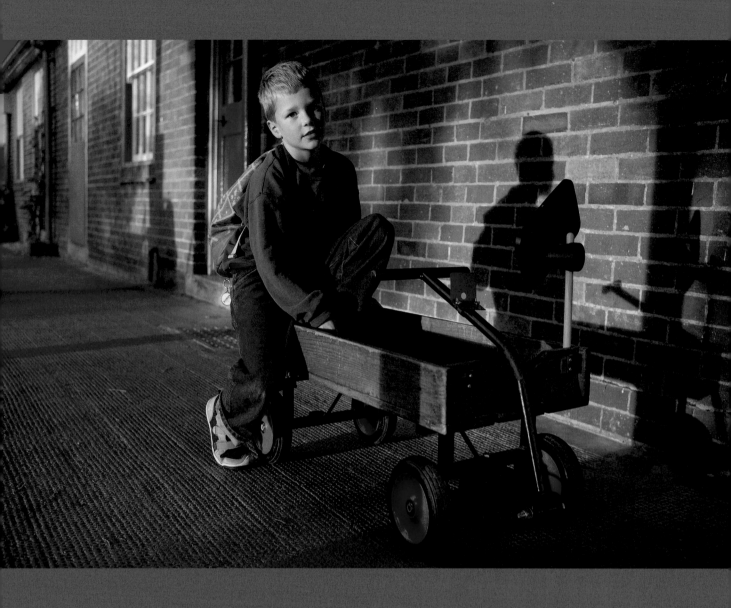

Through all the years I've been with children, I've always thought the most important thing is to have joy with them. Each day is a new day, a new chance. As a teacher, I have had to be humble, and to have reverence for each child.

Maidi Boller, kindergarten teacher and Bruderhof member
1933–2016

DUANE BAZELEY

1980–2011

Duane had his first grand-mal seizure at three months. Diagnosed with a rare form of epilepsy, he never learned to talk or walk unaided. Until he was nineteen, Duane's parents were his primary caregivers. Then Richard Scott (see page 237), a new pastor, arrived at the New York Bruderhof where the family lived. Richard didn't just see a disabled young man, he saw, as he put it, "a missionary without a field." And he had a startling proposal: pull Duane out of his special-needs school in a nearby town, and start a new "school" at the Bruderhof. Duane would be the teacher, and his caregivers, a roster of young men assigned for several hours a day, or for night duty, would be his students. As Duane's sister, Maureen, remembers:

It was counterintuitive, but the best idea ever, a crash course for his caregivers that included pushing his tricycle for hours, fighting to get more oatmeal into his mouth than onto his shirt, dealing with sleepless nights, and learning to change diapers.

It also meant learning that nothing you previously excelled at counted, for Duane. Best tackle on the field? Meaningless. He needed help simply turning over in bed. Straight-A student? Who cares? He'd never even graduated from kindergarten. Articulate, sociable, clever? Useless. Conversations were basically a one-way street.

No one graduated from Duane's school unchanged. Duane lived for thirty-one years, thirty more than his neurologists had predicted. After his death, his parents received dozens of notes from his former caregivers. One wrote, "During my early twenties my life was fraught with struggle and confusion, till I got the chance to care for Duane. He taught me that I really didn't know it all, that I had to start caring for others first, and that perfection and strength as God sees them were utterly different from my previous strivings for those qualities. I don't know where I'd be without having known him."

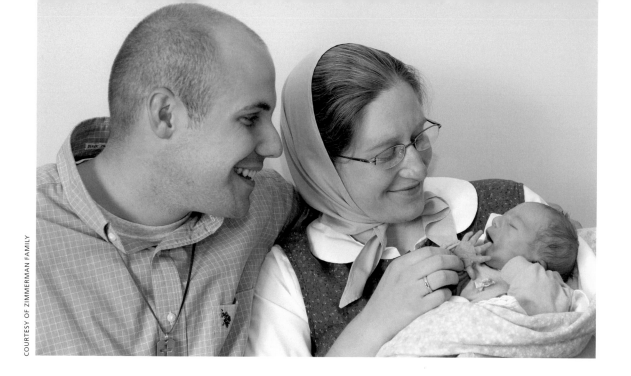

LUKE ZIMMERMAN

2015

Doctors told his parents he probably wouldn't survive birth. But Luke's few hours of life changed all who met him.

As Derek and Sara Zimmerman, a young couple at a Bruderhof in upstate New York, rushed to nearby Poughkeepsie to welcome their first child into the world, they knew that it was also the beginning of a farewell. In fact, because of a serious heart defect diagnosed several months earlier, their baby was likely to be stillborn, and, if born alive, he was unlikely to live for more than a few hours.

Within minutes of their arrival at Vassar Hospital, Luke was born – not only alive, but wide awake, and unusually alert, for a newborn. As Sara remembers:

My obstetrician, Dr. El-Kareh, was so happy that she began singing "Happy birthday to you," and calling other colleagues to tell them about the "miracle." We were all overwhelmed with happiness. You could taste the joy in the room. Amazingly, everything went so quickly and smoothly that we were ready to be discharged home within an hour. But not Luke: first, he wanted to be fed.

In the weeks preceding Luke's birth, his parents had repeatedly sought

the advice of medical experts and had decided that, if Luke were born alive, they would sign him out of the hospital as soon as possible, so that they could spend whatever time they had with him in the peace and quiet of their home, where a medical team was assembled and ready to care for them.

On arriving back at the Bruderhof, Derek and Sara were surprised to find a welcome sign in the driveway, and a crowd of well-wishers. A spontaneous meeting had been called, and within

<<

Inside on a cold, wet December day, watching a very tall Christmas tree being set up in the middle of the community

<blockquote>
"Looking back, Derek notes that Luke was with them much longer than a day. 'After all, he was already nine months old the day he was born.'"
</blockquote>

minutes, their entire community was gathered for the traditional blessing for the baby. The family's pastor, who had married the Zimmermans a year and half earlier, said a prayer of thanksgiving and a blessing. Then Luke was whisked home. Sara recalls:

We spent the morning with him in our apartment. I nursed him, and we bathed him, held him, and talked and sang to him. All four of his grandparents took turns holding him, and so did his great-grandparents and others.

Later, several of my sisters' children came by, and Luke waved, sucked his thumb, and kicked his feet. When Derek's buddy Phil came by, he held him, and Luke made little squawks.

Around noon, however, Derek and Sara sensed that something was changing. In Derek's words:

He moved less and less, and grew quieter. At first he looked up at us, but then he closed his eyes and gradually fell asleep. Our parents and other family members joined us as we cradled him in our arms and told him, over and over, how much we loved him. Thankfully, he didn't struggle, and we don't think he had to suffer. In fact, we'll never forget the deep peace that

surrounded us and him. It was so palpable and strong. Then he took his last breath and was gone. He was ten and a half hours old.

Looking back, Derek notes that Luke was with them much longer than a day. "After all, he was already nine months old the day he was born." In May, during a routine checkup, he had been diagnosed with a rare chromosomal disorder and a serious, complex heart defect. In the days and weeks that followed, the devastated young couple consulted numerous specialists, as well as the doctors and nurses in their extended family. They also turned to their pastor for advice.

We prayed like we had never prayed before. We kept asking, "Why us?" But we also wondered what God's will was for our little boy. Later, after a more complete medical picture emerged, and we learned that surgical interventions would not only be risky but unlikely to save his life, we decided to place his future into God's hands. We wanted to spend whatever time we might have with our baby at home as a family.

It was around this time that Dr. El-Kareh invited us to her house for coffee so that we could talk in a relaxed setting. By then we knew that Luke was unlikely to live for

more than a few hours, and so she encouraged us to write a medical directive to make clear our wishes for his care. Of course, she knew that abortion was not an option for us.

Sara explains, "No matter how incapacitated or disabled a child is, we see each one as a gift from the Creator. We wanted to welcome our baby however he was made." Around the same time, the couple chose his name, which they settled on after reading this passage in the Gospel of Luke: "People were bringing even their babies to Jesus so that he would touch them, and when the disciples saw this, they began to rebuke them. But Jesus called for them, saying, 'Let the children come to me, and do not hinder them, for the kingdom of God belongs to such as these.'"

All through the summer and fall, Derek and Sara lived with a growing tension: on the one hand, there was the excitement of anticipation; on the other, the knowledge that Luke's arrival would be "the beginning of the end." And yet, when the big day came, they were given a strength and calmness they say they couldn't have mustered on their own. In Derek's words, they were carried by the love of the community that surrounded them:

It was overwhelming how many people came to the funeral – and not just people from our communities, but also doctors and nurses from Vassar. David, a family friend, made the casket by hand. I helped him, and Sara's sisters painted it.

Of course, saying goodbye to our son was heartbreaking. But the main thing we feel today is

gratitude. That's because the hours he spent with us were filled, first and foremost, with happiness.

That happiness is evident even in a photo taken immediately after the funeral, which shows Sara and Dr. El-Kareh laughing. As Sara explains, "We were talking about Luke's arrival, and everything that happened. We held him. We sang to him. I fed him, twice. We even changed him. I did everything a mother wants to do for a newborn baby. No one can ever take away the joy of that morning."

In 2018, Derek and Sara experienced a miracle when their second child, Kaitlyn, a healthy daughter, was born. ♦

> Nathan and Evelyn and their children head home at the end of a day.

IN SICKNESS AND IN HEALTH

<
Daniel and Maura
love to join
Kendra on her
scooter.

>>
At the clinic,
Kendra takes a
baby's vitals and
gets an update
from her mom.

KENDRA MCKERNAN

1989–

Kendra, a nurse and mother of two who lives at Bellvale, was twenty-eight when she was diagnosed with a rare sarcoma.

That night I looked at my beautiful four-month-old baby, Maura, and my sleeping three-year-old, Daniel. I could not fathom the complete change taking place in all our lives, or control the thoughts whirling through my head. My husband Murray and I wept buckets, and I hugged Maura every time she woke for her bottle.

One thing was clear from the outset: we were going to fight that tumor with every tool at our disposal. Medically, that fight has involved a team of world-class specialists. Just as important, it has involved prayer — from friends and family as far away as Canada and Australia.

At two years post-diagnosis, Kendra is grateful to be tumor-free, though the surgery required cost her part of her foot and left her with chronic pain. Balancing requires concentration. She cannot walk long distances, so she gets around on a scooter. But the family still knows how to have fun together. "We have discovered many activities that don't require a lot of walking — camping in the back yard, cooking together, putting on music so the kids (and dad) can dance in the living room, and reading children's classics to our son."

Meanwhile, she knows that her cancer could return at any time.

I find fear and anxiety rearing their heads every time I go in for surveillance imaging. But whenever I go down that path of dark thoughts, my husband and I find relief in turning to prayer. We remind each other to live in the present and rejoice in the life we have.

Death has touched my family: My paternal grand-father, grandmother, and aunt all died agonizing premature deaths from cancer, and my father feared the same fate for himself. Then he died suddenly from a heart attack when I was fifteen years old. He was vibrantly here one moment and gone the next. I am not a stranger to the grief of children who have lost a parent, but God has weighed the cross he has chosen for Murray and me and he will see us through whatever life holds. In the meantime, here I am, with the gift of ongoing life.

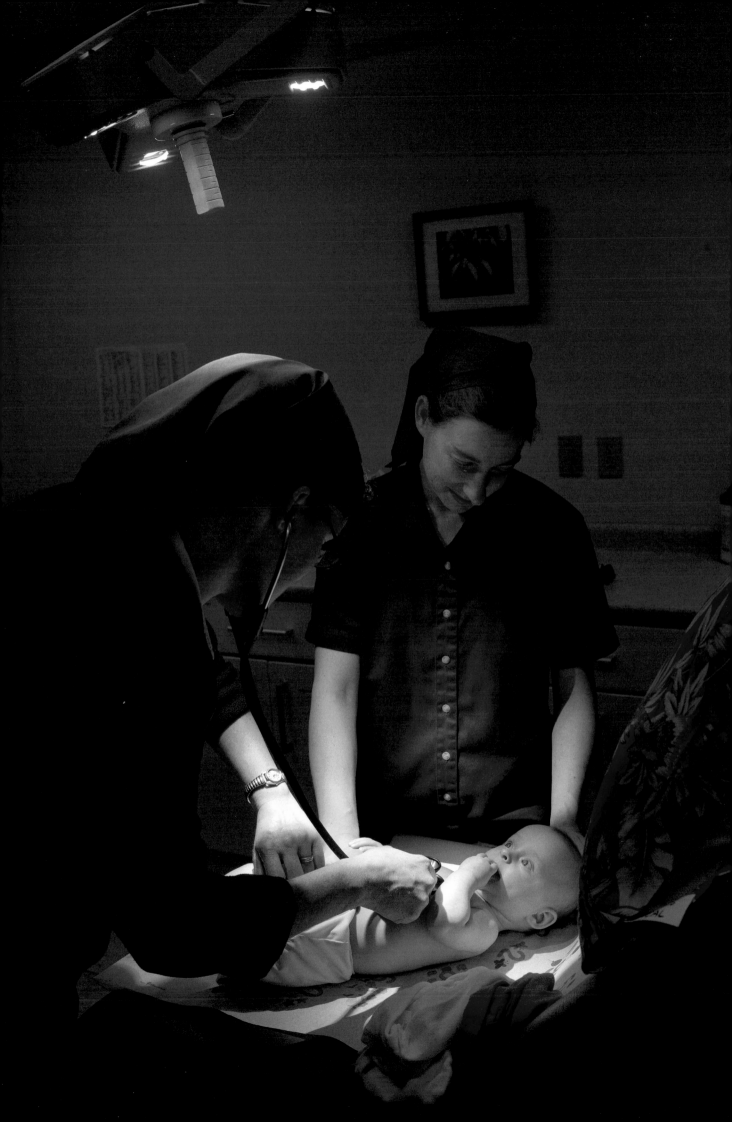

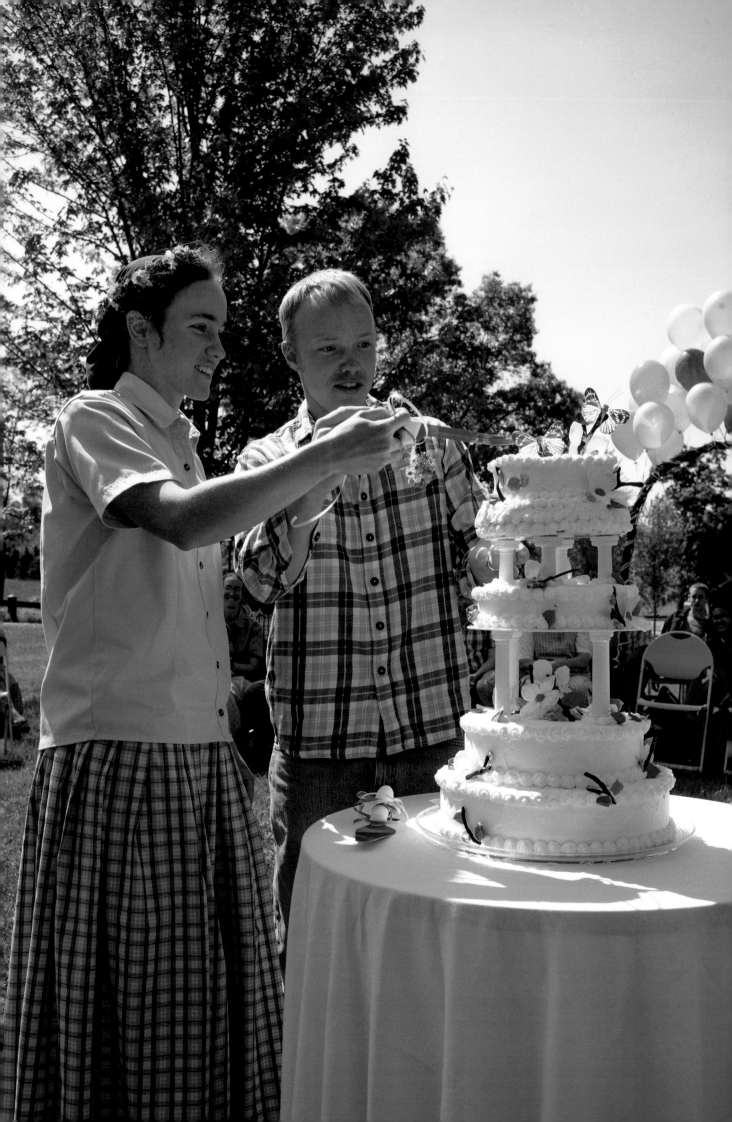

>
Sam and Brenda relax together in the gazebo Sam built near their house.

<<
Seth and Rosalind prepare to feed each other wedding cake during the week of community celebrations before their wedding. More pictures of their wedding are on the next few pages.

BRENDA HINDLEY

1973–

A couple struggles to navigate each day through constant pain and an uncertain future.

Brenda was a carefree teenager in southern England when an episode of nausea – and an unexpected diagnosis – changed the course of her life.

I was in ninth grade, and I started losing my breakfast every day. Or I'd wake up and vomit, first thing. Before long I had dropped out of school and was completely bedridden, because I couldn't keep anything down.

Over the next three months, they interrogated me in every hospital I went to. At one place, they were convinced I was pregnant and trying to hide it. Finally, an intern noticed a buildup of pressure behind my eyes, ordered a CT scan, and discovered a brain tumor. I was immediately scheduled for surgery.

Soon after that I began radiation. At that time, the type of tumor I had was thought to be malignant, and my entire head and spine were irradiated. My hair fell out; and the steroids I was on changed me completely. I had a big, fat face.

If Brenda's illness altered her physically, it also changed her inwardly and gave her maturity. That was especially true of the major brain surgery she underwent in 1988, in a risky bid to remove her tumor: "Surviving made me feel that God had given me another chance at life, and that I had to use it for something. I was less self-centered and more sensitive to what other people, like my peers, were going through."

One of those peers was Sam, who had developed a crush on "this energetic girl who liked to tease the boys"

Future in-laws arrange
flowers and craft the
bridal wreath for the
wedding ceremony.

"I think chronic pain
makes you more aware of what
is important, and less easily
bothered by the petty stuff
of life. And that, I think, is a
blessing. Because I don't think
I'd naturally be like that."

before she had become ill, and found himself praying for her – praying for the first time in his life. Those prayers were answered, and before long, Brenda recovered. Best of all, the tumor was determined not to have been cancerous.

In 1996, with Brenda in seemingly good health, she and Sam married. Over the next years they welcomed four healthy children – each an unexpected gift, says Brenda, given the amount of radiation to which she had been exposed. Then things took a turn. In Sam's words:

In 2003 Brenda started experiencing numbness and tingling. An MRI showed up a cavernous angioma in the brain stem, and the doctors warned us that she might go into a coma any minute. Our youngest was two months old, and our eldest six years. Brenda wrote a farewell letter.

Thankfully, the letter could be laid aside. But not the new fears, and

not the chronic symptoms – constant severe headaches, double vision, and other medical burdens – that have proven to be largely untreatable and incurable, and have dogged Brenda ever since.

By 2007, a specialist noticed meningiomas (tumors in the outer covering of the brain), most probably caused by the radiation treatments she had undergone as a teen. After three major brain surgeries, there was some respite, but each time the pain started increasing again. "It seemed like we visited just about every expert in New York," says Sam, "and tried everything from acupuncture to Botox. Anything, to allow Brenda to function."

In 2014, a new challenge arose: the treatment itself was becoming a problem. Brenda had grown increasingly dependent on painkillers such as oxycodone and fentanyl.

My physicians tried to convince me to reduce my meds slowly, but I was like, "I've had it with being

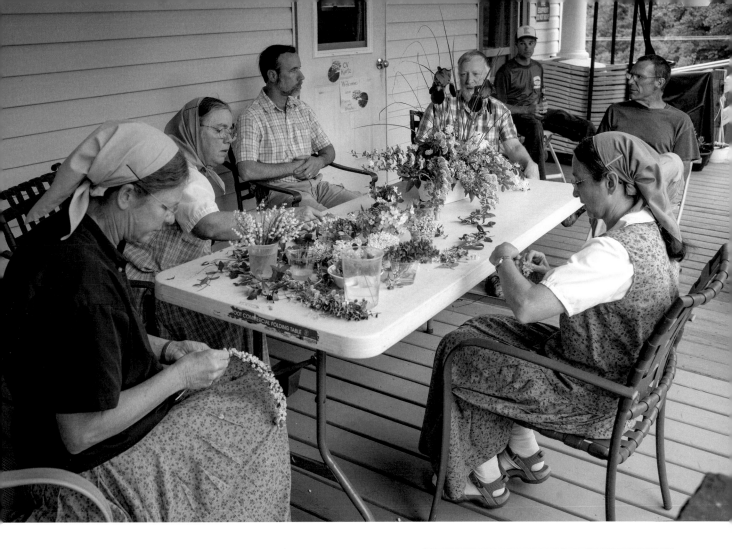

a zombie, and I'm not going to go back there." In the end, I basically went cold turkey. It was a total nightmare. I would curl up in bed, my whole body just aching.

I listened to Mendelssohn's *Elijah* over and over and over. When Elijah says, "It is enough, Lord; take away my life!" I felt like he was speaking for me. But then there were the words, "Be not afraid! I am your God! I am he that comforteth." Those also spoke to me.

In 2017 Brenda had major surgery again, followed by a risky infection. "Through it all," Sam says, "our community – our brothers and sisters – stood by us."

How else could we have survived this ordeal? At one point, I was in New York City for twenty-one days straight while Brenda was in the hospital. I didn't need a hotel. I stayed, like I often did, at the Bruderhof house in Harlem.

I'm a teacher. But I never lost my job. Our kids are adults now, but they never lacked care once in all those years. And the support of our primary-care doctors – Bruderhof doctors – who accompanied us to major appointments and went to bat for us again and again? The specialists couldn't believe it. Or the time the community sent us with our children to Florida for three weeks, just to be together as a family.

Of course, we still had dark times. Do you know how many times Brenda has said to me, "I wish I could just die. That would be better than this ongoing, no-end-in-sight pain. Plus, I feel so useless."

And yet, Brenda adds, her illness has also knitted the family deeply together over time, and strengthened her faith:

I don't see how you could get through what I've had to deal with

without some kind of faith – without turning to Jesus and relying on him to give you peace, or the courage to get up and go through another day. Plus, I think chronic pain makes you more aware of what is important, and less easily bothered by the petty stuff of life. And that, I think, is a blessing. Because I don't think I'd naturally be like that.

I've never said, "Thank you, God, for sending me this." But I do find comfort in knowing that Jesus knows what suffering is. And godforsakenness. That Jesus has become real to Sam and me. ♦

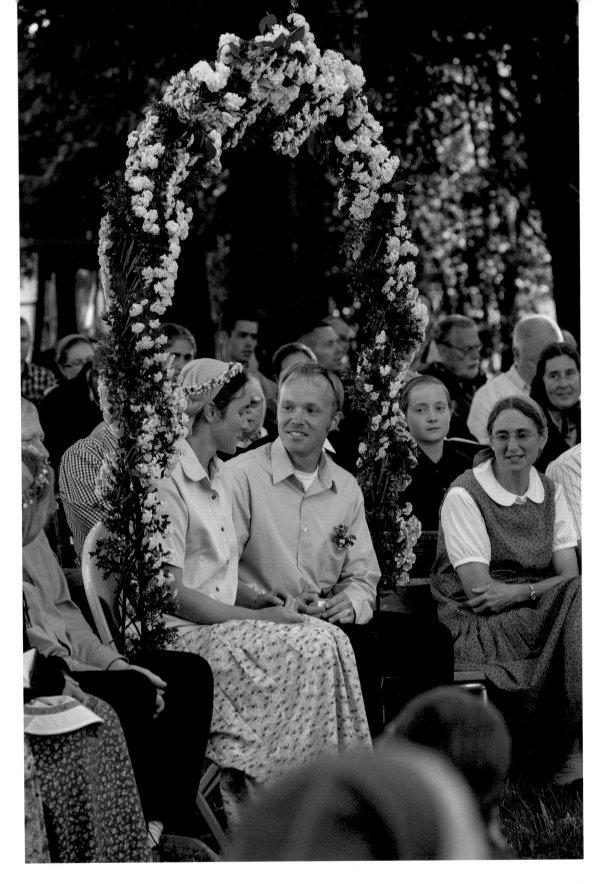

^
A promise of lifelong
faithfulness

>>
Seth and Rosalind's
getaway vehicle was
a raft that floated
across the lake to a
waiting car.

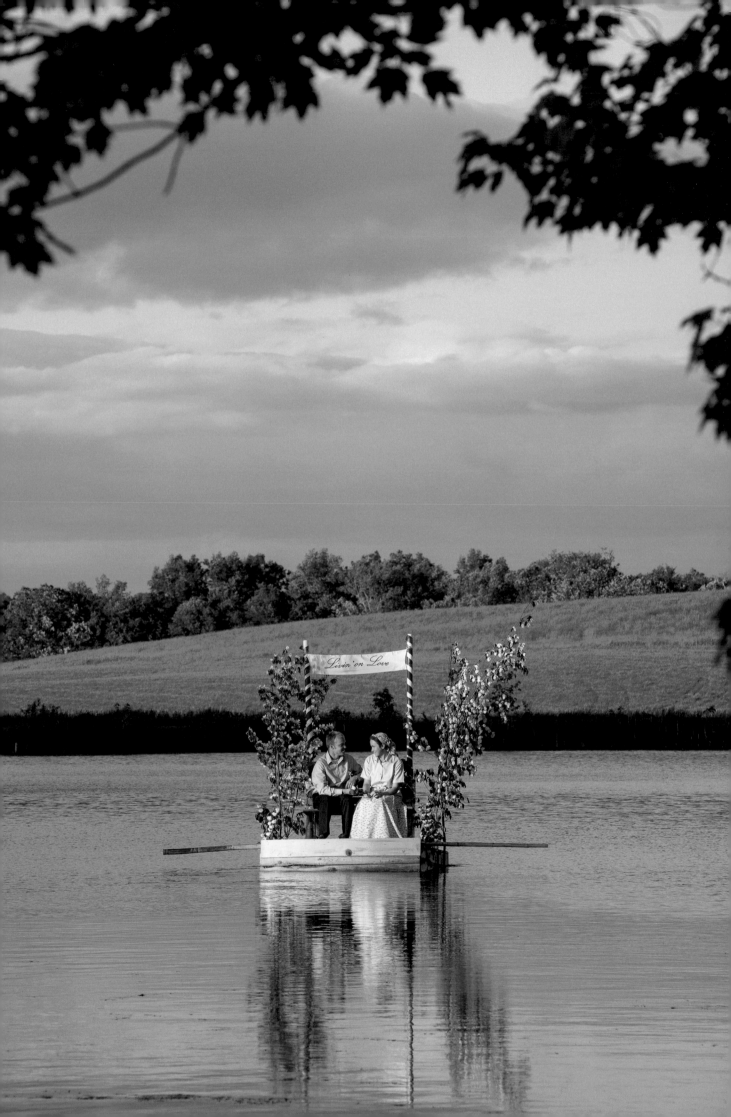

Just weeks before Carole died of breast cancer, she was still going to work in her office at Rifton Equipment. Above her desk hung a sign with the motto CARPE DIEM!

CAROLE NEAL

1943–1998

Having struggled with depression most of her life, she once told her husband, Dale, that "compared to depression, cancer was peanuts." In fact, she initially laughed off her diagnosis. "We joked that it would be a terrible shame if I died of anything else, since I'd worried about cancer all my life." Carole first fought her illness successfully with chemotherapy. Later it returned, but she declined further treatment: "I'm not going to spend the rest of my life in bed, vomiting. I'm going to live with everything I've got."

Asked for her thoughts about death, she said: "I'm leery of any emphasis on the hereafter. I say, forget the holy prayers. The best way to face death, I think, is to live." She banned hymns from her bedside in favor of the sounds from the volleyball court outside her window: "I need energy, strength for the fight. The fight for life."

Meanwhile, she saw to it that Dale would go on living too. In a letter to a pastor shortly before her death, she wrote:

I know this may seem strange or unusual, but I have given Dale my wedding ring. I cannot see putting it in a grave. I want him to remarry, and we have talked openly about this. It is a mystery, something I hardly understand — giving Dale up and yet feeling so very close to him. . . . I am sure that if we really live and die in God's will, our hearts will be together forever.

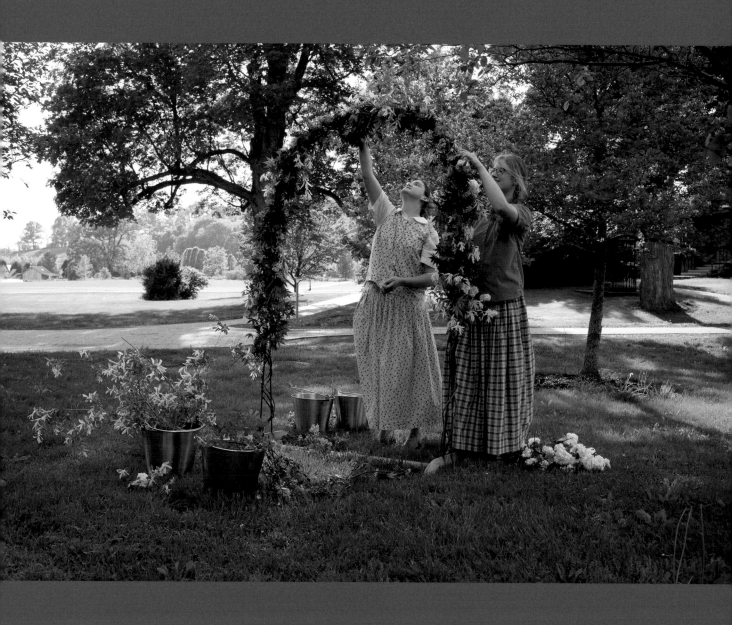

*Let us give up our work, our thoughts, our plans,
ourselves, our lives, our loved ones, our influence,
our all, right into His hand, and then, when we have
given all over to Him, there will be nothing left for us
to be troubled about, or to make trouble about.*

Hudson Taylor, physician and missionary
1832–1905

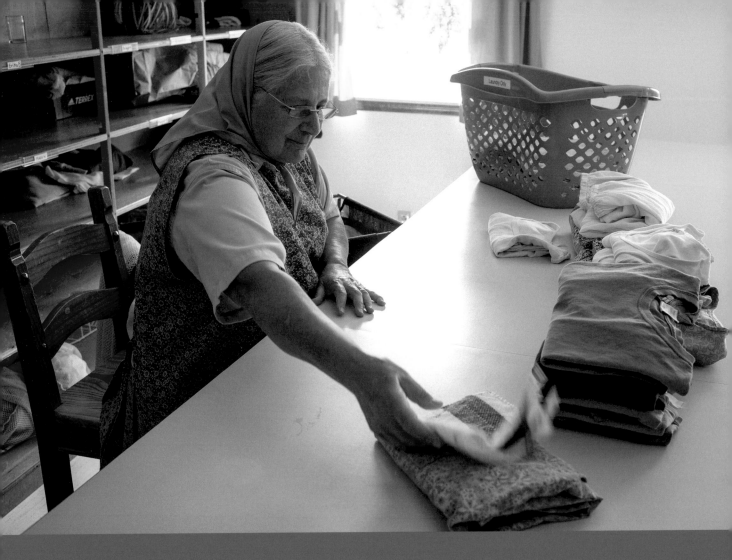

*In our former way of thinking, we would talk of "give and take."
But here right now was a life of "give and give." And that which
we give will never run out. For we all know that the more love we
give, the more will be given to us. It doesn't matter that I am old.
It wouldn't matter if I were bursting with youth. What does matter
is the precious love in which we live and have our whole existence.*

Johnny Robinson, agronomist and Bruderhof member
1905–1995

^
In the community
laundry, Anna-Mengia
folds clean clothes
for a family. Bring
your laundry in the
morning, pick it up
clean and folded in
the evening.

In 1972, Valerie had just graduated from divinity school when she visited Evergreen, a Bruderhof in Connecticut, for a weekend. She wasn't at all impressed at first, "but something – I don't know what – something touched my heart." She soon returned and decided to stay.

I was in the community for about twenty years. Then I began having psychiatric problems, and in 1993 I checked into a hospital. I was paranoid, and angry – my illness made me lose trust in the people I knew and in the community. There was misunderstanding and confusion on both sides. I told them I didn't want anything more to do with them.

I was away for the next twenty-five years, and spent about twenty of those in psychiatric care. I lived like a hermit. I tried to commit suicide multiple times. Then, I began falling and ended up in a nursing home.

VALERIE PARADIS

1942–

Then one day, someone came to the door and said, "Are you Valerie?" It was a couple from the Bruderhof who I used to know. For years I had reacted very negatively to any contact, but this time I didn't. I don't know why. They told me people had been looking for me – praying for me. I said, "No way!"

The next day, Verena, an old friend, came in to see me. "Why would anybody want me around?" I asked her. "I made such a mess out of things." She said, "The past is the past. It's forgiven and forgotten." I felt like a light came on in my life.

In early 2018, Valerie returned. Today, she spends several hours a day working in the community's woodshop in Maple Ridge, folds laundry, and reaches out to others, like Heidi, a forty-five-year-old with cerebral palsy whom she invites once a week for story time. She says:

I could still be in that nursing home. I actually thought I'd die there. But here I'm surrounded by so much love. And my source of joy is giving back that love.

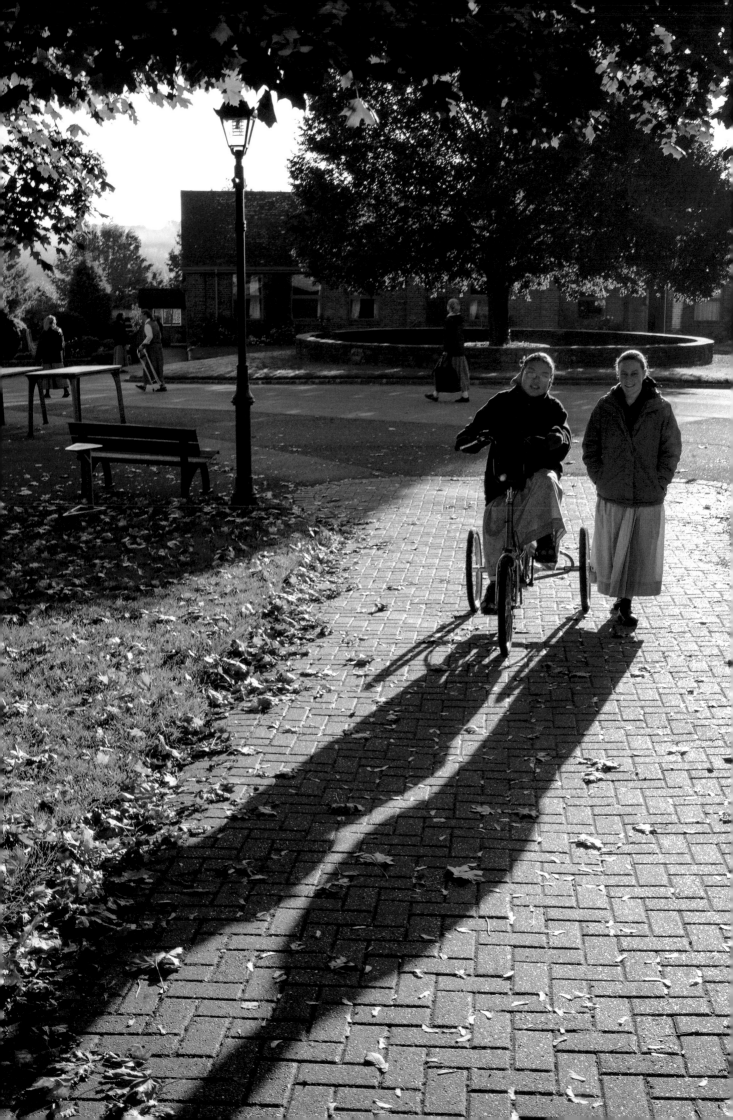

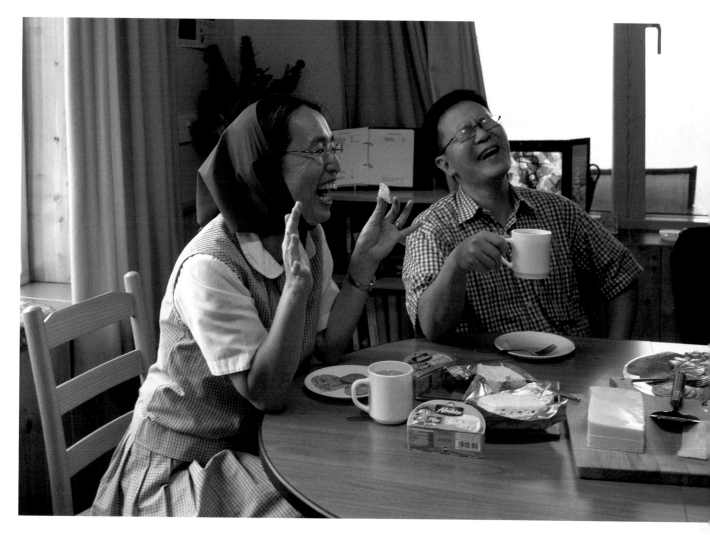

JEANIE OH

1971–

A mother of two daughters with disabilities shares how she came to terms with their suffering.

<<
Jeanie's daughter
Sarah bikes to work
with a friend.

^
Kevin and Jeanie at
home in Darvell

The daughter of a South Korean pastor, Jeanie dreamed of studying special education, but was thwarted by her mother. "Mom was afraid I might fall in love with a disabled man, so I majored in social work instead."

And then Jeanie and her husband, Kevin, had two disabled children of their own. First came Sarah, whose childhood, Jeanie says, "was an endless round of physical, occupational, speech, and play therapies."

Two years after Sarah came Sejune, a healthy boy. In 2001, when he was two, the family moved to Darvell, a Bruderhof in England that they had visited several years earlier. Part of

what drew them was the community's attitude toward people with disabilities. While some members of their former church had hinted that the Ohs' daughter was God's way of punishing them for conceiving her before they were married, Bruderhof members assured them that God is a God of mercy, and that Sarah was not a punishment, but a gift.

Not that life in the community was all easy: as if learning English and adapting to a completely foreign culture wasn't enough, Jeanie struggled to accept support when a young woman offered to join their family full time to do housework and care for Sarah.

You might wonder why extra help would be a burden, and in itself, it wasn't. In fact, I was grateful beyond words. Sejune was eighteen months old and Sarah three, and she couldn't walk. She was constantly having seizures. But accepting help offended my sense of dignity and hurt my pride. It made me feel that my family was a burden.

Then, in 2002, the Ohs had a second daughter, Serin. Her disabilities were even more severe than her older sister's. A second young woman was assigned to the family, and then a third, to help with night care.

I was always crying, and Kevin didn't know what to do with

me. He was happy for all the help. I thought he was an idiot. How could he just let go and allow other people to take over our family? I was so conflicted. I asked for advice, and got advice I couldn't accept. I needed help, but didn't want it.

Meanwhile, even with all the support we got, I was often at the end of my rope just taking care of the healthy members of my family. I remember Sejune telling me when he was four that he wanted to be blind. I said, "What?" He said, "No one ever notices me. If I were blind, then people would also say hello to me, and not just to Sarah and Serin." Today he's a student in

London, studying physiotherapy.

Then, one evening, I was sitting there wondering why I had two disabled girls – there was no rational explanation – and suddenly, all the tightness in my heart was gone, and I could laugh. I just laughed and laughed – I don't know why – and I found myself telling God that I was done with being stubborn: that I accepted my girls, and also all the love the community was giving us. I said, "I surrender."

Over the next years, Jeanie began to see her daughters in a completely new light. They were a gift, not only to her family, but also to the community at large, and most especially to the many

FRANCISCA MEIER
1991–

Francisca has been caring for elderly people for years. Looking back, she realizes that it all started with her grandmother:

I learned so much from being with her. Patience and compassion. About handling awkward situations, like filling in for an elderly person when they mishear something in a conversation.

But I think the most important thing I learned is that trying to "manage" an elderly person won't work. You have to be willing to let them care for you too, to listen to them and learn from their wisdom. It has to be a two-way street. Another grandmother I used to be with would go through these low moments. She'd say, "Who'd want to be with me? Nobody loves me anymore." Of course, I wanted to tell her that that wasn't true. But then it had to be genuine; she had to know that I really meant it. She could feel when my heart wasn't in it.

^
Serin, captivated
by an ingenious
marble chute

> Sarah and Serin,
> who call themselves
> The Marigolds,
> are counted on
> to stack serving
> bowls and cups
> for the community
> mealtimes.

young women who came through her house to care for Sarah and Serin, and to be cared for by them. Most of them were just out of high school, doing a gap year before college.

You have to imagine how cool some of these girls were. And then, to see them be changed by Serin, who could hardly talk. The only way they could interact with her was through singing or playing childlike finger games.

And Sarah – she is very sensitive and perceptive. She kept asking this one person, "What's up? Something is wrong. You need to talk with someone." Which turned out to be true.

Sarah has a simple, childlike faith. One time she told a caregiver, a rebellious young woman who was not the happiest character, "You need to find Jesus. You need to get baptized." A few months later, that young woman had a conversion, and did.

In the meantime, Jeanie was expecting a fourth child, and agonizing over the prospect of another one with disabilities. At a members' meeting one night, she and Kevin broke down as they shared their anxieties. Other people were in tears too, she says. Then one person after another got up and assured the Ohs that it would make no difference whether they had a typical child, or another one with disabilities. Their child "would be welcome, no matter what."

"They said, 'Your children are our children,'" Jeanie remembers. "The love was amazing." As it happened, the child was a perfectly healthy boy, Seroo.

Looking back, Jeanie says that her journey so far has been "like a snail trail."

Everything always moves so slowly in our house, and that sometimes hurts. While their classmates are going off to high school or college, my girls are having another seizure or healing from another fall.

Sometimes I lose my peace. At times, I can hardly pray anymore.

Then Kevin helps me by pointing out all the things we can be grateful for. Mostly he doesn't preach, though, because he knows I can't take sermons! One time – I'll never forget it – he just said, "Look, Jeanie, our girls can smile at us even after the most terrible seizures. Their rooms must be filled with angels. What more do you want than that?" ♦

ANOTHER LIFE IS POSSIBLE

224

Do not think that love, in order to be genuine,
has to be extraordinary. What we need is to love
without getting tired.

Mother Teresa, founder of the
Missionaries of Charity
1910–1997

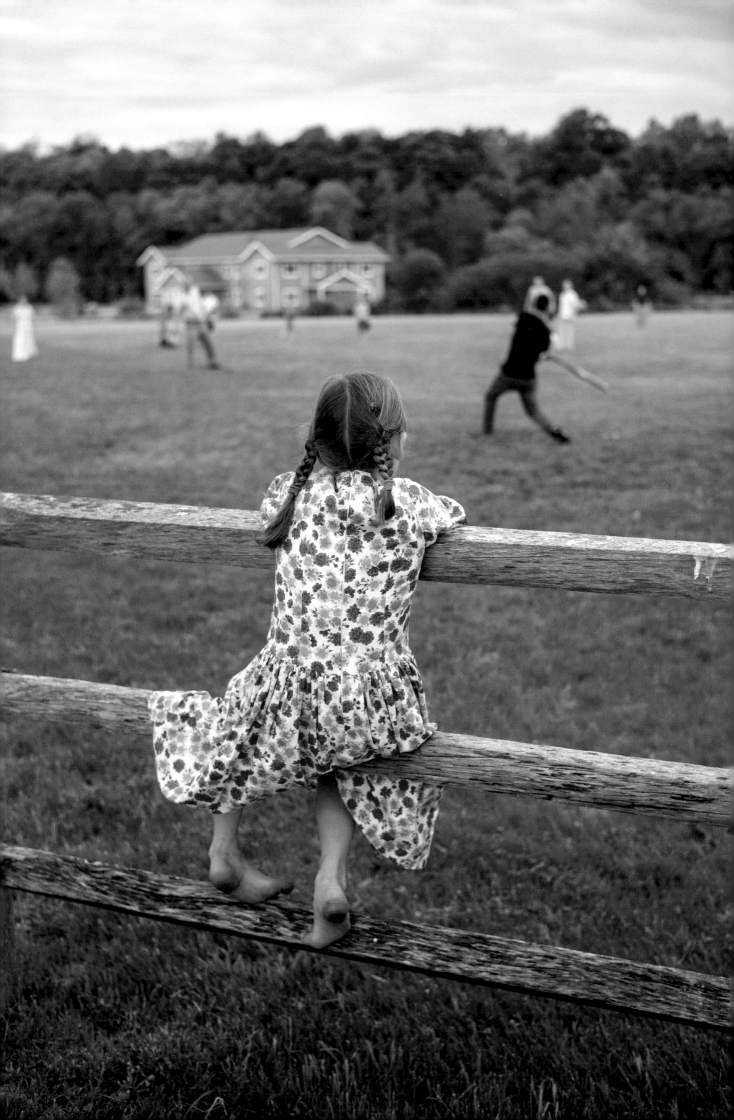

RANDALL GAUGER

1954 –

**He lost his twenty-two-year-old son to cancer.
His wife has a debilitating illness. Suffering,
Randall believes, can teach compassion.**

Randall, a pastor, and his wife, Linda, were
living in Australia in November 1999 when they
received the news that their twenty-two-year-old
son, Matt, who was living at a Bruderhof in Penn-
sylvania, had been diagnosed with an aggressive
lymphoma. Within the week the Gaugers were on
their way to the United States, a flight of twenty-one
hours. "Once in the air, we talked very little," Randall
remembers. "We mostly held hands, and cried.
I felt numb."

By Christmas, Matt seemed to be responding to
chemotherapy; in January, he married his fiancée
Cynthia, who insisted that no amount of uncertainty
or sickness would destroy their love. In mid-March,
Matt was doing so well that Randall and Linda re-
turned to Australia. But by the end of the month, the

cancer was back, and the Gaugers left Sydney once
more, this time with the unspoken certainty that it
was to say goodbye.

Twenty years after Matt's death, Randall reflects:

**It is unnatural to see your child die. There is
something inside that simply says that it should
not be like that. With Matt, dreams also died.**

**But to be in that room when Matt left us, and
to hear him speak of things he was seeing and
feeling – things of heaven and eternity – that
changed us forever. You cannot be in that
situation and not be changed. Matt saw things
we could not see, and for a few hours, we got
a little glimpse, through him, of what is on the
other side of that door that we will all have to
go through some day.**

View from the gallery
down into the Great
Hall of Beechgrove
Academy

"The issue of pain and suffering is as old as humanity itself, and the worst thing you can do for the person you are trying to help is to come up with some answer, even if it's a Bible verse."

I drag myself back to that experience from time to time, because it gives me an important perspective: the thought that life is rooted in eternity and not so much in this world.

When cancer struck our son, I was stopped in my tracks. Everything changed in a moment, and the things I thought were important suddenly weren't. I was driven to prayer. I suddenly realized how shallow my life was, how little time I actually spent focusing on the important things. All of a sudden it hit me that life is actually very short.

How do you make use of the one day before you – this one day you've been given? That question became so important to me and Linda. I am not saying that we always make the best use of our days, but I'd like to think that our experience with Matt sharpened that desire in us.

Matt's early death is not the only cross the Gaugers have had to carry. Around the time of his illness Linda, too, began to suffer, from what has since been diagnosed as a rare and crippling autoimmune disease. As Randall describes it:

This disease is characterized by fatigue, nerve pain, and an array of other symptoms. It moves around the body. The treatment is long-term steroids and immune suppressants, but naturally, they present their own challenges, especially in terms of side effects. For example, due to long-term steroid use, Linda has had three major back surgeries just since 2015.

Sometimes the pain simply cannot be controlled, and keeps her in bed. Those times are the most difficult, because the pain is so intense and unrelenting.

Another challenge is the way it just goes on and on, year after year, with numerous doctor's appointments every month. There are times when it really wears us both down.

Musing on the way living with illness has changed him and Linda, Randall says that even when it has cost them a fight, they have learned to look for blessings along the way.

First and foremost, it has slowed us way down. That has been tough to accept, especially for Linda, because she has always loved working. Now she can't do the things, even little things, that she used to do. So we have had to change priorities. Our focus has had to change from doing things to being – to spending time with others, and realizing how important that is: how important people are.

The other thing that comes to mind is how illness – any kind of suffering – reveals your helplessness. When Linda is fighting an especially tough bout of pain, for instance, and neither of us can really do anything about it, it can be very frustrating. You find yourself turning more to other people for support, and to prayer. That's an important lesson we've learned: when you can't help yourself, you can always turn to other people. Often you'll find help there.

As a pastor who has counseled countless fellow Bruderhof members over the years, Randall finds himself drawing on the trials that have shaped him and Linda. Reflecting on the struggle to make sense

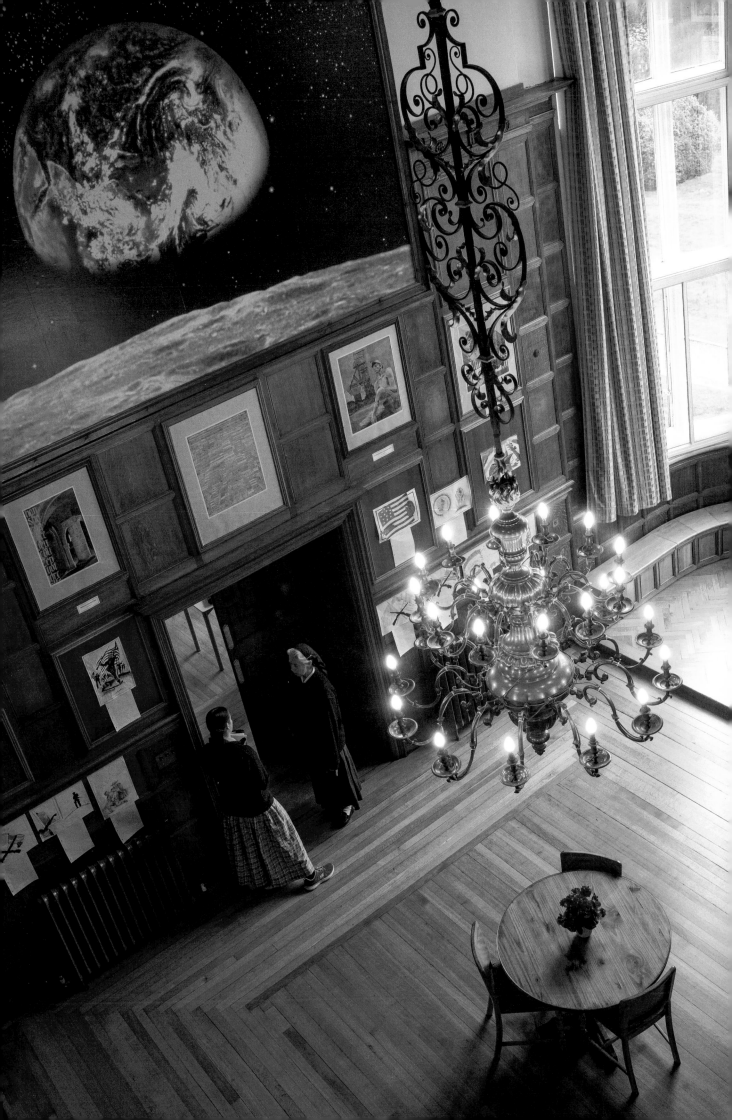

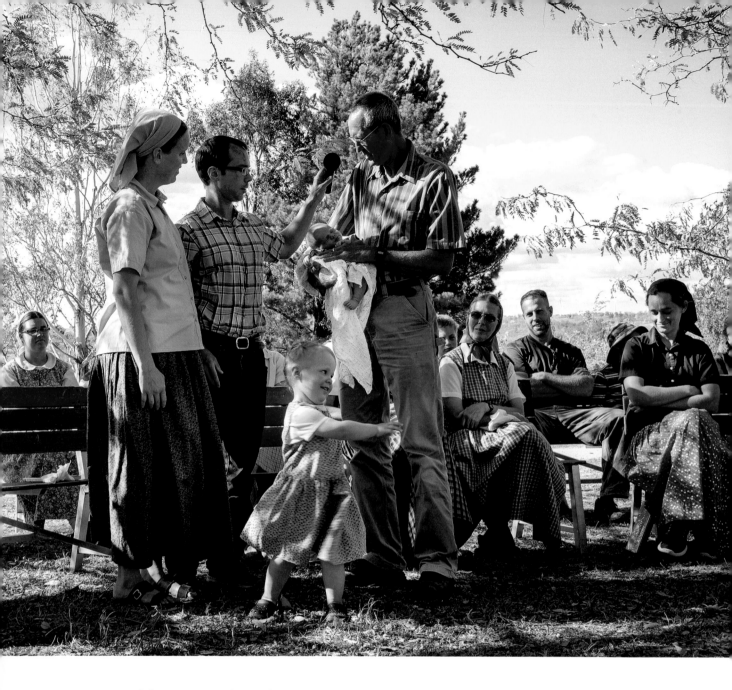

of illness – in particular, on that thorny question, "Why me?" – he says:

The issue of pain and suffering is as old as humanity itself, and the worst thing you can do for the person you are trying to help is to come up with some answer, even if it's a Bible verse.

I often think of the story of Job. Everything is taken away from him: material possessions, family, and health. Then his friends come along. They see his suffering and are deeply moved by it. They weep with him; they sit down in the dirt with him in silence for a whole week. But then they start talking and mess everything up!

The apostle Paul has some simple and good advice for us: he says we ought to "rejoice with those who rejoice, and weep with those who weep." Again, we don't have to have answers, but we can be present to a person and love them. ♦

^
A prayer for Alan and
Cynthia's new son at
an outdoor service

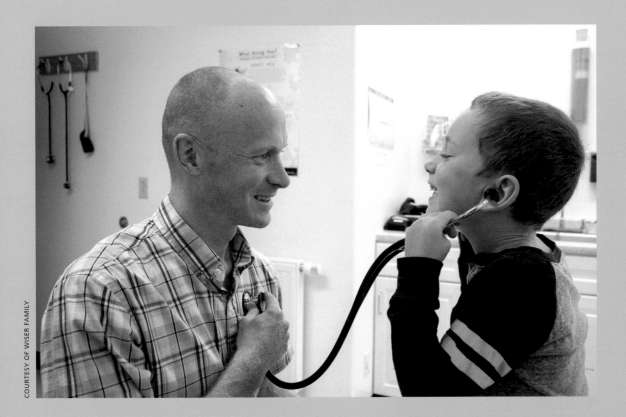

ART WISER

1987–

Art, a doctor and father of three, works at a Bruderhof medical clinic in Pennsylvania. While in training, he saw enough dysfunction in the US healthcare system to understand the epidemic of physician burnout.

The way I practice here solves almost all of the problems I saw in the healthcare industry. In medical school we designed the ideal patient-centered medical home as an exercise, but it didn't come close to this!

There are no barriers to care, our patients don't have to worry about bills, and we have a terrific team of nurses, doctors, physician assistant, secretaries, optometrist, and physical therapist all communicating and working together. My wife Renate is a nurse and makes sure that patients have a pleasant experience when they come to the clinic – no child leaves without a sticker and lollipop. The dental clinic is right down the hall and it can be very helpful to

consult with the dentists, for instance to help resolve someone's longstanding respiratory issues.

I'm able to provide care like an old-fashioned family doctor (which is what I am even though I've only been in practice for three years). I might be called to a family's home in the middle of the night to see a child for croup and the next day sit with someone to coordinate care for their grandmother. If a patient has major surgery I will accompany him to his pre-op appointment so I can make sure his concerns are heard and also be sure he has understood the surgeon's advice, and I'll follow up with home visits after surgery and make sure the family is adequately supported with nursing care and any extra equipment that might be needed. Yes, my days can be stressful at times but working as a team to provide the best possible care is incredibly rewarding.

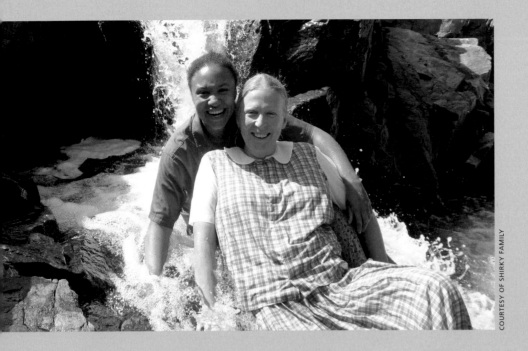

COURTESY OF SHIRKY FAMILY

ADIMA SHIRKY

1994–

Adima was always close to her mother, Anthea, who raised her as a single parent with the help of the community. (Her father left the community shortly after Adima's birth, divorced her mother, and remarried.) In the summer of 2015, Adima and her mother were living together again after several years apart, when Anthea was diagnosed with pancreatic cancer. The oncologist gave her three to five months.

Mom did not take things lying down. She was a junior-high teacher, and tough as nails. Plus, she was only forty-nine. But when she got cancer, her attitude surprised me. She said, "Rather than fight God and question him, we have to take the attitude of Mary: 'Here I am, Lord. Do with me as you will.'"

Armed with that mixture of resolve and acceptance, Anthea showed no signs of slowing down until the very end. She continued teaching as long as she could. She wrote to dozens of former students. She organized parties and outings. She spent hours reminiscing about the past with her sisters and her mother. And she always saved time to "just be" — one-on-one, with Adima:

She had always been my best friend, and wanted to be sure I was ready to face the future. Her basic message was "no self-pity." She said, "I'm leaving, but you won't be alone. You have people all around you, and so much to live for. I don't want you going down the road of bitterness. It leads to hell."

Of course, the community supported us throughout, medically and inwardly, and in every other way possible, also during the period of devastating inner loneliness I went through after her funeral.

Mom died in January 2016. Right before she went, I told her, "Mom, I'm going to be okay. So whenever you need to go, just go." I could say that with a free heart, and I really meant it. And I know she heard me, even though she wasn't responding anymore.

In 2018 Adima married Kent, and in 2019 they welcomed their daughter, Alivia Anthea.

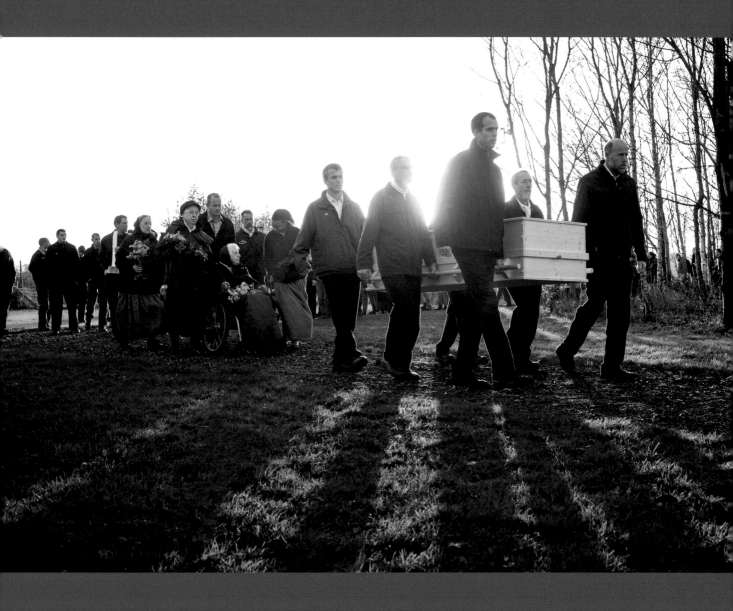

Three weeks ago, I was shoeing horses. Then a routine visit to my doctor changed everything: he discovered I have widespread cancer. Suddenly I am confronted with death.

"God, take over," is my prayer. I am grateful for medical help in easing the pain, but I do not hang on to hopes of being cured. My doctors admit there is little they can do. I feel sure, though, that the more I entrust myself to God, the more he can do with my life. Death is a bridge that everyone has to cross, but Christ promises everlasting life. We cling to this earth – and rightly so – and yet we all have to let go of it. God rules over the whole universe, and the victory belongs to him.

David Mason, farmer and Bruderhof member
1938–2007

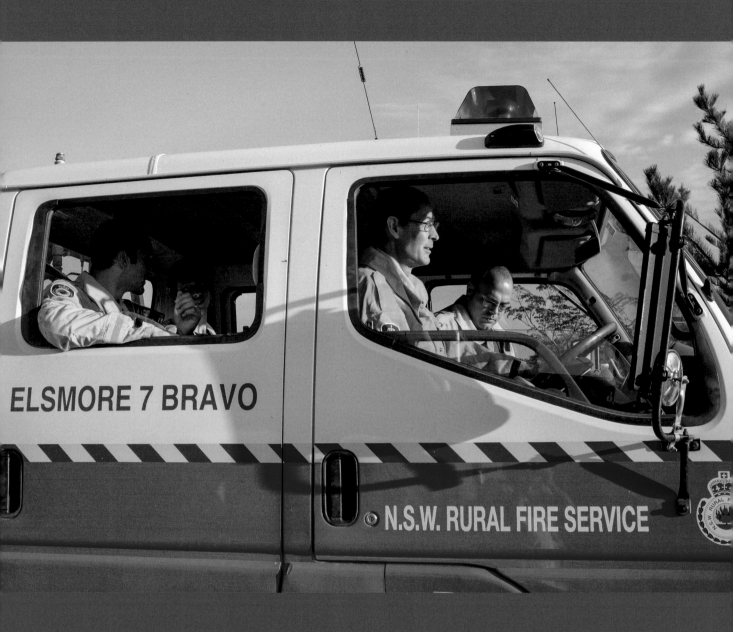

ELSMORE 7 BRAVO

N.S.W. RURAL FIRE SERVICE

It is to Jesus that we give our whole hearts in gratitude, love,
and trust. One glance at our wretchedness makes us long for a
firm support, which will never disappear. This firm support is
Jesus Christ who has come near, who has entered into our flesh.
We feel him, grasp him, and take him into our hearts as our
brother, in order that we may have the support of the Almighty
God in this world.

Christoph Blumhardt, pastor
1842–1919

^
Members of the
Danthonia community
serve on the New
South Wales Rural
Fire Service.

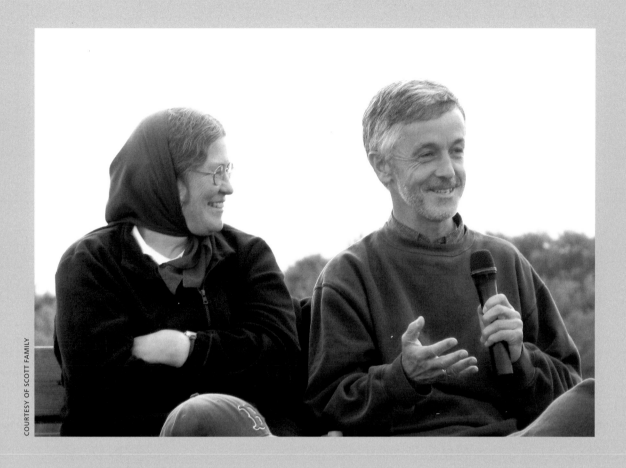

RICHARD SCOTT

1949–2011

Richard Scott was named the senior pastor of the Bruderhof in 2001 and served in that capacity with his wife, Kathy, until his death. An unassuming, slight man known for his blunt honesty and sense of humor, he hated attention. "Let's stop praising each other," he would say. "Let's give glory to God, where it belongs."

Richard was diagnosed with advanced cancer in May 2010. In early 2011, he told the community about how facing death affected him:

One's mind and heart turn away from this world, and all one's plans and ideas of what should and shouldn't happen just fade away. One is left with this great longing to go home to a different kingdom.

And yet there is also this: before you stands eternity; behind you, what all has happened in your life, and you know that you have to face God's judgment. So wherever you have opposed Christ, it comes to the foreground, and your heart cries out for redemption.

There is the longing of every heart to find peace. I say this as a needy soul who has hindered and opposed the Spirit so often: it's through showing love to one another that we find healing. May we all be drawn closer to the kingdom through these times. It's within reach of every person.

Richard died in February 2011.

WHAT ABOUT TECHNOLOGY?

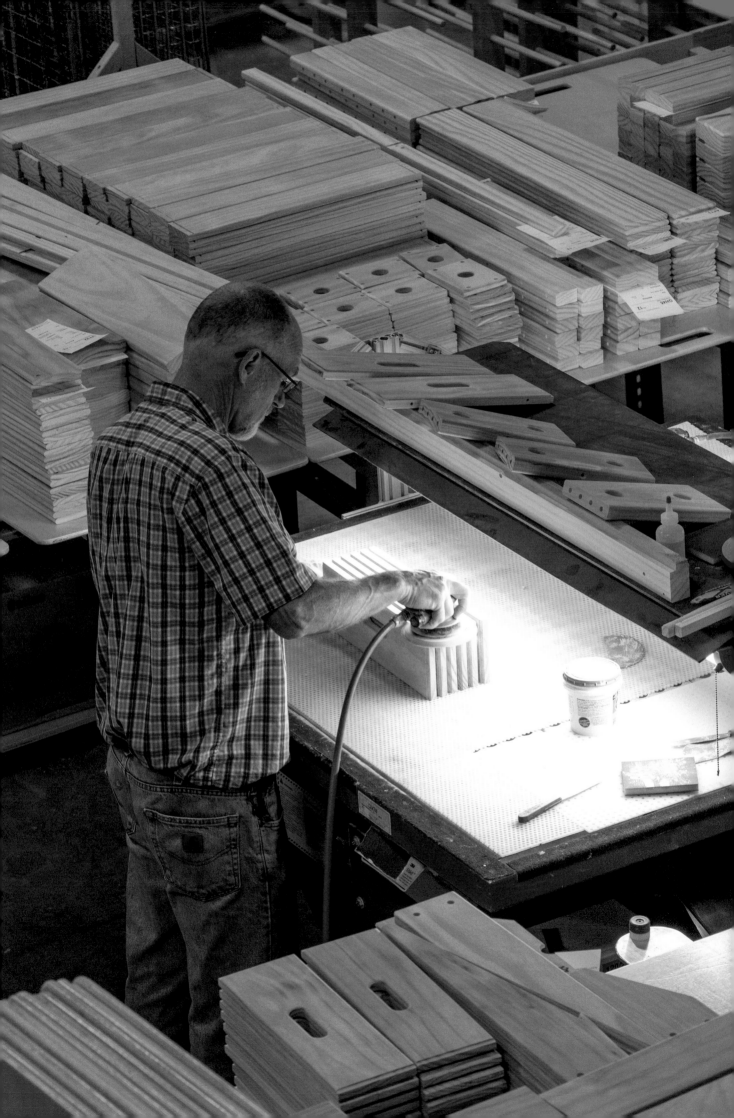

COURTESY OF RHODES FAMILY

A CEO with a unique set of challenges and opportunities – and no paycheck

JOHN RHODES

1951–

For the last three decades, John has run the Bruderhof's businesses, Community Playthings and Rifton Equipment. He has given considerable thought to the place of technology in community, and in 2017 he summarized some of those thoughts in an essay for *Plough Quarterly:*

Founded in 1948 by communitarian pacifists in Georgia, since the 1950s Community Playthings has been the main source of income and work for the members of the Bruderhof. . . . All those who work in the company are my fellow Bruderhof members; in keeping with our vow of personal poverty, none of us owns a share or earns a paycheck, with all earnings going to support the community or to fund its philanthropic and missionary projects.

Despite its communal context, Community Playthings has thrived

in the capitalist marketplace. Along with Rifton Equipment, another community-run company that makes therapeutic equipment for people with disabilities, it sells to customers around the world; in 1998, earnings were covering all costs for two thousand people in eight Bruderhof locations in the United States and Europe. Both companies, though medium-sized in terms of market share, are recognized as industry leaders for their durable products and vanguard designs. Such success sprang at least in part from our adoption of innovative technologies. The company had computerized already in 1979, buying a Wang minicomputer; a decade later, a second growth spurt resulted from adopting the Japanese "Just-in-Time" manufacturing philosophy, which made extensive use of manufacturing data.

<<

Tom, a cabinet maker, also puts in time in the Community Playthings workshop each day.

"Any use of technology that undermines the richness of human relationships must be presumed suspect, especially if it encourages passivity rather than creativity. That's why we minimize the use of social media in our communities."

Until the 1990s, bringing new technologies into the business was rarely controversial. Then, in the 1990s, the company introduced email. At first, everyone was smitten, but eventually there was a backlash, as frustration with the unintended consequences of electronic communication mounted. Before long, there were proposals for an enterprise-wide email ban.

At the time, I argued that in our communication-rich environment – we live and work together, meet daily for communal meals and worship, and are committed to avoiding gossip and backbiting – email's weaknesses should be manageable. But it didn't play out that way. And interpersonal relationships suffered as a result.

Now, email seems outdated (we still use it – our self-imposed ban only lasted a few weeks). But look at the role social media plays today – at Instagram, Twitter, Facebook, Snapchat. These things have completely altered the way people relate. In many cases, they represent a huge, unmanageable

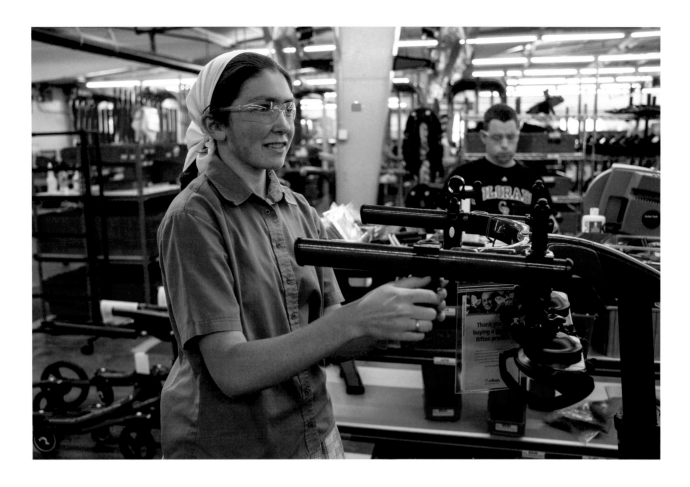

entity that has taken over their lives.

Paraphrasing French thinker Jacques Ellul, John says that the outcome of a given form of technology depends less on the user's intent than on the structure of that technology.

Programming our company's first computer, I realized how quickly I became obsessive about the project. In terms of its usefulness to the business, there's no question how valuable it was. But what it did to my mind is another question entirely. I found myself thinking all day long about how to fix this algorithm, how to make this next thing happen. And it became a very lopsided activity. So you need to keep your eyes open. It is vital to remain technology's master, and not become its slave.

What this demands of us is not outright rejection or acceptance, but constant careful thought about technology's consequences: Any use of technology that undermines the richness of human relationships must be presumed suspect, especially if it encourages passivity rather than creativity. That's why we minimize the use of social media in our communities, and why our homes don't have television. And why our laptops stay in the office when five o'clock rolls around. If a form of technology is proving deleterious to your relationships with others, you have to have the guts to drop it. Don't be afraid to walk away.

Ultimately, John points out that when the technology at hand "enables people to work with all the faculties of their being, and to work well with one another," it has "found its rightful place."

We intentionally hang on to work that could easily be outsourced, or entirely replaced with an automated piece of machinery. Because when a brother or sister who is, let's say, seventy-five years old, comes down to our shop and wants to put in a few hours of meaningful work – not busywork – we want to have it available for them. We will accept a certain level of inefficiency just to make that possible. ♦

<<
Ron led the Community Playthings sales team for over forty years. Now, at ninety-two, he has a place in the workshop where he builds the products he once sold.

∧
Rhoda assembles a Rifton Equipment Pacer gait trainer on her summer break from college.

243

I worked with my hands, and I still desire to work, and most earnestly do I desire that all my brothers should employ themselves in honest work. Let those who do not know how to work learn, not from anxiety to receive wages, but for good example.

Francis of Assisi
1182–1226

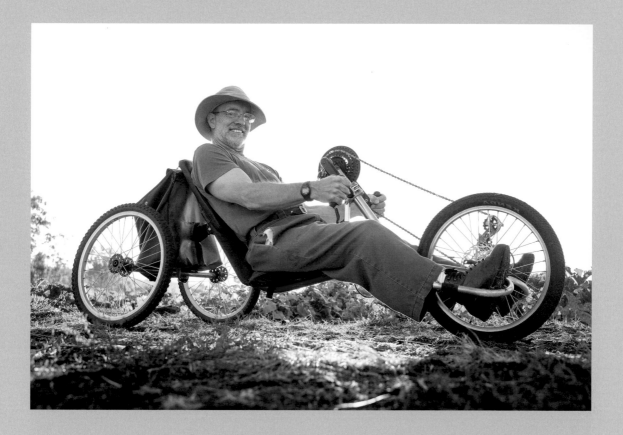

SAM DURGIN

1963–

Sam, a father of six, was born with a club foot. He spent his childhood undergoing one surgery after another. Today, his hobbies include swimming, going to the sauna, flying kites, and riding his custom-made bicycle. After attending a technical high school, he began working at Rifton Equipment, designing products for people with disabilities. In a way, he was already involved in the company as a child:

My dad was one of Rifton's earliest designers and made me a special chair that allowed me to sit comfortably and concentrate on my school work. Later, during high school, I drew up parts for the products another designer at the company was making. Eventually I became a designer myself, a job I thoroughly enjoy. There is a lot of interaction with therapists and with kids, thinking up solutions, building prototypes, and making improvements.

On one level, Sam's work is technical: "We use Solid-Works, highly sophisticated modeling software, and a 3D printer." But designing and manufacturing a winning product demands more than good tools: "It requires passion, a commitment to teamwork, and the readiness to keep learning new things." Talking about the Rifton Activity Chair, a bestseller he helped design, Sam says:

We had already garnered all the customer input we could, related to seating. But for this chair, we categorized all the particulars and ranked them on a big spreadsheet so that we could see which issues emerged at the top. We came out of that project having addressed the top thirty-five. It was an enormous effort, but it was worth it. That chair has become a standard seating solution for people with disabilities. It's now selling around the world.

During her Bruderhof childhood, Shaina says she had "almost no screen time, besides a few movies a year and a few hours here and there watching my father photoshop my mother's paintings to create greeting cards," and only learned to use a computer when she was sixteen. After studying law in London and Georgetown, she now works as a lawyer in Woodcrest.

During my years in London I was fortunate to live in a Bruderhof house in the city with about a dozen other students. I didn't do social media. None of us in the house did. I didn't even have a smartphone, and I usually turned my dumbphone off as soon as I got back from classes.

It could be inconvenient: classmates had to email or call me, when they would have preferred using

SHAINA HULEATT

1992–

Facebook messaging. Without Google Maps on my phone, I had to plan ahead—or get lost. But what you sacrifice in terms of convenience can often be regained in real time. Time for games, reading, cooking—we learned to make curry from Indian friends—and singing.

Sometimes we'd take a guitar to the park; a few times we even sang on the Underground. People looked up from their phones, surprised. Children smiled. A Scrooge or two would move to another car, but most people seemed to enjoy it. Some even joined in.

I now spend most of my working hours in front of a computer. All the more, I value any time I can get away from screens.

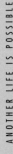

Seeing both the greatness of nature and the delicacy of flowers, we came to understand how human beings have their place in God's great plan of creation.

God's majesty is so great and unapproachable, and so endlessly kind; his power is to be felt in everything and through everything — even through us if we put ourselves at his disposal.

Trudi Hüssy, teacher and Bruderhof member
1897–1985

^
Admiring Stubbs
and Turner at The
National Gallery,
London

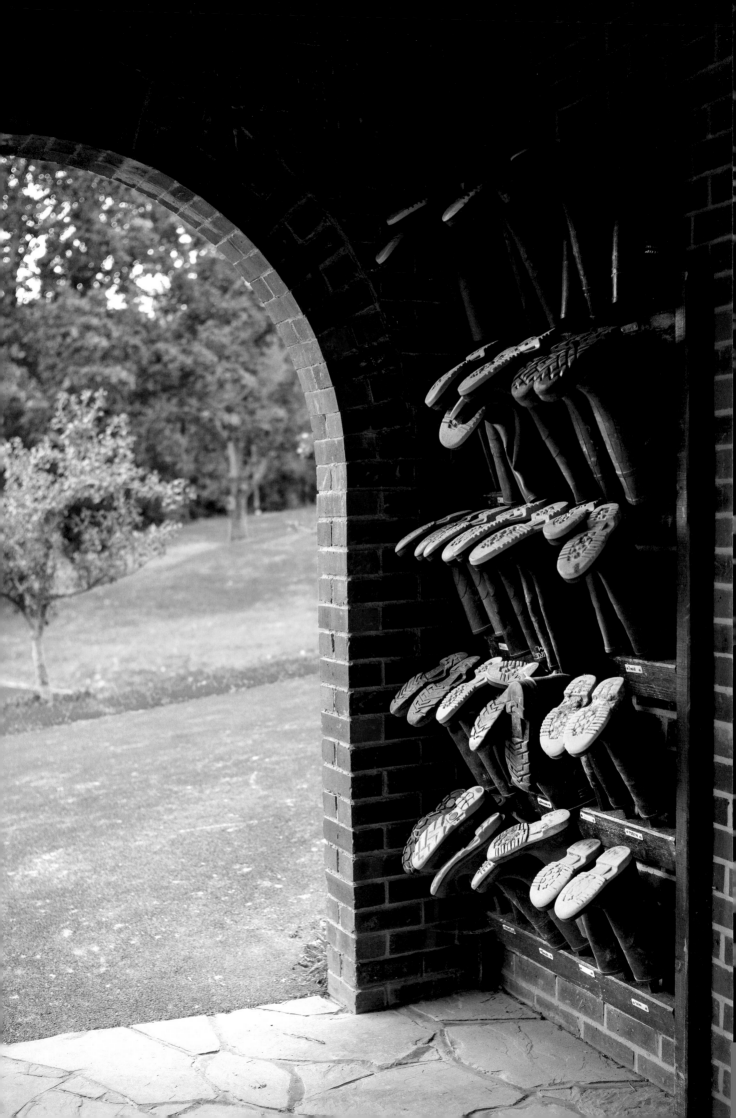

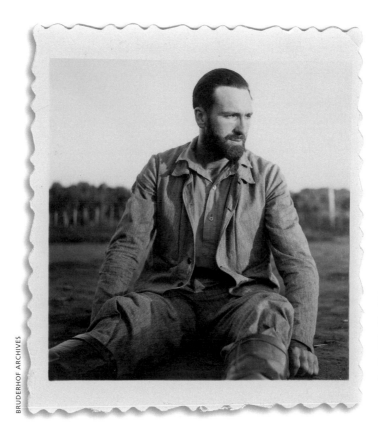

BRUDERHOF ARCHIVES

**Farmer,
scientist, and
poet – and a life
cut short at age
thirty-one**

PHILIP BRITTS

1917–1949

<<
A wall of wellies
outside the Darvell
school: after a
morning of classes,
students spend their
afternoon learning
practical skills in the
garden and barn or
enjoying the fields
and forests around the
community.

The first half of the twentieth century was full of
new technological marvels and horrors. In 1945,
the United States dropped atomic bombs on two
Japanese cities, finally ending World War II but also
showing, in stark destruction and staggering loss of
life, the power of scientific advances.

On a Paraguayan Bruderhof settlement far from
Japan, Philip Britts, a British scientist, poet, and
essayist, wrote:

**Are we really standing at the beginning
of a new age of scientific development, of
supersonic speeds, of atomic energy, of more
and more wonderful machines? . . . Are we
really about to enter an era of greater wealth,
greater luxury, greater leisure, and emancipa-
tion from drudgery? Or has this age reached its
climax, and will this civilization destroy itself
with those forces which it has created?**

**Time alone will answer this question, but it
is by no means certain that the scales will tip**

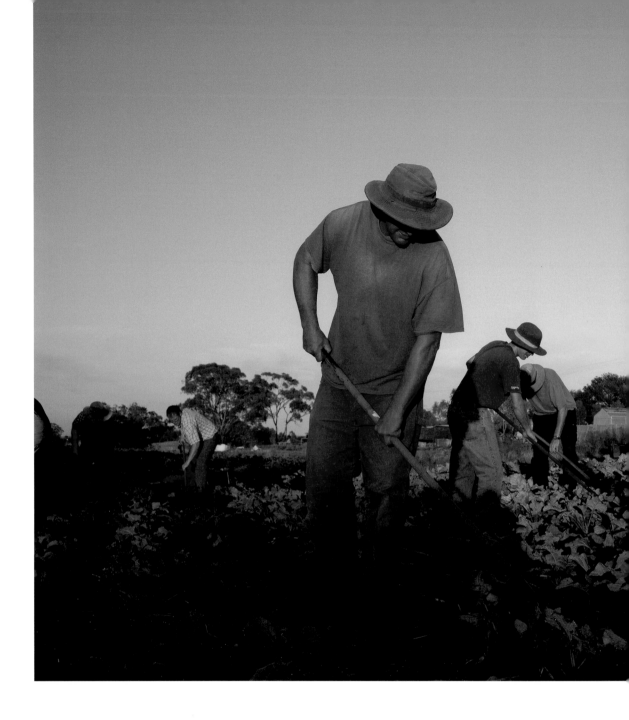

for peace and plenty. To sail onwards in the arrogant confidence that man can manipulate these tremendous forces for the good of all, is to drift toward catastrophe. Is not this the poison of the age, the belief of man in man?

For Philip, the news from Hiroshima and Nagasaki was a dreadful confirmation of the things he had worried about all along, that humans would seize more power, especially through technological innovation, than they could responsibly wield.

Philip was raised in the busy port city of Bristol, and attended the university there. Upon graduating and being named a Fellow of England's Royal Horticultural Society, he married a childhood friend, Joan Grayling, and bought a comfortable stone house with a walled garden.

Then war broke out. A convinced pacifist, Philip had founded a local chapter of the Peace Pledge Union, a national pacifist organization. After England entered the war in September 1939, however, the movement quickly caved in. Thousands of PPU members broke their pledge and threw their energies into defending the country against the threat of an invasion by Hitler.

Just at this juncture, feeling isolated in their convictions, Philip and Joan heard of the Bruderhof. Intrigued by its consistent stand for peace and the witness of its classless, international membership, they cycled there with their dog – a thirty-mile trip. After a week's visit, they decided to join.

That Christmas, Philip wrote a poem that expresses the heart of his calling:

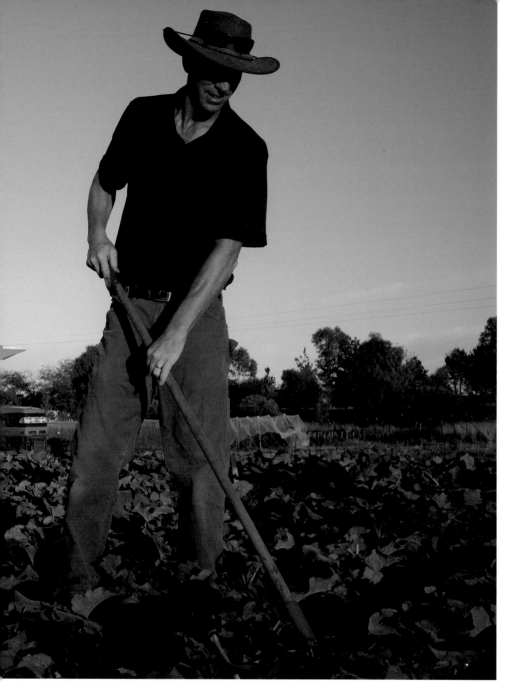

< The gardener gets some extra help from other community members during an early-morning project in the Danthonia garden.

The Carol of the Seekers

We have not come like Eastern kings
With gifts upon the pommel lying.
Our hands are empty, and we came
Because we heard a baby crying.

We have not come like questing knights
With fiery swords and banners flying.
We heard a call and hurried here –
The call was like a baby crying.

But we have come with open hearts
From places where the torch is dying.
We seek a manger and a cross
Because we heard a baby crying.

Already before the young couple came to stay in November, German members of the community were being called to appear before local tribunals to determine if, as "enemy aliens," they should be interned. Finally, the community was issued an ultimatum: it would either assent to having its German members interned for the duration of the war, or all its members would have to leave together. Taking the latter option, the community decided to look for a new home overseas, and found that the only country that would accept such a motley collection of nationals was Paraguay. By the end of 1941, everyone had miraculously made it across the submarine-infested Atlantic and resettled in South America.

In Paraguay, Philip's agricultural training was vital to the community's survival. It took time to build up a garden large enough to feed three hundred and fifty people, but under the expert eye of Philip and other members, the first crops – beans, corn, manioc, rice, and sweet potatoes – were soon being harvested.

Meanwhile, he experimented with plots of wheat, pineapple, grapefruit, and bananas, and took copious notes. Alongside his careful observations were notes and poems that expressed his sense of wonder at the beauty of creation:

The Field and the Moment

The shadows of three men sowing watermelons
Grew very long behind them as they crept down
 the field.
A pair of parrots flying homeward
Shouted noisily to them to look at the sky:
But they continued stooping and dibbling the seed
 in the earth.

In this way they grew a number more melons
And missed what was written in that particular
 sunset,
Which had never been written before
And, of course, will never be written again.

In 1943 Philip visited STICA (Servicio Técnico Interamericano de Cooperación Agrícola), a US-funded agricultural institute based in Asunción, to learn what crops might be most suitable for the community's land. A month later, two of its American researchers returned the visit. They were so impressed by the community's farming – and by Philip's record-keeping – that they offered him a job.

Although it meant leaving his young wife and their five-month-old child, Simon, the community needed the money, and Philip agreed to take the job. For most of the next two years, he lived in Asunción.

Among his successes was the development of a green bean variety later planted by farmers across the country, and a grass variety that resulted in a better milk yield from dairy herds.

After returning to the Bruderhof, Philip continued his work with the institute. STICA rented twenty acres of Bruderhof land, where Philip set up three experimental farms. His research notes fill eight volumes.

But, even as he worked at the institute, Philip had reservations about developments in agriculture. The Green Revolution started in the 1940s in Mexico, where American scientists developed new varieties of wheat with increased yield and high disease-resistance. These strains were dependent on big machinery, high-volume irrigation, chemical fertilizers, and pesticides. In an unfinished essay, Philip worried that chemical-dependent farming would have devastating long-term results:

Adam was charged with the double task to "subdue and replenish" the earth. If a graph could be plotted of the subjection of nature by man, it would show a line, rising slowly at first, through several thousand years, then abruptly and very steeply in the last few years. A graph

of the replenishment of the earth by man would probably show a slow rise throughout the centuries, but instead of following the sharp rise of the line of subjection in modern times, would perhaps curve downwards. This in spite of the extensive use of fertilizers, because chemicals without humus do not give lasting or balanced replenishment.

Where will the lines go from now on? Obviously if the measure of subjection continues to rise, and the measure of replenishment falls, if the lines get farther apart, nature will rebel, and bring down the measure of subjection by such hard steps as erosion, sterility, and disease.

In contrast, his own research focused on organic methods that worked with, rather than against, nature. But on its own, organic farming was not enough:

Man's relationship to the land must be true and just, but it is only possible when his relationship to his fellow man is true and just and organic. Thus we do try to farm organically, but we see this as only one part of an organic life, existing in the context of a search for truth along the

^
Harvesting
tomatoes – grown
under a protective
netting – in the light
of the rising sun

whole line. This gives rise to social justice as brotherhood, to economic justice as community of goods. We see these conditions as the necessary basis for a true attitude towards the land and towards work.

To the question, "How shall we farm?" must be added the question, "How shall we live?"

The only answer, to Philip's mind, was Christian community.

Instead of the glittering palace of manifold divisions, let us seek a simple house with an open door. Instead of the towering organization of worldly skill and worldly knowledge, let us seek a humble trust in God. Let us make the unconditional surrender to the spirit of love. "Except a man be born again he cannot enter the kingdom of heaven." Let us beware of trying to save ourselves by going the two ways. "He who seeks his life shall lose it." Are we standing at the brink of long vistas of prosperous evolution, or is civilization moving towards its own destruction? Has it the seeds of life or death within it?

Our only choice is a choice of service, and service means deed, not word. It is either-or. Serve one or the other. Prune the great tree of division or plant the new tree of brotherhood.

But Philip was also adamant that community "is not a panacea for the problems of life. The struggle is intensified, not lessened. But mutual aid in love gives strength and joy. So let each one who hears this call add his torch to the fire, so that the light of

brotherhood may shine clearly and warmly in the chilly darkness of our times."

In January 1949, at only thirty-one, Philip died of a rare tropical disease. His death shocked the community. Few had realized the gravity of his illness, and suddenly he was gone. He left three young children and Joan, who was carrying their fourth child.

At the time of his death, Philip's practical and intellectual work was barely begun. Had his short life done anything to combat the evils – war, injustice, scientific hubris, natural destruction – that he so deplored? This poem, written in 1941 and published posthumously in *Water at the Roots*, seems to anticipate that question:

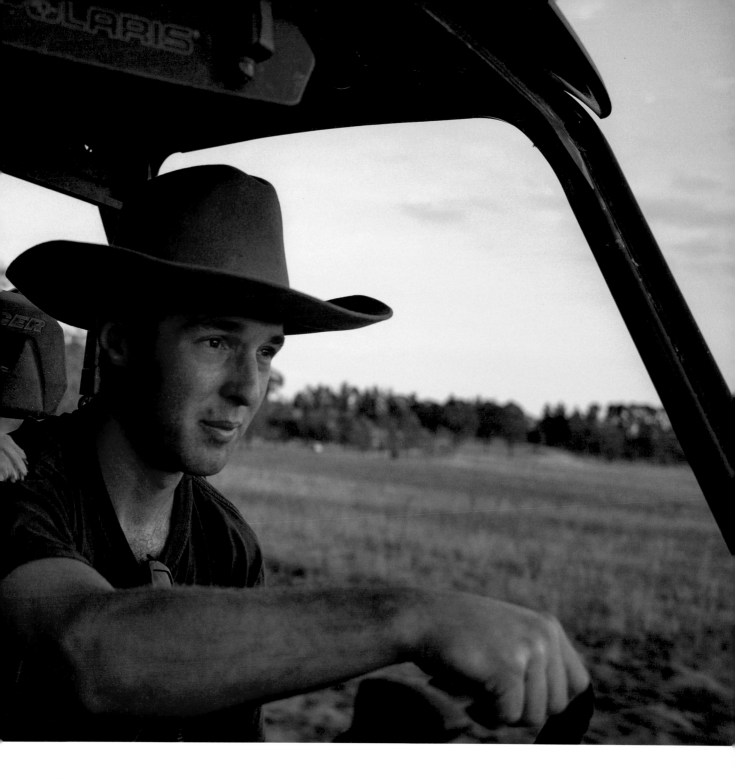

That My White Lamb

That my white lamb is being carried off
In steel-like talons to the unknown hills
And is a lost speck only, in the sky –
That is not the chief thing;

Or that I did not have the strength or skill
To drive off the attacker, to defeat
Merciless claw and swift unerring beak
Or shattering wing;

But my fist is smashed and bloody
And my arm is a scarlet rag,
Showing I struck at the eagle –
And that is the chief thing. ◆

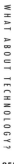

^
Jason and his dog,
Jess, herding cattle
at the Danthonia
community

Everybody needs beauty as well as bread, places to play in and pray in, where Nature may heal and cheer and give strength to body and soul alike.

John Muir, naturalist
1838–1914

^
A family watches the
hay being mown on a
summer afternoon.

JEFFREY KING

1987–

Jeffrey was working in the paint room of the community's metal shop and running a seed-saving project on the side, as a hobby, when someone noticed his passion for gardening. He's now been running a farm on the Bruderhof for eleven years — and collaborating with Hudson Valley Farm Hub, a nearby learning center for sustainable agricultural practices.

In his teens, Jeffrey read whatever farming literature he could get his hands on: material from the Rodale Institute, Masanobu Fukuoka's *One-Straw Revolution,* Suzanne Ashworth's *Seed to Seed.* Mostly he got the books through his father.

Dad studied conventional agriculture but saw the problems it causes. Long-term, it destroys the land. And over time, he became passionate about sustainable agriculture. I remember going to different farms with him and looking at their techniques, and then trying them on our fields.

In our house, Monsanto was always the bad guy. Dad saw their technology, which is marketed as something that will help people, as an affront to the way God designed plants. But it was also obvious to him that this technology doesn't improve agriculture: it's a means of controlling it in order to make a profit. He pointed out the injustice of that.

Dad used to say, "You can't get rich farming. If you are, you're either exploiting the land, or the animals, or people, or all three." He taught me that farming is not about making money. It's about serving people — about feeding them.

I am not afraid of being thought a sentimentalist when I say that
I believe natural beauty has a necessary place in the spiritual
development of an individual or a society. I believe that whenever
we destroy beauty, or whenever we substitute something
manmade and artificial for a natural feature of the earth,
we have retarded some part of man's spiritual growth.

Rachel Carson, writer and environmentalist
1907–1964

COURTESY OF WAREHAM FAMILY

DIRK WAREHAM

1990–

Teaching runs in the Wareham family: both of Dirk's parents are teachers, as were both of his father's parents. Now he himself is a teacher. Following a year of teaching high school earth science at a private Catholic school on Long Island, he returned to the Bruderhof. He is currently teaching first and second grade in Bellvale.

In the school I worked at on Long Island, every student had a school-issued iPad, not to mention a smartphone. Now and then we'd take them to a retreat center and confiscate their phones for the weekend. Some of them were afraid to give them up at first. How were they going to survive? Of course, in the end they did, and enjoyed themselves fully: boating, swimming, and everything else.

I love the fact that our communities' classrooms are technology-free. Without a screen in front of them, the kids are constantly faced with concrete situations and consequences. If I take my class out on a walk in the woods, and they cross a stream on a log and lose their balance, they get wet!

One of the activities my classes love doing each year is maple sapping: tapping the trees, hanging the buckets, collecting and boiling the sap. They even help cut the firewood. Last year we produced one hundred gallons of syrup. We grow vegetables in our summer program. Best of all, I like to teach them something I learned as a child: how to feed chickadees from your hand.

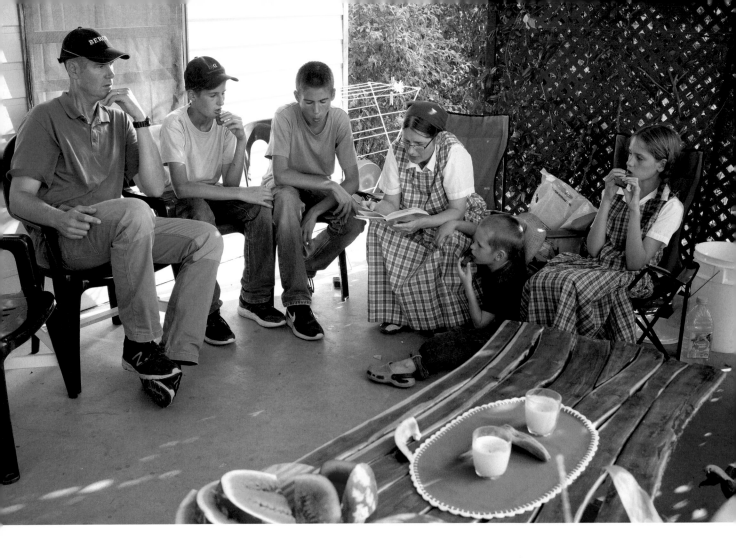

DORI MOODY

1974–

**From a video-game enthusiast
to an advocate for classic literature
and family read-alouds**

^
Watermelon and
Sir Walter Scott: Dori
reads *Ivanhoe* to
her family.

Dori grew up in suburban Maryland in a happy but chaotic household of ten children and two immigrant parents, neither of whom spoke English as a first language. As a child, she found a space for herself in books and, for a short time, computer games.

Dori traces her love of reading to the second grade, when she witnessed her teacher, who was scanning a bookshelf, come across an old favorite, gasp, and give it a hug. Before long she was devouring everything she could get her hands on, from Madeleine L'Engle to Roald Dahl.

Today an accountant at Danthonia and the mother of four children, Dori is still an insatiable bookworm and blogs about the virtues of reading aloud. At last count, she had read 135 books to her family. She has a ready arsenal of reasons why reading aloud is important:

It opens your mind. It enhances imagination. It gathers people around a common activity.

Teaching your children to listen also means teaching them compassion. Our world is torn apart by conflicts and misunderstandings. A lot of it is there simply because we are unwilling to listen to other people's stories: to walk in their shoes, to discover why they are the way they are. That takes time, and effort. Like a good book, life involves layers of meaning, riddles, mysteries.

Some audiobooks are fantastic, but they can't replace reading out loud. For example, if there is a funny passage and everyone is collapsing with laughter, a recording will just keep going. Parts of the story will be missed. If somebody is reading, they will stop and enjoy the merriment with their audience, or repeat a line, or allow for someone to go find a dictionary or trace a journey on a map.

Reading aloud instills good listening skills. And as my children grow into adulthood, I can only hope that they will give their full attention to others, especially someone who is lonely or in need of help, and listen with the same intensity as they do now when I read to them.

Dori recalls that computers entered her public school classroom in Maryland in the early 1980s, when she was

∧
"Goodnight clocks,
And goodnight socks"

∧
Sarah is a
customer service
representative
for Community
Playthings.

in the third grade, via spelling games. A few years later, her older brother John convinced her skeptical parents that they needed one at home.

It was an Apple IIe. Within a few short weeks of the arrival of that wonderful white box with its captivating, flickering screen, I was sitting for hours at my brother's elbow, and addicted to games. We frequently pointed out to our wary parents that they were harmless: that they taught chivalry and bravery, like Tolkien's Middle Earth sagas. But one night at two in the morning, Mom walked in, interrupting my umpteenth round of *Ultima*, and simply pulled the plug. Dad sold the computer. I turned back to books.

Today, as an accountant, I use a computer all day long. I am

probably spoiled by quick results and outcomes, more reliant on technology than my mind. Still, I love the software that interfaces logistics with manufacturing. I love the simplicity of online banking. I love the organizational qualities of email. I am generally thankful that my computer makes work enjoyable rather than tedious.

At the same time, Dori wonders about what she calls "IT creep," the way we can become too reliant on technology for everything from work to entertainment to social relationships, and the addictive nature of screens:

I have less willpower than I'd like to admit. If a TV or computer screen is within sight, I cannot stop myself from watching. Even ridiculous advertisements will arrest my attention.

I recently was traveling by train, and it struck me how each of my fellow passengers was in his or her own world, earbuds inserted, eyes glued to screens. I found the silence deadly, almost like a cemetery. Who's forcing us to sit there like that? No one's trapped us there or locked us into this state of silent bewitchment. As long as we're alive, it's still possible to emerge and embrace the full possibilities of human interaction. There's a vibrant world out there! But we'll first have to put down our phones. ♦

RONYA HORMANN

1996–

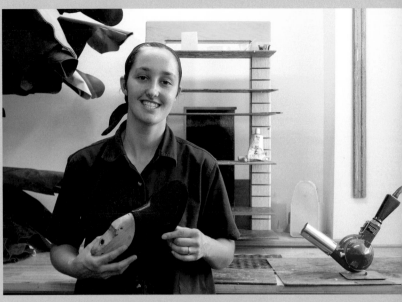

A certified orthopedic shoemaker who was raised on the Bruderhof, Ronya entered the field because it allowed her to combine two interests: making shoes and helping people with disabilities.

I first got into this through my dad. He's made shoes as a hobby for as long as I can remember. At one point I asked him, "Hey, can you teach me to do that?" That's when he started me on the basics: patternmaking and building lasts. Finally he helped me make a pair of shoes for myself.

I just finished a three-year apprenticeship in Germany. The program combined on-the-job learning with courses like basic anatomy and physiology. We sold custom-made shoes, orthotics, and braces to everyone from athletes and the elderly to amputees and people with foot deformities caused by diabetes.

There's a lot of new technology coming into shoemaking. Things like CNC routers, laser cutters, and 3D printers. But every time I learn about a new technology, I find myself thinking, "How can I do the same stuff with my hands? How can I find a simpler way?" Part of it is that as a child, helping my dad at his workbench, I was too young to use his power tools, so he taught me whatever I could do with my hands, or with simple tools. I think it's important to have the know-how before you depend on high-tech stuff.

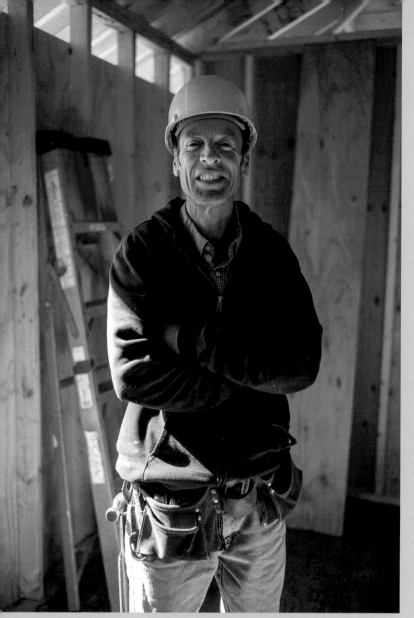

CLEMENT ROBERTSHAW
1962–

An avid outdoorsman who runs an afterschool construction club at the Bruderhof's high school, Clement has taught math, science, woodworking, and history for over thirty years. Surrounded by teenagers all day and dedicated to motivating them however he can, he is concerned that our reliance on technology and our tendency to settle for "the easy way out" is robbing us of the ability to think for ourselves.

I try to pass on the idea that a job well done is its own reward. Everyone knows that sports does more than keep you fit: it regenerates the soul. So does exertion of any kind, whereas ease and convenience kill. I'm 100 percent convinced of that.

Recently, our woodworking club has constructed a picnic pavilion, and now a fifty-foot observation tower out of hand-cut oak beams, and other timber-framed structures, all built with hand tools in the traditional manner. We even drew up the plans by hand.

When you do something the hard way, you develop perseverance. That's hugely important. This goes for academic work too: learning is not just absorbing information. The real question is, "What tool am I using that I can rely on in the future? How does this translate into real life?"

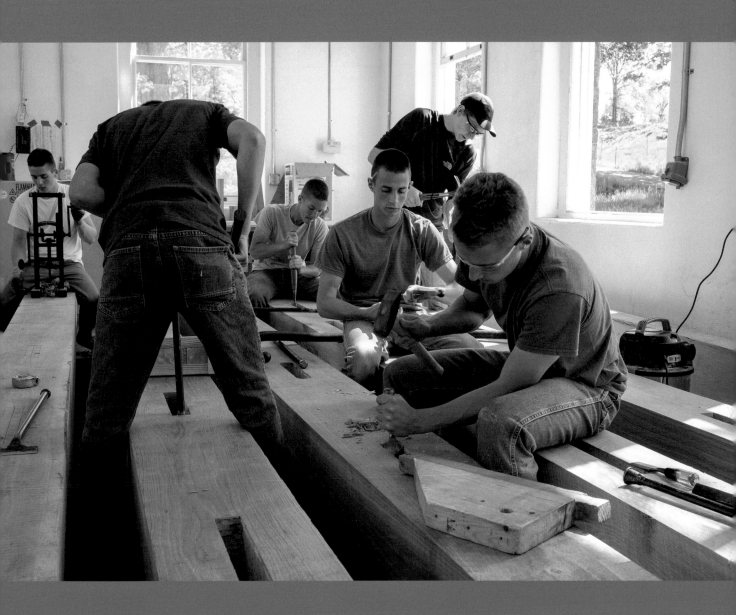

But man, proud man,
Dressed in a little brief authority,
Most ignorant of what he's most assured—
His glassy essence—like an angry ape
Plays such fantastic tricks before high heaven
As makes the angels weep . . .

William Shakespeare
1564–1616

^
Clement's
woodworking class
hand-drilling and
notching the posts
and beams for a
fifty-foot tower

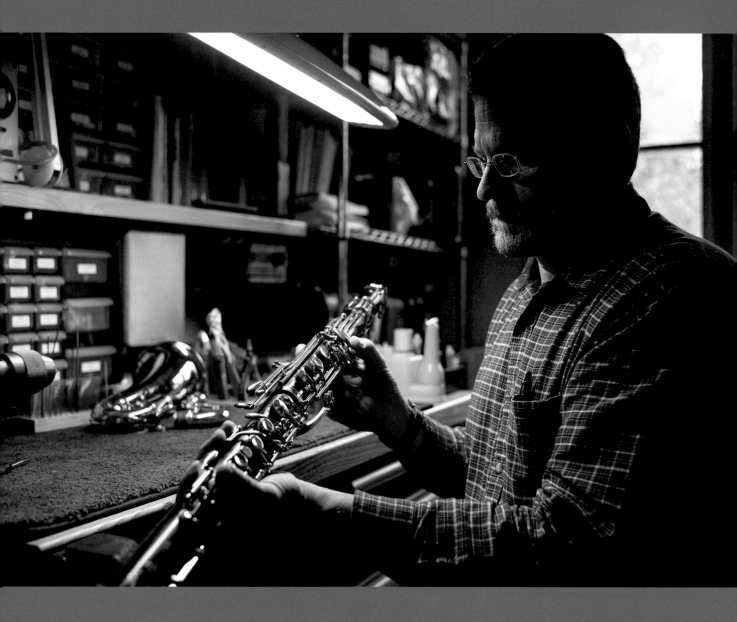

Where the bricks are fallen
We will build with new stone
Where the beams are rotten
We will build with new timbers
Where the word is unspoken
We will build with new speech
There is work together
A Church for all
And a job for each
Every man to his work.

T. S. Eliot, poet
1888–1965

^
Kim repairs
instruments for
both professional
musicians and
Bruderhof
schoolchildren.

A Rochester, New York, native with a master's degree in social work, Leslie, who has been blind since her twenties, joined the Bruderhof in 2008. In a way, coming represented the closing of a circle: she'd come across the community forty years earlier: "There were several young women from the Bruderhof at my college, and one, Annemarie Zimmermann, was my roommate. She would read my textbooks to me."

Years ago Leslie worked at a nonprofit, teaching blind youth how to use computers. Today, she assembles accessories in a Rifton Equipment workshop, and transcribes audio files for Plough Publishing House.

LESLIE UNDERWOOD

1947–

Leslie welcomes the technology she uses, from an electronic device that lets her download audiobooks and a computerized speech program, to her Braille reader and her infrared Cobalt Speech Master. ("You put it up against an object and it tells you the color. It has a wonderful British accent.")

I can fully understand the dangers of people "using" too much technology, whether they're on the internet all the time, or glued to their smartphone or tablet. On the other hand, the computer programs I use are my way of communicating with others—of having community with them.

But I also love physical books. I have a Braille Bible and I get *Harper's*, one of the only American magazines that still puts out a Braille edition. It comes every month in a huge box, like you're getting a big present. And to me, it is a gift: at least one magazine where I can actually read the hard copy. Digital reading just isn't the same. I like to open a book and turn the pages.

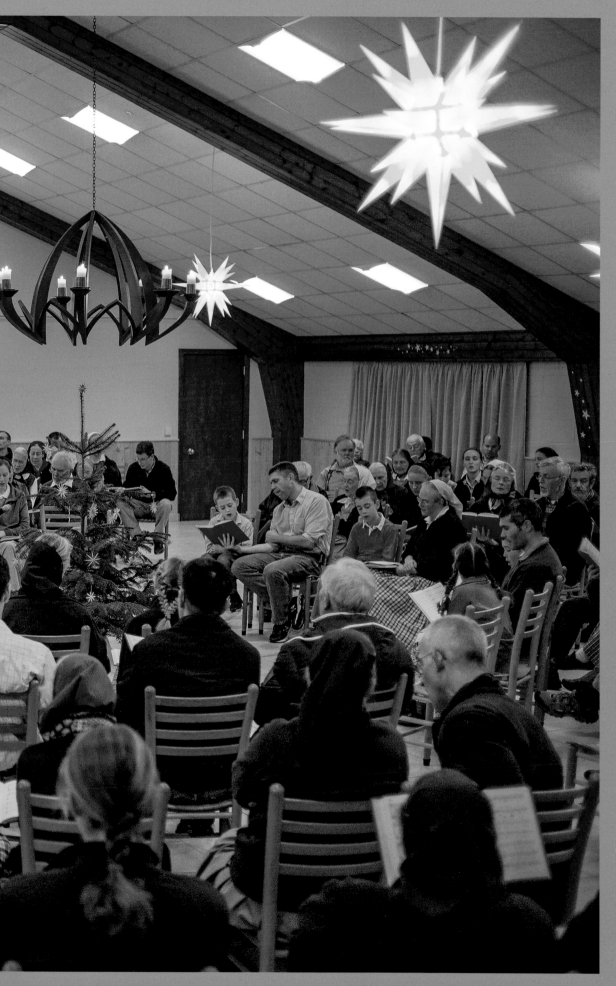

FROM ISOLATION TO COMMUNITY

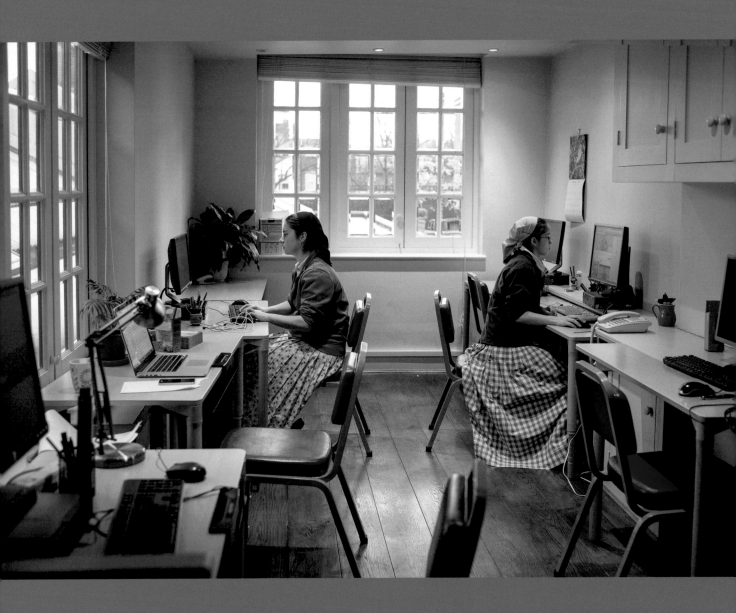

I try to meet each person with the thought, "Here is another
being made by God, who needs love and forgiveness like I do."

Ilse von Köller, nurse and Bruderhof member

1911–1995

^
Ryanne and Marcella
studying in Peckham
House, London

CHARLES GREENYER

1980–

After leaving the Bruderhof at twenty – "I grew up in the community, but wanted to find my own answers" – Charles spent a year in Ireland and then studied computer programming and found a job on Fire Island:

I pretty much threw away everything I'd grown up with. I wanted to make money, to have fun. Over time, though, I found that pursuing my own dream didn't fulfill me. I had this sense of isolation – in myself, but also in the people around me. The cutthroat competition was a real eye-opener for me. I realized that I actually wanted to follow Jesus; to center my life on him. That eventually led me back to the community.

In 2017, Charles and his wife, Ilace, moved to Durham, North Carolina, to lead a Bruderhof house whose primary focus is a campus ministry, Acts2 at Duke.

We had no idea how fulfilled we'd be here. Not having children of our own has been a source of pain to us. But developing relationships with the students that come to us has been amazing. It's like they become family.

We started by hosting a dinner once a week, and seeing who showed up. Now, we regularly set the table for twenty. We eat together, play games, sing, and talk. We've found such a hunger for genuine community: for an atmosphere of love and joy. We all need to share our anxieties and burdens, and for that you need a safe place and a listening ear.

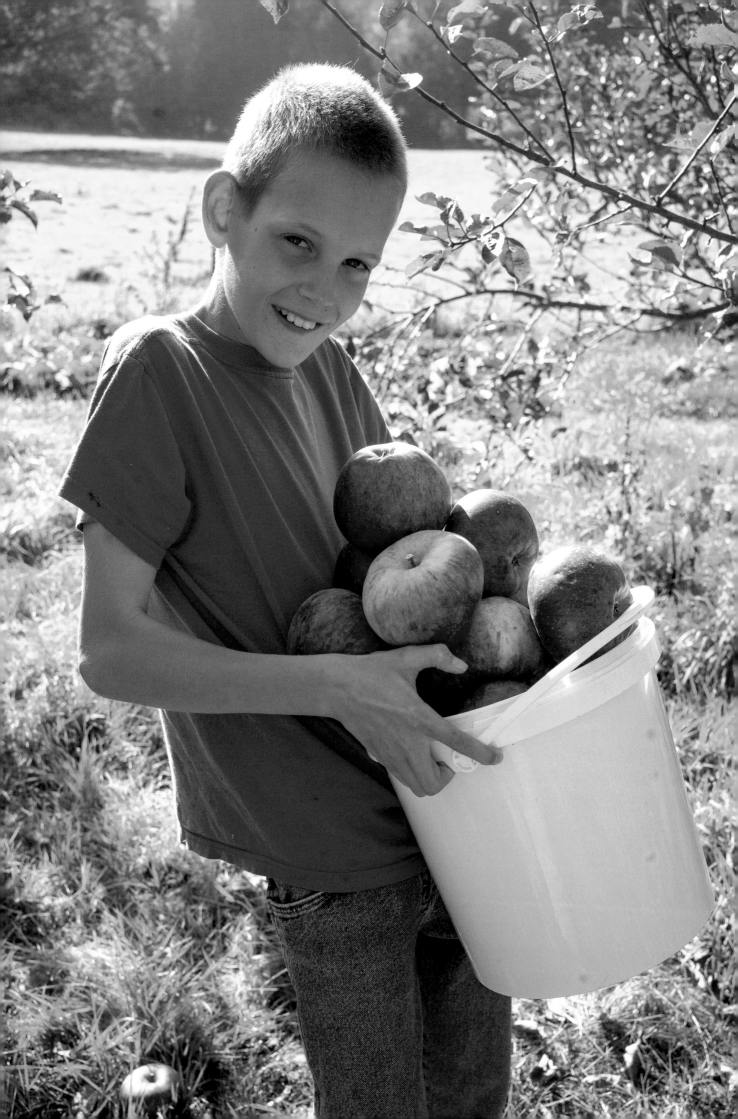

NORANN VOLL

1976–

Born and raised on the Bruderhof, Norann, a teacher, blogger, and passionate cook, has lived and breathed community for as long as she can remember. For years, she took it for granted. Then, in 2002, she and her husband, Chris, and their two little boys (they now have three teenage sons) moved to a new Bruderhof in Australia. In the bush, in a harsh climate marked by droughts, floods, and wildfires, she learned how community can be a life-or-death matter:

When we moved here seventeen years ago, everything was so new and different, and with that unfamiliarity came vulnerability. When you're uncertain, you need other people to help you through. And when your closest neighbor is ten kilometers down the road, a strong sense of community is vital. We're supporting each other through drought, fire, floods, storms.

And it's not just about the dramas the weather throws at us. When the hard stuff of life arrives on your doorstep – whether it's a child who's made a poor life choice, or aging or dying parents, or an accident or an upsetting diagnosis – it's important to have friends who can rally around you and look after you. If you can't depend on your next-door neighbor – well, there may not be anyone else to depend on.

I've spent a lot of time thinking about the pillars of human community: primal gathering elements like fire, food, and water.

Fire, because it brings people together in beautiful, non-threatening ways. Chris and I recently hosted a barbecue followed by a campfire. We invited fifteen people. Forty showed up. That's what a fire can do. Someone began

"It's no exaggeration to say that the hard things are what bring you together with others. A crisis can bring you together in a unique way and leave a deep and lasting bond."

telling stories from his childhood. Someone else talked about the loss of her teenage son. A campfire is a great venue for a deep conversation, maybe because you are not actually looking directly at each other, but at a fire. At a table, you can't avoid eye contact. Around a fire, in the darkness, it's a more relaxed setting, and the focus is not on any one person. You're continually drawn to the fire, to the center.

Food, because sharing it is one of the deepest expressions of

community we can have with one another. One skill I've learned from the farm women around us is what I call "inconvenient hospitality." Life here is akin to pioneering, and it happens all the time that someone suddenly has to deal with an unforeseen change of plans or an unexpected visitor. These women just take it all in stride. Who cares if the house isn't perfect, or the food isn't ready? You'll be invited not only to share the meal, but to help prepare it and to really make yourself at home. That in itself is a beautiful form of hospitality.

Water, because it's life-giving and healing and sustaining. In a land that is primarily desert, water has taken on new meaning for me. And the absence of water gathers people too: when it doesn't rain, month after month, you look out for your neighbors. You notice how their farms are doing and care for the farmers' mental health, which can be fragile at such times.

It's no exaggeration to say that the hard things are what really bring you together with others. A crisis can bring you together in a unique way and leave a deep and lasting bond. I'm not trying to sugarcoat anything, but I am saying that if you look at those around you with eyes of gratitude – if you look for community – you will find beauty and strength. It's a gift for me to be able to share the simple, pedestrian, joy-filled moments of the day via my blog and social media. Platforms like Twitter can be something of a wasteland, and yet it is possible to find and cultivate friendship there too, to encourage grace and gratitude, ask for advice, share questions or recipes, and bring people together. ♦

∧
Norann preparing food
with friends

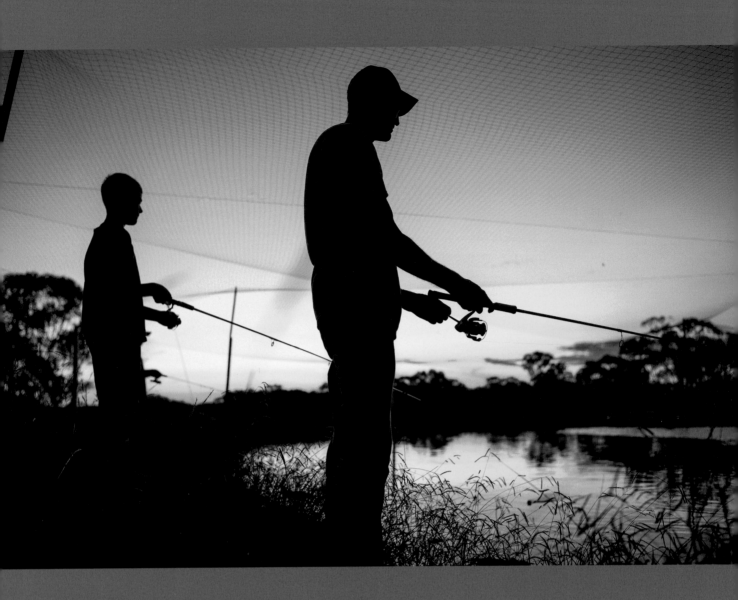

Now Christians can live with one another in peace; they can love
and serve one another; they can become one. But they can continue
to do so only by way of Jesus Christ. Only in Jesus Christ are we one,
only through him are we bound together.

Dietrich Bonhoeffer, pastor and theologian
1906–1945

Evening fishing
at Danthonia's
stocked pond

BILL CLEVA

1951–

By 1978, five years after Bill had graduated from Notre Dame, where he pitched for their Division 1 baseball team, he was working as a civil engineer on the ninety-second floor of the World Trade Center and possessed of every material trapping that was to have guaranteed happiness.

But two years later he quit his job for good, "totally finished" with the corporate world and his yuppie lifestyle. The near-catastrophe at Three Mile Island, plus a scandal involving the Filipino dictator Ferdinand Marcos, Westinghouse, and construction of that country's first nuclear plant played a decisive role:

I was not just disillusioned. It was a much deeper restlessness — a divine dissatisfaction that can only be explained as an intervention from God. I didn't will it on myself, and it didn't feel very divine at the time. My family, colleagues, and friends thought I was crazy. Some stopped talking to me altogether.

In 1994, after years of intense searching for something that would fill the void in his heart, Bill became a member of the Bruderhof. Reflecting on what he found, he says:

My initial infatuation with the outer workings of the community was before very long swallowed up by the overriding demands of trying to put Jesus' teachings into daily practice. The sacrifices never lessen. Yet here is a movement of brotherly and sisterly community that has been sustained for one hundred years by nothing but the fidelity of otherwise flawed people, and by the corresponding leading of the Spirit. I am not aware of any other such comprehensive answer to the ongoing need of the human condition.

> Ashlie with her twin
daughters in their
princess dresses

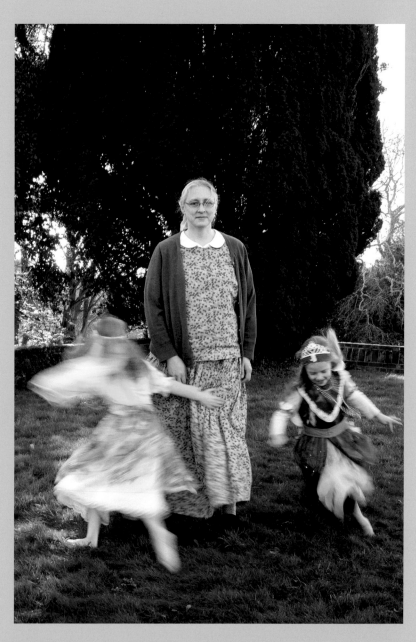

ASHLIE
KLEINER

1975–

Raised in small-town Oregon, Ashlie came to the Bruderhof with her parents and five siblings at fourteen, kicking and screaming. The family had been part of a Christian fellowship, but moving to the community was still like landing on a different planet. "Who'd want to go from Madonna, Bon Jovi, *The Cosby Show*, and *The A-Team* to these people who dress like the Amish?" Today, as a mother of four and an account manager with Community Playthings, she has a somewhat different take on things.

Coming from mainstream America to where I am today took years. I just couldn't fit in. I didn't talk with my parents. It was hell. I left at seventeen.

Later, however, I read *Salt and Light*, a book by Eberhard Arnold, and discovered the community's basis: the Sermon on the Mount. That stopped me. Around the same time, I had an experience I can't describe, except to say I was overwhelmed by God. All these outward things didn't matter anymore. God knocked at my door, and I had to open it. I came back home.

The community's no utopia, but I can't imagine living anywhere else. I was raised on TV, in a sexualized world driven by consumerism. My kids are growing up outdoors. There's an innocence here, a peace and security I wouldn't trade for anything.

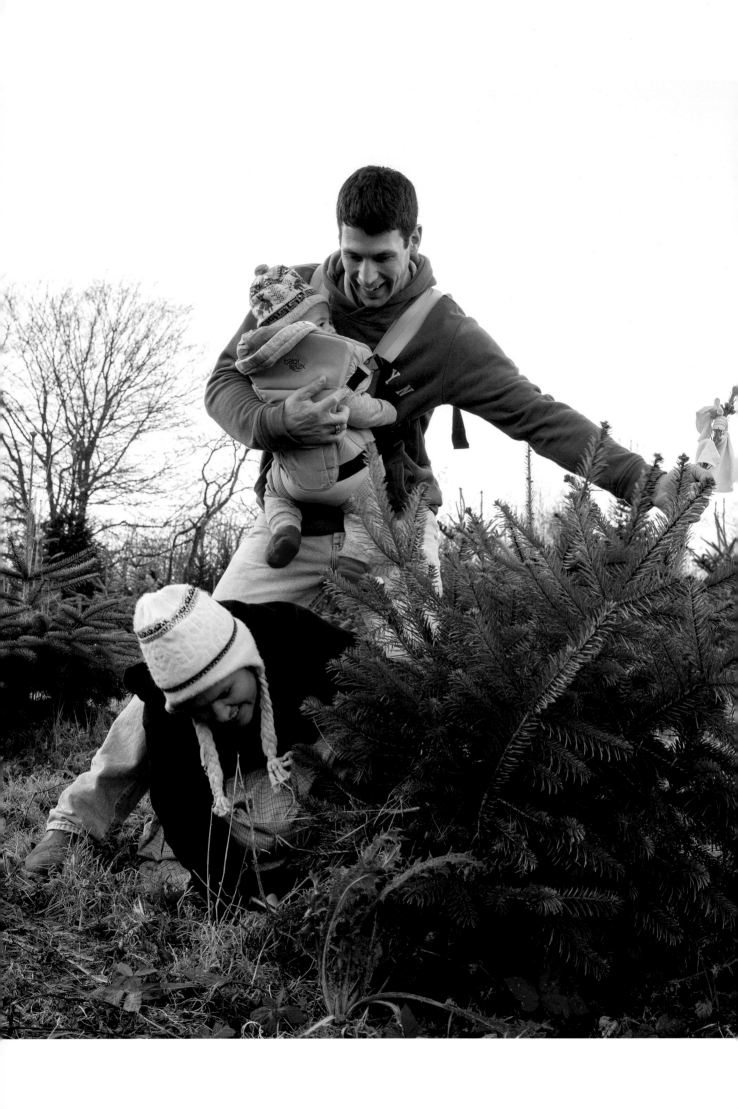

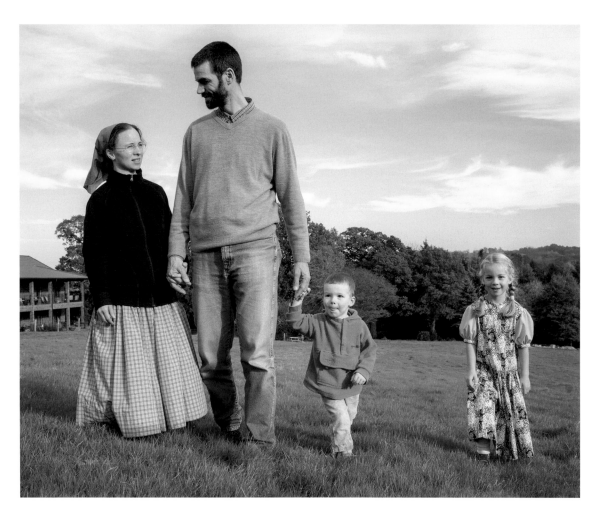

DANIEL HUG

1975–

At twenty-five, Daniel was living in the German university town of Mainz, wrapping up his master's degree in communications (he also studied psychology and philosophy), and wondering what he should do next.

I kept circling around the question, "What is life all about anyway?" I didn't have a religious background, yet in the end I went to a Buddhist monastery to try to find out.

Later I moved away from Buddhism and began a long journey through Christian communities and monasteries. I lived with a group of Franciscans. I also made a final foray back into Buddhism, at a hermitage in Sri Lanka.

Looking for life's meaning on your own terms is tempting because you can arrange everything just as you like it. But I think it is also

an illusion – the idea that it is the way that leads to God. One of my more providential encounters in this regard was with an old hermit in Scotland. He taught me that if you are always in the driver's seat, nothing will work – that God will not bless your search. He said, "You need to find someone to be obedient to."

Sometimes Daniel wasn't even sure what he was after. He knew only that he could not settle for the "fragmented, materialistic lifestyle of Western consumerism."

In 2007, Daniel visited Sannerz:

Outwardly, the forms were totally alien to me. I was used to the silence and solemnity of monasteries, and here it was all bustling activity and lots of children – a very different spirituality. Like

<<
Curtis and Fran
harvesting their
Christmas tree

every newcomer, I was a stranger to the particulars of Bruderhof customs and culture. Finally, there was the whole idea of giving up my "freedom" and being account-able to others, and trusting people in a position of leadership. That's not something a liberal academic upbringing prepares you for. Despite all this, Sannerz was an oasis for me in a time when I was pretty much in the desert – or to put it another way, a beacon of real hope, pointing to the kingdom of God itself: to the essence of all that is good. I didn't choose the Bruderhof. I was called here.

He became a member the next year, and in 2009 married Jessica, a teacher. They have a daughter and son. Today he does marketing for Community Playthings and translates books for Plough Publishing House.

Living in community means giving up things. That includes your wishes and plans. If you join a community in order to answer God's call, you have to really do that, and give up everything else.

Everyone has a different path, even within the community: there is a huge range of lives that are lived and can be lived. But in every case, the key question is, "What is God calling me to?" There's the person I might like to become, but then there's the person that God wants me to become. The two might be quite different.

Living in a community doesn't always mean experiencing true community. That has to be sought anew each day. Inner fellowship and heart-to-heart encounters can happen, but they're not a constant. There's no guarantee against frustration.

Community is not the be-all and end-all. It's more like a marriage partner. It will never be perfect. If you're looking for perfection, you're going to be disappointed. And it can't replace your relation-ship with God. You won't survive without personal communion with him. ♦

∧
Leanne teaches the art of flossing at Fox Hill's dental clinic.

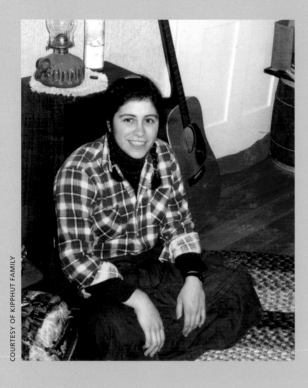

TAMI KIPPHUT

1959–

Co-founders of an intentional community near Buffalo known as Ransom House, Tami and her husband, Jeff, joined the Bruderhof in 1991. Since then they've raised two children. In 2018, the Kipphuts moved to Minneapolis to be a presence in the neighborhood and to connect with people who are looking for Christian community. In Tami's words:

We've met so many people who have a need to belong — to be united with God and with others. What they don't realize is that they'll have to change — their paradigms, but also their way of relating. They're looking for external answers, but underneath, there's this deep discontent.

The younger people we've met are looking for wholeness too, but they aren't interested in anything that feels like an institution. They are desperate to find the genuine and the authentic in life.

Others are engaged in all sorts of religious activity while their inner needs go unaddressed. Jesus calls us to a life of true love and healing and these form the pillars of a life together. Everyone longs for harmony between our inner and outer lives.

So we try to give them what we have: our time. I believe our most important service is listening to their problems. When I listen to someone and seek with them, maybe together we can find answers that neither of us would have found on our own. That's the mystery of community.

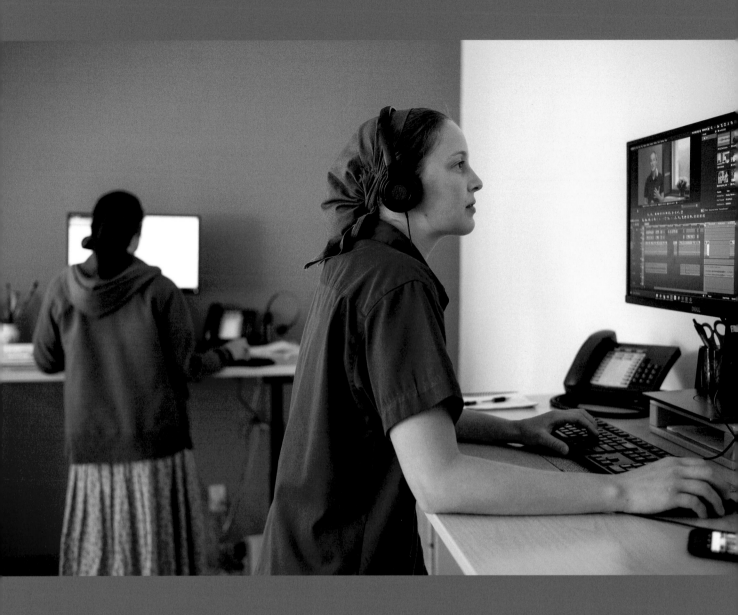

Love is not consolation. It is light.

Simone Weil, philosopher

1909–1943

BRUDERHOF ARCHIVES

MIRIAM BRAILEY
1900–1976

Miriam, a Vermont native who studied medicine and earned a doctorate in public health, was the director of the Johns Hopkins tuberculosis clinic in Baltimore by the age of forty-one. She authored a highly regarded study on the disease that is still referenced today. But despite her success and the accolades it brought her, she was inwardly lonely. As a Quaker with ideals of social harmony, she struggled to make sense of the "dividedness and lovelessness" she saw all around her. In 1950, she protested the Red Scare by refusing to sign a government-mandated loyalty oath, and lost her position as a result.

In 1959, Miriam joined the Bruderhof, which she had been visiting for a year. As she explained in a letter, she wanted to become part of a community "without religious cant and false piety, where people work for each other instead of competing against each other,"

and to "participate in an ideal I have always believed in but never had the chance or the courage to try." Over the next several years, until her eyesight failed her, she served in the community as a physician.

On the evening she became a member, Miriam told the community:

Love can't be willed. Yet it is our will – self-concern and pride – that keeps us from the visitation of love. The price of having love to give other people is the price of becoming small. That doesn't happen much unless you are in a group with the same commitment and purpose and frankness. We need each other, badly, in order to prevent God from being eclipsed by our own personalities and achievements. Even a little displacement of the ego lets in enough of God so that it seems wonderful to risk everything for it.

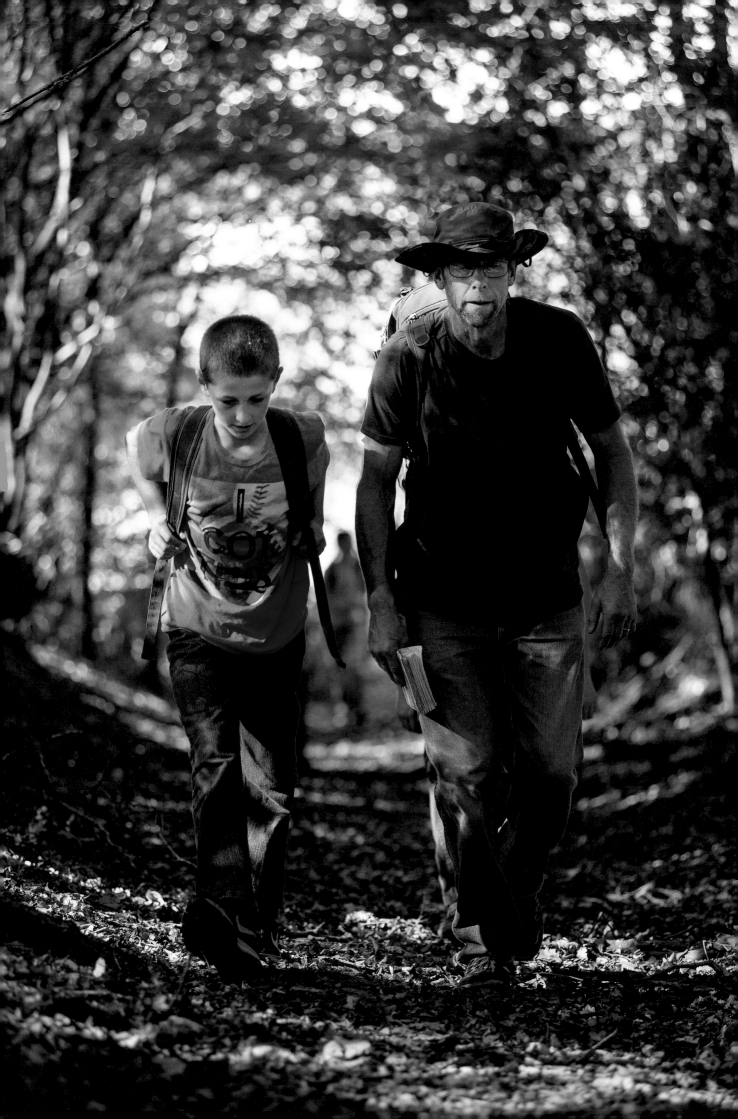

MARTIN BOLLER

1995–

Martin works as a sales rep for Community Playthings in Europe. His preparation for the job included a three-year training outside the community at a furniture manufacturer in Bavaria, where he did "everything from HR to logistics."

The work was enjoyable, but I was frustrated by tensions caused by backbiting and the drive to get ahead of others. There was this polite veneer, but underneath, mistrust and loneliness.

The highlight of each week was the evening I spent with young men I met at trade school – from Afghanistan, Syria, Somalia, and Pakistan. This was during the 2015–16 refugee crisis, and thousands were pouring into Germany. All it took was saying "Hi," and next thing you knew, they'd invited you to stop by the center where they were being housed. We cooked. We played a lot of soccer.

Many were traumatized by all that they'd been through. Some would sleep for days on end. Some mutilated themselves. But their biggest hurdle was feeling alone and invisible. These guys couldn't have been more different from my colleagues at work, but they were living under the same stress, and dealing with the same loneliness.

<<
Danny and a student take the lead on a school hike.

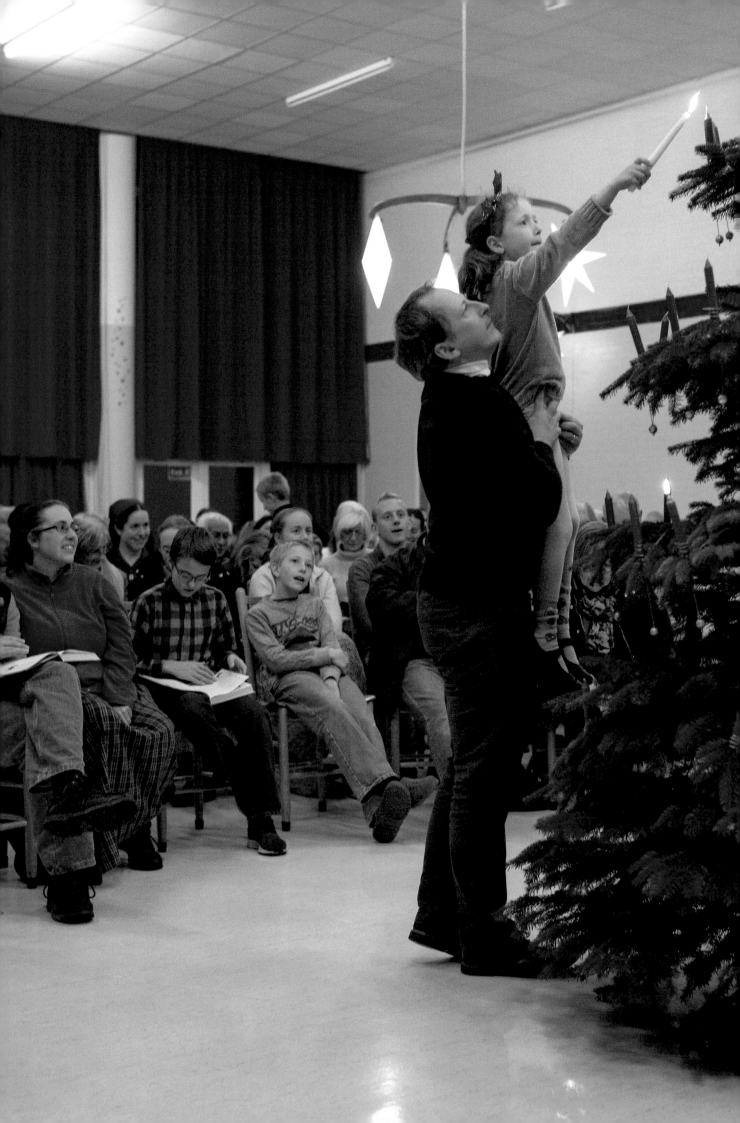

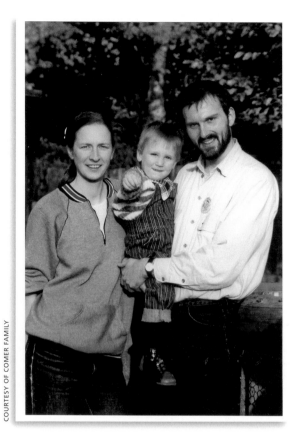

KIM COMER

1962–

**From a fatherless childhood
to community**

Kim's journey from loneliness to community began during his childhood in Alabama:

I grew up in a single-parent household: just me and my mother. Naturally, as I grew up, I wondered where my father was. She told me he was a very important person who had important things to do – things that kept him away from our home – and that our job was to keep the home fires burning and make him proud. Not surprisingly, I created, over time, a sort of fantasy picture of the world's greatest dad.

When Kim turned six his mother sent him to boarding school, a military academy that she hoped would instill discipline and perseverance in her son.

During his senior year of high school, Kim's fantasies regarding his heritage were shattered. A half-brother he had never heard of showed up one day and took him to visit their father, who was dying:

We talked as we drove to the hospital, and the more my half-brother told me, the more it became apparent to me that my father was no hero but just a regular married man with a family who had, somewhere along the way, gotten involved with my mom; and that I was an accidental result of that relationship. When we got to the hospital I was not really prepared

to meet him. The man I saw in that hospital bed was in no way the dad that I wanted. I left that room rejecting him, and in the process rejecting a big part of myself.

After high school, Kim attended Georgia Tech, where he studied engineering on a scholarship. But try as he might, he couldn't shake the feelings of confusion and bitterness and even hatred that followed his brief encounter with his father. When an opportunity to stay in Europe opened up, he took it. It was a chance to get as far away as possible from the mess he was in.

Kim spent six months in France on a dairy farm, and then six months working at a nursing home in Germany. Eventually, not really knowing what he wanted to do, other than stay in Europe, he applied to study Latin and Greek ("subject areas that always had empty slots for international students") and was accepted by the University of Hamburg. While studying there he met Ulrike, a medical student. Kim and Ulrike married in 1987.

Kim's time in Hamburg was the happiest chapter of his life thus far: he was embraced by Ulrike's extended family, which included not only her relatives but also the members of a vibrant network of youth groups associated with her church. He recalls:

>
The community
welcomes Marcus
and Becky's fifth
child — through a
window, of course, till
he's a little older.

These young people were grappling with finding a real faith: one that could be expressed and lived out, personally, and in society at large. They accepted me and made me feel that I was one of them.

And yet, the Comers grew uneasy with the pressures they faced as young professionals. In Kim's words:

I never saw my training as my calling in life; I knew very well that it was a fluke. On the one hand, there was the supposed privilege of working at a university. In Germany, a sense of awe and wonder pervaded the air around people with academic titles. But it was so empty: all this prestige, though they hadn't worked any harder than anyone else.

I was just coming into the final phase of my studies, finishing research and taking exams; and Ulrike was coming into the internship and residency phase of medical school. And both of us kept hearing these questions in the back of our minds: "What are we going to do with our lives, once we are finished with school? What is our vocation, our real calling?"

I kept on studying. Even though I sensed that my work wasn't all that important, it was interesting. And once our son Clemens was born, I had to provide for him. Plus, my job had been created for me by the university and couldn't have fit me better. My field of research was the transmission of ancient Greek mathematics through the Middle Ages, and I knew of only one other person specializing in it at the time – some guy in Austin. So I threw myself into producing quality academic work, getting published, speaking at conferences.

During the first year or two of our relationship, we were involved with youth work and the Salvation Army; we attended Bible study. By the time our second child, Bennet, came along, such activities were falling by the wayside, and we were being supported by our church, rather than the other way around: for example, an older lady came to take our kids out for walks when we felt that we should actually be supporting her. Despite our best intentions, we were increasingly caught up in the rat race and the need to present ourselves as "successful." Our lives were so disjointed.

Then two events brought everything to a head. The first happened on the night of January 17, 1991, when the United States began bombing

290

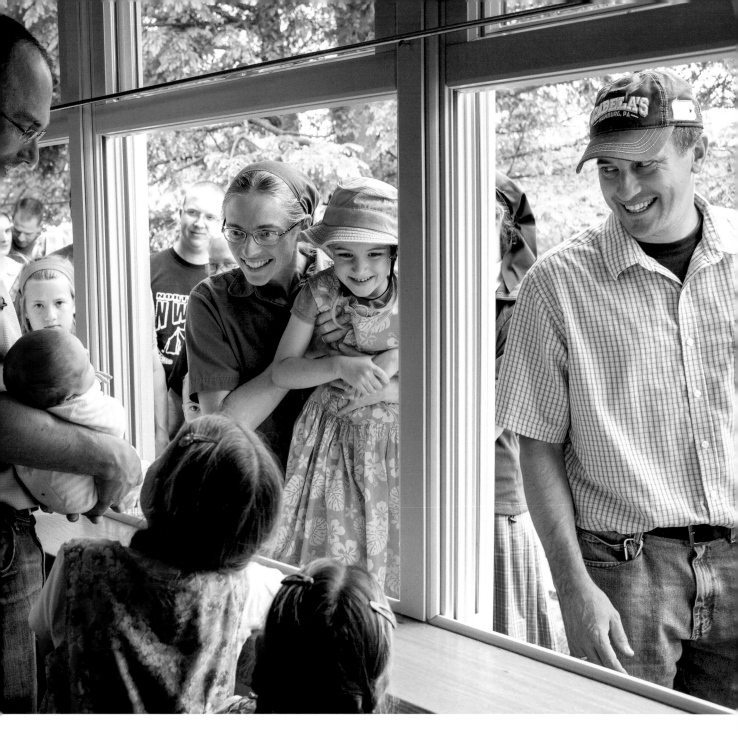

Baghdad. I was at the university, working late on some important papers that were to be presented at some important conference on some very unimportant things.

I was working in a tall building known as the Philosophenturm – the philosophers' tower, which housed offices for the humanities, and suddenly I heard shouting down in the streets. I looked out, and saw all these young people milling in the streets, protesting the bombing and setting things on fire. I turned the radio on, and there was a CNN reporter in Baghdad. It was horrific – grotesque – what was happening: all-out war in Baghdad and in the streets below me. And here I was, trapped in the proverbial ivory tower, completely detached from anything

of substance, poring over old Greek manuscripts. If I could put my finger on one place in my life where I almost snapped, it was there.

The second decisive event came the following week, when a couple – good friends of ours who had been married for ten years – told us that they were separating. Ulrike and I both felt then, and in the weeks and months afterwards, that we were actually on the same path: that there was nothing holding our marriage together that hadn't also been holding our friends' marriage together, so to speak. It left us wondering how we could change our life.

Then the Comers heard about Michaelshof, a Bruderhof community in Germany, and out of curiosity made plans to visit.

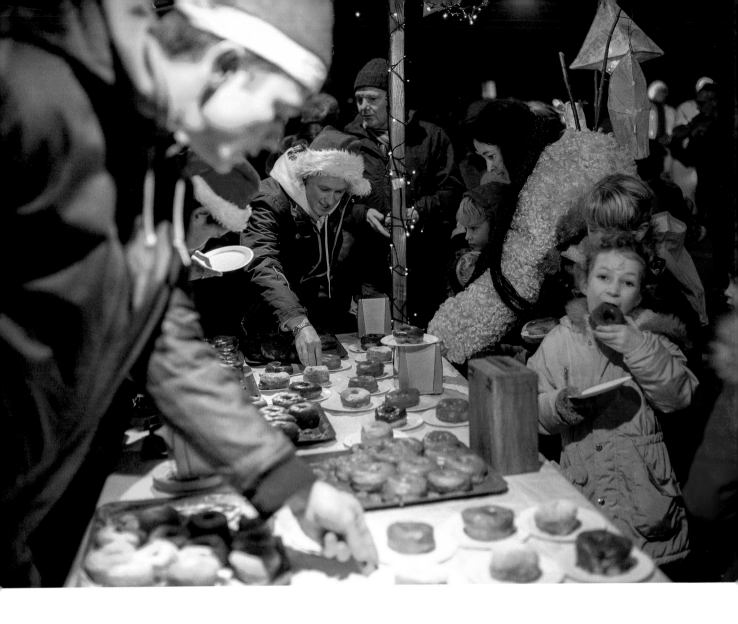

All we really knew was that we didn't want to slide into a life of materialism: we had just bought a new stereo system, and were talking about getting a car. And we knew that we wanted to be part of a church where we could do things together, also as a family.

We felt that the "modern" way of life, where each spouse is focused on working to pay the bills while the children are off on their own all day in school, was ultimately destructive. It pulls you in all directions at once. It never comes together anywhere. It never allows you to commit to anything, or even to really contribute to something bigger than your own happiness.

When we drove into the driveway, we knew we were home. We asked to become members the same week. Later, people wondered what had made us decide so fast. But there was really no decision to make. When you're drowning and somebody throws you a life ring, you just grab it.

In retrospect, Kim says he feels it was "a grace" that they weren't looking for community per se: "We knew people who went from one community to another, shopping for the ideal place. We were spared all that."

At the Bruderhof, he found a new context for addressing old challenges:

My whole life has been blessed (or plagued, according to my mood!) by different forms of community, so I have hardly ever experienced loneliness in the sense of social isolation. But I would say that none of them, including marriage and Bruderhof life, have solved or resolved or eliminated my tendency toward being a loner, or feeling alone. In some ways, I would even say that the aspiration to community exposes and highlights the problem.

But working through his problems with others who have made an unconditional voluntary commitment to each other provides "a security which stands in stark contrast to the precariousness of other human relationships." True community "does not depend

on living up to a particular standard," but "requires honesty, forgiveness, and vulnerability. You can live alongside others without those, and it may look and feel like community, but without them, you are missing its essence."

This vulnerability begins in one's relationship with God. Kim explains:

It is before God himself that you have to own up to your own weaknesses, and to the patent discrepancies between the person that you would like to be (that is, the person you would like others to see) and the person that you actually are. Someone once said that God doesn't love the imaginary person you try to be; he can only love you as you really are.

That was my struggle as a young man. I was angry about who I had found out I really was. Once you can accept who you are, and accept God's love for you, the community you have with him will allow you to overcome your lack of confidence, and your isolation, and to find community with others. ♦

<<
Darvell's famous
free donuts at the
Robertsbridge village
Christmas fête

∧
Mercy at a London
Christmas market

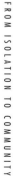

LEE SLEDZIANOWSKI

1949–2006

A small-town boy from New York State, Lee joined the army in 1968 and arrived in Vietnam the next year. He extended his tour three times and lived through unspeakable things. Within months of returning home he married his high-school girlfriend; they had a daughter and son. By 1989 he had been divorced by his wife, forbidden to see his children, and was on suicide watch in the Ulster County Jail. That Christmas he received a card from Dorothy, a ten-year-old girl at nearby Woodcrest Bruderhof whose class had decided to send cards and cookies to the jail inmates.

His thank-you note to her ("I always tried to be a courteous person," he said later) turned into a correspondence with Dorothy and her family. After he was released from jail, Lee visited Woodcrest and later moved into a small apartment on the edge of the community. He never became a member, but for over fifteen years he was part of the Woodcrest community. He joined Dorothy's family for meals every week. He worked as a groundskeeper and good-naturedly managed the community's wastewater treatment plant. Eventually he started joining the community for special occasions. Because his own daughter had loved horses, he organized and paid for riding lessons for over thirty community children. Although not conventionally religious, he had a deep admiration for Native Americans' connection to the created world: "Mother Nature is my god." He liked to tell about the beauty of Vietnam and its people.

Lee never stopped suffering from his war experiences. "Can I ever forgive myself for what I have done? No." In 1996 he wrote, "Since I came to the community, life has been worth living again. The letters of a ten-year-old have given me years I would not have had. Still, there are hard times. Part of my soul is missing."

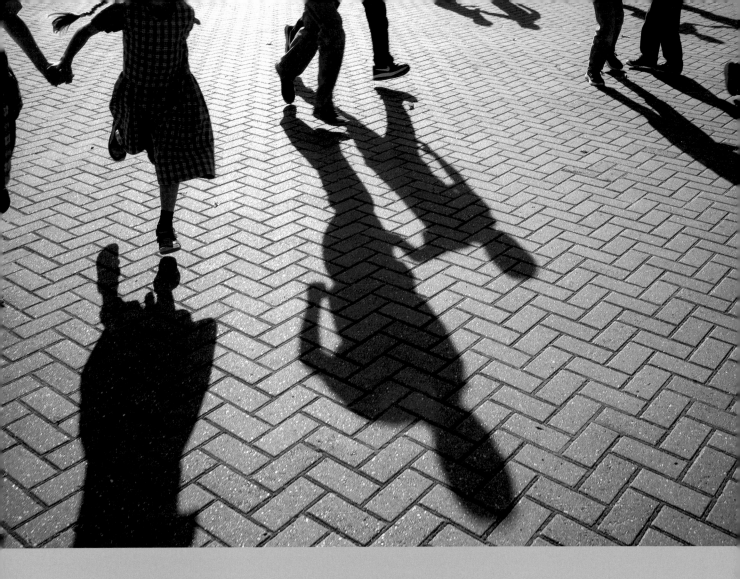

A week before he died unexpectedly of a stroke, Lee told Dorothy's father, Marcus, "My life has been a complete waste." Marcus disputes that:

I often said, "Lee, think about the future. Put something in the bank for when you can no longer work." But he'd refuse. He paid for riding lessons. He bought flowers and gifts for people. He left huge tips for tired waitresses in diners. He gave away money to neighbors who were in trouble. When he died, his bank account was empty, even though a few months before he'd gotten quite a bit of money from a workers' compensation payment. It had all been given to a family that was struggling to feed their children.

Hundreds of people came to Lee's funeral at the Woodcrest burial ground. Standing around his grave, the community sang a Dakota hymn.

Dakota Hymn

Many and great, O God, are thy things,
Maker of earth and sky.
Thy hands have set the heavens with stars;
Thy fingers spread the mountains and plains.
Lo, at thy word the waters were formed;
Deep seas obey thy voice.

Grant unto us communion with thee,
Thou star-abiding one.
Come unto us, and dwell with us.
With thee are found the gifts of life.
Bless us with life that has no end,
Eternal life with thee.

AFTERWORD
BY PAUL WINTER

When Clare Stober first told me she was putting together a book of stories of our fellow Bruderhof members, I loved the idea – but also wondered how it would work. It wasn't that I doubted the value of the material. As a Bruderhof pastor for the last four decades, I've had the privilege of hearing many of these stories firsthand. Often this was at a special occasion: a wedding, the birth of a baby, a graduation, a funeral. At such moments, fellow members often tell how they came to start on this way of life; of the joys and adventures they've found in it; of their sorrows and regrets. Listening to them speak, I often find myself thinking, as Clare says she did: "These stories deserve to become a book."

Yet the challenge of actually creating such a book seemed enormous. Could the heartfelt openness of ordinary people telling their stories really be captured in print?

All the greater was my surprise and gratitude when I opened my advance copy of the book you now hold. I found it hard to stop turning the pages. Reading the hundred stories told here and studying Danny Burrows's beautiful photography, I was overwhelmed once again by how each soul is so different, each life path so unique. As the chapters progressed, through unexpected and sometimes painful twists and turns, they spoke to the victories and defeats that make us human.

This book reminded me of a crucial lesson I learned early in my service as a pastor: the importance of listening to each person we encounter. Through careful listening, we may be given insight into how God has worked in other people – and into how God may be speaking to us through them.

The book also touches on themes that strike me as vital as I've reflected on the Bruderhof's hundred years of history. Since our community began in 1920 in Germany, there have been any number of times when human blundering and sin threatened to derail our greater purpose. In this respect, our history is just a microcosm of the history of the wider Christian church, going back to the time of the New Testament. The letters of the apostle Paul, for example, speak repeatedly of the believers' struggle to maintain the bond of fellowship through disagreements and failures. Yet Paul concludes: "My power is made perfect in weakness." This holds true not just for the individual, but for a community as well.

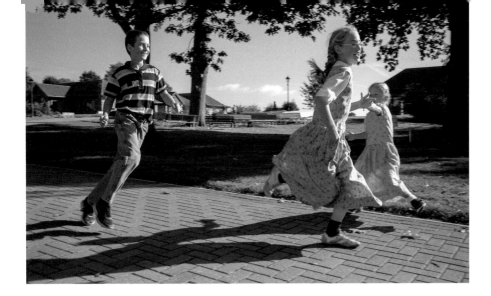

In 1933, just months after Hitler's rise to power, Bruderhof founder Eberhard Arnold spoke to his community about what holds a Christian fellowship together. It was his fiftieth birthday, and thirteen years since the Bruderhof's beginning. "On this day," he said, "I have been especially conscious of my lack of ability and of how unsuited my own nature is to the work I have been given . . . with the result that so much of what God must have wanted to do by his instrument has not been possible." Human beings, he went on to say, are incapable of building brotherly and sisterly community without Christ:

> This is the root of grace: the dismantling of our own power. Only to the degree that all our own power is dismantled will God go on effecting the results of his Spirit and the construction of his cause through us, in us, and among us – not otherwise. If a little power of our own were to rise up among us, the Spirit and authority of God would retreat in the same moment and to the corresponding degree. In my estimation, that is the single most important insight with regard to the kingdom of God.

The truth in these words has remained decisively important to the members of our community as we seek to follow Jesus together. Without this reliance on God, and the repentance and renewal that flows from it, life together becomes rigid or falls apart.

How will the next hundred years of the Bruderhof unfold? That is in God's hands. After all, a century is a mere blink of time in the context of God's history, and the Bruderhof is only one small cell in the body of the universal church. The task of every Christian, no matter what our place in that body, is to remain true to Christ's calling, working together to seek his kingdom, in the certainty that he will return.

And for readers who don't share this faith, I hope this book can still serve as an inspiration for imagining a better way than the injustice and alienation that plague today's society. Whatever our beliefs, let us hold on to the hope that another life is possible: the life of love, justice, and joy that every soul, in the end, longs to find.

Paul Winter is the senior pastor of the Bruderhof communities.

>>
Next spread:
A Darvell school group visits Cranbrook Union Mill, a working windmill and museum in a neighboring town.

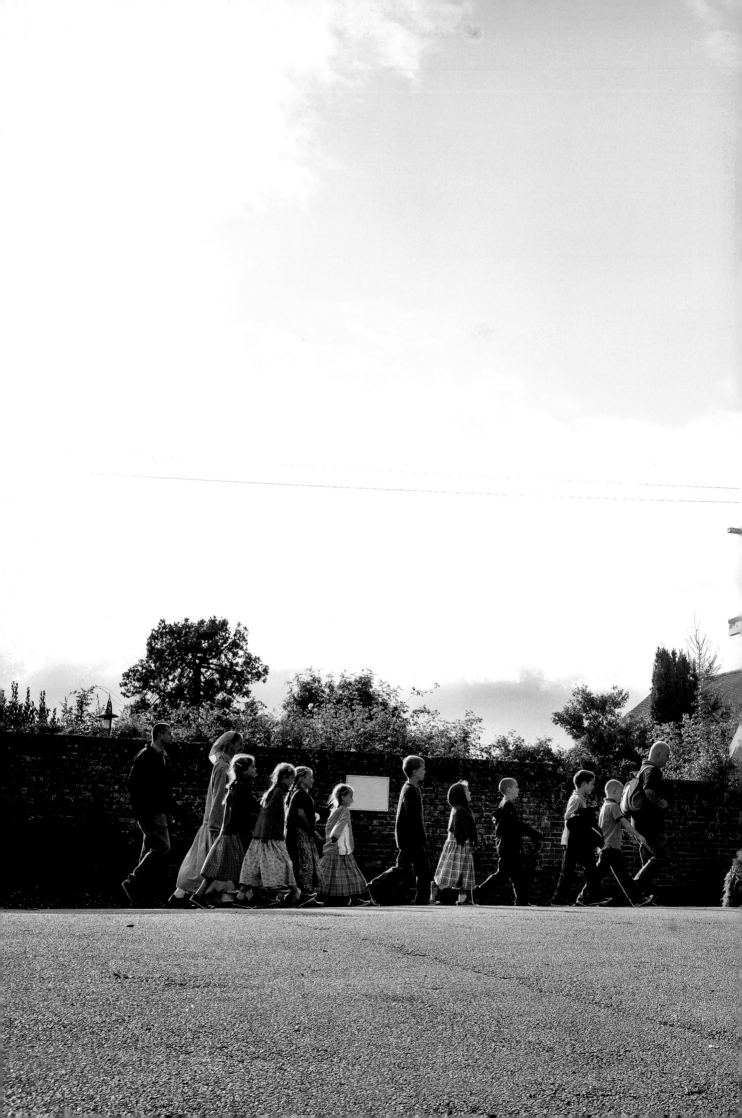

My plea to you as I think about the future is that God's work finds new expressions in you, and that you link it with the living history of what God is doing today. Different expressions will never contradict what God has given in the past.

What God worked in the past never remains in the past; it lives in the present and points to the future. Times change, demands change, but God's will never changes, and he is at work today. Your task is to go forward with courage and joy.

Johann Christoph Arnold
Author and Bruderhof senior pastor
1940–2017

LEARN MORE

To see additional photos, explore more stories,
and sign up for email updates, visit:

AnotherLifeIsPossible.com

To read more about the Bruderhof, get in touch,
or arrange a visit, see the community's website:

Bruderhof.com

To discover other Plough books and its
magazine, *Plough Quarterly*, visit:

Plough.com

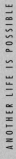

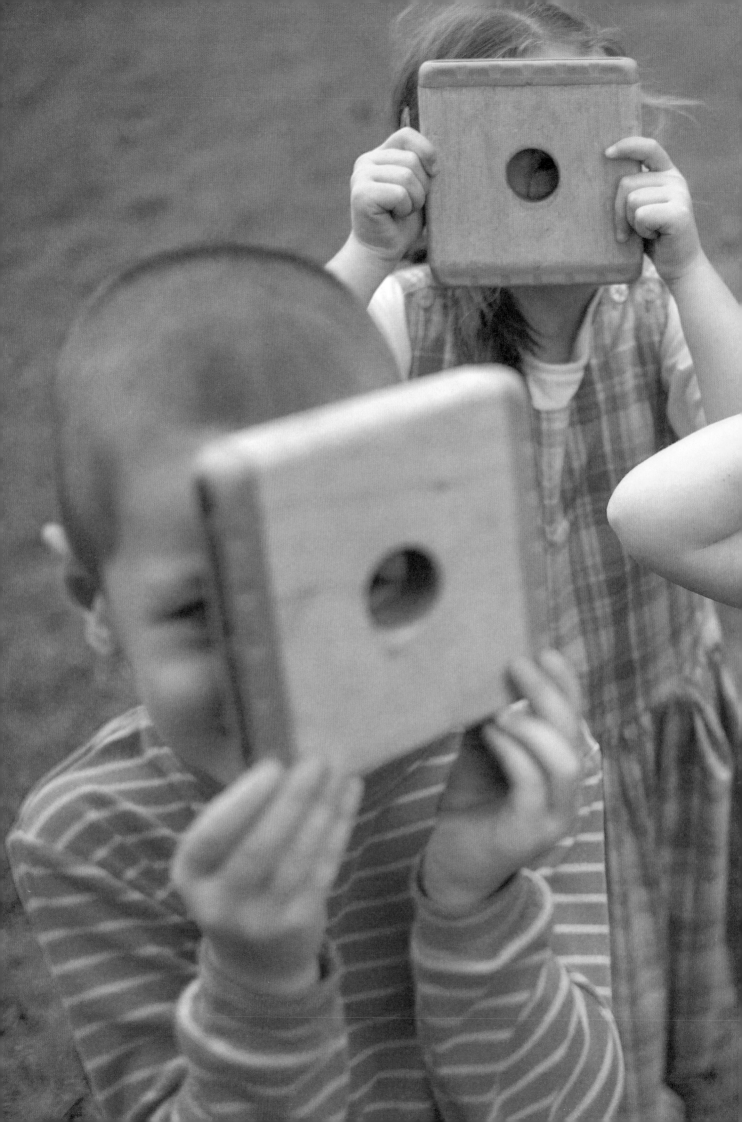